The Collector's Eye

The Collector's Eye

The Ernest Erickson Collections at The Brooklyn Museum

Linda S. Ferber

Diana Fane

Richard A. Fazzini

Robert S. Bianchi

James F. Romano

Amy G. Poster

Sheila R. Canby

The Brooklyn Museum

Printed for the exhibition
The Collector's Eye:
The Ernest Erickson Collections at The Brooklyn Museum

The Brooklyn Museum
March 27–May 18, 1987

The Brooklyn Museum, through the Department of Cultural Affairs, receives continuing support from the City of New York. The Museum also receives general operating support from the New York State Council on the Arts.

Library of Congress Cataloging-in-Publication Data

The Collector's eye.

 Catalog of an exhibition held at the Brooklyn
Museum, Mar. 27–May 18, 1987.
 Bibliography: p.
 1. Art, Ancient—Middle East—Exhibitions.
2. Art, Ancient—Asia—Exhibitions. 3. Indians
of North America—Art—Exhibitions. 4. Eskimos—
Art—Exhibitions. 5. Erickson, Ernest, 1893–1983—
Art collections—Exhibitions. 6. Art—Private
collections—New York (N.Y.)—Exhibitions.
7. Brooklyn Museum—Exhibitions. I. Ferber,
Linda S. II. Brooklyn Museum.
N5335.N4B763 1987 708.147'23 87–698
ISBN 0–87273–108–1

Cover: *Fragment of a Skirt* (Detail). Peru, South Coast, Paracas. 300–100 B.C. Wool, plain weave, single-face embroidery, 61 x 17¼ inches (155 x 44 cm). 86.224.112 (cat. no. 3)

Published by The Brooklyn Museum, 200 Eastern Parkway, Brooklyn, New York 11238.
Typeset in Sabon and printed in the U.S.A. by Meriden-Stinehour Press, Meriden, Connecticut.
Designed by Richard Waller. Edited by John Antonides and Elaine Koss.

Contents

Preface

This catalogue celebrates the gift of the Ernest Erickson Collections to The Brooklyn Museum. In making this historic gift, the Ernest Erickson Foundation continues the dedication of its founder to the growth and well-being of this great institution. The Brooklyn Museum is committed, as was Ernest Erickson himself, to the preservation of our cultural heritage and to the education of the public. The Museum's Board of Trustees, on which Mr. Erickson served with distinction for so many years, is deeply grateful and honored to accept this magnificent gift.

Alastair B. Martin
Chairman, Board of Trustees
The Brooklyn Museum

Acknowledgments

Many individuals have been helpful in the research and preparation of the exhibition and of this catalogue, and to all we extend our deep gratitude. In particular, the staff at the Museum is immensely grateful to Per Bjurström, Director, and Carl A. Nordenfalk, Director Emeritus, National-museum; Dr. Bengt Peterson, Director of the Museum of Mediterranean and Near Eastern Antiquities; and Dr. Jan Wirgin, Director, Museum of Far Eastern Antiquities, all of Stockholm. We also wish to extend special thanks to those whose expertise, advice, and support have made this exhibition and publication a reality: John Antonides, Jane Carpenter, Pramod Chandra, Tom Cummins, Christine Giuntini, Ellen Howe, Susan and John Huntington, Julie Jones, Lois Katz, Elaine Koss, William Lyall, Barbara Stoler Miller, Kenneth Moser, Antoinette Owen, Ellen Pearlstein, Ann Rowe, Ann Schelpert, Robert Skelton, Donald M. Stadtner, Rebecca Stone, Jeffrey Strean, and Richard Waller.

Color Plates

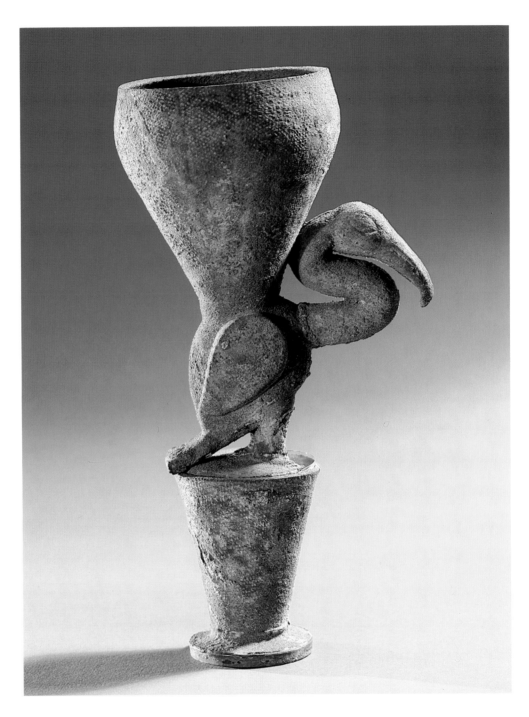

Plate 1
Goblet with Bird
Peru, North Coast, Chimu
1100–1500
Hammered silver, 9½ x 3¾ inches (24.1 x 9.5 cm)
86.224.203 (cat. no. 43)

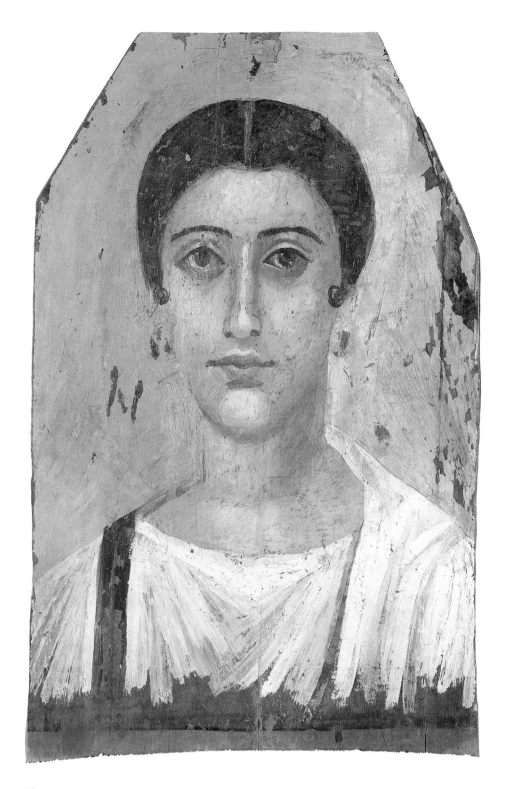

Plate 2
Portrait of a Noblewoman
Egypt, attributed to the site of Fag el-Gamus, within the Fayyum
Roman Period, circa 150
Encaustic on wooden panel, 17⅜ inches (44.0 cm) high
86.226.18 (cat. no. 89)

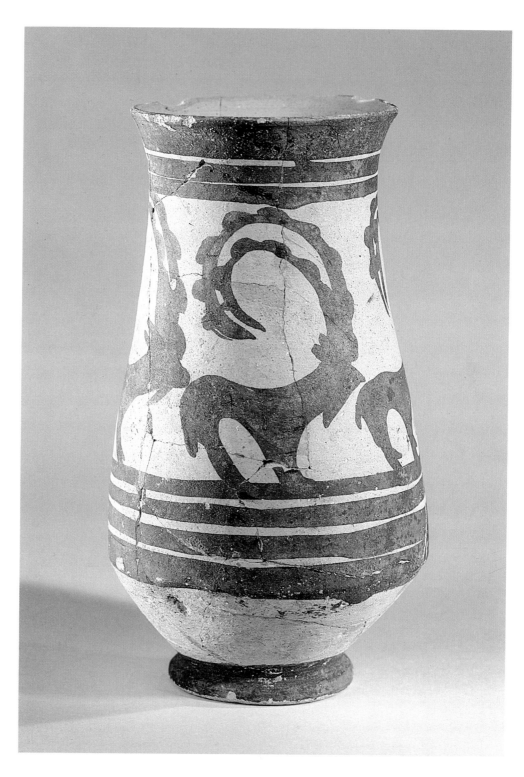

Plate 3
Beaker with Row of Ibexes
Central Iran, Kashan Region
Sialk III Period, circa 3200–3000 B.C.
Wheel-made painted pottery, 7¼ x 3⅜ inches (18.4 x 8.6 cm)
86.226.59 (cat. no. 90)

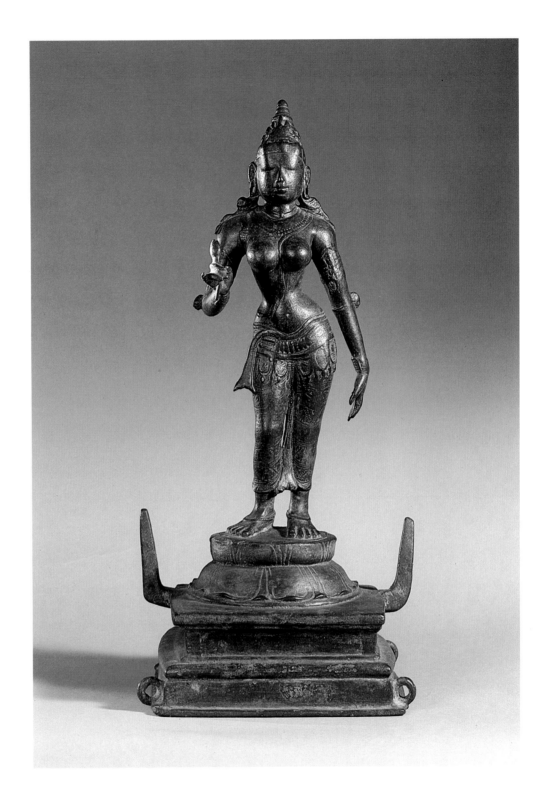

Plate 4
Parvati
Southern India, Tamil Nadu
Chola Period, 10th century
Bronze, 16¾ inches (42.5 cm) high
86.227.27 (cat. no. 107)

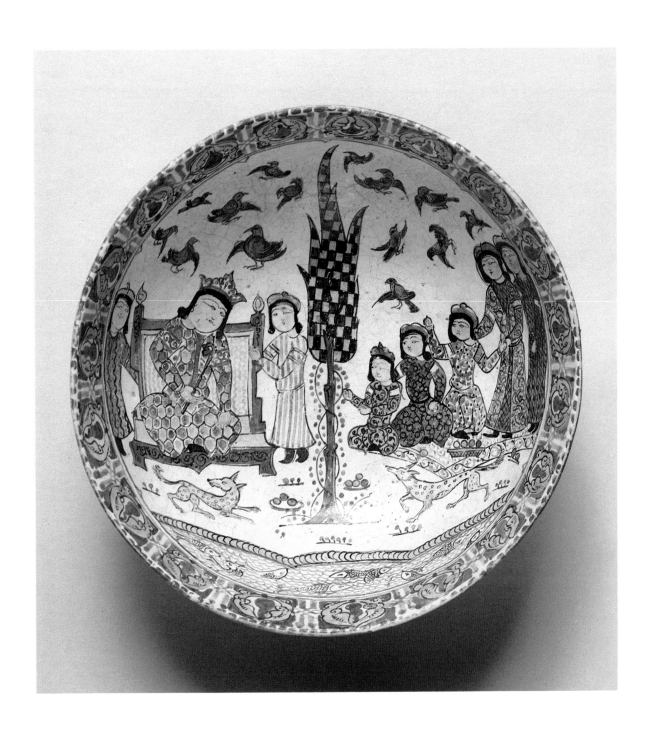

Plate 5
Bowl
Iran
Late 12th–early 13th century
Ceramic: black, red, gold-leaf overglaze;
green, brown, yellow, cobalt blue, and turquoise inglaze;
opaque white glaze; white frit body, 3⅜ x 8½ inches (9.5 x 21.0 cm)
86.227.61 (cat. no. 170)

15

Foreword

A great private collector can nourish a great public collection in many ways. So did Ernest Erickson, who was a member of The Brooklyn Museum Board from 1965 to his death in 1983, through the generosity of gifts, loans, and wise counsel, inspire generations of curators, directors, and fellow trustees at The Brooklyn Museum. Spurred by what he called his "social conscience," Erickson combined private passion and a delight in objects with a grand liberality in a lending program that spanned four and a half decades. He was as determined during this time to keep his identity private as he was to make his collection available to the Museum's visitors.

A collection is not a random accumulation of objects but rather the result of a quest fueled by both aesthetic and intellectual passion. There can be no doubt that Ernest Erickson was driven by both to an extraordinary degree, for he created a collection whose encyclopedic range, grand scale, and superb quality are almost unbelievable. The gift of the Ernest Erickson Collections is one of the most important events in the Museum's history in this century. The revelation, at last, of his identity as a great connoisseur and public benefactor is of special satisfaction to those who have known of his mission over these many years and is perhaps the most fitting tribute to his memory.

I am especially pleased to be able to acknowledge the vital role of Abraham Guterman, President of the Ernest Erickson Foundation, and his board colleagues for enabling The Brooklyn Museum to acknowledge the full measure of Mr. Erickson's discernment and involvement here over so many years. This exhibition, featuring objects in many fields, was an undertaking of large proportions, both in the scope and volume of the artworks and in the number of individuals who helped to make the exhibition possible. In addition to other ongoing duties, Dr. Linda S. Ferber, the Museum's Chief Curator, worked tirelessly and efficiently to organize this presentation spanning five collections and orchestrating perfectly the catalogue and installation of the exhibition. I am much indebted.

Ernest Erickson's appetite for beautiful objects and his extraordinary capacity to make them his by building such remarkable holdings, which he then shared, are the essence of American museums.

Robert T. Buck
Director
The Brooklyn Museum

Profile of a Collector

Linda S. Ferber
Chief Curator
The Brooklyn Museum

In welcoming you to this exhibition I hope that you will find objects which arrest your steps and that you will enjoy them as much as I have enjoyed acquiring them during forty-odd years of study and relaxation.

These words of welcome, with which Ernest Erickson concluded the Foreword to the catalogue of The Brooklyn Museum's 1963 exhibition of his Asian art collection, seem an appropriate epigraph with which to open this catalogue of all his collections at The Brooklyn Museum. With this publication, thanks to the generous gift of the Ernest Erickson Foundation, nearly five hundred objects that Mr. Erickson loaned to the Museum in the forty some years before his death in 1983 have now found a permanent home. Henceforth we can say with certainty that here, in the institution where they have long played an integral part, they will continue to arrest the steps of visitors for years to come.

Born in 1893 in Åland, an island belonging to Finland, Ernest Erickson came to the New World in 1923 and served successfully for many years as president of the Pulp Sales Corporation, sole outlet and distributor for all Finnish wood pulp to the paper industry of North America and portions of South America. While his formal training and education were practical and technical in nature rather than academic, his innate intellectual and aesthetic appetites stimulated an insatiable curiosity about the world's peoples that in turn fed his lifelong passion for the study of their artifacts and artworks. To the end he considered himself a student rather than a collector.

Having begun to collect during the Depression years, and buying well even then, Mr. Erickson started placing objects on loan to the Museum as early as 1942. Believing that art objects should be exhibited "without diverting the viewer's attention to their ownership," he always insisted on anonymity, a standing he relinquished only on the occasion of the exhibition in 1963. Though it may seem paradoxical that so private a collector—and one who considered the contemplation, study, and apprecia-tion of an object "an intensely personal experience"—should have placed most of his vast holdings in public institutions as long-term loans, he had a specific motive for his program of lending. Over the decades he loaned hundreds of objects, many upon purchase, to public collections in both America and Scandinavia in order to help "Westerners to better understand another culture."

At The Brooklyn Museum, Mr. Erickson's contribution took the form not only of loans but of service on the Board of Governors, of which he was an active member

from 1965 to 1976, when he became an honorary Governor. He was, in the words of one Governor, "possibly the most knowledgeable art collector to be a member of the Board in the past fifty years." While a natural reserve as well as a collector's sense of competitiveness seems to have added to his innate desire for privacy, he was on close terms with a succession of curators, in whose "business" he was intensely interested. Because he delighted in collecting and imparting art-world gossip, in sharing information about the market and private collections, and in searching for objects that would complement not only his own loans but the Museum's holdings as well, he must have relished being cast in a 1968 *New York Times* article as the anonymous "treasure scout" who recognized a section of the tomb of Nespeqashuty at a dealer's and alerted the Museum curator who acquired it.

Conversations with those who knew him confirm that Mr. Erickson was always looking, always collecting, and always in touch with dealers all over the world. The extent to which he traveled in the quest for unusual objects of high quality is indicated by the following itinerary from a letter of 1971: "I will stay at Djursholm (Sweden) until September 20 when I leave for Athens, Crete, Beirut, Iran, Kabul, Peshawar, Lahore, Karachi, New Delhi, Bombay (provided war hasn't broken out) and then home by October 19th." Despite the deposit of most of his holdings in public collections, few have realized the extent of these holdings, in large part because of his insistence on anonymity. The Foundation's inventory of his collection fills several volumes, a testimony to a lifetime devoted to the search for and possession of significant works.

Except for a small collection of medieval objects, Mr. Erickson focused his energies on ancient and non-European cultures. Unlike some collectors, he was unreserved in his appreciation for and understanding of archaeological artifacts. Nor was price a barometer for him of the intrinsic quality and value of an object. In fact, he was legendary for his determination to get the best for the least, once wryly observing of a white limestone Egyptian head of Dynasty XVIII offered to him that it "would be just as beautiful at half the price." This desire to purchase within his limits, together with his passion for quality, led him far afield, both literally and figuratively, as he sought new areas to explore well ahead of collecting trends and fashions. The ultimate tribute to his acumen and connoisseurship is summarized in one collector's observation that although "he got more out of his dollars in collecting than almost anyone . . . , the collection he left does not give the impression it was created with any limit on funds."

Curators and collectors who knew Mr. Erickson are unanimous on two points: he pursued his mission with a passionate, even compulsive, energy, and he had an instinct for quality that held true no matter what field he entered as a collector. In attempting to explain this instinct in 1963, he wrote of the mysterious chemistry between collector and object, the result of which he aptly termed "delight":

> *It is a very complex feeling which is extremely difficult to express in words to someone else. It is not enough to say that your conception is made up of a number of details like composition, form and balance, surface texture, color values, etc. The thing that gives an object life and meaning must come from inside yourself, a synthesis of years of accepting and rejecting what you have been fortunate in seeing and experiencing.*

According to one longtime acquaintance, Mr. Erickson's connoisseurship was ultimately based on an emotional reaction "born in him." He was like an artist in his response to objects, and his creative act was to build his collection in the hope of sharing that response—in his own words, "an aesthetic satisfaction, a kind of nirvana"—with others.

Although the illness of his last few years forced Mr. Erickson to curtail his travel, he remained interested in the business of the museum and art worlds until his death. At that time, The Brooklyn Museum's Board of Trustees hailed him as "a distinguished collector and friend."

The most fitting tribute to Ernest Erickson's memory, however, is the magnificent gift in his name of this great collection, a collection that has for so long enriched The Brooklyn Museum.

Catalogue

This catalogue of the exhibition is arranged by collection in the following order: Ancient Andean and North American Indian; Ancient Egyptian; Ancient Iranian; Indian and Southeast Asian; and Islamic art. Dimensions of the artworks are given first in inches then in centimeters; height precedes width precedes depth.

Ancient Andean and North American Indian Art

Diana Fane
Curator of African, Oceanic, and New World Art
The Brooklyn Museum

In March 1942 Ernest Erickson wrote a cordial letter to Dr. Herbert J. Spinden, the Curator of American Indian Art and Primitive Cultures at The Brooklyn Museum, introducing himself as a collector of "Pre-Inca Art Objects" and offering to lend the Museum his "small but . . . representative" collection should it prove to be "of interest and complementary to The Brooklyn Museum's permanent exhibit." In the concluding paragraph he succinctly stated his objective: "Permit me to add that this proposal is made with the desire to make these Pre-Inca Art Objects available to a large segment of the population of Greater New York, especially at this time when interest in and better relations with the South American Republics is being systematically developed."

Mr. Erickson's letter could not have been more welcome. Since becoming Curator in 1929, Spinden had devoted most of his time and energy to increasing the Museum's representation of ancient American art. Committed to furthering an understanding of Latin American culture and history in the United States, he had organized a major exhibition of the colonial and folk art of Latin America in 1941, collecting most of the material himself while on a lecture tour of South America for the State Department's Coordinator of Inter-American Affairs. Mr. Erickson's enthusiasm for Andean art and his recognition of the strategic role the Museum could play in increasing the public's awareness of it were precisely the response Spinden had hoped the exhibition would elicit, and the fact that Mr. Erickson's collection included rare and unique objects made his offer even more attractive. Within months the Museum had held a special exhibition of the collection. Not surprisingly, considering the quality of the art and the mutual interests of the individuals involved, it was a great success. No one was more pleased than Mr. Erickson himself. "I felt as if I had really seen my collection for the first time," he wrote to Spinden, and from that time on the collection remained an integral part of the Museum's South American holdings.

The more than twenty-five objects in a variety of media that Mr. Erickson offered as loans to the Museum in 1942 had originally been part of the Mandiola Collection, which had reportedly been brought from Peru in 1927 or 1928. Although we do not know when Mr. Erickson acquired these objects, they were probably his earliest and certainly some of his most important acquisitions in the Andean field. Included was a major textile, a Huari shirt that Mr. Erickson believed to be the "only one in existence in the U.S.A." (see cat. no. 35). Metalworking traditions were represented by a charming, virtually unique gold flute (cat. no. 42), while ancient wood carving was exemplified by a rare, remarkably well-preserved mirror handle (cat. no. 40) that was later included in the exhibition *Ancient Arts of the Andes* at New York's

Museum of Modern Art in 1954. These exquisitely crafted objects not only introduced Mr. Erickson to the richness and diversity of Peru's artistic heritage but also set the standards for his subsequent acquisitions.

Between 1942 and 1970 Mr. Erickson acquired Peruvian pieces practically every year, making them available to the Museum for exhibition and study purposes. In the 1960s he also contributed loans of African, Oceanic, Mexican, and North American Indian material, including the nine Native American objects exhibited here. In broadening the scope of his collection Mr. Erickson made no attempt to be comprehensive or even representative. The quality of the object, rather than its provenance or type, determined his choices. He was especially attracted to virtuoso craftsmanship wherever it occurred. Hence his selection of Native American art included an elegant tool (cat. no. 62), as well as intricately carved ceremonial rattles and charms (cat. nos. 64–68).

Mr. Erickson's commitment to and understanding of his Andean collection was profound. He fully realized that ownership of such culturally significant artifacts entailed responsibilities, and he did what he could to conserve the collection and make it accessible to both scholars and the general public. This portion of the exhibition is another step in the process Mr. Erickson initiated in 1942; it reflects the time and knowledge of specialists in a number of different fields. In particular I would like to thank the following individuals: Heidi King, Research Assistant, The Metropolitan Museum of Art, New York, for the entries on Andean metalwork; Ira S. Jacknis, Assistant Curator for Research, The Brooklyn Museum, for the entries on Native American art; Elena Phipps, Conservation Assistant, The Metropolitan Museum of Art, for the analysis of the Andean textiles; and Maria Manzari Cohen, Departmental Assistant, The Brooklyn Museum, for research on the collection and invaluable administrative help.

1 *Bowl*

Peru, South Coast, Paracas
500–200 B.C.
Ceramic, paint, 2 × 8¾
 (5.0 × 21.3)
86.224.200

2 *Bottle*

Peru, South Coast, Paracas
500–200 B.C.
Ceramic, paint, 3¼ × 3½
 (8.2 × 9.0)
86.224.192

This shallow bowl and small bottle, dating from the fifth to the third century B.C., are the oldest Andean pieces in Ernest Erickson's collection. Both are blackware decorated with incised designs and a thick resinous paint applied after firing. The technique and designs are characteristic of the Paracas culture, named after the peninsula where it was first discovered by the great Peruvian archaeologist Julio Tello (Tello 1959). Paracas-style ceramics have also been found in other parts of the southern coastal region of Peru. In fact most of the information we have on the development of this early artistic tradition is based on ceramics from sites in the Ica valley to the south of the Paracas Peninsula (Menzel, Rowe, Dawson 1964). A small number of Paracas vessels have been excavated in the Rio Grande de Nasca area (Strong 1957). Although there is no provenance for the Erickson bottle, the bowl has a label ("Pernil, Rio Grande, Florita") indicating that it may be from the Nasca region.

The designs incised on the outside of the bowl represent a "gliding bird" (Menzel, Rowe, Dawson 1964), a motif that often alternates with a feline mask on Paracas bowls. Here the bird's prominent eye and curved beak are easily recognizable, while its body and wings are lost in an abstract pattern of vertical bands. Inside the bowl is a freer design of concentric circles with curls and dots. The decoration on the bottle, while much simpler, is also organized in bands, with a guilloche design marking the shoulder.

The linearity and segmentation of the incised designs on these vessels recall the stone-carving style of Chavín de Huantar, a religious site in the central highlands of Peru that rose to prominence in the first millennium B.C. Chavin influence is also evident in the guilloche pattern on the bottle. Local artisans made the Chavinoid motifs their own, however, by adapting them to new vessel shapes and, most important, by adding color. Polychromy, first introduced in the Paracas Period, became a salient feature of the South Coast regional style. DF

3 *Fragment of a Skirt* (Detail)

Peru, South Coast, Paracas
300–100 B.C.
Wool, plain weave: warp 12, weft
 12 per cm; single-face
 embroidery, 61 × 17¼
 (155.0 × 44.0)
86.224.112
(Detail illustrated in color on cover)

Among the most spectacular Peruvian funerary offerings ever found are the richly embroidered garments from the Necropolis burial ground on the Paracas Peninsula (Tello 1959). This skirt in the Paracas Necropolis style has a border embroidered with vivid shades of red, green, yellow, and blue. The basic design motif—a figure in a square—is repeated with variations in the color and the direction of the figure, which has the round staring eyes and protruding tongue of a deity known in Paracas iconography as the "oculate being." Also characteristic of this deity are the serpentlike appendages that emerge from the figure's head. Each appendage on this example has two eyes and a mouth indicated by embroidered dots.

The "oculate being" is associated with a trophy-head cult and is frequently shown with a knife or trophy heads in his hands. Here he holds what appears to be a knife in one hand and a staff in the other. Because these objects are silhouetted in solid colors, it is difficult to be sure of their identification.

The skirt has been cut from its original length. Paracas skirts were generally long enough to wrap around the hips several times and were secured by woven bands attached to the upper edge of the skirt like suspenders. The embroidered designs went along the lower edge and up one side. When this skirt was worn, the figures on it would appear in a horizontal position, alternately facing up and down. DF

26

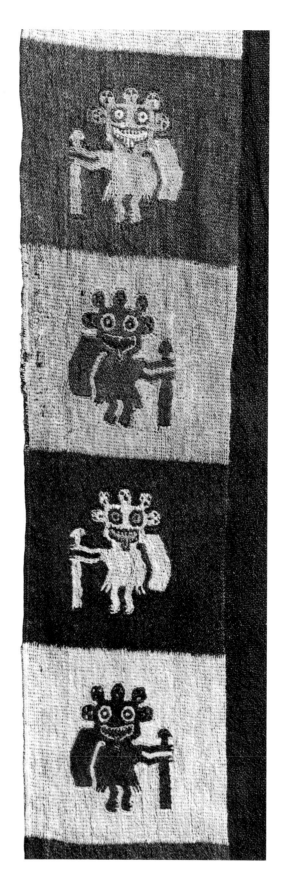

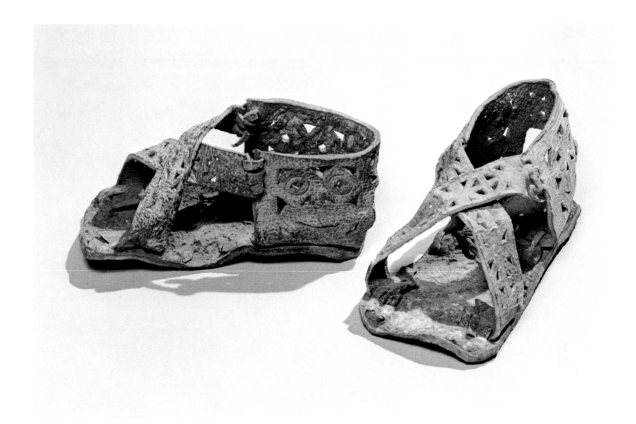

4 *Sandals*

Peru, South Coast, Paracas (?)
300–100 B.C.
Leather (llama skin), 4 × 2
 (10.2 × 5.1) each
86.224.103 a,b

These elegant little sandals are made of three separate pieces of llama skin joined by thongs. The leather of the upper part is cut in a decorative pattern of triangles with a stylized face on each side of the ankle support. Since the sandals are only four inches long, they must have belonged to a child.

Sandals are surprisingly rare in Peruvian collections, and little is known about their regional distribution or stylistic development (Montell 1929, 129). Because this pair is well preserved, a South Coast provenance seems likely; there are several indications that they belong to the Paracas culture. The face at the ankle resembles the "oculate being" that frequently appears on Paracas embroideries, painted textiles, and ceramics. And a similar pair of sandals is illustrated as part of a Paracas outfit in an early publication on Paracas artifacts (Carrión Cachot 1949, pl. XVII). Unfortunately the sandals are not discussed in the text, so there is no information on their size or burial context.

It is possible that sandals were especially associated with children's burials. According to Mary Elizabeth King, Pablo Soldi reported finding sandals of llama skin on children's mummies at Paracas sites. She notes, however, that sandals are conspicuously absent from Paracas mummy bundles that have been catalogued and concludes that the Paracas people "did not, as a rule, wear footgear, though they obviously were familiar with sandals and occasionally made them" (King n.d., 322). DF

Exhibited: *Ancient Art of the Americas*, The Brooklyn Museum, New York, November 1959–January 1960.

5 Bowl

Peru, South Coast, Nasca
100 B.C.–A.D. 1
Ceramic, polychrome slip,
3⁹/₁₆ × 5½ (9.0 × 14.0)
86.224.14

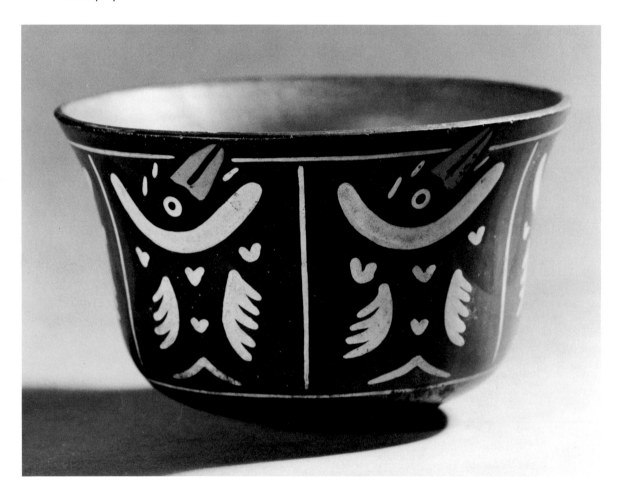

Nasca polychrome pottery is a direct outgrowth of the earlier Paracas style. Although there is a notable continuity in the vessel shapes and design vocabulary, Nasca artists substituted brightly colored clay slips for the post-fired paints their predecessors had used. They fired the decorated vessels in an oxidizing atmosphere, producing lustrous and durable surfaces that contrast sharply with the matte appearance of Paracas pots.

This bowl is an excellent example of the early Nasca style, which is characterized by relatively simple compositions and naturalistic depictions of animals, birds, and vegetables native to the South Coast. Six birds are represented in a ring around the vessel.

They are pictured as though poised for flight, and their potential for movement is emphasized by their beaks, which break through the line that encircles the bowl's rim. The birds have a white collar and whiskers, distinguishing attributes of the *vencejo*, a type of swallow common on the coast of Peru. These birds appear most frequently in periods of high humidity and may, therefore, have been associated with moisture and, by extension, with success in agriculture (Yacovleff 1931). In any case they are a favorite motif of Nasca painters and have a long history in the ceramic art of the South Coast.

DF

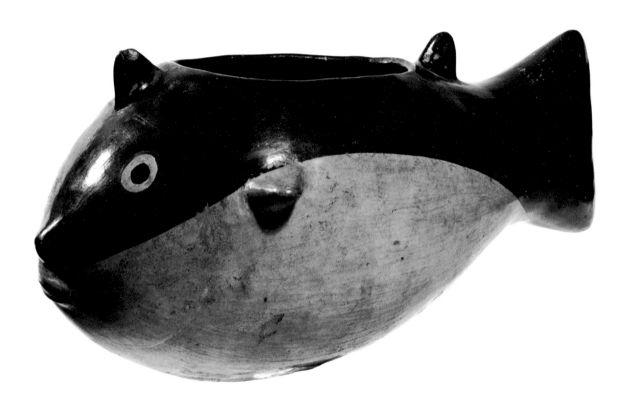

6 *Effigy Vessel*

Peru, South Coast, Nasca
100 B.C.–A.D. 200
Ceramic, polychrome slip,
 4^{15}/₁₆ × 8^{5}/₁₆ (12.5 × 21.1)
86.224.5

Although agriculture was the primary economic base in the Nasca Period (100 B.C.–A.D. 700), fish were an important supplement to the diet. Marine life is abundant in the coastal waters of Peru because of the Humboldt Current, which brings in a constant supply of fresh cold ocean water rich in nutrient salts. Nasca artists represented the bounty of the sea on painted vessels in a variety of styles.

A common motif on early Nasca bowls is a conventionalized fish with both dorsal and ventral fins. The body is divided longitudinally with the upper part painted in dark brown, black, or red and the stomach a light cream color. These plump fish often appear as the only decoration on the inside of shallow bowls. The effigy vessel seen here is a rare three-dimensional version. It is a fine example of Nasca modeling, a technique that was secondary to painting on the South Coast, and with its slightly pouted lips and snub nose has a timeless appeal.

29

7 *Jar*

Peru, South Coast, Nasca
A.D. 100–300
Ceramic, polychrome slip,
 4⁵⁄₁₆ × 4⁵⁄₈ (11.0 × 11.7)
86.224.17

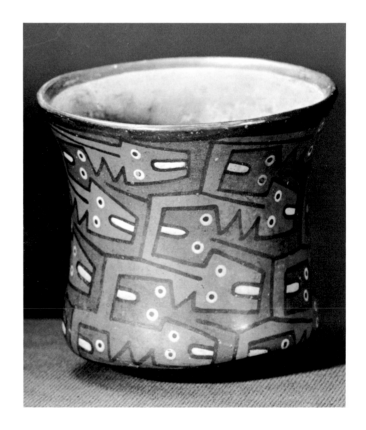

Fish are also the subject of the wide-mouthed jar dating to the Middle Nasca Period. Here they are represented as an overall decorative design in dark shades of red, orange, and brown with white paint emphasizing the eyes and mouth. Known as the "interlocking fish" motif, this distinctive pattern first appeared on Nasca pots after the first century A.D. (Gayton and Kroeber 1927). Not surprisingly, considering the intertwining elements that comprise the design, the pattern is also found on Peruvian textiles. DF

8 *Effigy Vessel*

Peru, South Coast, Nasca
100 B.C.–A.D. 200
Ceramic, polychrome slip,
5¹¹⁄₁₆ × 5⅛ × 6⅛
(14.5 × 13.0 × 15.5)
86.224.57

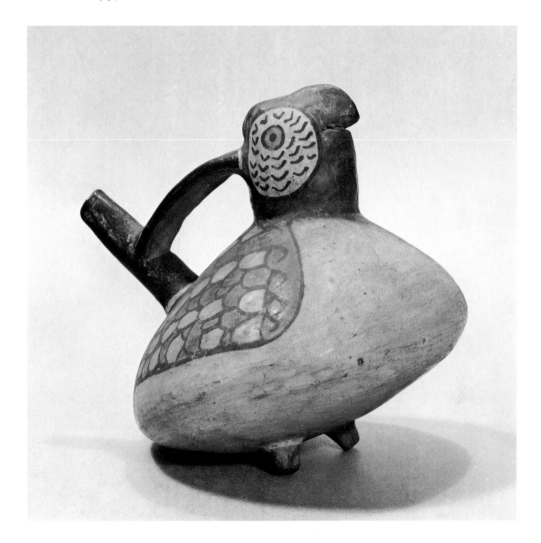

Like the fish (cat. no. 6), this vessel in the form of a bird testifies to the early Nasca artists' interest in the animals that shared their world. Avian imagery included local swallows (cat. no. 5) and sea birds as well as exotic imports from the Amazonian basin such as the parrot represented here. Parrots must have been prized, then as now, for the beauty of their feathers and their mimetic skills.

The parrot's large head and curved beak are modeled as a simple mass, while the eyes, face markings, and feathers are painted in subtle shades of brown, gray, and cream. Two little lugs of clay, painted brown, serve as feet on the vessel's rounded base, supporting the bird, somewhat unsteadily, with chest raised high. Nasca vessels are never flat on the bottom, presumably because they were designed to be set in sandy floors (Kubler 1975, 300). DF

9 *Double-Spout Vessel*

Peru, South Coast, Nasca
A.D. 100–300
Ceramic, polychrome slip,
 6³⁄₁₆ × 6³⁄₁₆ (15.7 × 15.7)
86.224.15

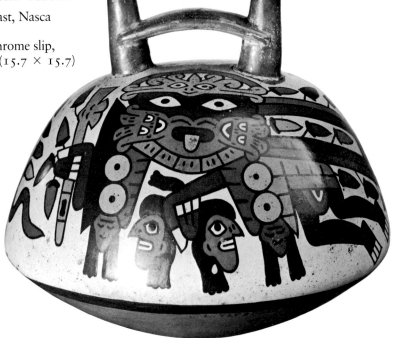

Head-hunting is an ancient and highly charged subject in the art of the South Coast of Peru. Trophy heads and knives appeared with some frequency on the textiles and ceramics of the Late Paracas Period (400–100 B.C.), and in the Nasca Period head-hunting became a major theme on pottery. This excellent example of the fully developed polychrome style dating to the Middle Nasca Period illustrates some of the associations head-hunting had for the Nasca.

The pot is dome-shaped with twin spouts joined by a straplike handle ("double spout and bridge"), a vessel type with a long history on the South Coast. As the spouts emerge from the top, a continuous curved surface is created for the painted decoration. Here two identical figures clasping severed human heads in one hand and a digging stick and cluster of vegetables in the other are represented as though floating against a white background. The figures wear elaborate costumes consisting of a forehead ornament, mouth mask, pendant disks, shirt, breechcloth, and cape painted in flat deep shades of red, yellow, orange, brown, and gray. The emphasis is on the figure's head, and head motifs abound: little faces animate the fore-

head ornament, mask, and digging stick, while small heads with closed eyes, presumably representing trophy heads, hang from the pendant disks. A profusion of vegetables decorate the cape, which ends suddenly in an animal's tail.

Masked individuals with these attributes are common in Nasca art. Though they have generally been identified as mythical personages or demons, it is possible, as Richard Townsend has recently argued, that they are men in costume who functioned as "living, moving, cult images" in religious ceremonies (Townsend 1985). Townsend's theory is supported by archaeological finds of actual costume elements such as the gold mouth mask in the Erickson Collection (see cat. no. 12).

Whether real individuals or mythical creatures, these figures are clearly involved in both head-hunting and the harvesting of crops. Plants and severed heads are frequently associated in Nasca iconography, suggesting that head-hunting was not exclusively a military activity. Instead it seems to have been perceived as analogous to reaping the fruits of the earth and was linked to life as well as death. DF

32

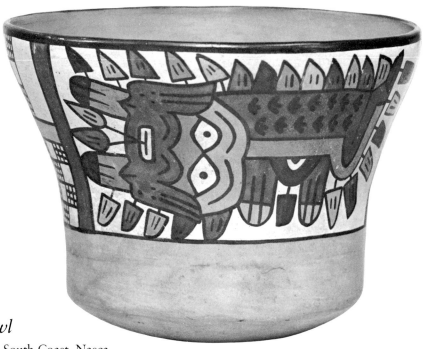

10 *Bowl*

Peru, South Coast, Nasca
A.D. 100–300
Ceramic, polychrome slip, 4¼ × 5¾
 (10.8 × 14.6)
86.224.113

The extraordinarily complex figure that appears to be flying around this bowl is essentially a feline with a spotted pelt and curved tail (Wolfe 1981). Two of its legs extend out in front and two drop down from the side, flanking a breechcloth. A large mask surrounds the cat's mouth and stylized plants project from all parts of its body. Because the whiskers on the mask stand straight up, it has been suggested that this multifaceted creature may be a mythical version of an otter, commonly called the *gato de agua* (cat-of-the-water), rather than a feline (Sawyer 1961). The absence of claws or fangs and the presence of human costume elements (the mask and the breechcloth) are also worth noting.

Felines associated with plants are a major theme of Nasca ceramic art and have been interpreted as guardian spirits of agriculture (Sawyer 1966). Because felines prey on rodents and other small animals that endanger crops, they do indeed help farmers. The ancient Nasca must have welcomed this hunting pattern and considered the feline a powerful ally. DF

33

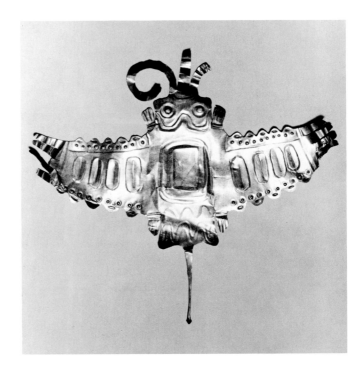

11 Oranament, Perhaps a "Dance Wand"

Peru, South Coast, Early Nasca
100 B.C.–100 A.D.
Hammered gold, 11½ × 13⅜
(29.2 × 33.5)
86.224.126

In contrast to the exquisite textiles and fine ceramics produced on the Peruvian South Coast during the Paracas and Early Nasca Periods, the metalwork made there then is extremely simple in design and technique. Technologically it had not advanced beyond what had been achieved by the skilled Chavin Horizon goldsmiths who lived on Peru's North Coast several centuries earlier. It consists mostly of two-dimensional sheet gold ornaments with simple repoussé decoration. These ornaments were attached to textiles, worn as face and head ornaments, or held.

One such example is this "dance wand" cut from thin, flexible sheet gold and decorated with shallow repoussé patterns. The image has been variously interpreted as representing the well-known cat-demon of Paracas and Nasca art (Lothrop 1957), the hummingbird moth (Emmerich 1965), the bat (Tushingham 1976), or the goatsucker bird, a relative of the whippoorwill with whiskerlike feathers on both sides of its beak (Morris 1977). Morris has also suggested that it might be a combination of a butterfly's head and a bird's body.

The creature's face has two big eyes under arched eyebrows; two curved streamers or "antennae" (one broken off) and a straight "tongue" project from its mouth. To the sides of the face and tail are pairs of short feet with toes indicated by grooves. The wings are extended, with dentate top and bottom edges decorated with embossed stylized faces—just mouths and eyes—assembled in groups of five. These faces might represent trophy heads (Lothrop 1957), which appear frequently on both painted Nasca vessels and Paracas textiles and are related to the ritual head-hunting cult prevalent during these periods (Emmerich 1965). At the tip of each wing are five separate feathers, some of which are now missing. The tail is splayed but thins to a narrow, stiff rod ending in a small cone.

Several ornaments of this form are known in various collections; they sometimes occur in pairs (Dumbarton Oaks Research Library and Collection, Washington, D.C.), with or without "handles" (The Metropolitan Museum of Art, New York). The long, strong handle on this example suggests it was meant to be held, perhaps during rituals or dances. Similar ornaments without handles have holes and were probably sewn on a textile. It has also been suggested that this type of object was used as a headdress ornament (Wardwell 1968). HK

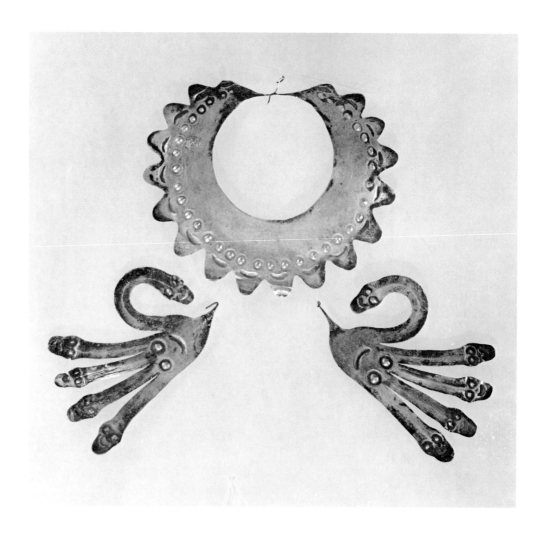

12 *Mouth Mask*

Peru, South Coast, Nasca
100 B.C.–300 A.D.
Hammered gold, 4⅝ × 5⅝
 (11.7 × 14.3)
86.224.110 a–c

Nasca goldworkers, despite their limited and simple metalworking techniques, were able to achieve striking effects with some of their objects through the use of complex cutout shapes (Wardwell 1968). A good example of this technique are mouth masks like the one shown here.

Numerous instances of faces wearing these masks on painted Nasca vessels as well as on painted and embroidered Nasca and Paracas textiles show that the masks were worn suspended from the septum of the nose. The lower part of the mask would encircle the mouth; it consists of a disk with a serrated outer edge decorated with shallow repoussé faces—just eyes and mouths—and a large central hole. The upper part seems to represent feline whiskers in serpent form; four serpents project to each side, and two curve upward and inward to encircle the nose. There are also two stylized embossed faces below the serpents' bodies.

Several mouth masks of this kind are known to exist in museum collections. Some are worked all in one piece. The separation of the parts of this mask might have occurred in modern times. HK

Published: Glubok 1966, 11.

That music played an important role in Nasca culture is clear from the number of musicians and musical instruments represented in the ceramic art. Actual clay instruments such as panpipes, drums, horns, and rattles have also been found in burials.

Ceramic panpipes have proved to be particularly interesting for the study of Nasca musicology (Haeberli 1979) and have provided insights into the clay technology. While most Nasca ceramics were built by hand from coils of clay, panpipes were cast in molds by a method known as "slip casting" (Dawson 1964). The relatively flat exterior surface of the pipes was left plain or decorated with designs ranging from simple geometric motifs to polychrome pictures of dancers in costume (Lapiner 1976, pl. 528). The paintings on this example are unusual in that they are outlined in a light color against a dark ground. In style and composition they resemble the famous Nasca groundlines that cover an area about sixty

miles long on the flat desert plain north of the Nasca valley. These remarkable landscape drawings were formed by removing the dark stones from the surface to reveal the yellow-white ground beneath. From the air they appear as a gigantic pattern of intersecting lines, spirals, and representational figures. Like the groundlines, the drawings on this musical instrument have no obvious orientation and are best understood when viewed from above.

The panpipes seem almost to have been used as an artist's sketch pad. On one side are several variations of the "killer whale" motif (Sawyer 1961, 296–98), a large spiky fish with a blunt jaw and human arm. On the other side a similar fish is depicted next to a frontal human figure holding a sling in one hand. As both killer whales and slings were associated with a trophy head cult in Nasca iconography, it is possible that the panpipes were played in ceremonies related to this cult. DF

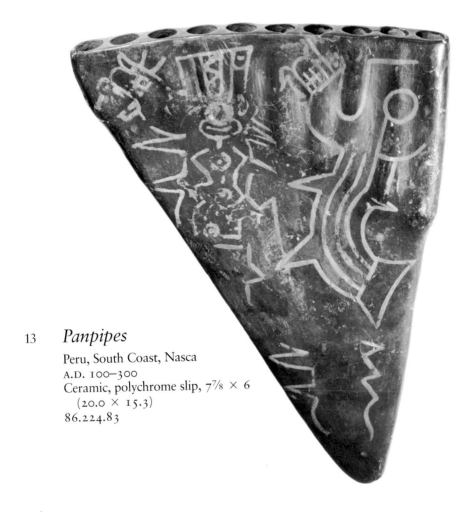

13 *Panpipes*

Peru, South Coast, Nasca
A.D. 100–300
Ceramic, polychrome slip, 7⅞ × 6
 (20.0 × 15.3)
86.224.83

14 *Jar*

Peru, South Coast, Nasca
300–400
Ceramic, polychrome slip,
 5⁷⁄₁₆ × 3⁹⁄₁₆ (15.0 × 9.0)
86.224.16

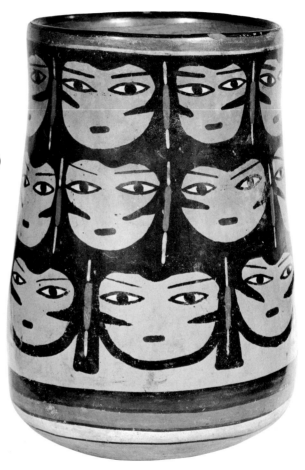

Although gender is rarely specified in Nasca art, the simple round faces painted on this jar have been interpreted as females because of the absence of facial hair (Gayton and Kroeber 1927, 45–46; Roark 1965, 27–28). With their large almond-shaped eyes and curls on their cheeks they have a disconcertingly contemporary look.

The frontal face motif was an artistic innovation of the Middle Nasca Period (Roark 1965, 27–28); it usually appears as a subsidiary element of the vessel design, organized in bands framing military or mythical subjects (see, for example, Lapiner 1976,

pl. 504). Here the faces uncharacteristically form an allover design.

Frontal female faces are a remarkably consistent motif in Nasca art. While there is some variation in the shape of the mouth, the nose (present or absent), and the hairstyle, they are always painted on a light background and outlined in black (Della Santa 1962, 134). In view of their context on other vessels, it is unlikely that these heads simply represent pretty ladies, but, in the absence of further information, it is impossible to determine their significance. DF

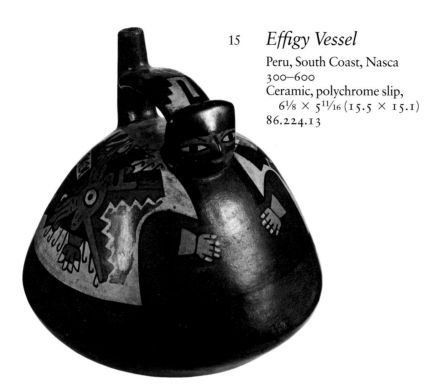

15 *Effigy Vessel*

Peru, South Coast, Nasca
300–600
Ceramic, polychrome slip,
 6⅛ × 5¹¹⁄₁₆ (15.5 × 15.1)
86.224.13

This vessel perfectly illustrates two of the main trends of the Middle to Late Nasca Period: a renewed interest in sculpture and an increased complexity in painted designs. By substituting a head for the usual second spout, the artist has managed to make the closed globular vessel read as an ample human figure. The nose and mouth are modeled, but the eyes, brows, and hair are painted, as are the hands and cape. The combination of modeling and painting is characteristic of the South Coast artistic tradition and can be traced back to Paracas times.

The figure represents a female with face paint and a sleek cap of hair that falls in tresses over her shoulders. She is dressed in a white cape painted with two fantastic creatures spewing blood from their gaping jaws. Close inspection of these monstrous designs reveals that the lower half of the body is human; the animal elements combined in the head and arms could be part of a gigantic mask. Within the context of Nasca art this masked individual or mythical creature can be understood as a late variant of the "killer whale," a motif that first appeared in the Paracas Period (Sawyer 1961, 296–98). A combination of man and predatory fish, the killer whale became increasingly abstract and complex after the third century A.D. A constant element in killer whale iconography is the blunt squared-off jaw and prominent single round eye. Late additions are the "scroll-and-lancet" motif, emerging from either side of the creature's eye, and the emphasis on blood. In representing blood, Nasca artists invariably applied the red slip unevenly on the pot without outlines so that, in contrast to the contained areas of solid color, the blood appears to be a different substance. The result is a startling note of realism in an otherwise highly conventionalized image.

The killer whale's association with death is here emphasized by the blood and by a row of cursorily drawn trophy heads painted on the banner that flies out from behind its head. Female figures with trophy head imagery painted directly on their bodies (Lapiner 1976, pl. 478) or their clothes (Eisleb 1977, pl. 197 a and b; Della Santa 1962, pl. 45) are not uncommon in Late Nasca art, suggesting that the ancient Nasca considered bloodshed and death an essential aspect of human fertility (Allen 1981). DF

38

In the Late Nasca Period artists began to paint figures on a smaller scale in compositions that can be read as narratives. The main subject of this new style of painting was war and its consequences. A number of vessels from this period vividly depict a battle in action; warriors are shown running with spears and arrows against a background strewn with blood-stained garments. Sometimes the actual confrontation between troops is shown (Benson and Conklin 1981, 67), and sometimes the warriors run around the vessel as though in flight or pursuit (Lapiner 1976, pl. 499, 500). Many of the figures in these frenetic scenes wear a distinctive headdress with a rosette, like the one worn by the severed heads painted on this miniature vessel. Other components of this headdress are jaguar skins, represented with black spots, entwined with scarves that appear to be spattered with blood.

Headdresses in ancient Peru were one of the primary indicators of ethnic identity and social status. Unfortunately we do not know the specific associations of the rosette, but it is noteworthy that it appears so frequently in military contexts and, judging by this pot, was worn by the victims as well as by the conquerors.

The small size of the bottle places it in an ancient and enduring tradition of miniatures in Andean art and makes clear its ceremonial significance. The shape, which is not a common one, reflects the Late Period's experimentation with new forms as well as innovative painting styles. DF

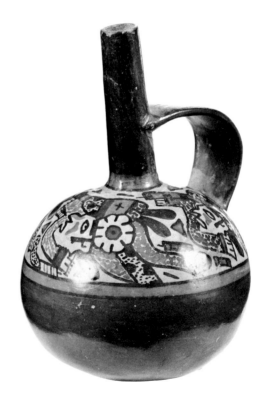

16 *Miniature Bottle*

Peru, South Coast, Nasca
300–600
Ceramic, polychrome slip,
 4⅛ × 2¹¹⁄₁₆ (10.5 × 6.9)
86.224.18

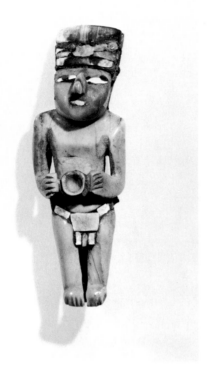
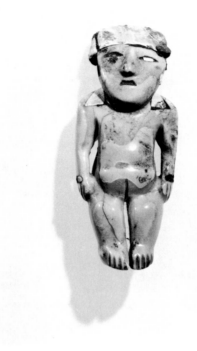

17 *Figurine*

Peru, South Coast, Nasca
300–700
Ivory, shell, stone, 2⁹/₁₆ (6.5) high
86.224.196

18 *Figurine*

Peru, South Coast, Nasca
300–700
Ivory, shell, stone, 2¹⁵/₁₆ (7.5) high
86.224.195

Nasca figurative art is well represented in the Ernest Erickson Collection by these three rare ivory carvings. Two of the figurines, a male and female (cat. nos. 17 and 18), were reportedly found together and should be considered a pair. According to a note on their catalogue card, another female figurine was found with them; unfortunately its present whereabouts is unknown.

The male of the pair holds a bowl and has pieces of shell and stone inlaid in his eyes, headdress, and loincloth. The visual effect of these bright, smooth inlays is similar to that of the ceramic slips on Nasca painted pottery: the outlines are clear and the colors vibrate. Although the front of the figure appears to be entirely human, he has a tail in the back. This tail may link him to the animal world or it may simply be part of his costume.

The female, on the other hand, has no animal traits. She is portrayed as a nude with heavy thighs and buttocks. Originally a headdress and locks of hair were represented by inlays, and a bracelet is still inlaid on each arm. It is possible that figurines such as this were dressed, for examples of clay figurines have been found fully clothed in miniature garments (for an example see Lapiner 1976, fig. 481).

The third figurine here (cat. no. 19) can be identified as a male on the basis of his facial hair, which is represented by applications of a dark resinous substance. He wears a rounded headdress made from shell inlays and resin and has bright eyes inlaid with bits of shell. Just over an inch in height, this tiny sculpture testifies to the skill of Nasca artists in carving ivory.

Practically nothing is known of the

40

19 *Figurine*

Peru, South Coast, Nasca
300–700
Ivory, shell, resin, 1¼ (3.2) high
86.224.107

function of these elegant inlaid figurines. Somewhat more common, although still comparatively rare, are clay figurines with painted details of dress (Spielbauer 1972). A few of these have been found as burial offerings in graves (Lothrop and Mahler 1957), but many are without provenance. The ivory figurines may have been elite equivalents of the clay examples.

There have been some minor losses of both the ivory and the inlay. Part of the leg and the tip of the nose are missing from the larger male figurine, and most of the inlay is missing from the female figurine's headdress and hair. DF

Published: Cat. nos. 17 and 18: Lapiner 1976, fig. 505; cat. no. 19: fig. 508.

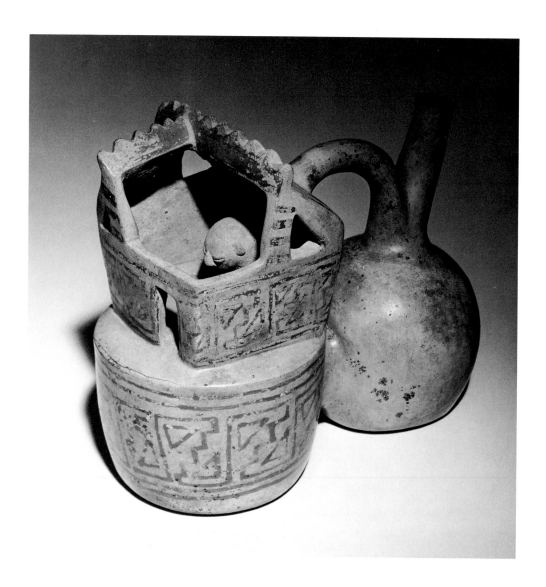

20 *Double-Chambered Effigy Vessel*

Peru, North Coast, Gallinazo (?)
300 B.C. – A.D. 200
Ceramic, bichrome slip, 7 × 8¼
 (17.8 × 21.0)
86.224.171

Much of what we know about architecture in ancient Peru comes from representations of buildings on ceramics. This finely modeled vessel in the shape of a house or temple, for instance, provides information on doorways, roof structure, and interior space. Inside the house is a mysterious little figure with a simplified columnar body and bulbous head. Neither the figure nor the house

interior is painted, but the rest of the vessel is a cream color with geometric designs in red on the house exterior and the drumlike base. As is often the case on architectural forms, a stepped motif is prominent in the painted pattern.

The vessel has been tentatively attributed to the Gallinazo culture. It was originally catalogued as Chimu, but the shape and theme are more characteristic of earlier cultures on the North Coast. Similar vessels (illustrated in Larco Hoyle 1945, 8) have been found in the Viru valley, where the Gallinazo culture flourished. DF

Exhibited: *Ancient Sculptures in Clay*, The Brooklyn Museum, December 1985–March 1986.

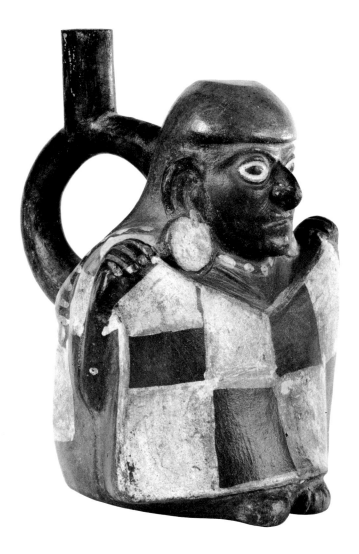

21 *Effigy Vessel*

Peru, North Coast, Moche
Phase III, A.D. 100–300
Ceramic, polychrome slip,
 7½ × 6¼ (19.1 × 15.9)
86.224.170

The Moche culture flourished in the valleys of the northern coastal region of Peru between A.D. 100 and 700. In contrast to the painterly style of the South Coast, Moche ceramic art was predominantly sculptural. The preferred vessel form was the stirrup spout pot, which Moche artists fashioned into a great variety of shapes including animals, plants, humans, supernaturals, and even mountains.

This Moche vessel depicts a seated man holding a V-necked shirt in front of his chest. He is wearing large pendant-disk earrings and a caplike headdress with a long flap hanging down his back. Over one shoulder, as though pushed out of the way of the shirt, is a striped bag hanging from a cord around his neck. The cord is represented in low relief and painted with dashes of white, creating a pattern of alternating dark and light lines. Similarly, on the shirt, squares of light cream color contrast with squares of dark brown. Squares of white paint appear on the individual's back as well, but it is not clear whether a shirt is represented by these or if they have some other meaning. The painting of this part is rather casual; the back of one arm, for example, has been left plain while the other arm is fully decorated.

Men holding shirts appear on a number of other Moche vessels (see, for example, Donnan 1978, fig. 6) and have been variously interpreted as salesmen, mourners displaying the deceased's shirt (Montell 1929, p. 34), or participants in coca ceremonies (Benson 1976, p. 31). The last interpretation is based on an analysis of fine line drawings on a pot in the Linden-Museum, Stuttgart (Benson 1976, fig. 26) in which the checkered shirt, the pendant-disk earrings, and the bag with the dark-and-light alternation on the cord are all present in a scene depicting a coca chewing rite. It is certainly likely, considering the importance of textiles in ancient Peru, that this figure is engaged in a ceremonial rather than a commercial activity. In any case the shirt he holds up allows us to see the form and design of Moche shirts of the period, most of which have not been preserved. DF

Published: Benson 1976, fig. 1.

43

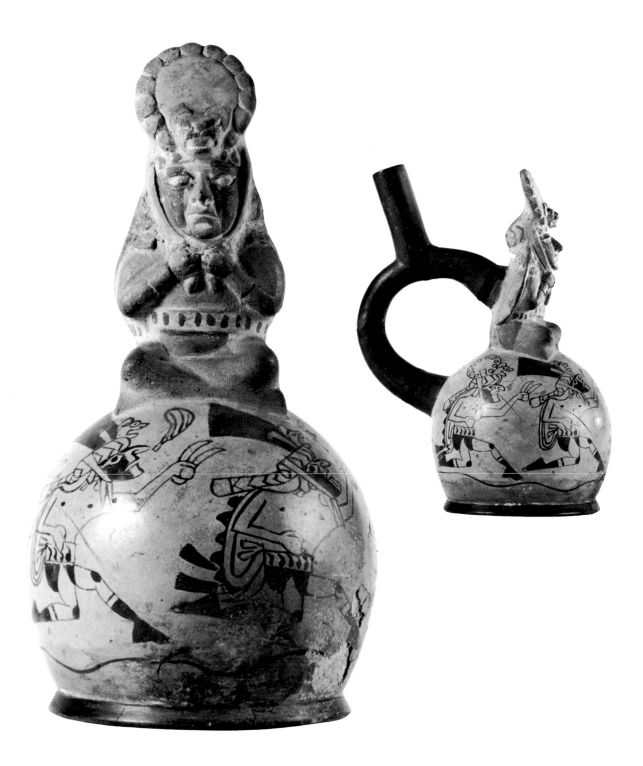

22 *Effigy Vessel* (Two views)
Peru, North Coast, Moche
Phase IV, 300–500
Ceramic, bichrome slip, 8⁷/₁₆ × 6¹¹/₁₆
 (21.5 × 17.0)
86.224.48

44

Moche artists were masters of fine line drawing as well as sculpture. Sometimes they combined the two techniques so that the drawing on the body of a vessel provides an animated context for the sculpture on top. Such is the case with the first vessel here (cat. no. 22): the seated human figure wearing an elaborate disk-shaped headdress on top of the piece appears in action in the scene below leading three similarly attired runners carrying little bags. The headdress of one of these runners is also disk-shaped, while those of the other two are shovel-shaped. An animal head is attached to the base of the superstructure of each of the headdresses. In contrast to their elaborate headgear, the runners are bare chested and wear simple kilts around their loins. Knee pads and socks complete their outfits. A wavy groundline suggests that a hilly landscape is the scene of the race. Two comma-shaped fruits, identified as ulluchu (Larco Hoyle 1939, II, 98), float in the space between the running figures, and miniature versions of this fruit adorn their belts.

In Moche graphic art both the disk-shaped headdress and the shovel-shaped headdress are consistently associated with running figures carrying bags in their outstretched hands. Another component of this theme is the lima bean or ulluchu fruit. Because of the close connection between beans and bags, it has been assumed that the bags contain beans, and actual bags containing beans have reportedly been found in the Moche area (Benson 1972, 48). As for the beans or fruits themselves, they have been variously interpreted as seeds to be distributed throughout the state, as inscribed documents, as instruments of divination, or as accounting devices. There is general agreement that the beans have an important symbolic dimension and that the runners represent a distinct group in Moche society — either priests, messengers, or warriors. Metal disks similar to those depicted on the headdresses have been found in the graves of adult males along with luxury goods, indicating that runners enjoyed considerable wealth. It is possible that Moche runners were ancestral to Inca runners, who traversed great distances in the service of the state.

The drawings on cat. no. 23 also depict runners: two large-scale figures fill most of the surface, while lima beans are scattered in the background, and uprooted desert plants float above the groundline. There are signs that this is not an ordinary race, for the

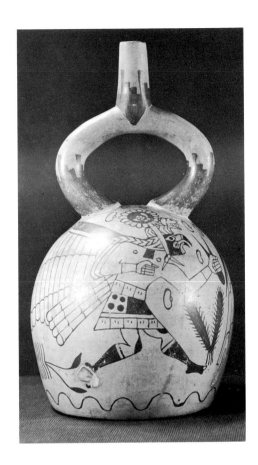

23 *Stirrup Spout Vessel*
Peru, North Coast, Moche
Phase IV, 300–500
Ceramic, bichrome slip,
 10¹³⁄₁₆ × 6⁵⁄₁₆ (27.5 × 16.0)
86.224.49
(Photograph before restoration)

runners have wings and the curved beak of a raptorial bird with sharp teeth. Although runners with animal or bird attributes are depicted frequently in Moche art, they are never shown in combination with human runners. Perhaps, as Benson has suggested (1972, 50), hybrid runners represent a mythical activity that human runners reenact. It is also possible, as Larco Hoyle has argued (1939, II, 94), that nonhuman runners are visual metaphors for the qualities of certain humans — i.e. they are as swift and powerful as hawks.

The stirrup spout on this vessel is a modern replacement. DF

24 *Trumpet*

Peru, North Coast, Moche
100–700
Ceramic, bichrome slip, 4¾ × 13
 (12.0 × 33.0)
86.224.50

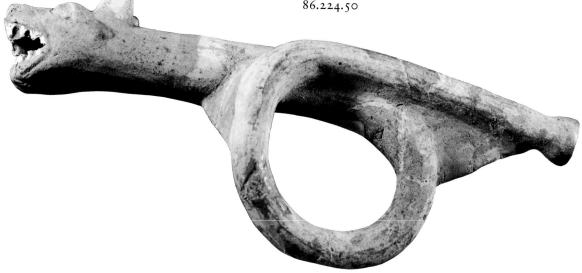

This trumpet or bugle, made of clay, ends in a feline's head. When played, the sound would have appeared to come out of the animal's open mouth. In contrast to highly burnished Moche ceramics, the trumpet has a coarse brick-colored surface. The lower part was originally slipped with white, but much of the color has worn off. There is a band of red paint around the feline's neck, and the teeth, eyes, and ears are highlighted with white paint. Whiskers are represented on either side of the nose in low relief.

Music played an important role in Moche funerary rites. Skeletal musicians are frequently depicted in a "dance of death" in drawings and reliefs on pots, and musical instruments were deposited with the de-

ceased in the grave (Benson 1972, 114). A representation of an elaborately dressed individual playing an animal-headed trumpet (illustrated in Donnan 1978, fig. 169) indicates that these instruments were also played in ceremonies of state or military parades.

Published examples of similar trumpets are variously described as representing snakes, felines, or a combination of the two. One unusual piece ends with a kneeling prisoner with hands bound behind his back (Sawyer 1975, fig. 42). All these modeled instruments show the Moche artists' skill at uniting functional and sculptural forms.

DF

Exhibited: *Ancient Sculptures in Clay,* The Brooklyn Museum, December 1985–March 1986.

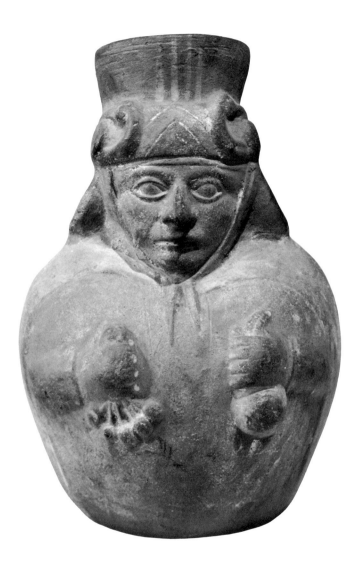

25 *Effigy Jar*

Peru, North Coast, Moche
Phase IV, 300–500
Ceramic, slip, 10½ × 7¼
 (26.5 × 18.3)
86.224.117

Although the stirrup spout bottle was the form most commonly elaborated by Moche artists, other vessel types were also used as vehicles for artistic expression, including dippers, bowls, and jars. This jar, compactly modeled to represent a standing human figure, is similar to a group of effigy jars reportedly found in the southern part of the Moche territory near the mouth of the Rio Santa (Montell 1929, 95–99). Characteristics of this group are sparse use of slip, relatively coarse finish, and subordination of sculptural detail to overall vessel shape.

The figure wears a simple mantle tied over his shoulders and a headdress composed of a turbanlike band decorated with two graceful birds nestled on either side of a central design of incised triangles. He holds a gourd rattle in one hand and a cluster of round objects identified as bells in the other (Hocquenghem 1977, 126). The details of his face and costume are highlighted with white slip, some of which has worn away.

On the basis of analogies with current healing practices in northern Peru, scholars have suggested that rattles and bells were attributes of the shaman, a spiritual healer who acted as an intermediary between the affairs of men and the supernatural world (Sharon and Donnan 1974; Donnan 1976; Hocquenghem 1977). This figure may thus represent a shaman prepared to attract guardian spirits with the sound of his rattle and bells. It is also possible, however, that he is a participant in some military or state occasion, for the distinctive headdress he wears appears on both warriors and rulers in Moche art (Larco Hoyle 1938–39, pl. XXVIII; Domingo 1980, fig. 109).

Human effigy jars without stirrup spouts are assigned to phases on the basis of the jar's neck. While in Phase III the upper portion of the neck is an integral part of the headdress, in Phase IV the headdress is modeled separately with the neck extending above it (Donnan 1976, 54). Because the neck on this example extends above the headdress, a Phase IV date has been proposed. DF

26 Crescent-Shaped Ornament with Bat Figure

Peru, Loma Negra, Cerro Vicus
 area, Moche
A.D. 1–300
Hammered copper, 4⅛ × 4⅝
 (10.5 × 11.7)
86.224.202

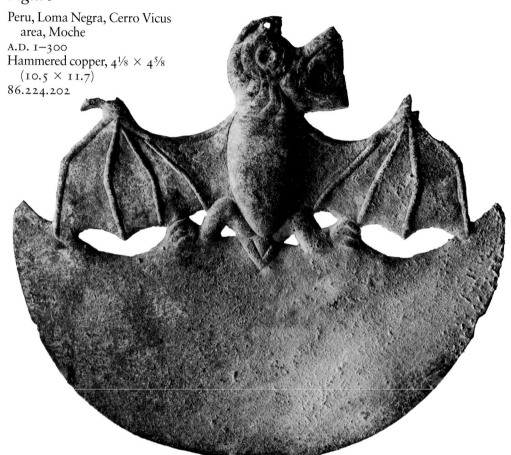

This ornament is from Loma Negra, a complex in the Cerro Vicus area of the upper Piura valley in northern Peru where several hundred objects were unearthed in the 1960s, mostly by treasure hunters. Such crescent-shaped ornaments are characteristic of one of two distinct styles of Cerro Vicus objects, which in general display sophisticated metalworking techniques and a high degree of skilled workmanship. Crescent ornaments are mostly made of cut-out hammered sheet copper, sometimes gold- or silver-plated and inlaid with other materials. Although they depict a wide variety of subject matter, all have the plain crescent shape in the lower section in common. Disselhoff (1972) has suggested that they might be related to a moon cult because the principal deity venerated by the inhabitants of the northern region was a moon goddess.

The ornament shows a frontal bat figure worked in low relief. The bat's head, with a big round eye and huge open mouth with bared teeth, is shown in profile. Its bulging oval body ends in a short pointed tail, to the sides of which are two bent legs with clawlike feet. The wings are fully extended, showing the digits or "fingers" as raised ribs between the membranes; the "thumbs" are the claws (one is broken off) at the top. Tracing was done along the raised areas to emphasize the forms or mark details such as the tail, the mouth ridge, the teeth, and the wrinkles around the eyes. A hole for suspension is provided at the top of the head. The front of the ornament is completely covered with a light green patina. HK

Exhibited: New York, André Emmerich, Inc., 1969, no. 47, ill.

27 Belt Ornament

Peru, Loma Negra, Cerro Vicus area,
 Moche
A.D. 1–300
Hammered copper, 3⅛ × 6
 (7.9 × 15.2)
86.224.191

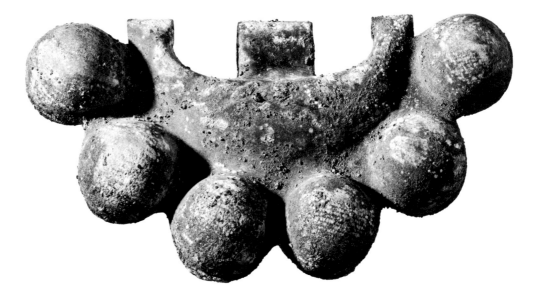

This ornament was made of a single sheet of copper that was cut out and hammered into the shape of two crescents with six strongly bulging bosses along their outer edges. It was then folded along the central axis, creating three loops for suspension at the top and six spheres at the bottom. Inside the spheres are clappers that would stir with the slightest movement of the ornament's wearer, making a rather loud ringing noise. Both sides of the ornament are now covered with a light green patina, and in some parts textile remains or the imprints of textiles can be seen. Disselhoff, who carried out limited controlled excavations in the Cerro Vicus area, reports (1972) that many of the metal objects found there were wrapped in textiles. He also suggests (1976) that this type of ornament was worn by warriors on their belts and that it corresponds to the knife forms depicted hanging from the backs or sides of warrior figures in many of the fine line drawings on Moche pots. HK

28 *Six Beads*

Peru, Loma Negra, Cerro Vicus
 area, Moche
A.D. 1–300
Gilt copper, hammered with shell
 and stone inlays, 1¼ to 1½
 (3.2 to 3.8) diameter each
86.224.197a–f
(Photograph before restoration)

At the time these beads were made, the Moche were the most skilled metalworkers in the Americas. They fashioned such beads by hammering copper sheet metal over a carved mold and then applying a thin, brilliant gold surface by an ingenious process of electrochemical replacement plating (Lechtman 1982). Although many centuries of interment have caused their once gleaming surfaces to be almost completely covered with a thick layer of corrosion, one of the beads has had its surface cleaned and its deteriorated inlaid left eye replaced so that the

maker's remarkable craftsmanship and aesthetic feel for combining different types of materials can be appreciated.

The beads are made of two halves, with the decorated front half crimped over the plain back half. The fronts show an impressive repoussé feline face with a flattened squared-off nose, elegant arched eyebrows over almond-shaped eyes, and a wide-open mouth outlined by a prominent ridge and displaying teeth and fangs. The shell and stone inlay of the eyes, in particular, emphasizes the felines' threatening nature.

In the upper section of each bead's back are two pairs of holes, indicating that the beads were strung and worn as a necklace, as can be seen on numerous painted and sculpted Moche vessels. During the cleaning of the restored bead, two small pellets were discovered in its interior, one of which is still stuck to the corrosion deposits. Presumably the other beads also contain such pellets, which would have created a ringing noise with each movement of the wearer. HK

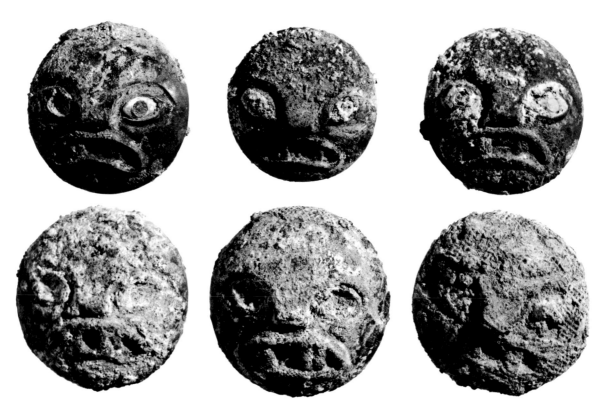

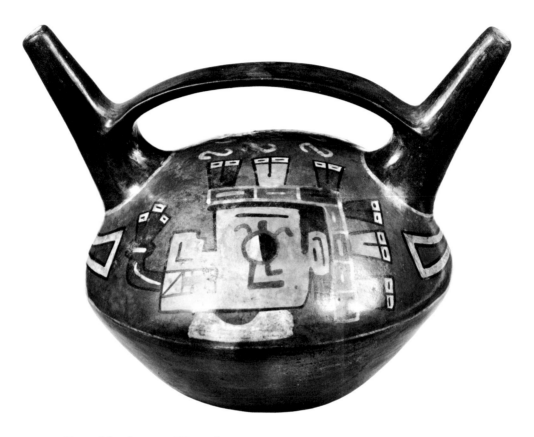

29 *Double-Spout Vessel*

Peru, South Coast, Nasca-Huari,
 Atarco style
600–1000
Ceramic, polychrome slip,
 $5^{11}/_{16} \times 6^{1}/_{8}$ (14.5 × 15.6)
86.224.11

During the Middle Horizon Period (500–1000), the Nasca civilization came under the influence of two powerful states, Huari and Tiahuanaco, located in the Andean highlands. These two states shared a religious iconography that was most fully expressed on the monumental stone carvings at the site of Tiahuanaco in what is now Bolivia. This vessel is a good example of the Atarco style, a pottery type that reflects the interaction of the Nasca ceramic tradition with the Huari design repertory (Menzel 1964). While a Nasca aesthetic is evident in the rich colors and burnished surface, the emphasis on straight lines and geometric motifs shows a distinctly highland approach to design.

The widely diverging tapered spouts are characteristic of Atarco vessels, as is the profile head design, repeated twice on this pot. Although the head combines feline and human attributes, it reads not as a composite creature but rather as an orderly arrangement of discrete parts. Images on Atarco vessels mix and match these parts in a variety of ways, but they share a number of constant features such as the split eye and crossed fangs, the latter represented by a line through a square at the end of the mouth. DF

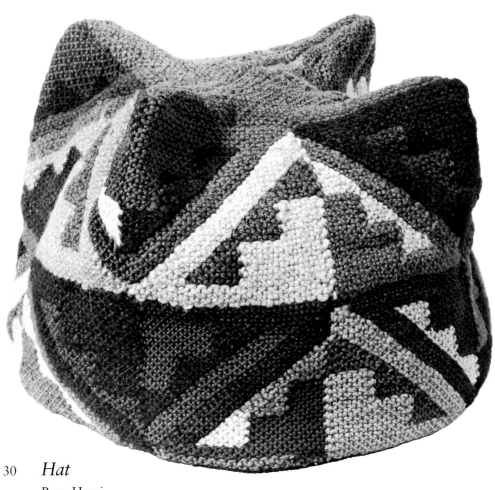

30 *Hat*

Peru, Huari
700–800
Wool, simple looping, 4 × 4⅜
 (10.2 × 11.1)
86.224.84

Important individuals in Huari society were portrayed in stone (cat. no. 33), on ceramics, and in wood wearing a distinctive square hat with four prominent corners. This type of hat has been found made of wool in a variety of techniques: simple looping, looping with pile, and, rarely, tapestry (Kajitani 1982, pl. 73). Whether decorated with stylized animals or geometric shapes, the hats show a distinctly Huari approach to design, with an emphasis on rectilinearity and the systematic juxtaposition of contrasting colors. On this example, fabricated by simple looping, color has been skillfully used to add visual complexity and variety to a pattern of steps and triangles. DF

Small stone figurines stylistically related to the massive stone carvings of richly attired human figures found at or near the site of Huari in Peru's Ayacucho Basin have been collected not only at Huari, where some have been found on the surface of the ground, but also far from there—at Pikillaqta, Pachacamac, and Ica (Lumbreras 1974, 177). In 1927 forty finely carved figurines of turquoise and greenstone were discovered in a cache buried beneath a floor at Pikillaqta (Valcarcel 1933). These figurines almost all represent men with large almond-shaped eyes and prominent jaws; their heads cantilever out from their stocky bodies with no indication of a neck, creating the impression of a compact and powerful physique. Like the large stone carvings of Huari, they wear headdresses and tunics. Although their significance is still a subject of scholarly debate, it is generally recognized that they reflect the physical ideal and costume of the Huari ruling class. Their inclusion in an offering cache suggests that in spite of their seemingly secular subject matter they had some religious significance. Moreover, they also document a Huari interest in exotic materials such as turquoise, which is not found in the Ayacucho region and must have been imported, perhaps from as far as Bolivia (Lumbreras 1974, 163).

The two figurines illustrated here (cat. nos. 31 and 32) are closely related in size, material, and style to the Pikillaqta group. The smallest (cat. no. 31), carved in a bright turquoise stone, represents on a miniature scale a well-dressed Huari individual wearing a turban wrapped around his head and a simple tunic covering most of his body. Although the body is foreshortened and greatly simplified, the head is carved with considerable detail and naturalism, suggesting portraiture.

The second figurine (cat. no. 32) is more stylized but still clearly represents a human of the same physical type with large eyes and a prominent nose. Instead of a turban the figure wears a hat shaped like a pillbox with flaps hanging at the sides. An incised line on his chest indicates a mantle or collar worn over his tunic. Unlike most Huari figurines, which have no holes for suspension, this example has a flange carved in the back with five holes drilled through it. It may have originally been the centerpiece of a five-strand necklace.

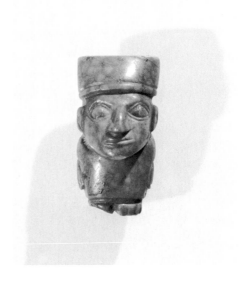

31 *Figurine*

Peru, Huari
700–1000
Turquoise, 1¼ × ⅝ × ¹¹⁄₁₆
 (3.2 × 1.6 × 1.7)
86.224.106

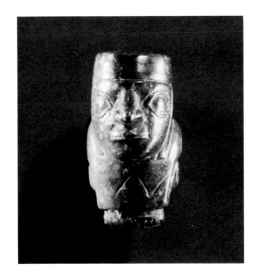

32 *Figurine*

Peru, Huari
700–1000
Turquoise, 1¼ × ¹³⁄₁₆ × 1³⁄₁₆
 (3.2 × 2.0 × 3.0)
86.224.29

Although the third carving here (cat. no. 33) is part of a foot-shaped stone hook, it also belongs to the Huari figurine tradition. A rare piece, it is made of an attractive amber-colored stone and contains traces of red paint in all the crevices of the carving. The kneeling figure on top of the hook wears a four-cornered cap with flaps hanging down the sides and back. He carries a bow and arrow in one hand and what looks like an ax in the other. Besides identifying the figure as a warrior, the presence of the weapons suggests that the hook itself had some military function. It may have been a spear thrower, but in the absence of further information on Huari weapons it is impossible to be sure of its function. DF

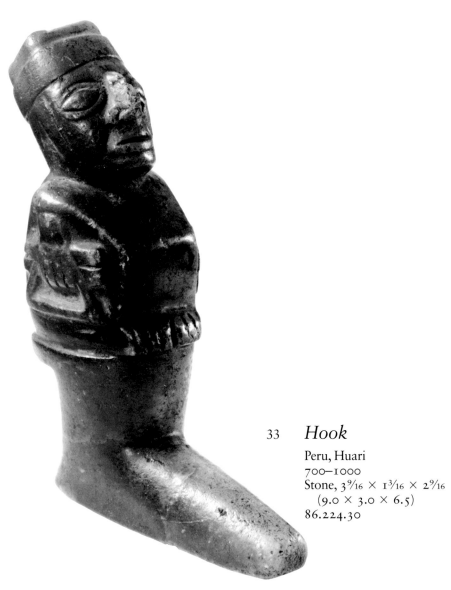

33 *Hook*
Peru, Huari
700–1000
Stone, 3⁹/₁₆ × 1³/₁₆ × 2⁹/₁₆
 (9.0 × 3.0 × 6.5)
86.224.30

34 *Tunic*

Peru, Huari
Circa 600
Wool, tapestry weave: warp 19, weft
 100 per cm, 38 × 28⅜
 (96.5 × 72.0)
86.224.109

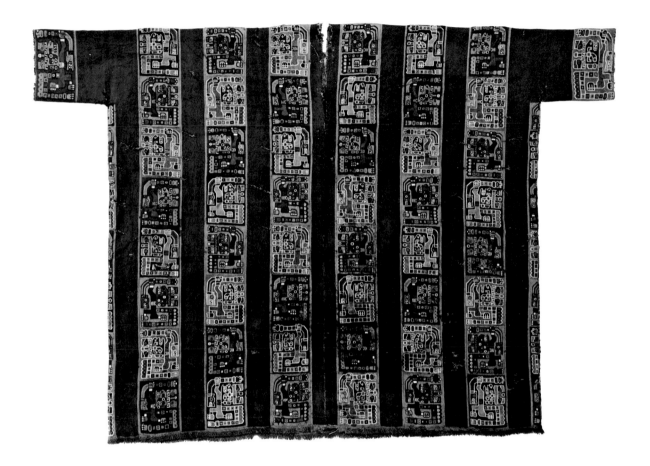

Huari tapestry tunics are technically and artistically among the finest textiles produced by ancient Andean weavers. More than prestige garments, they are complex statements of political affiliations and religious beliefs.

Although the center of production of these extraordinary tapestries seems to have been at or near the site of Huari in the South-Central Highlands of Peru, the imagery woven into the shirts reflects the iconography of the monumental stone sculpture of Tiahuanaco in Bolivia, a great religious and commercial center during the Middle Horizon Period (500–1000). On the stone doorway known as the "Gateway of the Sun" at Tiahuanaco, the main deity is represented flanked by rows of profile attendants running with staffs in their hands. Variations of these attendant figures appear in brilliant color on Huari textiles, arranged in precise vertical bands.

Huari tunics show a high degree of standardization in size and technique. They were all woven sideways in interlocked tapestry, presumably on a wide vertical loom (Bird and Skinner 1974), and were constructed from two loom widths of cloth sewn together in the middle and at the sides, leav-

ing openings for the neck and arms. When worn, the bottom edge of the tunic would have just covered the kneecaps.

As the Huari weaving tradition developed during the Middle Horizon, there was a marked tendency to abstract and distort the basic design vocabulary (Sawyer 1963). Figurative motifs were divided into small-scale geometric units of contrasting colors and woven in perspective so that the designs in the middle of the shirt were expanded and those at the edges compressed.

The three magnificent tunics seen here illustrate this chronological development. The earliest of the three, cat. no. 34, can be dated on stylistic grounds to around 600. It is unusual, but not unique, in having loom-shaped sleeves and a fringe added at the bottom. It is also exceptional in the fineness of the weave. With a thread count of 100 wefts per centimeter, the designs are so tightly woven that they appear to have been painted.

Six bands of eight figures each decorate the main body of the shirt. Like the Sun Gate attendants, these figures carry staffs and are in active postures. Although all the figures are the same, their direction alternates and they are patterned by four different color combinations. These variations make the overall design seem rich and complex. An elongated version of the figure decorates each sleeve. It is as though the weaver stretched the motif to fill the available space.

The expansion and compression of motifs characteristic of Huari textile art is far more pronounced on the second, later shirt here (cat. no. 35). On this tunic a profile figure with clawed feet is portrayed repeatedly on two wide bands. The figure's upturned head is surrounded by a rayed headdress, and wings project from his back. The hands and staffs have been laterally expanded toward the center of the shirt while the wings have been compressed. This visual distortion systematically introduced by the weaver adds a dynamic element to the design and makes the flat textile appear to be more three-dimensional.

At first glance the pattern on the third Huari shirt here (cat. no. 36) seems totally disjointed and abstract. Close inspection, however, shows that one element of the design is a profile animal head with a teardrop-shaped eye. This motif alternates with a stepped scroll design that may represent an animal's tail. Known as the "split-face" de-

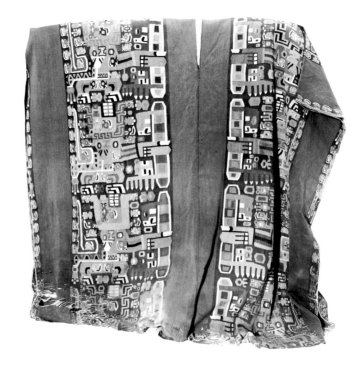

35 *Tunic*

Peru, Huari
Circa 700
Wool and cotton, tapestry weave:
 warp 12, weft 40 per cm,
 38¾ × 43½ (98.5 × 110.5)
86.224.1

sign, this pattern is a common one on late Huari tunics (for another example see Bird and Skinner 1974, fig. 1).

This tunic was reportedly one of two found in a grave lot on the hacienda of Monte Grande in the lower Nasca drainage (A. Rowe in press). Because of the climate in the highlands, textiles have not survived from the vicinity of Huari. Most have been found, like this one, in burials along the coast, where they were obviously prestigious imports dating to the time when the coastal region was under Huari control.

Little is known about the weavers of these masterpieces. Although it is generally assumed that they were a highly specialized group working for the Huari elite, the extent

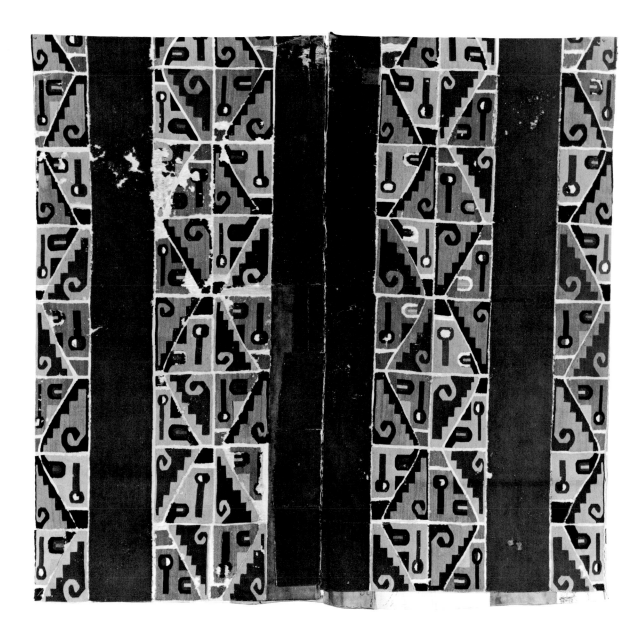

to which the designs were controlled by the state is a subject of scholarly debate. Rebecca Stone (in press) has argued that there was room for individual expression, particularly in the choice of color, and has suggested that in some instances at least several weavers collaborated on a single shirt. As a group the Erickson tunics show continuity and change over several centuries within a highly conventionalized design tradition. They also testify to the importance of weaving as an expressive medium in the Huari state. DF

Published: Cat. no. 35: Zimmern 1949, no. 14.

36 *Tunic*

Peru, Huari
Circa 800
Wool and cotton, tapestry weave:
 warp 12, weft 40 per cm,
 39 × 41½ (99.1 × 105.3)
86.224.144

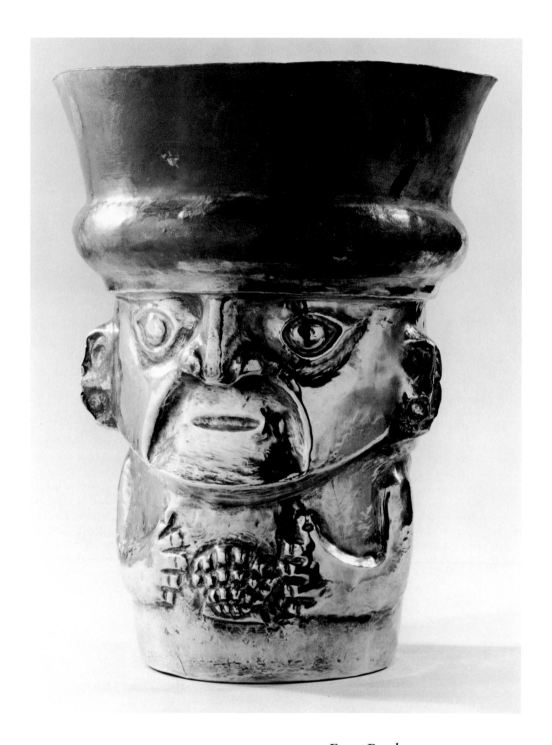

37 *Face Beaker*

Peru, North Coast, Sican
850–1050
Hammered silver, 10⅞ × 8½
 (27.6 × 21.6)
86.224.189

Among the largest objects in gold and silver made by ancient American metalsmiths are beakers like the one illustrated here. They were discovered in great numbers in the rich burials of the ceremonial center of Batan Grande in the Lambayeque valley on Peru's North Coast. Extensive archaeological investigation in recent years in this area has established that Batan Grande was ruled by a dynasty of lords as an important religious-funerary center from about 850 to 1050 (Carcedo and Shimada 1985). During this period, which is now called Sican after the name for Batan Grande (house, or temple, of the moon) in the now extinct Muchik language, the lords amassed great wealth, part of which was buried with them. One of the richest Sican tombs, discovered in the late 1950s, contained more than 200 precious metal objects, including 176 gold and silver beakers of various sizes and shapes grouped in stacks, often as many as ten to a stack (Carcedo and Shimada 1985). The tallest beaker measured three feet in height.

Many of these beakers are decorated on their fronts with a broad repoussé human face similar to the one on this beaker. In this case, the face has wide-open, almond-shaped eyes, a straight nose with flaring nostrils, and a narrow mouth worked as a simple groove framed by two slightly curved lines between the nose and the squared-off chin. The ears are adorned with circular plugs, and the figure wears a cap with a bulging brow band that ends in the flaring rim of the beaker. Below the face are two bent arms held across the chest, with the outstretched fingers of the hands touching a shell patterned with horizontal and vertical grooves. In back the hair hangs from underneath the cap in two layers. The lower layer, embellished at the bottom with a row of disks, is held by a decorative band with a chevron pattern and a central medallion ornamented with circles.

Beakers like this were made by patiently hammering a single round sheet of thick silver over different types of carved wooden molds, eventually raising the walls of the vessel and shaping the facial features and decoration (Easby 1956). Constant annealing during the hammering and stretching of the metal was required to avoid breakage. There is some damage near the rim of this beaker, and the whole surface is tarnished. HK

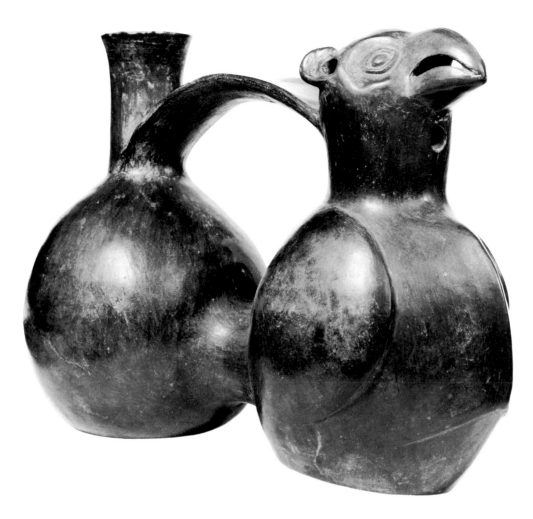

38 *Double-Chambered Effigy Vessel*

Peru, North Coast, Chimu
Circa 1400
Ceramic, 6 × 8¼ (15.2 × 21.0)
86.224.149

Between the thirteenth and fifteenth centuries Chimu kings ruled the entire northern half of the Peruvian coast from their capital city of Chan Chan in the Moche valley. Something of the history of this great coastal state is known from oral traditions recorded by early Spanish chroniclers and from modern archaeological excavations (Moseley and Day 1982). The artistic legacy of the Chimu is notably varied, including monumental funerary architecture, impressive textiles (cat. no. 41), metalwork in gold and silver (cat. nos. 42–46), and quantities of blackware ceramics. The ceramics were predominantly mold-made, and many were poorly crafted, suggesting that the emphasis in production was on quantity rather than quality.

This handsome vessel with its streamlined shapes was well designed for mass production and has the elegant simplicity of the best Chimu pottery. The two chambers are almost equal in size, but one has been cleverly altered to represent a birdlike creature with a curved beak and rounded ears. The vessel emits a whistling sound when air is blown into the spout. While this characteristic seems especially appropriate for a bird form, it is, in fact, a common feature of Chimu effigy vessels (Stat 1979). Like most Chimu ceramics, this vessel was fired in an unvented kiln so that carbon from the organic fuel impregnated the clay, producing a rich black surface color. DF

39 *Double-Chambered Effigy Vessel*

Peru, North Coast, early Chimu
(possibly Lambayeque)
900–1000
Ceramic, polychrome slip, 7 × 6¼
(17.8 × 15.9)
86.224.172

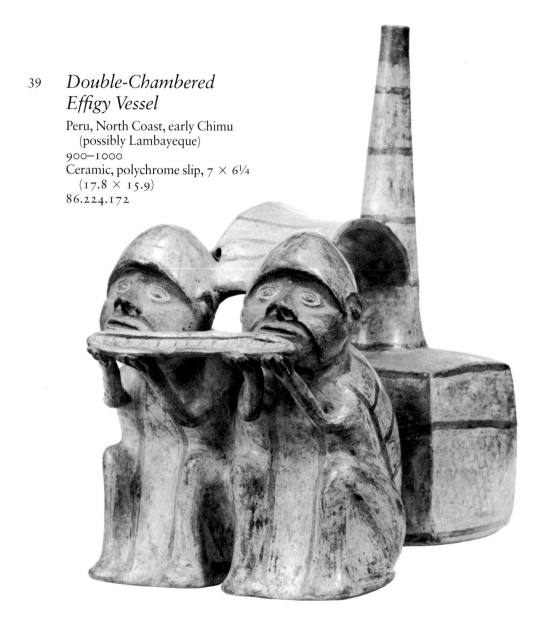

This double-chambered vessel has the tall tapered spout and straplike handle that characterize early Chimu ceramics (Sawyer 1975, 47). One chamber is a rectangular box; the other represents two seated monkeys sharing a pod held up in front of their mouths. Behind each monkey's head there is a whistle. Except for the monkeys' faces, which are painted a dark reddish brown, the entire vessel is a warm cream color decorated with red lines applied so as to emphasize the sculptural shapes. Parts of the vessel are also covered with fine line drawings in dark brown that suggest a delicate textile pattern. These cursive lines—barely visible in places—may reflect the influence of the Huari center at Cajamarca (Sawyer 1975, 45).

Monkeys are a common subject of Chimu art. On later blackware vessels they frequently appear as a stirrup spout ornament. Although the significance of the Chimu emphasis on these animals is not clear, the ceramics show that Chimu artisans observed them carefully and appreciated their expressiveness and agility. DF

Wood carvings representing human figures were quite common during the Late Intermediate Period in Peru (1000–1400). They ranged from roughly carved statues to elegantly finished artifacts like this mirror handle, which portrays a well-dressed individual holding a trophy head in each hand. The elaborate headdress, serpent-headed collar, and sleeved tunic clearly identify the individual as a member of the ruling class. They also testify to a relatively realistic carving style: costume elements similar to the ones depicted have been found in Chimu burials (see A. Rowe 1984 for illustrations of the costumes). The trophy heads and the distinctive facial markings may indicate a special prowess in battle.

Although the handle has been broken and repaired and there are several chips missing from the front, the carving is well preserved and retains an impressive crispness in all the incised details. Triangles are dominant in the patterns as they are in certain Chimu textile designs. The addition of tiny turquoise bead inlays on the handle, collar, and headdress adds color and preciousness to the richly textured surface. The eyes of both the central figure and his victims are inlaid with thin sheets of gold covered over with red paint. There are also traces of red paint around the bead inlays on the handle.

A shallow circular concavity in the back of the carving probably held a mirror made of pyrite. Unfortunately, practically nothing is known of the function of mirrors in ancient Andean civilization. It is interesting to note, however, that at least two other mirror handles represent the elite (Lapiner 1976, fig. 625; Schmidt 1929, 539). It is possible, therefore, that mirrors were the personal possessions of the lords of Chimor. If this were the case, carved image and reflected image would have duplicated and confirmed each other. DF

Published: Bennett 1954, fig. 132; Jane P. Powell, *Ancient Art of the Americas* (The Brooklyn Museum, 1959), p. 57; Lapiner 1976, fig. 624.

Exhibited: *Ancient Arts of the Andes*, The Museum of Modern Art, New York, 1954.

40　*Mirror Handle*

Peru, North Coast, Chimu
Circa 1200
Wood, gold, turquoise, traces of red
　paint, 11⅝ × 5⁹⁄₁₆ (29.5 × 14.2)
86.224.4

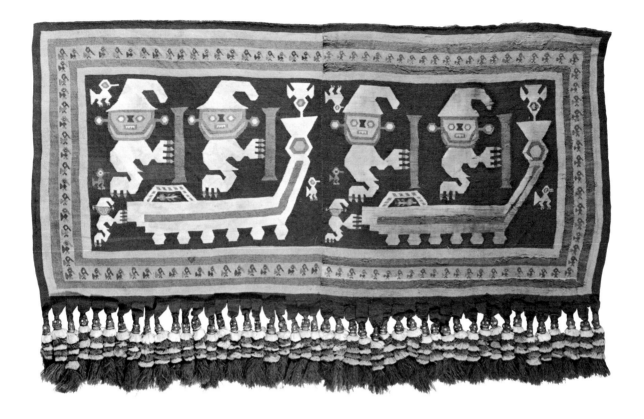

41 *Tapestry Hanging*

Peru, North Coast, Chimu
Circa 1400
Wool and cotton, tapestry weave:
 warp 8, weft 36 per cm, embroi-
 dered tassels, 41¾ × 24⁷⁄₁₆
 (106.0 × 62.0)
86.224.136

Both the imagery and the technique of this dramatic tapestry indicate a Chimu origin. Several of the technical features that Ann Rowe has identified as distinguishing Chimu tapestries from those of the Central Coast (1984, 26–27) are evident here: the cotton warps are S-spun and Z-ply, and the slits are sewn up with an overcasting stitch. While the textile, composed of two panels, appears to be complete, there are small stitches sewn around the edges, suggesting that something else was originally attached. The tapestry may have been part of a ceremonial garment.

On each panel the same scene is repeated with minor variations. Two men with frontal faces and profile bodies are kneeling in a boat. Highly stylized with angular bodies and forklike hands and feet, they wear stocking caps and hold paddles. Miniature replicas of these figures appear behind the boat, on the same scale as the birds scattered throughout the background. One bird, surprisingly, appears upside down, and two are represented as though flying within the boats. Heavy tassels embroidered with little grinning faces hang from the bottom edge of the panels.

The men-in-a-boat theme is an important one on Chimu textiles and appears in the architectural reliefs, ceramics, and metalwork of the North Coast as well. This version resembles the men in a boat depicted in an adobe frieze in the Velarde compound at Chan Chan (illustrated in Moseley, Mackey, and Brill 1973, 330). The type of boat represented is square in back with an upcurving prow in front. Similar boats, made out of bundles of reeds, are still used on the North Coast today. The fact the boat theme appears on luxury goods shows the importance of maritime activity to the Chimu state.

DF

63

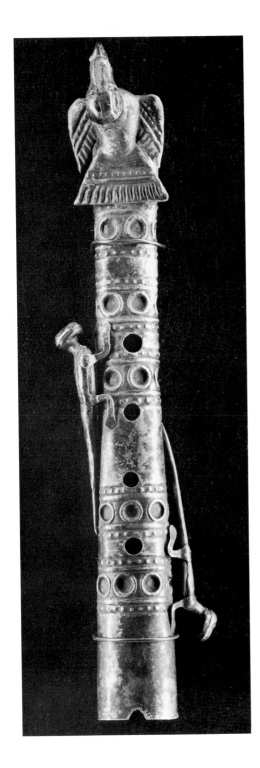

Simple short flutes (*quenas*) like this one in gold are the most famous Peruvian wind instruments. Archaeological examples, mostly made of bone and cane and not more than eight to twelve inches long, are known from as far back as the Early Nasca culture. Flutes in Peru are always played by men and have phallic, regenerative, and magic connotations. (Museo de la Cultura, Lima 1951.)

This flute, which has an oval cross section and tapers slightly toward the end, is made of rather thick sheet gold joined in back by soldering. There are four holes in the front and a semicircular notch at the mouthpiece. The discoloration on part of the surface is the result of copper corrosion.

The flute is decorated with rows of raised dots alternating with bands of recessed circles and plain bands. In addition to the repoussé decoration, it is further embellished through the addition of separately made animal sculpture, a feature that also characterizes Chimu ceramics and gives the objects a certain playful quality.

Near the end of the instrument sits a bird with spread wings and splayed tail. It is made of seven separate parts joined by crimping and soldering and features banded repoussé decoration on the wings and tail. The huge circular eyes and strong half-open beak with a carbuncle indicate that it might be a condor.

Attached to the sides of the flute are two alligators or lizards. Each is made of ten separate pieces of sheet metal and has a long pointed tail and eyes like dots set into deep sockets. Two nostrils and a big closed mouth are indicated by cavities and a groove respectively. A band with an incised chevron pattern runs along their backs. The posture of the animals, especially the way they hold their heads, expresses a great deal of realism. They appear to be investigating their surroundings while balancing on their narrow support.

This type of simple flute is still much played in Peru today. However, modern ones tend to be longer and have more holes. Seldom is there a hole in the back for the thumb.

HK

42 *Flute*

Peru, North Coast, Chimu
1100–1500
Hammered gold, 7½ × 1⅞
(19.1 × 4.8)
86.224.22

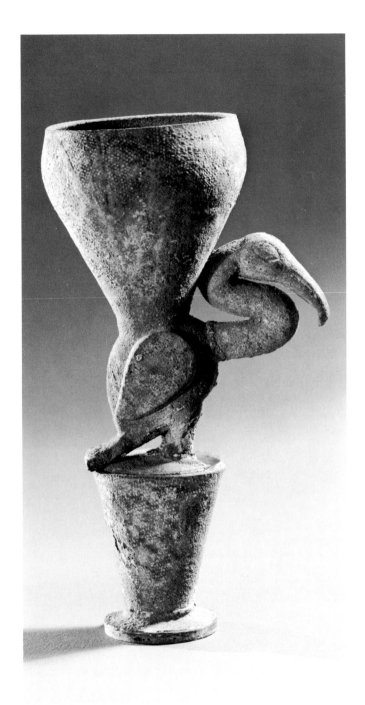

43 *Goblet with Bird*

Peru, North Coast, Chimu
1100–1500
Hammered silver, 9½ × 3¾
 (24.1 × 9.5)
86.224.203
(Illustrated in color on page 7)

Compared with the many gold objects discovered over the years in Peru, only a few ancient silver pieces have been found. Either silver was used less or silver objects, being more fragile than those of gold, disintegrated during the course of many centuries in the soil.

However, enough silver pieces are known (The Metropolitan Museum of Art in New York has one of the finest groups) to show that Peruvian silversmiths possessed a high degree of technical skill and artistic sensitivity. This elegant goblet, for example, reflects a mature feeling for well-balanced form.

The goblet consists of a top and bottom cup, the former being a lid as well as a container. Although corrosion hides some of the seams, close inspection reveals that it is made of many separate parts of silver sheet joined by soldering. Both cups were made by hammering a round sheet of silver over a mold and were then set into a separately shaped base—in the case of the top cup, the base on the bird's back. The bird itself, probably a cormorant, has a long neck, a beak curved at the tip, and a wedge-shaped tail. It is composed of several individually shaped and embossed sections; seams are visible around and along the neck, under the body, and around and along the legs.

The distinctive shape of the goblet—the bulging walls near the top—occurs often on metal Chimu vessels. Several silver beakers with this silhouette are in the collection of The Metropolitan Museum; some of them are associated with animal, bird, or human forms. The well-known ceremonial gold goblets found in the ruins of Chan Chan (Emmerich 1965) also have this contour.

HK

Exhibited: *Peru, Sun Gods and Saints*, André Emmerich Gallery, New York, December 1969.

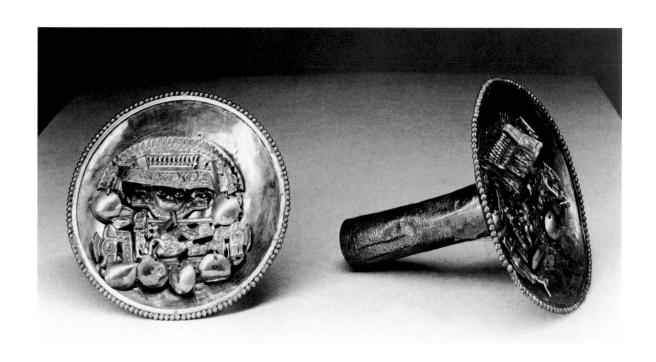

44 *Pair of Earplugs*
Peru, North Coast, Chimu
1100–1500
Hammered gold, 5¼ (13.3) diameter
of frontal, 5⅛ (13.0) long
86.224.19 a,b

Ear ornaments, also called earplugs, were among the favorite personal adornments of men in ancient South America. Numerous examples survive even from the earliest known Peruvian cultures. Some of the largest and most ostentatious, in gold, come from Chimu times, when the powerful kingdom of Chimor reigned on Peru's North Coast from its splendid capital city of Chan Chan. Worn by the Chimu leaders as a symbol of their wealth and authority, they show complex scenes with small details of dress and ornament carefully worked out as on this pair, which according to Julio Tello was found about 1928 in Salitre just outside Chan Chan (Museum records).

These two ornaments are made of many pieces of sheet metal joined by stapling or soldering. After the design was embossed, various elements were cut out from the front. Both ornaments have a wide decorated frontal surrounded by a frame of small hollow gold beads that were made in two halves, strung on wire, and then soldered into place. Soldered in the center-back of both frontals is a long shaft for insertion into the extended earlobe to counterbalance the weight of the frontal. Both shafts are decorated with a traced design of geometric motifs such as dots and scrolls alternating with wide bands of anthropomorphized bird figures on one ornament and a two-legged creature with a tail standing in profile on entwined serpents on the other.

The main motif on both ornaments is a big frontal repoussé face of a Chimu lord wearing a huge fanned-out headdress with embossed decoration, circular earplugs, and a wide collar ending in profile snake heads on both sides. The face is partially obscured by a separately attached awning embellished with repoussé birds and geometric patterns. On both sides of the awning small embossed fish and plain round danglers are attached with strap metal. Below the lord's face is a scepterlike bar featuring an arrow-shaped point on one side and a serpent's head with two pointed ears on the other. Underneath this bar in turn is the profile body of a creature with two legs pointing to the left—the top one clawed and the bottom one ending in a serpent's head—and a wavy tail terminating in another serpent's head on the right. This creature, whose spots indicate that it may be a jaguar, sits on a U-shaped bar decorated with two snakes with embossed spots, big eyes, bared teeth, pointed ears, and fanned crests. Strapped to the snakes are four free-hanging danglers.

Despite their resemblance to each other, these earplugs are not a matched pair and were probably assembled from parts that originally belonged to different pairs. There are differences in decorative detail—such as the motifs on the awnings, the pattern on the snake collar worn by the lord, and the traced design on the shafts—and the repoussé sections of the frontals are small for the size of their concave backings compared to similar examples. Furthermore, the extremities of the creatures point in the same direction, unlike most ear ornaments of this type (Jones 1985). An examination of the earplugs by Museum conservators revealed areas of modern repair in back where the shafts are joined to the frontals and possibly along the seams of the awnings and parts of the beaded frame. HK

Published: Zimmern 1949.

Exhibited: *Ancient Arts of the Americas*, The Brooklyn Museum, November 1959–January 1960.

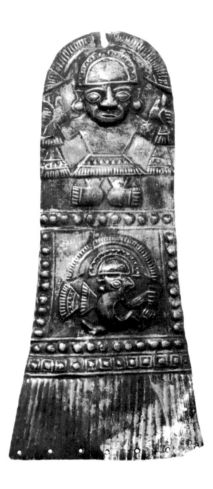

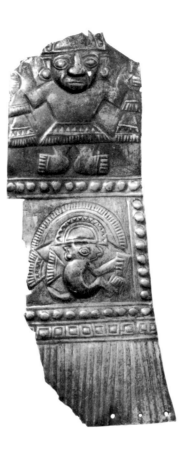

45 *Repoussé Plaque*

Peru, North Coast, Chimu
1100–1500
Hammered gold, 7⅛ × 3½
 (18.1 × 9.0)
86.224.25a

46 *Repoussé Plaque*

Peru, North Coast, Chimu
1100–1500
Hammered gold, 7 × 2½
 (17.7 × 6.4)
86.224.25b

Although full-figure frontal representations of a dignitary with standard features and attributes of the kind shown on these two plaques are found frequently on twelfth–fifteenth-century Peruvian North Coast objects in all media, they occur particularly often on metalwork. Rather squat, with their feet splayed sideways, the repoussé figures here wear huge crescent-shaped headdresses, round earplugs, and tunics with a decorated border along the bottom. Their faces, worked in higher relief than their bodies, have almond-shaped eyes, broad, flat noses, and small mouths framed between lines on both sides. Their arms are outstretched, and they appear to be holding staffs, traditional symbols of high rank and power often car-

ried by deity and warrior figures, in each hand.

Below both these figures is a tailed creature in profile sitting in a frame of repoussé dots. Interpreted as monkey attendants (Lapiner 1976), these creatures also wear crescent-shaped head ornaments and hold objects in their hands, possibly beakers.

Although there are losses along the edge of one of the plaques, the other is in good condition and shows the original shape: it is cut at the top along the crescent of the headdress and broadens somewhat toward the bottom. The holes at the top and bottom are for attaching the plaque to a wall, a textile, or, most likely, a piece of furniture such as a litter. HK

68

47 *Double-Chambered Whistling Vessel*

Peru, Central Coast, Chancay
1000–1400
Ceramic, slip, 11½ × 7⅝ × 3⅞
 (29.2 × 19.4 × 9.8)
86.224.140

The Chancay culture flourished in the Chancay and Chillón valleys of the Central Coast, just north of Lima, the present capital of Peru. It was one of several regional states that emerged on the coast with the waning of Huari influence. Chancay pottery has been found in abundance in burials along with textiles and silver objects. Painted in a distinctive black-on-white style, the pottery

69

48 Double-Chambered Whistling Vessel

Peru, Central Coast, Chancay
1000–1400
Ceramic, slip, 11¼ × 7½ × 3½
 (28.6 × 19.1 × 8.9)
86.224.141

is markedly different from the earlier Huari polychrome styles and, by comparison, seems crude and naive. The vessels' surfaces are grainy, and the dark black-brown painted designs often appear to have been hastily applied over the white slip; drips and irregular outlines are common. Many of the pots were mold-made (Lumbreras 1974, 192), and consequently forms are repetitious and simplified. Dismissed as a provincial style, Chancay pottery has received little art historical attention (Esser 1982, 313), and yet, as the three vessels in the Erickson Collection demonstrate, good Chancay ceramics have considerable charm. In fact the restrained color scheme and bold painting style make them particularly appealing to modern taste.

Two of the vessels form an amusing pair; they are both double-chambered with a long tapered spout and a handle connecting with a modeled figure, in one case a monkey eating fruit and in the other a man with his hands on his hips. Man and monkey seem equally at home on top of the globular pot, although their separation from it is made absolutely clear by the liberal use of black

paint. On both vessels there is a whistle outlet where the handle connects with the figurine. The whistle sounds when the spout is blown or when liquid is passed from one chamber to the other.

Monkeys are common in Chancay art and appear on the large egg-shaped jar here as well. Located on each side above the handles, these monkeys are a whimsical combination of drawing and modeling: the head and hands are fully three-dimensional, the knees and feet are appliqué, and the profile body is formed by a sweeping line. While the bottom of the urn is plain, the entire upper part is covered with a pattern of rectangles suggesting a textile design. Textile motifs are also evident on the vessel's rim, which resembles a small bowl. Sawyer (1975, 135) has interpreted this form as "a reflection of the custom of using such bowls as a combined lid and handy receptacle with which to drink the liquid stored within the jar." DF

Published: Cat. no. 47: Alan Lapiner, *Pre-Columbian Art of South America* (New York, 1976), fig. 669.

49 *Jar*
 Peru, Central Coast, Chancay
 1000–1400
 Ceramic, slip, 23 × 16⅛
 (58.5 × 41)
 86.224.134

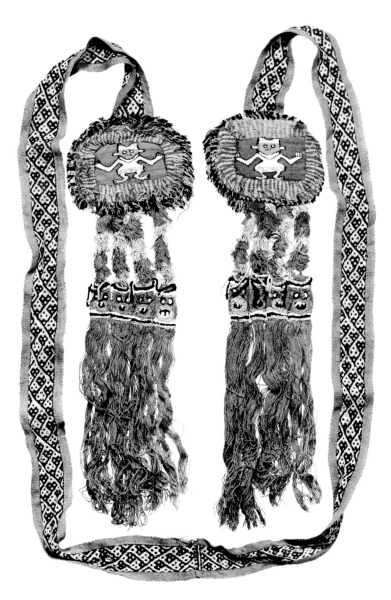

50 *Sash*

Peru, Central Coast, Chancay
Circa 1400
Wool and cotton composite con-
struction: band, 82 × 2⅛
(208.4 × 5.5); tapestry
medallions, 5 × 6¼ (12.6 × 16)
each
86.224.182

In contrast to Chancay black-on-white ce-
ramics, Chancay weavings can be extremely
colorful, with liberal use of yellows, reds,
and pinks. Several techniques were used to
create this sash, which is composed of a band
woven in a complementary warp float pat-
tern with tapestry medallions attached at
each end. Faces are embroidered on the four
tassels that hang down from the medallions.
Although the band appears to be complete,
it has been cut and reattached. Two similar
sashes are in the Amano Collection in Lima,
Peru (Tsunoyama 1979, pl. 1 and 63). DF

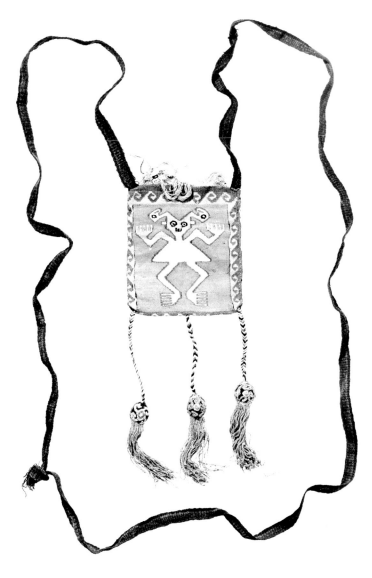

51 *Bag*

Peru, Central Coast, Chancay
1000–1400
Wool and cotton, tapestry weave:
 warp 8, weft 40 per cm;
 braided and embroidered tassels,
 6½ × 5⅜ (15.2 × 13.7)
86.224.137

The figure woven on this tapestry bag appears to be dancing with flexed knees and raised hands. Two birds emerge from his head, forming an animated headdress. The three round tassels on the bottom of the bag are characteristic of Chancay bags, as are the straps, which are tied together (A. Rowe 1984, 158). Unusual features are the cut warps visible at the top of the bag and the fact the design is upside down on one side. It is possible that the two tapestry panels were not originally intended to be used as a bag but were adapted to this function at a later date.

Although small bags are generally described as coca bags in the literature, there is not enough evidence about Chancay bags to be sure of their function. They have been found in burials sewn up or stuffed as pillows. DF

73

52 *Collar*

Peru, Chancay or Chimu (?)
1300–1500
Shell and stone beads, cotton yarn,
 8 × 7½ (20.3 × 19.1)
86.224.181

This finely crafted collar is composed of purple and orange shell beads and turquoise stone beads strung on cotton yarn. The beads, closely fitted together, create solid fields of color in alternating bands with orange at the center. There is one tie attached at the inside edge of the back of the collar. Originally there must have been several such ties to fasten the neckpiece securely. Only the back edges of the necklace show signs of wear; the rest is in excellent condition.

Although its provenance is not known, the collar is similar to pieces of shell jewelry (illustrated in Lapiner 1976, fig. 672) said to have come from a Chancay tomb dating to the period when the Inca ruled the Central Coast (1460–1532). This richly stocked burial contained a full-sized ceremonial wooden litter and numerous miniature objects in silver (Lapiner 1976, 448). In a recent discussion of the tomb group and related objects, Anne Rowe (1984, 155–60) suggests a Chimu origin for many of the pieces, including the shellwork, because of the textile materials associated with them. Such a mix of Chimu and Chancay objects in a single grave shows that there was trade between the two areas, at least of luxury goods. Intercultural trade, however, makes it difficult to be certain of the place of manufacture of individual objects. This necklace may well be of Chimu origin, for the cotton yarn of the tie is S-spun, a manner characteristic of North Coast weaving.

DF

53 *Pin (tupu)* (Left)

Peru, North or Central Coast,
 Chimu or Chancay
1100–1400
Hammered silver, 10¾ (27.2) long
86.224.183

54 *Pin (tupu)* (Right)

Peru, North or Central Coast,
 Chimu or Chancay
1100–1400
Hammered silver, 9¼ (23.5) long
86.224.187

Pins, or *tupus* (also called *topus*), were used by Peruvian women to secure cloaks and shawls. Although they were among the relatively few precious metal objects in ancient America that were not mere ornaments, when they were made for use by the elite they were often—as these examples illustrate—painstakingly detailed.

The objects were fashioned by hammering sheet metal into the appropriate shapes and joining the individual parts with solder. Comparable objects from Colombia, the so-called lime-spatulae, or pins in gold, were made by the lost-wax casting technique. Although Peruvian metalsmiths were aware of this technique as early as Moche times (A.D. 1–300), they had a traditional preference for hammering metals even when making three-dimensional objects (Lechtman 1980).

The longer *tupu* here is embellished at the top with a hunchback figure squatting on a box with open meshwork on the front and back. The figure's arms are resting on his knees, and he holds his hands to his mouth. On his shoulders are two sticks tied in a tumpline that hangs over his chest. He has a long face with a prominent nose and two big oval eyes and wears a conical cap decorated in front with an inverted U-shaped ornament.

The other *tupu* features a vessel-like form at the top. This form has a circular flat body with open meshwork in front and back and a cone-shaped neck with two small handles. It is made of many separate parts joined by soldering.

55 *Ornamented Object*

Peru, North or Central Coast,
 Chimu or Chancay
1100–1400
Hammered silver, 22¼ (56.5) long
86.224.188

Similar to these *tupus* is the long or-
namented object here. At its lower end is a
flattened vessel-like form worked in two
halves with a circular body, cone-shaped
neck, and two handles (one of which is bro-
ken off). Near its upper end the object is
decorated with a small hunchback figure
playing a panpipe and sitting on top of a
drum-shaped object with delicate open
meshwork on both sides and two small pel-
lets inside. The figure's body is worked in
two halves joined along the sides to which
details like arms and legs are soldered. The
head and facial features are also separately
attached. There is a band with a diamond
pattern around the head and two streamers
hanging down the back.

The function of the object is not
known. Its length and the small vessel form
attached near the bottom make it unlikely
that it was used as a pin, and the figure near
the top excludes its use as a spindle. The
remains of corrosion-covered yarn wrapped
around the shaft, however, indicates that it
might somehow be related to the spinning
or weaving process, perhaps in a ritual con-
text. HK

56 *Scale*

Peru, Coastal
1000–1500
Wood, traces of resinous paint, fiber:
 beam, 6⅞ × ¹⁵⁄₁₆ (17.5 × 2.4);
 bags, approximately 11¾ (29.9)
 long
86.224.104

This charming scale, complete with a wooden beam and net bags, shows the ancient Peruvians' interest in making functional objects decorative. The beam is carved on both sides with a little procession of birds in a style reminiscent of the adobe reliefs at Chan Chan. Three of the birds look to the left, and three look to the right. At the center of the beam, where the two groups of birds meet, is a hole with a cord for suspending the scale. The two knotted bags are attached through holes at the corners of the beam.

Small balances were used for weighing light materials like yarn. They have been found as grave offerings along with weaving equipment (Menzel 1977, 49). Often the net bags have disintegrated and only the wooden part remains. (Another complete scale is illustrated in Bennett 1954, fig. 134.)

There are remains of a thick resinous paint in red and yellow in the spaces behind the birds. This type of paint is well preserved on a number of tomb posts from the Ica valley (Jones 1964, 42–43). Since red and yellow were colors favored by the Inca, this scale may have been made during the period when the Inca controlled the coastal region of Peru. DF

57 *Tunic*

Peru, Coastal
Late Intermediate Period, 1000–
 1470
Cotton and wool, plain weave: warp
 28, weft 12 per cm; patterned by
 ground warp floats, tapestry in-
 serts, and weft-faced, supple-
 mentary-weft float, 35½ × 31
 (90 × 78.8)
86.224.93

The Ernest Erickson Collection includes an unusually large number of complete shirts, or tunics, illustrating the remarkable range of prestige garments that have been preserved in burials in the dry desert sands of the coastal region of Peru. This tunic, composed of two lengths of cotton cloth sewn up the center and sides, was probably woven and worn in the Central Coast area during the Late Intermediate Period, a time of great regional diversity. The upper part of the tunic is subtly patterned by warp floats forming a geometric design against a plain weave ground, an ancient technique in Peru that can be traced back as far as 2500 B.C. (A. Rowe 1977, 54). Tapestry inserts in red and brown wool accent the monochrome pattern. The bottom third of the tunic is plain weave with a border design woven into the basic fabric and an added fringe. Discolored with brownish stains, presumably from burial, it is torn at the neck.

Similar cotton tunics have been found at the famous "Necropolis of Ancon," a site located about twenty-two miles north of the city of Lima (Reiss and Stubel 1880–87). The closest comparison to this tunic, however, is a fragment in the collection of The Textile Museum in Washington, D.C. (A. Rowe 1977, fig. 57). Because this fragment is also without provenance, it cannot be used to determine the cultural affiliations of the Erickson piece. DF

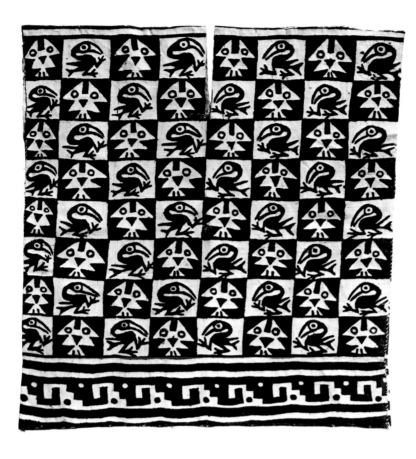

58 *Tunic*

Peru, Central Coast
1000–1470
Cotton, plain weave, warp predom-
 inant; dye; warp 18, weft 9 per
 cm; weft reinforcing at neck,
 25 × 23¼ (63.5 × 60.0)
86.224.121

One of the simplest and most direct methods
ancient Andean artists used for decorating
cloth was painting. Painting on plain weave
was particularly common in the Late Inter-
mediate Period (1000–1470) when a "pre-
mium was placed in all crafts on the achieve-
ment of a maximum effect with a minimum
of effort" (Sawyer 1979, 129–30). The im-
agery on these painted textiles ranged from
large-scale figurative compositions drawn
with broad brush strokes to small-scale re-
petitive patterns precisely executed with
stamps.

 This tunic is painted with birds and
fish in alternating squares that replicate the
structural figures of woven designs. The
stepped wave, dots, and stripes in the border
also suggest the geometry of weaving. The
crisp silhouettes and strong contrast between
figure and ground, however, are characteris-
tics of the painting medium as it was used in
ancient Peru.

 The tunic is made up of one piece of
plain-weave cotton cloth sewn at the sides
with an opening woven in at the neck. It is
unusually small in size and may have be-
longed to a child. Although the tunic itself
shows signs of wear, especially at the shoul-
ders, the painted designs are remarkably
fresh.

 Birds, fish, and waves appear fre-
quently both together and individually on a
great variety of media dating to the Late In-
termediate Period, including architecture,
ceramics, and metalwork as well as textiles.
Judging by the contexts in which they occur,
these motifs are related to agricultural pro-
duction as well as to fishing activities. Cere-
monial agricultural implements, for exam-
ple, were often ornamented with carvings of
sea birds eating fish (Menzel 1977, 11). DF

59 Seated Figure with Tweezers

Peru, North Coast, Inca?
14th–16th century
Hammered gold, 1⅞ × 1¼
 (4.8 × 3.2)
86.224.33

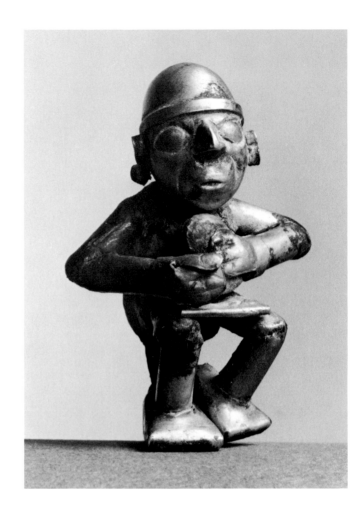

In working gold and silver, ancient Peruvian metalsmiths had a marked preference for hammering (Lechtman 1980). Although familiar with the techniques of smelting, alloying, and casting of metals since Moche times, they used hammering, soldering, and welding by hot-hammering to create appealing three-dimensional objects such as this small gold sculpture of a man plucking his beard. It has been suggested that "the specific qualities of sheet metal, when shaped by hammering," had significance for the ancient Peruvians, "since the tradition lasted from the earliest recorded working of gold in the second millennium B.C. until indigenous practices were disrupted by the Spanish Conquest in the 16th century" (Jones 1985, 210).

Creating a sculpture like the one illustrated here from sheet metal represents a rather complex construction process. It requires the separate shaping of many individual parts, nineteen or more in this instance, which are then joined by soldering or crimping.

The figure shows a seated man, supported in the back by a separately inserted gold tab, holding a pair of tweezers in his left hand while resting his right hand on his knee. He wears a belt and loincloth and a simple cap with a headband. The facial features and fingernails are worked in repoussé, while the scroll-shaped ears are made of strap metal. He has big, slightly protruding almond-shaped eyes, a strong aquiline nose, and a small narrow mouth with lines on each side. The feet are disproportionately large, and no details are indicated. While some of the seams are plainly visible, others are skillfully concealed. The belt and headband, for example, aptly hide the joints between the top and bottom parts of the body and head respectively. The dark areas are products of corrosion. Repair work was carried out in several places.

This charming little figure has been published in the past as an Inca-style object (Bird 1962; Jones 1964; Emmerich 1965). It shows more realism in its animated posture, however, than is customary in other known Inca figures in gold and silver, which are rather stiff and conventionalized and are usually shown standing with straight legs, holding their hands on their chests. The facial features, and the treatment of the eyes in particular, more closely resemble Chimu-style objects. Stylistically, the object follows the North Coast tradition. HK

Published: Emmerich 1965, 56; Bird 1962; Jones 1964.

Exhibited: *Art and Life in Old Peru*, American Museum of Natural History, New York, 1961, no. 19D; *Art of Empire: The Inca of Peru*, The Museum of Primitive Art, New York, 1963, cat. no. 52.

Tunic

Peru, Inca
1470–1532
Wool, tapestry weave: warp 10,
 weft 46 per cm, 34¼ × 29½
 (87.0 × 75.0)
86.224.133

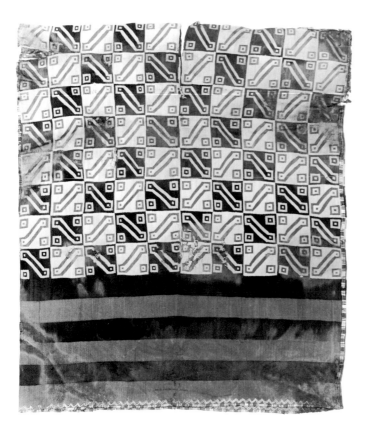

It is difficult to exaggerate the importance of cloth and clothing in the Inca Empire. As one scholar has written, "No political, military, social or religious event was complete without textiles being volunteered or bestowed, burned, exchanged, or sacrificed" (Murra 1962, 722).

The most prestigious type of cloth was *qompi*, or tapestry. Three categories of weavers were responsible for its production: cloistered women, wives of provincial administrative officials, and male specialists who wove to fulfill their tax obligations to the Inca government (J. Rowe 1979, 239). The ownership and use of tapestry tunics were strictly controlled by the state. Along

with gold, silver, and coca, tapestry shirts were common royal gifts, bestowed by the emperor in exchange for military or political services.

This tunic is an excellent example of Inca tapestry weaving. It is made from a single piece of cloth, with a neck opening woven into the middle. The sides are sewn together, leaving holes for arms at the shoulders. The neck slit, sides, and lower edge are embroidered with narrow stripes of purple, red, and yellow (some missing). A zig-zag line is embroidered just above the lower edge.

The woven design on the tunic is known as the "Inca key" checkerboard. It is one of four patterns cited by John Rowe as evidence of standardization in Inca tapestry tunics (1979). At least nine Inca checkerboard tunics have been published, all very similar in layout and design (J. Rowe 1979; A. Rowe 1978). On this tunic yellow squares with red keys alternate with dark purple squares with yellow keys on the upper two-thirds of the shirt; the bottom third is decorated with six horizontal purple and red stripes. All the Inca keyboard shirts have the six stripes, but there are slight variations in the number of squares and the sequence of colors. Although the meaning of the key motif is not known, its existence on a coherent group of tapestry-woven shirts suggests that it had considerable social significance.

Stains on the shirt show that it was part of a burial. Clothes played as important a role in an Inca man's death as in his life; they were part of mourning rituals and were buried with the deceased. Although new clothes were often woven specifically for the dead, this shirt was clearly worn before burial. It is torn at the shoulder, and there is an ancient repair at the neck opening. DF

Published: J. Rowe 1979, 239–64.

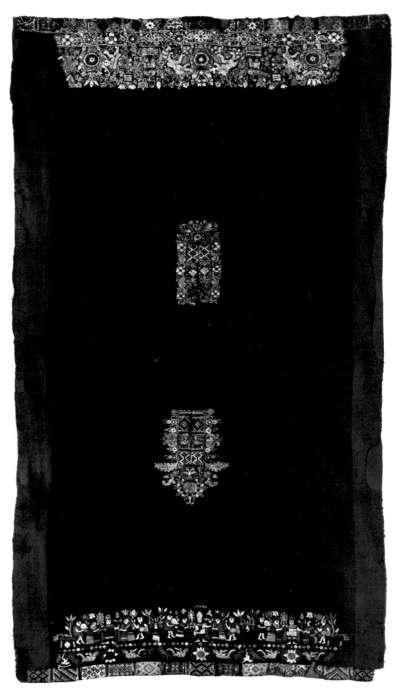

61 *Tunic*

Peru
Late 17th century
Wool, warp-faced plain weave:
warp 46, weft 10 per cm; embroi-
dered with wool and metallic (on
linen core) threads, 27 × 31
(68.6 × 78.8)
86.224.51

The Spanish conquest of Peru in the first half of the sixteenth century brought the short-lived Inca Empire and its imperial art style to an abrupt end. Some native artistic traditions continued, however, and even developed during the Colonial Period. This tunic, embroidered with Spanish heraldic motifs and scenes of Inca ceremonies, is a striking example of the creative cross-fertilization of cultures that gave native forms new meanings in the centuries following the conquest.

The tunic is composed of a single length of warp-faced plain weave wool with a subtle herringbone pattern produced by alternating the direction of the spin of the warp yarns, a technique still used in several parts of South America (A. Rowe 1977, 16). It is a rich dark brown in color with broad stripes of red at the sides and embroidered designs at the neck opening and the bottom. In several places the embroidery is covered by small appliqués of cloth.

The most unusual feature of the tunic is the marked contrast in the border designs. On one side two Inca warriors are represented amid three pairs of heraldic animals; on the other side three Inca are portrayed attended by musicians and women offering flowers. The heraldic animals and Inca warriors are sewn with silver threads in a dense composition that resembles European textile designs, while the Inca and their attendants on the other side are sewn in bright colors with each figure standing out clearly against the background in an arrangement similar to the painted designs on native drinking cups (keros). The bottom edges of both sides are the same, however, and are embroidered with a row of small rectangular patterns that recall the tocapu designs woven on pre-Conquest Inca tapestry tunics. While the precise meaning of tocapu designs has not been determined, they clearly denoted high status and can in a sense be seen as native equivalents of Spanish heraldic devices. The neck of the tunic is decorated with tocapu-type designs, floral motifs, and, on one side, an appliqué of a double-headed eagle of European derivation.

One possible explanation for the diversity of subjects and decorative styles evident on this tunic is that it was embroidered in several stages and shows the acculturation process over time. Perhaps it was an heirloom elaborated upon by successive generations or perhaps it reflects the concerns of the native elite during a specific time period. Tom Cummins has argued convincingly that it is an adaptation in embroidery of the battle/presentation motif he has identified on wooden kero cups (personal communication). According to Cummins, this motif was introduced on kero cups sometime after 1630 and remained popular until 1732. He suggests a late seventeenth-century date for the textile.

In an early publication on Peruvian costume (Zimmern 1949), Natalie Zimmern dated the tunic to the mid-sixteenth century. As Joanne Pillsbury has shown, however (Pillsbury n.d.), several other factors support Cummins's dating. During the sixteenth century important designs on tunics were usually represented in tapestry weave; embroidery of pictorial motifs was a relatively late development in Colonial Peru. Moreover, the tunic is shorter than pre-Conquest or early Colonial tunics, allowing for the inclusion of the Spanish trousers that were part of the native elite's costume during the seventeenth century. DF

Published: Zimmern 1949, no. 18.

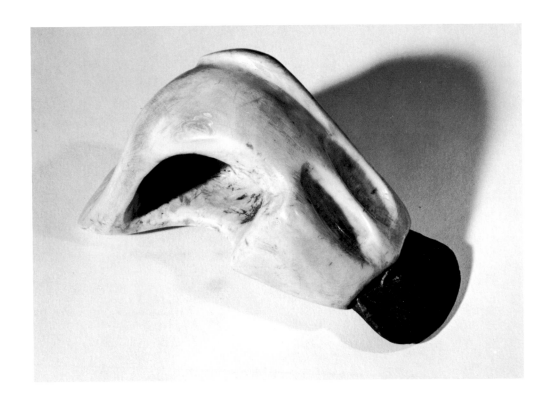

62 *Skin Scraper*

North America, Eskimo
19th century
Ivory, flint, 4¼ × 1⅝ × 2
 (10.8 × 4.2 × 5.1)
86.224.167

Ivory—most commonly walrus tusk but also whale and mastodon tooth—was one of the most important materials used by the Eskimos (Smith 1980). Hard, durable, and attractive, it was especially valuable given the Arctic's shortage of wood and frequent lack of suitable stone. Eskimo men employed it to make a wide range of objects. Although these objects tended to be functional, they were also often, like the two pieces here, superbly sculptural.

Both these pieces appear to have come from the area of ivory carving's greatest elaboration—northern and western Alaska (Ray 1977). The scraper, used by women to remove the fat and flesh from animal skins and to make the skin pliable after drying, is in the northern Alaska style, made to fit a woman's hand; a different style was characteristic of the southern region. The blades for such scrapers were originally made of stone, which was later replaced by iron. Handles were also made of wood and bone (Damas 1984, 308; Fitzhugh and Kaplan 1982, 131; Smith 1980, 54).

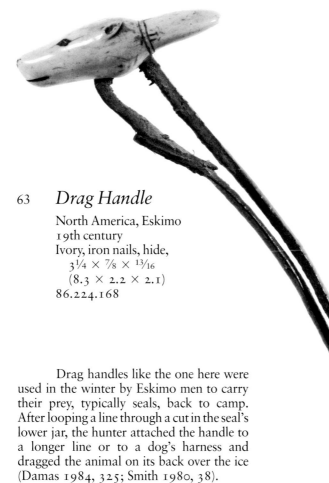

63 *Drag Handle*

North America, Eskimo
19th century
Ivory, iron nails, hide,
3¼ × ⅞ × ¹³⁄₁₆
(8.3 × 2.2 × 2.1)
86.224.168

Drag handles like the one here were used in the winter by Eskimo men to carry their prey, typically seals, back to camp. After looping a line through a cut in the seal's lower jar, the hunter attached the handle to a longer line or to a dog's harness and dragged the animal on its back over the ice (Damas 1984, 325; Smith 1980, 38).

The handle's small seal form is typical of the animal shapes found on a range of Eskimo objects, including toggles, charms, and amulets. The eyes of such animal forms, as in this piece, were often inlaid bits of stone or beads. Although the precise significance of these shapes is uncertain, there was, most likely, a relation between their form and the function of the objects they decorated. Prey animals such as seals, wolves, and polar bears, for example, are often depicted on hunting implements. The reflexive use of a seal image on a form used to hunt the animal would have reinforced its magical, and thus technical, potency (Fitzhugh and Kaplan 1982, 78–79; cf. Smith 1980, 92). The back part of this handle takes the shape of a mitten. ISJ

64 *Globular Rattle*

North America, Northwest Coast
19th century
Wood, hide, nails, paint,
 12 × 7 × 4¼
 (30.5 × 17.8 × 10.8)
86.224.152

Along with drums, rattles are the principal musical instruments of the Northwest Coast Indians. Invariably associated with the ceremonial, they are used to accompany song and dance and for emphasis in oratory. When the rattle sounds, the spirits are invoked; some Indians even regard the sound as supernatural voices (Wade and Wade 1976). Globular rattles are often thought to have been shamans' rattles used in the curing of patients, but this was not always the case (Johnson 1973, 15–17).

Some kind of bird, probably a thunderbird, is depicted on the globular rattle seen here. The animal's head is on one side; on the reverse is the rest of its body—torso with the backbone and ribs defined, wings, talons, and tail. Interestingly, this back side is inverted, so that the creature's tail is at the top and its torso below.

Bird rattles are common on the Northwest Coast, and of these the raven rattle (cat. no. 65) represents without doubt the best known (Holm 1983, 25–28). Raven

rattles are said to have originated among the Tsimshian of the Nass River in British Columbia, but by the end of the nineteenth century they were in use throughout the region. Often called the chief's rattle, the raven rattle is used by chiefs at ceremonial occasions. Dressed in a frontlet and a ceremonial blanket, the chief holds the rattle with the raven's belly up. Some natives have suggested that this is to prevent the bird from flying away (Holm 1972, 30).

Formally, the raven rattle is a complex sculptural composition. Though variations are found in the details, the basic elements are almost always the same. Made with a thin, light hardwood shell in two halves, the rattle is joined together with sinew or (as in this case) fiber and filled with pebbles or shot (missing here). A raven's body forms the basic shape. In its mouth the raven almost always carries a small rectangle. On its back lies a recumbent man, facing another bird (usually with a long, straight beak and a stiff tail) on the raven's tail. Sharing a tongue with the man is a frog, held here in the beak of the bird at the rear; the frog may also sit on the man's chest. On the raven's belly is a birdlike face with a recurved beak or nose. This particular rattle, a classic example of the type, is made from three pieces: the raven's lower half; its head, its back, and the man; and the rear bird, frog, and protruding tongue.

Because native informants have been able to shed little light on the identifications and meanings of the raven rattle motifs, there is much room for scholarly speculation (Holm 1983, 25). The shared tongue, for instance, has been interpreted as signifying either the transference of poison or more generally the transmittal of spiritual power from the frog to the man. The man himself is most often interpreted as a shaman, and it has been suggested that the raven rattle was originally a shaman's rattle. As for the small rectangle in the raven's mouth, it probably refers to the myth of the raven stealing the box containing the sun, from which light was brought to the world. There is some difference about what the birdlike face on the raven's belly represents. Though usually thought of as a hawk, because of its recurved beak, it may be a salmon or a supernatural creature. The bird at the raven's tail has usually been interpreted as a kingfisher, but, again, there is little evidence for this. ISJ

65 *Raven Rattle*

North America, Northwest Coast,
 Tlingit (?)
19th century
Wood, fiber, paint,
 13¼ × 5¾ × 3¾
 (33.7 × 14.6 × 9.5)
86.224.154

As an intermediary between the human and spirit worlds, the shaman was a powerful man in the Northwest Coast Indian community. In addition to his ability to cure the sick, he could control the weather, ensure success in war or hunting, and find lost persons (Johnson 1973).

The shaman's ritual paraphernalia might include masks, costumes, rattles, amulets, and boxes (Gunther 1966, 147–64). These objects would be handed down to his successor or buried with him in his grave.

Amulets are most closely associated with the Tlingit, but they were also used by the neighboring Tsimshian or Haida. Often part of the shaman's ceremonial costume, which along with masks and an apron might include armor and knives, they could be worn in several ways—hung around the neck, either as a single pendant or as part of a necklace, or sewn onto the dance apron or cape. Sometimes the shaman would touch a charm to the afflicted part of a patient's body. The smoothed features on the humanoid charm seen here (cat. no. 67) suggest that it may have been used in this fashion.

The shaman was aided by familiar spirits (called *yeks* by the Tlingit) which might appear to him in a visionary trance, and from which he would seek aid during his seance. These spirits, of which for the Tlingit the land otter was the most important, supplied the motifs for the shaman's charms (Jonaitis 1978). In addition to the humanoid head, seen here are a bird (cat. no. 66) and what may be a wolf. More specific identifications are difficult.

Amulets were formed from a range of materials. Bone, ivory, and teeth were especially common, but antler, wood, shell, and stone were also used. Some amulets were single figures; others were more complex. The humanoid head, for instance, has a second face carved in its bottom and the bird has an inverted "copper," or ceremonial shield, on its back. While some shamanic objects are left in natural form or are crudely carved, signifying contact with the spirit world, others, such as these charms, are stunning examples of the complex visual language usually associated with secular art. This secular look may represent the power of the shaman to restore cosmic order to his society (Jonaitis 1983). ISJ

66 *Shaman's Charm*

North America, Northwest Coast,
 Tlingit (?)
19th century
Ivory, abalone shell inlay,
 3¾ × 1⁵⁄₁₆ × 1¾
 (9.5 × 3.4 × 4.5)
86.224.175

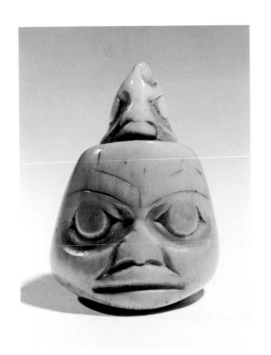

67 *Shaman's Charm*

North America, Northwest Coast,
 Tlingit (?)
19th century
Ivory, 1¾ × 1¼ × 1
 (4.5 × 3.2 × 2.5)
86.224.176

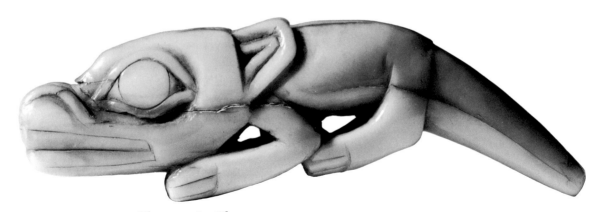

68 *Shaman's Charm*

North America, Northwest Coast,
 Tlingit (?)
19th century
Ivory, 3 × ⁷⁄₁₆ × ⁷⁄₈
 (7.6 × 1.2 × 2.2)
86.224.179

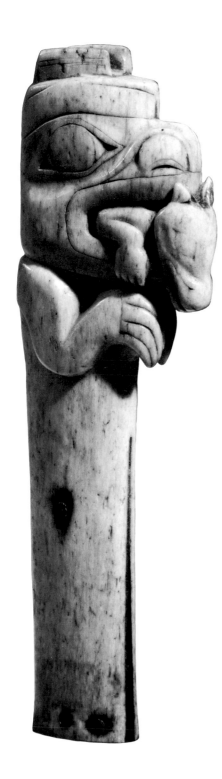

69 *Dagger Handle*

North America, Northwest Coast,
 Tlingit (?)
19th century
Ivory, iron, 6½ × 2 × ⅞
 (16.5 × 5.1 × 2.2)
86.224.174

Northwest Coast metal daggers, often of fine workmanship, are today highly prized by collectors. However, not much is known about the use of these weapons, for the Europeans suppressed the often ceremonialized warfare in which they were employed before good accounts of it could be made. In battle, the dagger might be tied to the warrior's hand. When not in use it was worn in a sheath, usually of hide, which was suspended with a strap around the neck. Although the dagger was still an important weapon until the early nineteenth century, with the introduction of firearms it gradually assumed a purely ceremonial significance. Used as items of display at potlatches, or ceremonial feasts, the weapons were often handed down as family heirlooms.

Even before contact with the Europeans, the Northwest Coast Indians were skilled metallurgists. Although some traditions claim the use of iron, the most common metal used for daggers, as well as for tools and ornaments, was copper (Holm 1982, 64; 1983, 98). After the arrival of the white man, factory-made blades of iron and steel supplanted native metals. Sometimes the entire dagger — blade and handle — was forged from a single piece of metal; other times, as here, the handle was made separately. The handle would then be secured to the blade with rivets, and the upper part wrapped with sinew. At some point in its history, the blade of this dagger was cut off at the hilt, leaving the upper end sandwiched between the sides of the ivory handle. While hardwood was the most common material for dagger handles, bone, ivory, and horn were also used. Sometimes the handle was inlaid with abalone shell. Dagger hilts were usually decorated with totemic or crest designs. A bear with a creature in its mouth, a common Northwest Coast motif, is represented on this dagger (cf. Holm 1982, 74; 1983, 99).

ISJ

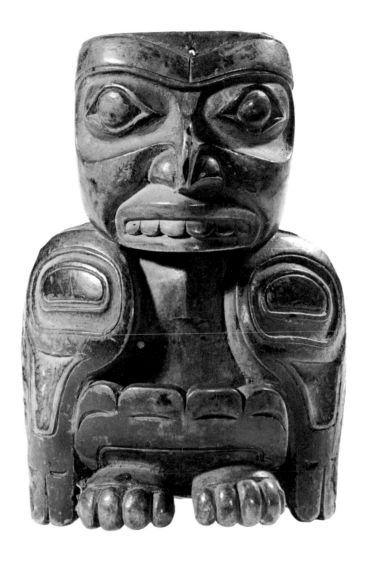

70 *Bird Figurine*

North America, Northwest Coast,
 Tlingit
19th century
Wood, resin, paint,
 4⅝ × 3⅛ × 1½
 (11.7 × 8.0 × 3.8)
86.224.177

Most Northwest Coast Indian art is applied or "decorative," intended to enhance functional objects, be they houses or fishhooks. Exceptions include a distinct genre of sculptures carved from the black slate argillite and made for sale to Europeans, large sculptures like totem poles and potlatch figures, and small freestanding sculptures like this bird figurine.

Such small sculptures are rare; most are shamans' charms. This piece, whose angular and linear style is characteristically Tlingit, is thus something of a puzzle for, although it could be a pendant of some sort, it does not appear to be a charm. It is apparently a fragment, possibly from a speaker's staff. There are several small holes, two near the feet, one in the forehead, but whether these are native-made is unclear. The back is undecorated and slightly hollowed out. While the wings at the sides and the turned-up tail at the bottom unmistakenly brand the creature as a bird, its humanoid nose and toothed mouth suggest that at the least it is a bird of the supernatural realm. ISJ

Works Cited: Ancient Andean Art

Allen 1981 Catharine J. Allen, "The Nasca Creatures: Some Problems of Iconography,"
 Anthropology, 5, 1 (1981), 43–70.

Bennett 1954 Wendell C. Bennett, *Ancient Art of the Andes* (The Museum of Modern Art, New
 York, 1954).

Benson 1972 Elizabeth P. Benson, *The Mochica* (New York, 1972).

Benson 1976 Elizabeth P. Benson, "'Salesmen' and 'Sleeping' Warriors in Mochica Art," in
 Actas del XLI Congreso Internacional de Americanistas, II (Mexico, 1976).

Benson and Conklin 1981 Elizabeth P. Benson and William J. Conklin, *Museums of the Andes* (Newsweek,
 Great Museums of the World, New York and Tokyo, 1981).

Bird 1962 Junius B. Bird, "Art and Life in Old Peru," *Curator*, 2 (1962), 145–210.

Bird and Skinner 1974 Junius B. Bird and Milica Dimitrijevic Skinner, "The Technical Features of a
 Middle Horizon Tapestry Shirt from Peru," *Textile Museum Journal*, 4 (1974),
 5–11.

Carcedo and Shimada 1985 Paloma Carcedo Muro and Izumi Shimada, "Behind the Golden Mask: Sican
 Gold Artifacts from Batan Grande, Peru," in *The Art of Precolumbian Gold—The
 Jan Mitchell Collection* (The Metropolitan Museum of Art, New York, 1985),
 61–75.

Carrión Cachot 1949 Rebecca Carrión Cachot, *Paracas: Cultural Elements* (Lima, 1949).

Dawson 1964 L. E. Dawson, "Slip Casting: A Ceramic Technique Invented in Ancient Peru,"
 Ñawpa Pacha, 2 (1964), 107–12.

Della Santa 1962 Elisabeth Della Santa, *Les Vases Péruviens de la Collection de Ll. MM. Le Roi
 Albert et La Reine Elisabeth de Belgique* (Musées Royaux d'Art et d'Histoire,
 Département de l'Ethnographie, Brussels, 1962).

Disselhoff 1972 Hans-Dietrich Disselhoff, "Metallschmuck aus der Loma Negra, Vicus (Nord
 Peru)," *Antike Welt* 3, 2 (1972), 43–53.

Disselhoff 1976 Hans-Dietrich Disselhoff, "Die Kunst der Andenlaender," in *Alt-Amerika, Kunst
 der Welt* (Baden-Baden, 1976).

Domingo 1980 Mariano Domingo, *Cultura y Ceramica Mochica* (Ministerio de Cultura, Madrid,
 1980).

Donnan 1976 Christopher B. Donnan, *Moche Art and Iconography* (UCLA Latin American
 Center Publications, Los Angeles, 1976).

Donnan 1978 Christopher B. Donnan, *Moche Art of Peru* (Museum of Cultural History, UCLA,
 Los Angeles, 1978).

Easby 1956 Dudley T. Easby, Jr., "Ancient American Goldsmiths," *Natural History* 65, 8
 (1956), 401–9.

Eisleb 1977 Dieter Eisleb, *Altperuanische Kulturen—Nazca* (Museum für Völkerkunde, Ber-
 lin, 1977).

Emmerich 1965 André Emmerich, *Sweat of the Sun and Tears of the Moon* (Seattle, 1965).

Esser 1982 Janet Brody Esser, "Chancay, a Pottery Style of Ancient Peru," in *Pre-Columbian
 Art History—Selected Readings*, edited by Alana Cordy-Collins (Palo Alto, 1982),
 313–29.

Gayton and Kroeber 1927 A. H. Gayton and A. L. Kroeber, "The Uhle Pottery Collections from Nazca,"
 University of California Publications in American Archaeology and Ethnology,
 24 (1927), 1–46.

Glubok 1966 Shirley Glubok, *The Art of Ancient Peru* (New York, 1966).

Haeberli 1979 — Joerg Haeberli, "Twelve Nasca Panpipes: A Study in Ethnomusicology," *Ethnomusicology*, 23, 1 (January 1979), 57–59.

Hocquenghem 1977 — Anne Marie Hocquenghem, "Les Representations de Chamans dans l'Iconographie Mochica," *Ñawpa Pacha*, 15 (1977), 123–30.

Jones 1964 — Julie Jones, *Art of Empire: The Inca of Peru* (The Museum of Primitive Art, New York, and New York Graphic Society, Greenwich, Connecticut, 1964).

Jones 1985 — Julie Jones, *The Art of Precolumbian Gold—The Jan Mitchell Collection* (The Metropolitan Museum of Art, New York, 1985).

Kajitani 1982 — Nobuko Kajitani, "Textiles of the Andes," *Textile Art*, 20 (Autumn 1982), 9–87.

King n.d. — Mary Elizabeth King, "Textiles and Basketry of the Paracas Period, Ica Valley, Peru," Ph.D. dissertation, University of Arizona, 1965.

Kubler 1975 — George Kubler, *The Art and Architecture of Ancient America* (Harmondsworth, England, 1975).

Lapiner 1976 — Alan Lapiner, *Pre-Columbian Art of South America* (New York, 1976).

Larco Hoyle 1938–39 — Rafael Larco Hoyle, *Los Mochicas*, 2 vols. (Lima, 1938–39).

Larco Hoyle 1945 — Rafael Larco Hoyle, *La Cultura Viru* (Trujillo, 1945).

Lechtman 1980 — Heather Lechtman, "The Central Andes," in *The Coming of Age of Iron*, edited by T. A. Wertime and J. D. Muhly (New Haven, 1980), 267–334.

Lechtman 1982 — Heather Lechtman, Antonietta Erlij, and Edward J. Barry, Jr., "New Perspectives on Moche Metallurgy: Techniques of Gilding Copper at Loma Negra, Northern Peru," *American Antiquity*, 47 (1982), 3–30.

Lothrop 1957 — Samuel K. Lothrop, *The Robert Woods Bliss Collection of Precolumbian Art* (New York, 1957).

Lothrop and Mahler 1957 — Samuel K. Lothrop and Joy Mahler, "Late Nazca Burials at Chaviña, Peru," *Papers of the Peabody Museum of American Archaeology and Ethnology*, 50, 2 (1957), 3–61.

Lumbreras 1974 — Luis G. Lumbreras, *The Peoples and Cultures of Ancient Peru* (Smithsonian Institution, Washington, D.C., 1974).

Menzel 1964 — Dorothy Menzel, "Style and Time in the Middle Horizon," *Ñawpa Pacha*, 2 (1964), 66–73 and 104–5.

Menzel 1977 — Dorothy Menzel, *The Archaeology of Ancient Peru and the Work of Max Uhle* (R.H. Lowie Museum of Anthropology, University of California, Berkeley, 1977).

Menzel, Rowe, Dawson 1964 — Dorothy Menzel, John Howland Rowe, and L.E. Dawson, *The Paracas Pottery of Ica* (Berkeley, 1964).

Montell 1929 — Gösta Montell, *Dress and Ornaments in Ancient Peru: Archaeological and Historical Studies* (Göteborg, Sweden, 1929).

Morris 1977 — Craig Morris, *Peru's Golden Treasures* (American Museum of Natural History, New York, 1977).

Moseley and Day 1982 — Michael E. Moseley and Kent C. Day, eds., *Chan Chan: Andean Desert City* (Albuquerque, 1982).

Moseley, Mackey, and Brill 1973 — Michael E. Moseley, Carol J. Mackey, and David Brill, "Peru's Ancient City of Kings," *National Geographic*, 143, 3 (1973), 318–45.

Murra 1962 — John V. Murra, "Cloth and Its Functions in the Inca State," *American Anthropologist*, 64, 4 (1962), 710–28.

Museo de la Cultura, Lima 1951 — Museo de la Cultura, Lima, *Instrumentos Musicales del Peru: Collección Arturo Jimenez Borja* (Lima, 1951).

Pillsbury n.d. Joanne Pillsbury, "Early Post-Conquest Andean Textiles: An Analysis of Uncu Design Structure and Function," M.A. thesis, Columbia University, 1986.

Reiss and Stübel 1880–87 Wilhelm Reiss and Alphons Stübel, *The Necropolis of Ancon in Peru*, 3 vols. (Berlin, 1880–87).

Roark 1965 Richard Paul Roark, "From Monumental to Proliferous in Nazca Pottery," *Ñawpa Pacha*, 3 (1965), 1–92.

A. Rowe 1977 Ann Pollard Rowe, *Warp-Patterned Weaves of the Andes* (The Textile Museum, Washington, D.C., 1977).

A. Rowe 1978 Ann Pollard Rowe, "Technical Features of Inca Tapestry Tunics," *The Textile Museum Journal* (1978), 5–28.

A. Rowe 1984 Ann Pollard Rowe, *Costumes and Featherwork of the Lords of Chimor: Textiles from Peru's North Coast* (The Textile Museum, Washington, D.C., 1984).

A. Rowe in press Ann Pollard Rowe, "Textiles from the Nasca Valley at the Time of the Fall of the Huari Empire," in *The Junius B. Bird Conference on Andean Textiles, April 7th and 8th, 1984*, edited by A. P. Rowe (in press), 151–82.

J. Rowe 1979 John Howland Rowe, "Standardization in Inca Tapestry Tunics," in *The Junius B. Bird Pre-Columbian Textile Conference, May 19th and 20th, 1973*, edited by A. P. Rowe, E. P. Benson, and A. Schaffer (The Textile Museum, Washington, D.C., 1979), 239–64.

Sawyer 1961 Alan R. Sawyer, "Paracas and Nazca Iconography," in *Essays in Pre-Columbian Art and Archaeology*, edited by D.Z. Stone, J.B. Bird, G.F. Ekholm, and G.R. Willey (Cambridge, Massachusetts, 1961), 269–99.

Sawyer 1963 Alan R. Sawyer, *Tiahuanaco Tapestry Design* (The Museum of Primitive Art, Studies no. 3, New York, 1963).

Sawyer 1966 Alan R. Sawyer, *Ancient Peruvian Ceramics — The Nathan Cummings Collection* (The Metropolitan Museum of Art, New York, 1966).

Sawyer 1975 Alan R. Sawyer, *Ancient Andean Arts in the Collections of the Krannert Art Museum* (University of Illinois, Urbana-Champaign, 1975).

Sawyer 1979 Alan R. Sawyer, "Painted Nasca Textiles," in *The Junius B. Bird Pre-Columbian Textile Conference, May 19th and 20th, 1973*, edited by A. P. Rowe, E. P. Benson, and A. Schaffer (The Textile Museum, Washington, D.C., 1979), 129–50.

Schmidt 1929 Max Schmidt, *Kunst und Kultur von Peru* (Berlin, 1929).

Sharon and Donnan 1974 D. Sharon and C. Donnan, "Shamanism in Moche Iconography," in *Ethnoarchaeology* (UCLA, Archaeological Survey Monograph IV, Los Angeles, 1974), 49–77.

Spielbauer 1972 Judith Spielbauer, "Nazca Figurines from the Malcolm Whyte Collection," *Archaeology*, 25 (1972), 21–25.

Stat 1979 D.K. Stat, "Ancient Sound: The Whistling Vessels of Peru," *El Palacio*, 85, 2 (1979), 2–7.

Stone in press Rebecca R. Stone, "Color Patterning and the Huari Artist: The 'Lima Tapestry' Revisited," in *The Junius B. Bird Conference on Andean Textiles, April 7th and 8th, 1984*, edited by A. P. Rowe (in press), 137–204.

Strong 1957 William Duncan Strong, "Paracas, Nazca, and Tiahuanacoid Cultural Relationships in South Coastal Peru," *American Antiquity*, 22, 4, part 2 (Society of American Archaeology, Memoirs, no. 13, Salt Lake City, 1957).

Tello 1959 Julio C. Tello, *Paracas; Primera Parte* (Publicación del Projecto 86 del Programa 1941–42 de The Institute of Andean Research de New York, Lima, 1959).

Townsend 1985 Richard F. Townsend, "Deciphering the Nazca World: Ceramic Images from Ancient Peru," *Museum Studies*, 2, 2 (The Art Institute of Chicago, Spring 1985), 117–39.

Tsunoyama 1979 Yukihiro Tsunoyama, ed., *Textiles of the Andes—Catalog of Amano Collection* (Heian International, San Francisco, 1979).

Tushingham 1976 A.D. Tushingham, *Gold of Gods* (Royal Ontario Museum, Toronto, 1976).

Valcárcel 1933 Luis E. Valcárcel, "Esculturas de Pikillaqta," *Revista del Museo Nacional* (Lima), 2 (1933), 21–48.

Wardwell 1968 Allen Wardwell, *The Gold of Ancient America* (Museum of Fine Arts, Boston, 1968).

Wolfe 1981 Elizabeth F. Wolfe, "The Spotted Cat and the Horrible Bird: Stylistic Change in Nasca 1–5 Ceramic Decoration," *Ñawpa Pacha*, 19 (1981), 1–62.

Yacovleff 1931 Eugenio Yacovleff, "El vencejo (Cypselus) en el arte decorativo de Nasca," *Wira Kocha*, 1 (1931), 25–35.

Zimmern 1949 Nathalie H. Zimmern, *Introduction to Peruvian Costume* (The Brooklyn Museum, New York, 1949).

Works Cited: North American Indian Art

Damas 1984

David Damas (ed.), *Arctic. Handbook of North American Indians* 5. William C. Sturtevant, general editor (Washington, D.C., 1984).

Fitzhugh and Kaplan 1982

William W. Fitzhugh and Susan A. Kaplan, *Inua: Spirit World of the Bering Sea Eskimo*, exhibition catalogue (National Museum of Natural History, Washington, D.C., 1982).

Gunther 1966

Erna Gunther, *Art in the Life of the Northwest Coast Indians* (Portland Art Museum, Oregon, 1966).

Holm 1972

Bill Holm, *Crooked Beak of Heaven: Masks and Other Ceremonial Art of the Northwest Coast*, exhibition catalogue (Henry Art Gallery, University of Washington, Seattle, 1972).

Holm 1982

Bill Holm, "Objects of Unique Artistry," in Thomas Vaughan and Bill Holm, *Soft Gold: The Fur Trade and Cultural Exchange on the Northwest Coast of America*, exhibition catalogue (Oregon Historical Society, Portland, 1982).

Holm 1983

Bill Holm, *The Box of Daylight: Northwest Coast Indian Art*, exhibition catalogue (Seattle Art Museum, 1983).

Johnson 1973

Ronald Johnson, *The Art of the Shaman*, exhibition catalogue (University of Iowa Museum of Art, Iowa City, 1973).

Jonaitis 1978

Aldona Jonaitis, "Land Otters and Shamans: Some Interpretations of Tlingit Charms," *American Indian Art* 4, no. 1, 62–66.

Jonaitis 1983

Aldona Jonaitis, "Style and Meaning in the Shamanic Art of the Northern Northwest Coast," in Bill Holm, *The Box of Daylight: Northwest Coast Indian Art*, exhibition catalogue (Seattle Art Museum), 1983, 129–31.

Ray 1977

Dorothy Jean Ray, *Eskimo Art: Tradition and Innovation in North Alaska* (Seattle, 1977).

Smith 1980

J.G.E. Smith, *Arctic Art: Eskimo Ivory*, exhibition catalogue (Museum of the American Indian, New York, 1980).

Wade and Wade 1976

Edwin L. and Lorraine Laurel Wade, "Voices of the Supernaturals: Rattles of the Northwest Coast," *American Indian Art* 2, no. 1, 32–39, 58–59.

Ancient Egyptian Art

Richard A. Fazzini
Curator of Egyptian, Classical, and Ancient Middle Eastern Art
and
Robert S. Bianchi
Associate Curator of Egyptian, Classical, and Ancient Middle Eastern Art
The Brooklyn Museum

While Ernest Erickson's Egyptian collection was neither his first nor his largest collection, it is nevertheless a relatively early, as well as a relatively significant, American private collection of Egyptian art, as distinct from Egyptian antiquities. That this should be so for a collection formed after World War II reflects a fundamental transformation in Western attitudes toward things Egyptian.

Popular Western interest in Egypt and its monuments, which declined with the Roman Empire, first revived in the seventeenth century, becoming widespread in the 1800s thanks in part to the Napoleonic expedition to Egypt in 1798, the publication of that expedition's scientific work in 1809, and the decipherment of hieroglyphs in 1822. During the nineteenth century, museums and individuals in Europe and, to a lesser extent, the United States assembled a number of important Egyptian collections (see Oliver 1979; for a history of ancient Egypt's impact on European civilization, see, for example, Harris 1971).

With few exceptions, however, these early collectors treasured their Egyptian objects for their rarity, their archaeological and historical significance, or their relationship (real or imagined) to the Holy Land and the Bible. When curators at The Brooklyn Museum began to assemble an Egyptian collection in 1902, for instance, they were guided mainly by an interest in history, religion, and archaeology rather than art and art history (Bothmer 1979, 81).

Such attitudes have begun to change only in the last fifty years in the wake of the abandonment by modern Western artists of Classical artistic norms sanctified during the Renaissance. As the late Joseph Alsop observed, this abandonment led to a situation in which "all art gradually became equal," and "the products of all the known non-Western cultures, whether surviving above ground or wrenched from the shelter of the silent earth . . . [were] scrutinized anew." Eventually,

> *grimy archaeological finds and obscure ethnographical specimens, curios from family whatnots, souvenirs of life on far frontiers and loot from half-forgotten military expeditions to remoter corners of the globe [all] came to be seen as works of art deserving the grave, minute attention of art historians, the angry rivalry of art collectors, and the more polite but no less cutthroat pursuit of museum curators* [Alsop 1982, 14–15].

Although Alsop was unfair to many collectors and curators, his general point is valid: the West has developed a new regard for non-Western aesthetics.

Ernest Erickson was one of the first of what is still a small group of serious American collectors to apply this new attitude to Egyptian art. From the time of his first loan to The Brooklyn Museum of an Egyptian object, an Old Kingdom *Head of a Man* that he purchased in 1955 (see cat. no. 71), his main interest was aesthetic. In fact, according to Bernard V. Bothmer, retired Chairman of The Brooklyn Museum's Department of Egyptian, Classical, and Ancient Middle Eastern Art, only once was Mr. Erickson specifically interested in the historical value and archaeological context of an Egyptian object.

On that occasion, in 1968, Mr. Erickson came to suspect that a relief block of a female offering bearer he had seen in the shop of a New York dealer belonged with blocks in the Museum's Egyptian collection from the Theban tomb of the Vizier Nespeqashuty of early Dynasty XXVI (about 650 B.C.). Archaeologists from The Metropolitan Museum of Art, New York, had excavated that tomb in the winter of 1922–23 and, with the permission of the Egyptian government, removed the tomb's surviving reliefs to New York, where large sections of them were sold to The Brooklyn Museum in 1952. Confirming with Curator Bothmer his suspicion that the figure of an offering bearer adjoined the Nespeqashuty reliefs in Brooklyn and must have been removed from the tomb prior to its official excavation, Mr. Erickson resolved at first to buy the piece and place it on permanent loan to the Museum. In the end, however, he stepped aside so that the Museum could acquire it directly. In 1986 it and the other Nespeqashuty reliefs, only some of which had ever been displayed, became the focus of a reinstallation of a gallery devoted to art of the Egyptian Late Period.

Although this incident is atypical of Mr. Erickson's usual interest in Egyptian objects, it is a perfect example of his concern for the Museum's Egyptian collection. As *The New York Times* referred to him in an article on the Nespeqashuty relief on April 9, 1968, he was a "treasure scout" for the Museum who, in the words of Bothmer, had "adopted a second career in the museum's interests." While Bothmer and his predecessor as Curator, John D. Cooney, sometimes steered him to objects, he acquired many pieces on his own, often buying them with the knowledge that when he loaned them to the Museum they would fill gaps or augment strengths in the Museum's collection. That he had a special feeling for the Museum's Egyptian collection is indicated by the fact that we know of only a few Erickson Egyptian pieces elsewhere, such as some Coptic works in the National Museum in Stockholm and a fine, large bronze Osiris he gave to a friend.

If one looks at the chronological order of Mr. Erickson's collecting, one sees no great changes over time except, perhaps, that his interest in the minor arts grew more limited. Like many important private collectors of Egyptian art, he bought objects from most of the major periods of Egyptian history and emphasized statuary and relief rather than the minor arts. Indeed, in that regard his acquisition policy resembled that of The Brooklyn Museum during the same period. Unlike both the Museum and most private collectors, however, he clearly favored relief sculpture over sculpture in the round, which is one reason his collection is such an important addition to our holdings.

Although such material was readily available on the art market, Mr. Erickson never acquired a work made before the Old Kingdom, perhaps because the art of the earliest eras of Egyptian prehistory and history does not display a fully evolved Egyptian style. His earliest piece is the Old Kingdom *Head of a Man*, an aesthetically striking private sculpture of Dynasty V. The only other work of an early era he acquired

is a *Stela in the Form of a False Door* dated to Dynasty VI or later (86.226.2: Fazzini 1972, 33–37). It is the best such object, indeed the only exhibitable object of its type, at The Brooklyn Museum.

Mr. Erickson must have found the Middle Kingdom only slightly more appealing, for it is represented in his collection by only three pieces. One, a faience *Statue of a Standing Hippopotamus*, is a fine example, larger than the Museum's own specimens (Riefstahl 1968, 17 and 94–95), of a universally appealing Middle Kingdom type. Much rarer are a *Funerary Figure of a Man* (cat. no. 73) and a wooden statuette of a *Noblewoman* (cat. no. 72), both of which are excellent sculptures of significant Middle Kingdom types otherwise unrepresented at the Museum. According to Bothmer, the latter was one of the finds Mr. Erickson purchased without consulting the Museum's curators but with the certainty they would be happy to have the object to display.

By far the largest portion of Mr. Erickson's collection is devoted to works of the New Kingdom. While displaying many of the most important achievements of, and changes in, the art of their era, especially Dynasty XVIII, these pieces also fit beautifully with the Museum's own New Kingdom holdings. Mr. Erickson's *Face of a Woman* (86.226.36), his *Head of a High Official* (cat. no. 77), and his splendid *Shabti of Maya* (cat. no. 78), for instance, all add dramatically to our own display of private sculpture of pre-Amarna Dynasty XVIII (Bothmer 1967). Similarly, although one of his royal reliefs of early Dynasty XVIII, that of a *Meret Shemau* (cat. no. 74), is in essentially the same style as a contemporary relief of Amenhotep I we acquired in 1971 (Fazzini 1975, 70–71)—the closest the Museum ever came to duplicating an Erickson Egyptian piece on loan—his other such reliefs, *Oarsmen and Dancers on a Tow Boat* (cat. no. 75) and *Relief Representation of Royal Statues* (cat. no. 76), are fine complements to our other, limited acquisitions in this area, such as our relief of Ahmose and a queen (Romano 1983). Moreover, if the queen on our Ahmose relief is Ahmose-Nofretari, then Mr. Erickson's Dynasty XIX relief of *Amun-Re, the Deified Ahmose-Nofretari, and Amenhotep I* (cat. no. 81) joins it and three other Brooklyn Museum pieces to form an interesting group of depictions of Ahmose Nofretari and her son Amenhotep I as queen, king, and deities during the course of the New Kingdom.

As for Mr. Erickson's works of the Amarna Period and its immediate aftermath—a relief of *The Aten's Herd and Its Warden* (cat. no. 79), a *Relief of a Woman* (86.226.33), a three-dimensional head, probably of *Tutankhamun* (cat. no. 80), and a *Relief of a Bowing Courtier* (86.226.26)—their importance as works of art in their own right and as significant additions to the Museum's extensive holdings in the art of this era was emphasized by the inclusion of the first three in the 1973 exhibition *Akhenaten and Nefertiti* (Aldred 1973, 147, 168, and 199).

Sometimes Mr. Erickson's acquisitions clearly reflect not only his taste but the capricious nature of collecting as well. Take, for instance, his five Theban tomb reliefs of late Dynasty XXV–early Dynasty XXVI—a *Sunk Relief of a Man* (cat. no. 84), a fragment with finely carved *Hieroglyphs in Raised Relief* (86.226.10), a *Relief of a Workman* (86.226.6: Bothmer 1985, 101 and pl. IVb), and two reliefs of priests or noblemen (86.226.5 and 86.226.9: Fazzini 1972, 64, figs. 34–35). Although Mr. Erickson may have been drawn to them in part because of an interest in Late Period art and in part because some of them resemble Theban reliefs of Dynasty XVIII (a dynasty whose art he especially treasured), his acquisition of them also demonstrates the vagaries of the art market. Just as his purchase of a wooden Ramesside *Head of a Son of Horus* (cat. no. 82) was probably made possible by the dispersal of the

holdings of the Egyptian collector Kashaba Pasha in the early 1970s, so his acquisition of these objects was facilitated by the existence on the market between the 1940s and the 1970s of a number of Late Period Theban reliefs—many, but not all, from the tomb of Mentuemhat, a near contemporary of the Vizier Nespeqashuty. Together with the ones the Museum purchased and our Nespeqashuty reliefs, Mr. Erickson's reliefs make our holdings in this area outstanding.

In addition to the Theban reliefs, Mr. Erickson acquired several other works of the Late Period or later. As befits the variety that characterizes later Egyptian art, these range from pharaonic-style works such as a relief of *Ptah, Creator God of Memphis* (cat. no. 85) to a very different Coptic *Relief with Vine Motif* (86.226.27); from an idealizing *Head from a Ptolemaic Female Figure* (cat. no. 86) to a later and much more individualistic painted *Portrait of a Noblewoman* (cat. no. 89); and from a lovely silver *Ibis of the God Thoth* (cat. no. 88) to an ivory *Openwork Plaque* (86.226.4). The last-named piece, acquired early in his career as a collector, is a Roman-style work supposedly from Roman Egypt. Mr. Erickson's only wholly non–Egyptian-style Egyptian acquisition, it is the only forgery to enter his Egyptian collection—not a bad record for any collector.

Mr. Erickson's collection will long remain an important collection of its type, for there are still only a few significant and consistent American collectors of Egyptian art, and a variety of factors—such as rapidly escalating prices for antiquities now perceived as art—will presumably limit the number of dedicated collectors in the future. The Brooklyn Museum is therefore delighted that the objects gathered by its "Egyptian treasure scout" will remain permanently in the company of several distinguished earlier collections that were assembled, to be sure, with much different goals in mind. It is also pleased to be able to make some of these objects available, through this catalogue, to a broad audience. While Ernest Erickson wished to remain an anonymous collector in his lifetime, the time has come to make public his accomplishments.

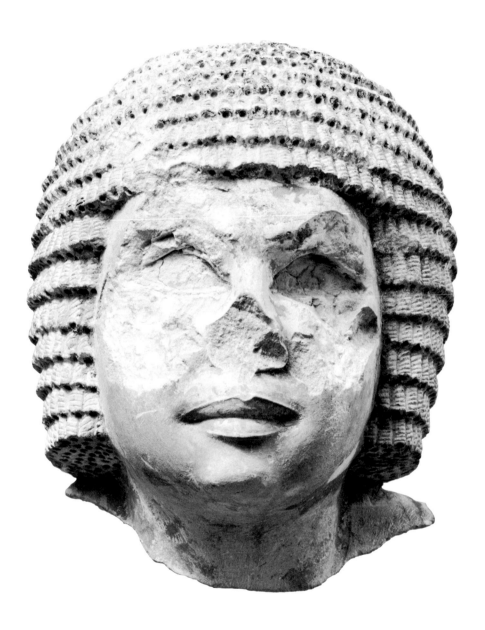

71　*Head of a Man*

Egypt, find spot not known
Old Kingdom, Dynasty V, circa
　2475–2345 B.C.
Painted limestone, 5½ × 4⅜ × 4⅞
　(13.8 × 11.3 × 11.9)
86.226.1

Despite the damage it has suffered, this head displays extremely high quality in the elegant almond shape of its once-inlaid eyes, the sharply outlined cutting of its lips and philtrum, and the embellishment of its otherwise typical Old Kingdom short wig with striations carved on each individual hollow-drilled curl. As was common for male figures, the skin was painted an orange-red and the wig black. The shoulders preserve traces of a painted broad-collar necklace.

At the 1953 auction of objects belonging to the Cairo antiquities dealer Maurice Nahman (d. 1948) the head was sold as an "Old Kingdom" work, and when Mr. Erickson loaned it to The Brooklyn Museum in 1955 it was catalogued as "probably Dynasty V." In 1959 then-Curator of Ancient Art John Cooney amended the Museum's records to include a reported statement by Nahman that the head came from the tomb of a man named Kaiaper, whom Cooney identified with the Kaiaper from whose early Dynasty V tomb at Saqqara came reliefs in museums in Detroit and Kansas City (cf. Fischer 1959).

Unverified reports of provenance cannot, however, always be trusted; several years later the Erickson head came to be viewed and displayed as a sophisticated archaizing work of late Dynasty XXV or early Dynasty XXVI. Now the attribution has come full circle, and the head is again assigned to Dynasty V, although not necessarily to the tomb of Kaiaper, making it the earliest Egyptian piece in the Erickson Collection.

There are two main reasons for this change. One is the lack of truly close Late Period parallels for the head. To be sure, there are some statues of Dynasties XXV and XXVI inspired, ultimately, by Old Kingdom sculptures (cf. Russmann 1973, 105–7), including some with short echeloned wigs of a type similar or related to the Erickson head: one in Cairo (C.G. 704: Borchardt 1930, vol. III, pl. 130; Vernus 1978, 70–71), one in Paris (Louvre A89: Bothmer 1970, 44 and pl. XI,18), and one in London (British Museum 1682: Iversen 1955, fig. 8). Yet none of these provides parallels for the specific forms of the Erickson head's facial features or for the use of inlaid eyes, a rarity in private stone statuary of the era. Nor do they provide close parallels for the precise form of the wig—the distinct projection of each tier of curls or the hollow drilling of the curls, a phenomenon that, to our knowledge, is limited in the Late Period to reliefs (Bothmer 1960, 42–43). (For the phenomenon in relief in Dynasties XVIII and XXII see The Epigraphic Survey 1980, pl. 18, A, and 75.167, an unpublished relief in The Brooklyn Museum. Paris 1976, 72–74, and Satzinger 1980, fig. 22 illustrate statues of Dynasties XIX and XXII with drilled curls.)

The second major reason for the reevaluation of the Erickson head is that there are numerous good parallels for most aspects of it in the works of the Old Kingdom, especially Dynasty V. These include the face's general round form; the use of inlaid eyes for private statuary (cf. Lucas 1934, 84–87); the eyes' almond shape (e.g. Curto 1963, pl. X); the carving of the mouth with a bow-shaped upper lip, a strong philtrum, and a narrower lower lip (e.g. the family statue group of Nykare in Brooklyn: Cooney 1952, figs. 1–2; Scott 1952, 120, illus.); and the basic form of the wig, although without the striations and hollow drilling of the curls (e.g. Scott 1952, 117, 120). I cannot as yet offer another example of striations on a short, echeloned wig, although they do occur on wigs of other types in the Old Kingdom. Drilled curls, however, occur on a late Dynasty III statue of Sepa in the Louvre (Paris 1935–36, 6, fig. A), and B.V. Bothmer has noted their appearance on "some exceptionally fine Old Kingdom sculpture in the round" (1960, 42). If its attribution to Dynasty V is accepted, the Erickson head is surely one of those exceptionally fine sculptures. RAF

Published: Paris, Hotel Drouot, *Succession de Mr. Maurice Nahman du Caire, Égypte. Antiquités égyptiennes, grecques et romaines . . . Le jeudi 26 et vendredi 27 Février 1953 . . .* (Paris, 1953, lot 13 [not illus.]).

72 *Noblewoman*

Egypt, find spot not known
Middle Kingdom, second half of
 Dynasty XII, 1900–1781 B.C.
Painted wood, 13¾ (35.5) high
86.226.11

Throughout the history of ancient Egypt, in-
dividuals prepared for the hereafter by com-
missioning statues of themselves for their
tombs. This piece belongs to that tradition.
It represents the deceased, whose name is
unfortunately not preserved in the text on
the base, in the time-honored attitude of re-
pose after having taken a step forward with
her left leg. At first glance the subject appears
to be naked, but closer examination reveals
the lower hem of a sheath at the calves and
a pair of shoulder straps, indicated by paint
now scarcely visible, across the breasts. The
configuration of these straps, forming a
trapezoidal pattern with the top of the
sheath, is a stylistic feature that establishes
the dating for the sculpture (Vandier 1958,
258). The sheath itself, with modifications,
was the most frequently represented garment
in the female wardrobe of ancient Egypt. Ac-
tual sheaths discovered in burials dating to
the Old Kingdom indicate that such dresses
may have been made expressly for death and
may not have been intended to be worn in
life (Hall 1986, 28–32).

The deceased also wears a necklace
and a tripartite wig, two elaborate sets of
braids falling over each shoulder, and a third
down the back. The wig is parted in the mid-
dle and decorated with ribbons. Such wigs,
which are known from the Old Kingdom on
(Vandier 1958, 253–54), have a long tradi-
tion in Egyptian art. This example, like
others, was carved from a separate piece of
wood and then doweled to the head of the
statue (Drenkhahn 1985, 70).

The three lines of inscription in
hieroglyphs on the base contain a standard
funerary spell that grants a boon of all things
good and pure on which a god lives to the
ka, or soul, of the deceased. RSB

Published: *Handbook of the Minneapolis Institute of
Art* (Minneapolis, 1917), p. 26.

This figure, one of the last additions to the Erickson Egyptian collection, is inscribed for an individual identified only as the "one revered with Osiris, Lord of the West [a reference to both the cemetery and the realm of the dead], Heqa-ib." Although the text is executed in a relatively crude and careless manner, with most notably a Λ instead of a Δ for the "q" in Heqa-ib, the head and face are well carved and detailed. Such a dichotomy between the quality of a statue and its inscription was not infrequent during the Middle Kingdom, nor was the dramatic juxtaposition of a more or less naturalistic head and a relatively abstract body shown wrapped in a heavy cloak or, as here, in the manner of a mummy.

The Erickson Heqa-ib is one of a relatively few early examples of a sculptural type that was usually depicted mummiform. The Egyptians first called this type of figure a *shabti* or *shawabti*, words whose meanings and origins are still uncertain. After the New Kingdom it came to be called an *ushebti* (Aubert 1979, 62; Schneider 1977, 135–39), which is relatable not only to *shawabti* but also to *usheb*, "to answer," an *ushebti* being an "answerer," a figure expected to respond in place of its deceased owner whenever he or she might be called upon to perform the hard and menial labor necessary for the production of food in the next life. That *shabtis* and *shawabtis* of earlier eras were believed to function in this manner is demonstrated by the appearance on them, beginning sometime in late Dynasty XII or early Dynasty XIII (Schlögl 1985, 896), of variants of a spell invoking such labors on their part (cf. cat. no. 78).

Still, the *shabti* was more than a mag-

73 *Funerary Figure of a Man*
Egypt, find spot not known
Middle Kingdom, Dynasty XII,
 1994–1781 B.C.
Egyptian alabaster (calcite),
 6⅝ × 1⅞ × 1⁹⁄₁₆
 (16.7 × 4.8 × 4.0)
86.226.34

ical insurance policy against postmortem toil. Some scholars believe *shabtis* originated as substitute dwellings for the deceased's spirit, especially in case his mummy should not be preserved (see, for example, Hayes 1953, 329; Schlögl 1985, 896; but contrast Schneider 1977, 62). Others, citing the mention of Osiris on some early *shabtis* and the rise in importance during the Middle Kingdom of that god of the dead, see the evolution of the mummiform *shabti* as dependent upon a desire to associate the deceased with Osiris. That, however, is far from certain (cf. Schneider 1977, 66, and fn. 69, pp. 74–75), for it is also possible to interpret mummiform *shabtis* and other related Middle Kingdom sculptural types as essentially expressions of the *Sah*, a divine and eternal manifestation of the deceased created by mummification (Schneider 1977, 5–6 and 65–66; Yoyotte 1972). Moreover, one could argue for a complex origin and evolution of the *shabti*, with a piece such as the Erickson Heqa-ib seen as having been made to function magically in several ways on behalf of its owner and as representing simultaneously both Heqa-ib and a servant of Heqa-ib (Schneider 1977, 32–77).

Even the physical development of *shabtis* is controversial. Many scholars (e.g. Schlögl 1985, 896), but not all (Aubert 1979, 58), would see the first *shabtis* in small, typically nonmummiform figures of wax and mud of Dynasties IX–XI, the transformation to the mummiform coming, with a few possible exceptions, in Dynasty XII, when stone was their most common medium. Some (Aubert and Aubert 1974, 13–21) would place the first mummiform stone *shabtis* in the reign of Amenemhat III (1842–

1794 B.C.). As for the Erickson Heqa-ib, that it is a work of the Middle Kingdom is immediately apparent from good typological and stylistic parallels in other stone *shabtis* of Dynasty XII (e.g. Hayes 1953, 328, fig. 216). When it arrived on loan to The Brooklyn Museum it was attributed to "ca. 1878–1785 B.C.," meaning from the reign of Amenemhat III's predecessor, Sesostris III, to the end of Dynasty XII (*TBMA XIV.1972–1973*, 1973, 11). Now we are suggesting that it might be slightly earlier in time because of stylistic parallels with statuary of the time of Sesostris II (1900–after 1881 B.C.). Some of these parallels are general stylistic traits such as the decidedly transverse articulation of the face, its broad form, and the basically nonrealistic rendering of the facial features, with eyebrows and eye paint lines in relief. Others are stylistic details, including the slight dip of the eyebrows over the root of the nose; the long, narrowly opened eyes with relatively straight lower lids; and the broad mouth (see, for example, Vandier 1958, pls. LXI, 2; LXXIV, 1, 3, 6; LXXXII, 6; for a more recent discussion of Middle Kingdom sculpture see Junge 1985). While it can be risky to draw chronological conclusions from stylistic comparisons between minor art objects such as *shabtis* and major statuary, the *shabti* of Heqa-ib is as large as or larger than many "major" sculptures of Dynasty XII. RAF

Published: New York, Sotheby Parke Bernet, *Egyptian Coptic. . . . Antiquities. The Property of Various Owners . . . Friday. December 1 . . .* New York, 1972, lot 9 (illus.); *TBMA XIV*, 11.

74 *Meret Shemau*

Egypt, Thebes, Karnak
New Kingdom, Dynasty XVIII,
 reign of Amenhotep I, 1525–
 1504 B.C.
Limestone, $9^{9}/_{16} \times 12^{7}/_{8} \times 1^{15}/_{16}$
 (24.2 × 32.7 × 5.0)
86.226.15

This relief was once described as a strange depiction of a "one-armed girl" and condemned as a forgery based somehow on a genuine Old Kingdom relief of dancing girls (H. Herzer, in the publication listed below). Happily, however, that adverse opinion was later retracted (cf. Bothmer 1972, 27). Indeed, even though only one of the figure's overlapping arms is visible, there is no reason to view the relief as other than an entirely ancient depiction of a woman represented according to ancient Egyptian drawing conventions with both arms raised before her (cf. Schäfer 1974, 302–4). In fact, this is a classic depiction of one of the goddesses named Meret (Berlandini 1980), divine songstresses and metronomists who brought a protective and vivifying power to religious rituals. There were Merets of northern and southern Egypt, and the text above this figure indicates she was the southern (*shemau*) goddess. Her pose, which is normal for depictions of Merets, has been variously interpreted as hand clapping—perhaps the beating out of musical measure—or as a gesture of welcome or consecration. Whatever its precise meaning, the pose is emphasized by the elongation of the arm and hand, an exaggeration common in Egyptian art, in which a figure's action is often conveyed mainly by such gestures.

The certain attribution of the relief to Karnak and the second reign of Dynasty XVIII is based on its material ("creamy" Theban limestone) and its style (cf. the detailed commentary of Myśliwiec 1976, 31–33). The bold, raised relief; the eyebrows in relief with a slight dip toward the root of the nose; the long narrow eyes with pronounced tear ducts; the demarcation of the iris from the white of the eye (cf. Romano 1976, 103); the eyepaint lines in relief with spreading ends; the distinct break between the lines of the forehead and the slightly aquiline nose; the emphatic, though small, naso-labial furrow; the thick, straight lips; the heavy chin and throat—all are paralleled perfectly on reliefs of Amenhotep I at or from Karnak (Porter and Moss 1972, 523 [index]; Myśliwiec 1976, pls. III–VIII; Myśliwiec 1985, pl. IV).

The style of these reliefs is related to reliefs of Amenhotep I's predecessor, Ahmose (Myśliwiec 1976, 32), with the reliefs of both reigns also clearly related to works of late Dynasty XI and especially the reign of Sesostris I (1974–1929 B.C.) of early Dynasty XII (cf. Fazzini 1975, 59 and 70; Myśliwiec 1976, 32, 36, 140–41; Romano 1983, 109–11). The same might be true of reliefs of Dynasty XVII, but not enough have been preserved to tell for sure. Comparable archaizing tendencies are apparent, however, in some of the few private statues of that era (Vernus 1980, 186).

Amenhotep I's artists sometimes imitated the monuments of Sesostris I so closely that Egyptologists have mistaken some of their works, including pieces similar to the Erickson relief, for works of that earlier king. This archaizing was due to a number of factors. Important ones were the use by kings of early Dynasty XVIII of existing buildings as part of their restoration of Karnak after the troubles of the Second Intermediate Period; these same kings' furtherance of the offering cult of the royal ancestors; and these kings' desire to express, propagandize, and immortalize their perception of themselves as the spiritual and political heirs of Dynasty XII (cf. Redford 1986, 165–78, esp. 170–71).

There are a great many closely related blocks of Amenhotep I that come from structures at Karnak that were dismantled in antiquity to be used as building material and have not yet been reconstructed (cf. Björkman 1971, 58–60, 141). Since only a few of these blocks have been published, it has not been possible to determine from what type of scene the Erickson Meret came. One possibility is that she greeted a larger figure of the king running a ritual course, a common element of temple iconography attested elsewhere for Amenhotep I (Porter and Moss 1972, 133–34). RAF

Published: *TBMA VIII*, 160; H. Herzer, "Ein Relief des 'Berliner Meisters'," *Objets* 4 (1971), 6–7, with fig. 6.

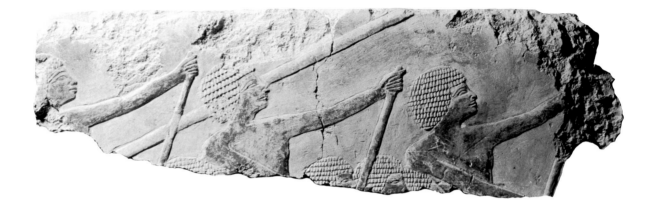

75 *Oarsmen and Dancers on a Tow Boat*

Egypt, from the mortuary temple of
 Queen Hatshepsut at Deir el-
 Bahri
Dynasty XVIII, time of Hatshepsut,
 1479–1458 B.C.
Painted limestone, 3⅞ × 13⅛
 (10.0 × 33.3)
86.226.7

Collecting works of art often involves an aesthetic appreciation independent of a knowledge of an object's history. In fact, discriminating collectors often maintain that true works of art can exist in a vacuum devoid of time and place. Such was the case with this charming relief, the jewel-like precision of which attests to its superlative quality. Had this object not entered the collections of The Brooklyn Museum as a loan, its history might have remained forever unknown.

Using the vast resources of the Department of Egyptian, Classical, and Ancient Middle Eastern Art and the Wilbour Library of Egyptology, however, curator Richard Fazzini determined that this relief once decorated the eastern wall of the upper court of the mortuary temple of Queen Hatshepsut at Deir el-Bahri (Fazzini 1972; Porter and Moss 1972, 357, [79]). The scene to which it belongs represents one of two tow boats transporting statues of Hatshepsut, her half brother Tuthmosis II, and the state god Amun from Luxor on the east bank of the Nile to Western Thebes on the opposite bank for use in rituals associated with the queen. The attitude of the three oarsmen, shown standing and holding their oars, indicates that the boat is about to dock. One of the hawsers supporting the mast of the vessel passes behind the head of the central rower. Below him, to the left and right, appear the heads of five seated men, dancers ready to perform as the procession of statues and priests wends its way from the dock to the temple (Naville 1906, 3–5, pl. CXXIV).

The blue-gray color of the background represents the waters of the Nile, and the reddish-brown flesh tones of the oarsmen are those traditionally associated with figures of males in Egyptian art (Manniche 1982, 9). The wig of each figure is indebted to models from the Old Kingdom, particularly in the rendering of the smaller, striated locks on the crowns of the heads of the oarsmen. The artists have attempted to generate space by the convention of overlapping, arranging the heads of the dancers on a diagonal to the plane of the relief so that the figures appear to be sitting side by side. Within a rather narrow depth of field, the sculptors have thus successfully created a spatial environment. RSB

Published: Fazzini 1972, 46–47.

76 Relief Representation of Royal Statues

Egypt, Deir el-Bahri, Temple of
 Hatshepsut
New Kingdom, Dynasty XVIII, joint
 reign of Tuthmosis III (1479–
 1425 B.C.) and
 Hatshepsut (1479–1458 B.C.)
Limestone, 6⁷/₁₆ × 6⁷/₈ × ¹³/₁₆
 (16.3 × 17.5 × 2.0)
86.226.3

Preserved on this relief are portions of two kingly figures wearing the *khepresh*, a crown that appears to have symbolized a constellation of such related ideas as coronation, legitimate succession to the throne, royal renewal, and triumph (Davies 1982, 75–76). The figure to the left is labeled "the Good God, Lord of the Two Lands, Menkheperre," i.e. Tuthmosis III. Both figures are identified as images of statues of Tuthmosis III, or of Tuthmosis III and another king, on the basis of their similarities to such New Kingdom depictions of royal sculptures as those referred to in Eaton-

Krauss 1984, 200–6 and Redford 1986, 29–58. These include depictions of the time of Tuthmosis III on both the east and west banks of the Nile at Thebes. (For the west bank see, for example, Bruyère 1952, pls. V–VIII; Lipińska 1974, 170–71, pl. 23C; Naville 1894–1908, V, pls. CXLV and CLXII. For the east bank see, for example, Myśliwiec 1985, pl. XXII, 2.)

Even a brief survey of recent studies on contemporary Theban depictions of Tuthmosis III and Hatshepsut (e.g. Lipińska 1976; Myśliwiec 1976, 46–57; Tefnin 1979 and 1983) provides excellent parallels for most of the stylistic details of the Erickson relief. As happens in depictions attributable in general to the joint reign of Hatshepsut and Tuthmosis III (Lipińska 1976, 136–38; Myśliwiec 1976, 52–55), the line running from the outer corner of the eye curves downward (cf. Myśliwiec 1976, pl. XXXVII), though here it is rendered in the manner of a fold of skin rather than as an extension of a cosmetic stripe (for a partial parallel cf. Myśliwiec 1976, pl. XXVIII, 67).

Given these parallels, it is not surprising that when the relief came to Brooklyn then-curator John D. Cooney dated it to the reign of Tuthmosis III and attributed it to Thebes. Because it is limestone, he guessed that it had come from Hatshepsut's temple at Deir el-Bahri, where limestone, rather than the sandstone most often used in Theban temples, was the main building material. Later, Cooney's successor, Bernard V. Bothmer, added to our accession records photographs of several parallel pieces, the most important being a limestone relief in Hannover (Kestner-Museum Inv.-Nr. 1935.200.-200) whose study helps answer several questions about the Erickson relief.

The Hannover relief preserves parts of three depictions of royal statues of approximately the same size as those on the Erickson relief. Though the figures face left rather than right and hold their staffs at a slightly greater angle, they are otherwise so similar to the figures on the Erickson relief as to make it logical to link them to the same original monument. Of the two figures preserving parts of their labels, one has epithets similar to that of the Erickson relief, though with the name missing. The other figure has different epithets followed by a name of Tuthmosis III, which suggests that Tuthmosis III was the king represented by at least two of these figures. Moreover, the horizontal text above the figures makes reasonable the restoration of the less preserved text on the Erickson relief as a reference to something plural (possibly the statues) being "in the following of the majesty of [this noble?] god." Such rendering in turn suggests an interpretation of both reliefs as a depiction of royal statues in one of the famed Theban religious processions, such as those of the Min Festival, the Valley Festival, or the Festival of Opet.

A recent letter from Dr. Rosemarie Drenkhahn of the Kestner-Museum in Hannover confirms this reconstruction. According to her, Dr. Janusz Karkowski, who plans to publish the Hannover relief, has expressed the opinion that it could very well belong with scenes of a religious procession in Hatshepsut's temple at Deir el-Bahri, the provenance of the Erickson relief guessed by John Cooney, which is now being studied and restored by a Polish-Egyptian mission. Moreover, Dr. Drenkhahn has expressed her own belief that the Erickson piece could also come from there. We hope at least one (and perhaps both) of these reliefs will soon be published in detail in a study of their probable archaeological setting.　　　　RAF

Published: M. Friedman, "A New Tuthmoside Head at The Brooklyn Museum," *TBMB* 19 (1958) 3, fig. 6.

Egypt, find spot not known
New Kingdom, Dynasty XVIII,
time of Tuthmosis IV to
Amenhotep III, 1387–1350 B.C.
Reddish-black granite, 4½
(11.4) high
86.226.28

During ancient Egypt's long history, periods of domestic tranquillity, relative material prosperity, and peace abroad were often accompanied by an exceptional level of quality in works of art commissioned by her high officials. That axiom certainly applies to the first half of the fourteenth century B.C., during which this fine head of a courtier was made.

The courtier is shown wearing a double wig. On the upper part of the wig the strands of hair are rendered by a series of striations, while on the lower portion they are treated as a series of stylized, echeloned curls that partly cover the ears. Such double wigs, developed from a type known earlier in Dynasty XVIII, were common among courtiers in the first half of the fourteenth century B.C. (Trolle 1978, 139ff; Vandier 1958, 485). An incised line framing the neck represents the rounded neckline of a bag tunic, an antecedent of today's kaftan that was an immensely popular male garment in the New Kingdom (Cherpion 1977; Hall 1986, 27–39).

The face itself is characterized by small almond-shaped eyes articulated by so-called cosmetic lines. These lines continue toward the ears, as do the arched plastic, or sculptural, eyebrows. The modeling of the cheeks and chin is as subtle as that of the mouth, which is outlined by the fine ridge, or vermilion line, that separates the flesh of the lips from the skin of the face. Such a line invariably characterizes Egyptian art of the highest quality.

These features indicate that the head proceeds from the traditions of ideal, classic beauty found in the sculpture of private individuals created during the reign of Tuthmosis IV but anticipates the official, rather conventional style of some of the statues of courtiers made during the reign of Amenhotep III (Vandier 1958, 514, 517–18). Thus it can be dated to the period between the reigns of those two monarchs (Seidel 1975, 246–47).

RSB

Published: Parke Bernet Galleries, Inc., *Antiquities* (New York, January 24, 1969), Lot 126.

with the deceased to perform specific tasks outlined in Chapter VI (found in abbreviated form on this shabti) in the *Book of the Dead* (Hornung 1979, 47–48). The deceased might be called upon, for instance, "to move sand from the West to the East," an apparently odious task. To spare the deceased such an imposition, the shabti would reply, or answer the roll call for the deceased, thus serving as a surrogate.

This particular statuette is inscribed for a man named Maya (Ranke 1935, 146, no. 10), whose only title in the inscriptions is that of *sedjem-ash* (Bogoslovski 1970; 1974; 1979; Smith 1982, 281), which translates as "the-one-who-obeys-[his-lord's-] summons." Since this title is accompanied neither by the name of the place in which Maya exercised his authority nor the name of his sovereign, it is difficult to place Maya in time. Nevertheless, several distinctive features appear to link the object to the reign of Amenhotep III. These include the form of the writing of Maya's title, which corresponds to similar orthographies attested during that reign (Bogoslovski 1974; 1979). Moreover, the facial features, especially the lips and the eyes, are characteristic of works of art created for Amenhotep III and imitated by works produced for private individuals at that time (Bogoslovski 1974; Müller 1980; Simpson 1970; Seidel 1975, 240–43 and 247–49; Vandier 1958; Vaillancourt in progress). In fact this shabti is so close in material and style to one made and inscribed for Amenhotep III himself (Schneider 1977, vol. I, 270–73 and vol. III, pl. 3), that it may have been sculpted in a royal workshop. Both figures exhibit exquisite modeling in hardwood, carefully carved hieroglyphs, and inlaid eyes and eyebrows of Egyptian blue (Kaczmarczyk 1983, 123, 149–56; Fuchs 1982; Dayton 1980), the finest of the glazed materials in vogue during Dynasty XVIII. Despite the absence of biographical data for Maya, there can be little doubt that he was a wealthy member of the Egyptian court and an intimate of Amenhotep III. RSB

Published: F.G. Hilton Price, *A Catalogue of the Egyptian Antiquities in the Possession of F.G. Hilton Price*, I (London, 1897), 157, no. 1535; Sotheby and Company, *Catalogue of Egyptian, Greek, Etruscan and Roman Antiquities, Monday 11th November 1963* (London), 22, Lot 90; E.S. Bogoslovski, "Два Памятника Сподвижника Аменхотпа III," ВДИ 2 (128) (1974), 86–96; E.S. Bogoslovski, "Спуги" фараонов богов и частных пну (Moscow, 1979), 208–209.

78 *Shabti of Maya*

Egypt, find spot not known
Dynasty XVIII, time of Amenhotep
 III, 1387–1350 B.C.
Wood with inlaid eyes and eyebrows
 and hieroglyphs filled with paste,
 16 (40.7) high
86.226.21

Contrary to popular opinion, funerary statuettes such as this were not intended to wait hand and foot on the deceased. Called shabtis, an English word derived from the ancient Egyptian hieroglyphs meaning "the-one-who-replies," these figurines were interred

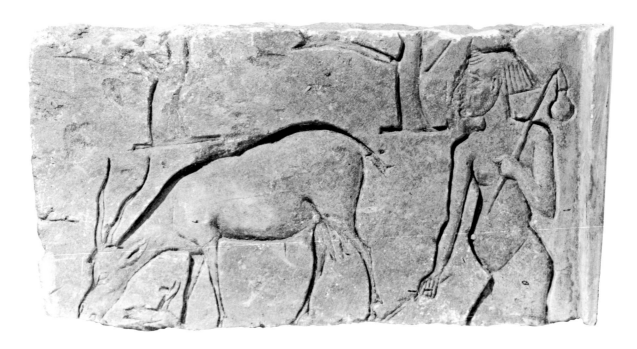

79 The Aten's Herd and Its Warden

Egypt, reportedly from Amarna
Dynasty XVIII, time of Akhenaten,
1350–1333 B.C.
Limestone, 8⅝ (22.0) high
86.226.30

This interesting and most unusual scene, sculpted in sunk relief, is set in the wild, as the random placement of the preserved trunks and limbs of at least four trees reveals. The animal grazing at the left, incorrectly identified as a goat (Aldred 1973, 147), is in fact a gazelle, depicted naturalistically in one of its most characteristic attitudes (Anderson 1902, 340–42). Although this has been called a simple genre scene (Aldred 1973, 147), it cannot be dismissed as such, for the man attending the gazelle is not a simple herdsman. His wispy hair, though balding, is neatly combed, and his beard is well trimmed. These attributes, together with his paunch, are artistic conventions in Egyptian art for men of superior status who live reasonably prosperous lives (James 1984, p. 107). Although such men are rarely shown performing menial tasks, there can be no doubt that this nobleman is responsible for the well-being of a herd because his other

attributes—a staff and a "hobo's stick"—relate to the disparate paraphernalia often carried by herdsmen (Omlin 1973, 30 and pl. XV; de Garis Davies 1926, 59 and pl. XXXIV).

A clue to the meaning of the scene is provided by the raised edge along the right side, which suggests that the block originally came from the inside corner of a building (Aldred 1973, 147). The rectangular shape of the block and its material, style, and dimensions associate it with at least four other blocks depicting gazelles and antelopes. Tefnin (1976, 91) and Roeder (1969, pl. 99) deal with three of these blocks. The fourth, of which only the left side is preserved, is in a private collection in Europe and is unpublished. One of these shows two gazelles cavorting in a setting of similarly rendered leafless trees beneath a beneficent sun disk inscribed with the full but fragmentarily preserved titulary of the Aten, Akhenaten's god (Bittel 1934, 32 and fig. 12). These blocks may have come, therefore, from one or more scenes of a now lost building dedicated to the Aten and may depict a high official, in his capacity as game warden, keeping a watchful eye on the herds of wild gazelles and antelopes under the Aten's protection.

RSB

Published: Aldred 1973, 147.

80 *Tutankhamun* (Two views)

Egypt, suggested to have come from
 Amarna
Dynasty XVIII, time of Tutankha-
 mun, 1333–1323 B.C.
Painted limestone, 1¾ (4.5) high
86.226.20

Of all the epochs of Egypt's past, none is more provocative for the scholar or appealing to the public than the Armana Period and its aftermath. The artists of the period created works of art that cannot be confused with those of any other period of ancient Egypt.

This head is just such a product. Despite its small scale, it is monumental both in its modeling and in the impression it makes on the viewer. Although uninscribed, it can be attributed to the time between the ascension of Akhenaten and the death of Tutankhamun on the basis of its physiognomy alone.

That the head represents a male rather than a female is proved by the presence of a diadem that would normally accompany a blue crown (Aldred 1973, 168; Steindorff 1917; Davies 1982). During the course of Dynasty XVIII, this crown formed part of the king's regalia during either his coronation or his jubilee, a subsequent ritual that commemorated his ascension to the throne (Aldred 1973, 168). Because the heavily modeled bow-shaped lips and relatively small almond-shaped eyes with a deep recess at the canthi, or inner corners, find their closest correspondences on other examples identified as Tutankhamun (Aldred 1973, 168), this head, too, probably represents Tutankhamun. RSB

Published: Aldred 1973, 168.

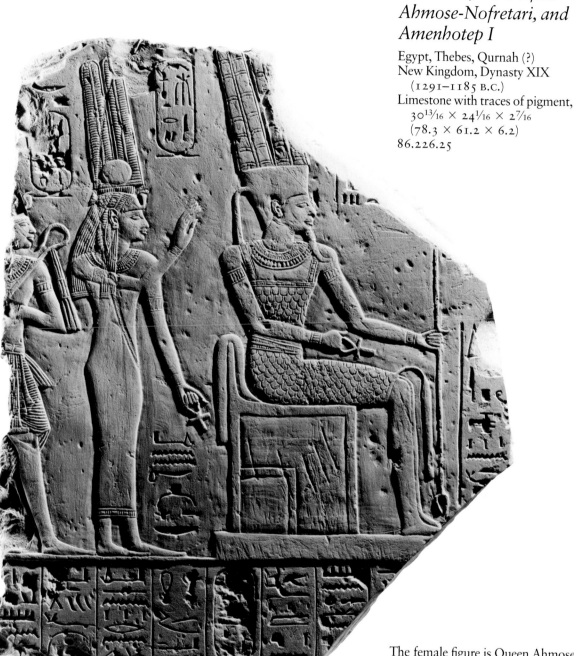

81 Amun-Re, the Deified Ahmose-Nofretari, and Amenhotep I

Egypt, Thebes, Qurnah (?)
New Kingdom, Dynasty XIX
(1291–1185 B.C.)
Limestone with traces of pigment,
30¹³⁄₁₆ × 24¹⁄₁₆ × 2⁷⁄₁₆
(78.3 × 61.2 × 6.2)
86.226.25

The enthroned figure holding a life-sign and scepter in this relief is Amun or Amun-Re, chief deity of the southern Egyptian capital of Thebes. There are traces of green pigment on his corslet and headgear plumes and four horizontal green bands on his throne.

The female figure is Queen Ahmose-Nofretari. The wife of King Ahmose (1550–1525 B.C.) and mother of King Amenhotep I (1525–1504 B.C.) of early Dynasty XVIII, Ahmose-Nofretari was a God's Wife of Amun, a major religious position at Thebes (cf. Gitton and Leclant 1977; Robins 1983). Here she holds a life-sign in one hand and raises the other protectively behind Amun, as might a figure of his divine consort, the goddess Mut, if represented with him. She wears a tight shift, which was painted green;

a tripartite wig with vulture headdress and uraeus, worn by queens and goddesses; and a modius, or cylindrical headdress, surmounted by tall plumes and solar disk, worn by God's Wives of Amun and by queens, especially when the queens are depicted in cultic activities (Gitton 1975A, 104). This headgear, which sometimes includes cow's horns, can be associated as a whole with various goddessess (cf. Malaise 1976; Desroches-Noblecourt 1980, 20).

The third figure in the relief is Ahmose-Nofretari's son, Amenhotep I, also labeled "ruler of Thebes." He holds a royal crook and flail and wears a pleated kilt of a type invented well after his lifetime.

The relief is part of a private stela whose decoration may have included a figure of a king offering, as says the text before Amun, to the deities and receiving, according to the text before the queen, Ahmose-Nofretari's gift of "all joy." The text below may have been accompanied by a figure of the stela's donor.

As noted by F. Yurco (Krauss 1977, 143), the names of Sety II (1199–1193 B.C.) in the cartouches below replace other names so thoroughly erased that the identity of their owner is a matter of speculation. That he was a king of Dynasty XIX is certain from the relief's style, but the style does not appear to be clearly diagnostic for a single reign. Given his long years as king (1279–1212 B.C.), Ramesses II is, however, a logical candidate. If the headdress worn by Amenhotep I were preserved, we might be more certain. The break could accommodate the lines of a *khepresh*-crown, which might make the figure a depiction of Amenhotep *pȝ-ibib* or *hȝtj* (Schmitz 1978) or *pȝ-i·ȝw* (Bell 1985, 56, fn. 175)—a cult form of Amenhotep I that survived as late as Dynasty XXV but all of whose known depictions come from the reign of Ramesses II (e.g. Altenmüller 1981, 5).

That the primarily Theban cults of Ahmose-Nofretari and Amenhotep I began prior to the Ramesside Period (Dynasties XIX–XX) is evidenced by many monuments, including a private stela of Dynasty XVIII in Brooklyn on which the deified king and queen are depicted offering to the god Osiris above a probable depiction of an opening-of-the-mouth ceremony for the stela's owner and his mother (James 1974, 113–14). That monument is one of a small number of private representations of the deified Amenhotep I or Ahmose-Nofretari giving offerings on behalf of a monument's dedicator rather than, as on the Erickson stela, being the direct recipients of offerings and/or adoration (cf. Altenmüller 1981, 5–6). If our reconstruction of the Erickson stela's format with offering king and adoring private person is correct, then the Erickson stela is of a Ramesside type that served, in part, to stress its owner's loyalty to the throne (Redford 1986, 185). It could also be related in ways to other private Ramesside stelae, including one in Brooklyn (Redford 1986, 51 and pl. I), on which the adored figures of Ahmose-Nofretari and Amenhotep I are joined by images of other deceased rulers, thus reflecting the worship of the royal ancestors going back to gods such as Amun, whose cult was a source of power and legitimacy for a reigning king (cf. Redford 1986, 45–56, and 194–95). Indeed, the cults of Ahmose-Nofretari (Gitton 1975A and B) and Amenhotep I (Hornung 1975, 202–3) derive in part from their being important royalty at the beginning of the New Kingdom as well as from their actual achievements.

Many depictions of the deified king and queen have come from the village at Deir el Medineh, one of their major cult centers and the home of the workmen of the royal tombs of the New Kingdom (for the archaeology of the village, including the recently identified remains of habitations earlier than the reign of Amenhotep I's successor, Thuthmosis I, see Bonnet and Valbelle 1975). The dealer who sold this stela fragment to Erickson, however, claimed that the piece was from "Kama," which could be a garbled transcription of Qurnah, a village north of Deir el Medineh on the West Bank of the Nile at Thebes (cf. Gitton 1975B, 46, no. 21). Ahmose-Nofretari in similar guise appears alone (Osing 1977, pls. 9 and 33), behind Amun (Osing 1977, pl. 26), between Amun and Amenhotep I (Osing 1977, pl. 40), and with other deceased pharaohs (Caminos 1955, 19) in the Ramesside temple at Qurnah. Her cult was also important, apparently more so than that of Amenhotep I, in the nearby temple of Amun called Meniset (cf. Van Siclen III, 1980). Hence a provenance for the Erickson relief in this part of Thebes seems quite possible. RAF

Published: *TBMA IX*, 130; Fazzini 1972, 54–56; Gitton 1975B, 46, no. 21; Krauss 1976, 186; Krauss 1977, 143, fn. 42.

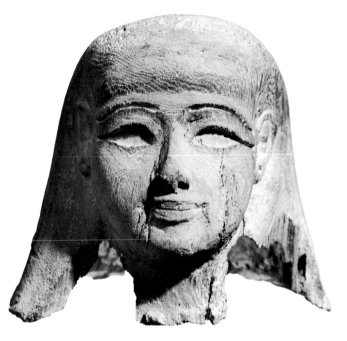

82 *Head of a Son of Horus*

Egypt, find spot not known
New Kingdom, Dynasty XIX (?),
 1291–1185 B.C.
Wood, originally painted,
 5⅞ × 6¼ × 6⅛
 (13.7 × 15.9 × 15.4)
86.226.35

This late addition to the Erickson Egyptian collection, a partially hollowed out male head that retains traces of the painted striping of its wig, is a lid from a canopic jar. Such jars, which came in sets of four, served as coffins for internal organs removed during the process of mummification (e.g. Brovarski 1978, introduction; Martin 1980). They were believed to function magically to preserve the organs and their owner by the identification of each jar and its contents with one of the four divine sons of Horus: Imsety, Hapy, Duamutef, and Kebehsenuef (cf. Heerma van Voss 1980).

In the brief notice of its arrival on loan to the Museum, the lid was identified as a head of the god Imsety dating to "late Dynasty XVIII–XIX, ca. 1300 B.C.(?)." To this the Museum's accession records add "provenance not known, former collection of Kachab Pacha," a reference to the late Egyptian collector Sayed Pasha Khashaba, to use the English form of his name and title. Although much of Khashaba's collection was made up of objects from the region of the city of Assiut in Middle Egypt, the provenance of the Erickson lid remains uncertain because the lid is not mentioned in the *Selective Catalogue* of Khashaba's now-dispersed collection or in publications of his excavations (cf. Wild 1969).

Uncertainty still exists about the lid's precise date as well. Parallels for its general form can be found in canopic jar lids of late Dynasty XVIII, Dynasty XIX, and later. The same is true of its facial features, but these seem most at home in the sculpture of Dynasty XIX beginning with the reign of Ramesses II, such as a calcite canopic lid with a head of Queen Tuya, the mother of Ramesses II (Paris 1976, 31), and a sphinx of Ramesses II (Paris 1976, 241). The former had inlaid eyes and eyebrows, rare in private canopics like the Erickson lid.

If this son of Horus dates to the time of Ramesses II or later, then it is quite possible that it is a head of Imsety; if it is earlier, the identification is less certain. With one disputed exception, it was not until the time of Ramesses II that the lids of canopic jars depicting the other three sons of Horus began to be carved as ape, jackal, and falcon heads instead of the human heads all four had once shared. Moreover, this practice did not become the rule until even later (cf. Brovarski 1978, introduction, 3; Martin 1980, 317–18). RAF

Published: *TBMA XIV,* 11.

83 *Heart Scarab* (Two views)

Egypt, find spot not known
Third Intermediate Period, Dynasty
 XXII or XXIII (945–718 B.C.)
Blue frit, 1 × 1¾ × 2⅜
 (2.5 × 4.4 ×6.0)
86.226.22

Among the most ubiquitous Egyptian antiquities are the small seals and amulets called scarabs (Giveon 1984; Martin 1985). Generally less than an inch in length, they are images of the beetle *Scarabeus sacer*, a symbol of the rising sun, creation, birth, and rebirth. Much less common are the larger heart and heart-related scarabs (Feucht 1977; Malaise 1978) like the one seen here. These the Egyptians associated magically with the human heart, which they believed to be the seat of thought, will, emotion, and conscience (Brunner 1977; Malaise 1978, 9–11). Heart scarabs had the symbolism of other scarabs, but they were also believed to perform several important magical functions. One was to assist the deceased to achieve a happy and perpetual hereafter by preserving or restoring his heart. Another was to prevent the heart from testifying against its owner at the final judgment, when it was weighed against the feather of Maat, a goddess who incarnated the divinely ordained scheme for the functioning of the universe, including human behavior (Helck 1980).

 The inscription on this scarab's back begins "The Good God, who makes monuments," an epithet perhaps more appropriate for a living being than a dead one (for the range of objects and activities classifiable as *mnw*, "monuments," see Taufek 1971

and Vittmann 1977). Following this are two names of a king who could be either Osorkon II (883–850 B.C.) of Dynasty XXII or Osorkon III (786–760 B.C.) of Dynasty XXIII. The former is perhaps more likely because the cartouches lack the epithet "Son of [the goddess] Isis," normally though not invariably included in the titulary of Osorkon III.

Reasonably close parallels for the scarab's specific forms are provided by some of the limited number of large scarabs known from Dynasties XXI–XXII (e.g. Montet 1951, pls. XXVI, XXX, XLIX, CXVII–CXVIII, and CXXXVI). As for the texts and images adorning the scarab, they are somewhat unusual but can be related to the decoration of other heart scarabs and to the constellation of ideas surrounding them.

The horizontal text on the scarab's base is part of Chapter 30B of the *Book of the Dead* and was intended to conjure the heart of the scarab's owner not to oppose its owner after death. Although this magical spell is often found in abbreviated form on heart scarabs, the text here is abbreviated to a fault, most noticeably in the omission of the negative in what should otherwise have read "do *not* rise up against me as a witness."

Above the text is a figure of Maat facing a *benu*-bird, or "phoenix," backed by a fan of protection (cf. Bell 1985, 36–37 for this fan in connection with images of a different nature). The appearance of the *benu*, another symbol of regeneration, on a number of heart scarabs relates to its role as protector of the soul, as the soul or heart of both the sun god and Osiris, and as one of the possible postmortem manifestations of the human soul (Kákosy 1982; Malaise 1978, 52–58; cf. El-Banna 1985). Indeed, the *benu* here could be the deceased, who might be described in the text before the *benu* but oriented with the figure of Maat as "making Maat every day."

As observed by one scholar, the relative paucity of comparable works of Dynasties XXII–XXIII makes it difficult to determine whether the scarab's peculiarities cast doubt on the piece in general or merely on its being a royal (as opposed to private) object. Most scholars who have examined it have judged it (to quote the second reference below) a "splendid" heart scarab of the time of Osorkon II, and some have viewed it as made for that king. It is characteristic of Ernest Erickson as a collector that the single scarab he chose to acquire should be unusual as well as lovely. RAF

Published: *TBMA IX*, 130; E. Hornung and E. Staehelin, *Skarabäen und andere Siegelamulette aus Basler Sammlungen*, Ägyptische Denkmäler in der Schweiz I (Basel, 1976), 184.

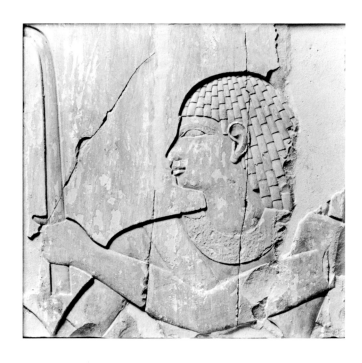

84 *Sunk Relief of a Man*

Egypt, Thebes, the Asasif
Late Dynasty XXV–Early Dynasty
 XXVI, circa 670–650 B.C.
Limestone with traces of pigment,
 6⅝ × 7 × 1
 (16.8 × 17.8 × 2.5)
86.226.8

To judge from comparable depictions in Theban tombs of the New Kingdom, the small-scale figure in this later relief was represented holding a candle with a curving top in his near hand and either an ointment jar (de Garis Davies and Gardiner 1915, pls. XXIII and XLVI; de Garis Davies and de Garis Davies 1933, pl. XXIX; de Garis Davies 1923, 29 and pl. LVII) or another candle (de Garis Davies 1923, pl. XXXV) in the missing far hand. Although the figure could conceivably be an image of the tomb owner, it is most probably a representation of a priest.

Because of its style, the relief is definitely attributable to one of the large tombs of late Dynasty XXV and Dynasty XXVI in the Asasif, the plain in front of Deir el Bahri, the great natural amphitheater in the cliffs on the west bank at Thebes (Eigner 1984, passim). Figures with closely related facial features can be found in more than one tomb of the period (e.g. Assmann 1977, pls. 11, 18, and 21; Kuhlmann and Schenkel 1983, pls. 152d and 153a). Since these tombs often display archaizing tendencies (Der Manuelian 1983B, passim; cf. Redford 1986, 318–31) directly or indirectly inspired by the decoration of Dynasty XVIII tombs at Thebes (e.g. Bietak and Reiser-Haslauer 1982, 231–

47; Der Manuelian 1985, 107–15), it is not surprising that many details of the Erickson relief, including its wig and facial features, also have good parallels in Dynasty XVIII Theban tombs. The closest parallels for the Erickson relief, however, are provided by reliefs from Theban Tomb 34 (e.g. Carter 1963, 14, fig. 17; Der Manuelian 1983A, pls. 27 and 30; Leclant 1961, pls. LXI–LXII; Lesko 1972, fig. 3). These include images of the tomb owner wearing a broad-collar necklace, a priestly sash, and precisely the same wig with stepped curls as the figure of the Erickson relief.

Thebes 34 is the immense and elaborately decorated sepulcher of Mentuemhat, Fourth Prophet of Amun and Mayor of Thebes. Excavated, constructed, and decorated during late Dynasty XXV and early Dynasty XXVI, it has long been considered the certain or possible source for numerous fragmentary reliefs scattered throughout the world's collections (cf. Der Manuelian 1983A and 1985). With the Egyptian Antiquities Organization now taking up the task of further excavation and restoration of the tomb, it may someday be possible to confirm or deny that provenance for pieces such as the Erickson relief, and to identify their subject matter fully. RAF

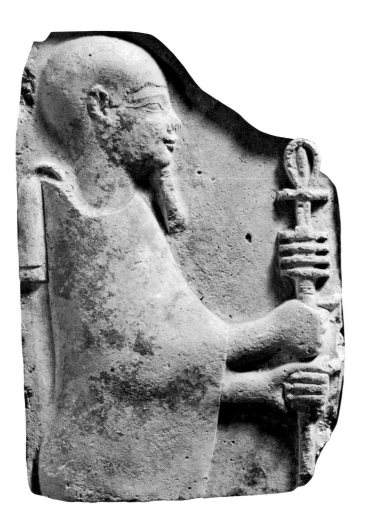

This exceedingly interesting fragment depicts the god Ptah, the creator god of the city of Memphis. Facing his left, the deity is coiffed in a neat, almost modern, short and well-groomed hairstyle. He wears a tightly fitting garment from under which his hands protrude grasping a scepter composed of the *djed*-pillar, representing the human spinal column and symbolizing stability, surmounted by the sign of life. A *menat*, or counterpoise, resting on his upper back, and a false beard complete his costume.

The object is made of plaster, a material that had always been the traditional modeling medium of the Egyptians (Philipp 1972, 6) and that they put to a variety of uses, including funerary equipment and sculpture in the round and relief. From the time of Akhenaten (Aldred 1973, 40) into the Ramesside Period (Hornung 1982, 67–84), royal tombs were often decorated with relief representations, occasionally painted, sculpted into the plaster that was applied to the walls of the tombs. This practice continued into the Late Period as a plaster relief showing "the White Hippopotamus" (De Wit 1958) in the collections of The Brooklyn Museum reveals (New York Cultural Center 1974). The Erickson relief must be regarded as part of this long tradition. Its size and subject matter indicate that it was originally part of a small private tomb, as a comparison with a second relief, also in plaster, in The Brooklyn Museum suggests (Chassinat 1922, 25–28 and pl. XV—The Brooklyn Museum acc. no. 35.1312).

The dating of the Erickson relief rests exclusively on stylistic criteria. The shape of the skull, which resembles an egg, the projecting chin, which is round and golf ball-shaped, the depression at the corner of the mouth, the fine paint stripes of the eye, and the pencil-thin cosmetic line of the brow are all stylistic features codified during Dynasty XXX (Bianchi 1981, 31–32) and perpetuated into the reign of Ptolemy II Philadelphus in the third century B.C. (Steindorff 1944–45). One can therefore suggest that this depiction of Ptah once decorated the wall of a private tomb, perhaps located in the vicinity of Memphis, built and decorated between 300 and 250 B.C. RSB

85 *Ptah, Creator God of Memphis*

Egypt, find spot not known
Fourth to third century B.C.
Stucco, 5¼ × 3⅝ (13.4 × 9.2)
86.226.17

Published: Hôtel Drouot, Salle No. 8, *Collection Ch. Haviland: Objets d'art—antiques égyptiens, grecs, romains* (Paris, December 11–12, 1922), p. 10, no. 23.

86 *Head from a Ptolemaic Female Figure*

Egypt, find spot not known
First half of the Ptolemaic Period,
 305–200 B.C.
Limestone, 4⅛ (10.8) high
86.226.32

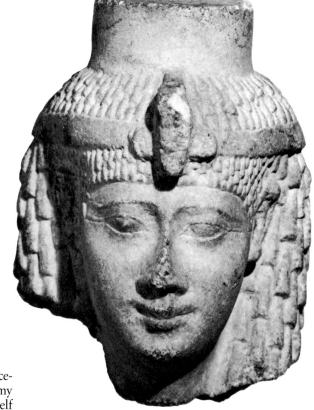

In 305 B.C., Ptolemy, a Greek from Macedonia who was an able general in the army of Alexander the Great, proclaimed himself the king of Egypt and inaugurated a dynasty that was to rule the land of the pharaohs until the death of Cleopatra VII in 30 B.C. Although the Ptolemaic rulers perpetuated the language and culture of Greece in their capital city of Alexandria, they also on occasion encouraged the development of Egyptian culture. As this female head demonstrates, Egyptian artists continued to work in traditional styles without succumbing to the artistic influences of the Greek presence.

The head's tripartite wig with echeloned curls has a long history in Egyptian art, as is attested by other examples in this catalogue. The wig is adorned by a diadem fronted by a cobra, or royal uraeus, the Egyptian emblem of queens and goddesses, and is topped by a columnarlike protrusion that served as support for a now lost attribute.

Had that attribute been preserved, the identity of the figure might have been adduced. Unfortunately, a lack of characterization in the physiognomy thwarts any attempt at identification. The oval face, the almond-shaped eyes with their cosmetic lines, the plastic, or sculptural, eyebrows, the thin nose, and the sickle-shaped mouth and

chin are all stylistic formulae for both Egyptian sculpture and relief that became standardized during Dynasty XXX in the fourth century B.C. and continued to be employed in works created well into the Ptolemaic Period (Bianchi 1978A).

This idealizing formula is encountered, for example, on statues inscribed for Arsinoë II, a dynamic queen of about 270 B.C. whose aggressive political involvement in the affairs of state may have served as an example for Cleopatra VII (Botti 1951, 22–24 and pl. XXIII; Macurdy 1932, 102–223; Pomeroy 1984, 17–20, 175–76, passim). Arsinoë II was identified with numerous Egyptian goddesses and was often represented in sculpture in their guise (Quaegebeur 1971A; 1971B). So influential was this woman that subsequent queens of the Ptolemaic Dynasty imitated the style of her statues and coins in their own works (Kyrieleis 1975, 78–94, 97–98; Brunnelle 1976, 10–29). It is possible, therefore, that this image represents either a queen or a goddess depicted with stylistic features associated with Queen Arsinoë II. RSB

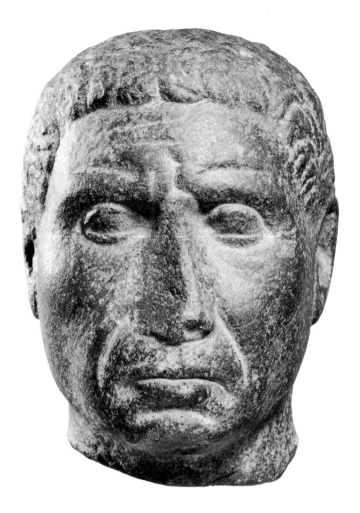

87 *Portrait of an Egyptian Official*

Egypt, find spot not known
Ptolemaic Period, 2nd century B.C.
Black basalt, 6⅞ (17.3) high
86.226.14

Despite the opinion current in many histories of world art (Janson 1970, 139–43), portraiture, in the Western sense, was not an exclusively Roman development. Indeed, ancient Egyptian artists since the Old Kingdom had experimented with rendering hard, intractable stones into soft flesh. These experiments quickened in the centuries after 700 B.C. so that by the beginning of the Ptolemaic Period in the late fourth century B.C. the native Egyptian artists had at their command all the technical skills and stylistic vocabulary necessary for creating portraits of outstanding vitality (Bothmer 1960, ix–x).

This head stands within that tradition. Its surfaces are crisscrossed with a series of incised lines resulting in a network of features displaying nature's own signs of age. The brow is wrinkled, the root of the nose gnarled; crow's-feet spring from the outer edges of the eyes; deep naso-labial furrows frame the upper lip under the nose; and the thin lips are drawn downward as if in a frown. This interplay of linear adjuncts sculpted into the broadly modeled planes of the face is typically Egyptian, as are both the treatment of the curly hair resting on the skull like a cap and the presence of the back pillar. With traditionally pharaonic means the artist has captured a poignant feeling of melancholy and resignation.

The dating of such veristic heads involves complex issues too numerous to outline here (Bianchi 1982). Suffice it to say that the most diagnostic feature for the dating of this head is the eyes. They are somewhat almond-shaped with faintly outlined lids and are not set into deep, round sockets. Their inner corners assume the shape of a right angle. All these features are unique to a small group of realistic portraits tentatively assigned to the second century B.C. (Bothmer 1960, 148–49). RSB

Published: Parke Bernet Galleries, Inc., *Antiquities* (New York, Dec. 14, 1962), Lot 53; (Anonymous), "Additions to the Museum Collections," *TBMA IV*, 115.

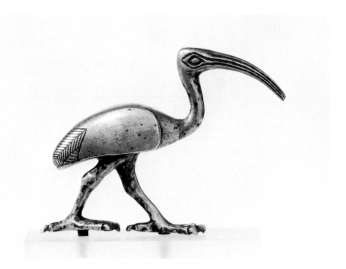

88 The Ibis of the God Thoth

Egypt, find spot not known
Ptolemaic Period, 305/304–30 B.C.
Silver, 2½ × ¾ × 3
(6.3 × 1.9 × 7.6)
86.226.19

Of all the deities of the Egyptian pantheon, none had a longer or more varied history than Thoth. As the god of writing and the patron of scribes, Thoth came to symbolize erudition and, under the classical influences of Roman Egypt, became Hermes Trismegistos, the thrice-great god, around whom revolved all the occult sciences of the Middle Ages. So long lived was this aspect of Thoth that Hermes Trismegistos even figures prominently in Thomas Mann's *Death in Venice*.

Scholars are in disagreement about how the white ibis (*Ibis religiosa*) (Gardiner 1957, 470, G26–G26*) came to be associated with Thoth. Of all the theories advanced to date, the most persuasive is the one that recognizes a pun between the word for ibis and the word for discriminating reason, an attribute of Thoth as an official in the mythological bureaucracy of the supreme deity, Re (Helck 1976). Whatever the reason for the association of the ibis with Thoth, it became so pervasive that by the Late Period pious pilgrims to cemeteries throughout Egypt were offering ibis mummies to Thoth by the thousands, either in anticipation of his benevolence or as thanks for benefactions rendered. More affluent pilgrims sometimes substituted more costly images of the bird. This statuette is just such a substitution.

The dating of these statuettes is always problematic. Nevertheless, a dating after 650 B.C. seems assured for this particular piece because it shares stylistic features with a bronze statuette of an ibis of similar size found in the so-called Palace of Apries at Memphis (Petrie 1909, 12 and pl. XV). A more precise dating can be suggested by the fact that the piece is made of silver, a metal often regarded by the ancient Egyptians as more precious than gold (Leclant 1954, 39[p]). Although few objects in silver have survived from ancient Egypt because of the tendency of the metal to corrode, the silver statuettes that are known are generally attributed to the Ptolemaic Period (Lunsingh-Scheuleer 1984, 144, Allard Pierson Museum acc. nos. 7030–32). Silver was used, for instance, for the feet and head of a Ptolemaic statue of an ibis in The Brooklyn Museum that served as a coffin for an ibis mummy (Bianchi 1978, no. 22, The Brooklyn Museum acc. no. 49.48). Such objects lend credence to the suggestion that Ptolemaic Egypt in general and Alexandria in particular were in the vanguard of a school of sculpture in silver between 305 and 30 B.C. (Adriani 1972, 66ff). On balance, then, this silver statuette of an ibis ought to be regarded as an offering to the god Thoth from a wealthier citizen of Ptolemaic Egypt.

RSB

Published: Sotheby and Company, *Catalogue of The Ernest Brummer Collection of Egyptian and Near Eastern Antiquities and Works of Art* (London, November 16–17, 1964), Lot 59.

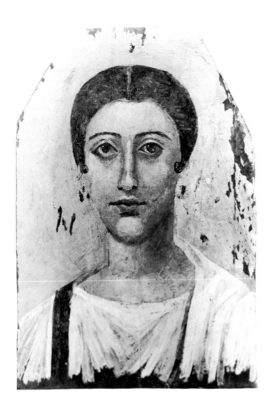

89 *Portrait of a Noblewoman*

Egypt, attributed to the site of Fag
el-Gamus, within the Fayyum
Roman Period, circa A.D. 150
Encaustic on wooden panel, 17⅜
(44.0) high
86.226.18
(Illustrated in color on page 9)

Of all the art forms that have survived from ancient Egypt none is more contemporary in feeling than the group of panels to which this object belongs. Generally called "Fayyum portraits," after the rich agricultural area to the southwest of modern Cairo where they were first discovered (Parlasca 1966, 18–58; Shore 1972, 10–11; Thompson 1976B, 3–5), these portraits display a painterly technique that anticipates the innovations of Western canvases of the Baroque period. Using melted wax as the medium (Lüdecke 1961; Nowicka 1984; Thompson 1976A, 8–9) rather than oils, the anonymous artist first coated the thin panel with dark tones then gradually built up thicker layers of pigment culminating in a final application of whites that highlight the chin, nose, forehead, and pupils. The immediacy and expressiveness of the work are conveyed by the eyes, which engage the spectator with their empathetic glance. It is no wonder, then, that individuals in the West have been avidly collecting such works (Bresciani 1984), particularly because of their great affinities with eighteenth-century miniatures created for the European aristocracy (Hopkins 1980, 353; cf. Hamilton 1969, 1).

Despite the Fayyum portraits' great aesthetic appeal, scholars are only now beginning to interpret and date them. It is assumed that only wealthy members of the upper classes were able to afford these works because less than one percent of all burials from Roman Egypt are estimated to have contained such panels. Although most of them were attached to the heads of mummies, Fayyum portraits were not necessarily funereal (Shore 1972, 25–29; Thompson 1976C). Several burials contained two or three portraits within the sarcophagus of one individual, and some of those had the remains of frames around their edges (Thompson 1976B, 8–10; Shore 1972, 24–29). Presumably, most such images were used in the same way one might employ a photograph of a family member today, framed and placed on the wall of a home. When the individual depicted died, the Fayyum portrait might then be removed from the wall and employed as the image of the deceased on the mummy. The trapezoidal shape of the top of this panel indicates how the original panel was cut in order to accommodate it to the mummy. The somewhat individualized features of this woman and the extreme thinness of the panel on which it is painted suggest a dating in the middle of the second century A.D. (Parlasca 1966, 34–36 and pl. 26, figs. 3–5; Thompson 1976A, 10–11; Thompson 1976B, 10–11).

Having been removed from its original environment in Egypt, this panel, like so many others, has had to be treated by skilled conservators (Martin-Reisman 1978; Thompson 1976B, 13). Members of the Conservation Department of The Brooklyn Museum designed a special case for it in order to prevent it from curling and fading (Sack-Stolow 1978). RSB

Published: Robert S. Bianchi, "Collecting and Collectors," *The Art Gallery*, 22 (1979), 104; S. Sack and N. Stolow, "A Micro-Climate for a Fayum Painting," *Studies in Conservation*, 23 (1978), 47–56; Anonymous, in *The Brooklyn Museum Annual*, 8 (1968), p. 160.

Abbreviations: Ancient Egyptian Art

ÄA — *Ägyptologische Abhandlungen* (Wiesbaden)

AVDAIK — *Archäologische Veroffentlichung. Deutsches Archäologisches Institut. Abteilung Kairo*

BES — *Bulletin of the Egyptological Seminar* (New York)

BIFAO — *Bulletin de l'Institut Français d'Archéologie Orientale du Caire*

BMFA — *Bulletin of the Museum of Fine Arts* (Boston)

BMMA — *Bulletin of The Metropolitan Museum of Art* (New York)

ВДИ — Вестник: Древней Истории (Moscow)

CdÉ — *Chronique d'Égypte* (Brussels)

FIFAO — *Fouilles de l'Institut Français d'Archéologie Orientale du Caire*

GM — *Göttinger Miszellen. Beiträge zur ägyptologischen Diskussion*

IFAO — Institut Français d'Archéologie Orientale du Caire

IFAO BdÉ — Institut Français d'Archéologie Orientale du Caire. Bibliothèque d'Étude

JARCE — *Journal of the American Research Center in Egypt*

JEA — *Journal of Egyptian Archaeology* (London)

JNES — *Journal of Near Eastern Studies* (Chicago)

JSSEA — *Journal of the Society for the Study of Egyptian Antiquities* (Toronto)

LdÄ — *Lexikon der Ägyptologie* (Wiesbaden)

MÄS — *Münchner Ägyptologische Studien* (Berlin)

MDAIK — *Mitteilungen des Deutschen Archäologischen Instituts, Abteilung Cairo*

MIFAO — *Mémoires pulbiés par les Membres de l'Institut Frqncais d'Archéologie Orientale du Caire*

MMAJ — *Metropolitan Museum of Art Journal* (New York)

MW — *Miscellanea Wilbouriana* (Brooklyn)

OIP — Oriental Institute Publications, The University of Chicago

RT — *Recueil de Travaux Rélatifs à la Philologie et a l'Archéologie Égyptiennes et Assyriennes* (Paris)

SAK — *Studien zur altägyptischen Kultur* (Hamburg)

SSEA — Society for the Study of Egyptian Antiquities (Toronto)

TBMA — *The Brooklyn Museum Annual* (Brooklyn)

TBMB — *The Brooklyn Museum Bulletin* (Brooklyn)

WZKM — *Wiener Zeitschrift für die Kunde des Morgenlandes* (Vienna)

ZAS — *Zeitschrift für Ägyptische Sprache und Altertumskunde* (Leipzig and Berlin)

Works Cited: Ancient Egyptian Art

Adriani 1972 — A. Adriani, *Lezioni sull'arte Alessandrina* (Naples, 1972).

Aldred 1973 — C. Aldred, *Akhenaten and Nefertiti* (London, 1973).

Alsop 1982 — J. Alsop, *The Rare Art Traditions. The History of Art Collecting and Its Linked Phenomena Wherever These Have Appeared* (Princeton and New York, 1982).

Altenmüller 1981 — H. Altenmüller, "Amenophis I als Mittler," *MDAIK* 37 (1981), 1–7.

Anderson 1902 — J. Anderson, *Zoology of Egypt: Mammalia* (rev. W. E. de Winton) (London, 1902).

Assmann 1977 — J. Assmann, *Grabung im Asassif 1963–1970. VI, Das Grab der Mutirdes, AVDAIK* 13 (Mainz am Rhein, 1977).

Aubert 1979 — J.-F. Aubert, "Chaouabtis, chabtis et ouchebtis," *CdÉ* 54, No. 107 (1979), 57–72.

Aubert and Aubert 1974 — J.-F. and L. Aubert, *Statuettes égyptiennes. Chaouabtis, ouchebtis* (Paris, 1974).

Bell 1985 — L. Bell, "Aspects of the Cult of the Deified Tutankhamun," *Mélanges Gamal Eddin Mokhtar* I, IFAO BdÉ XCVII, 1 (Cairo, 1985), 31–59.

Berlandini 1980 — J. Berlandini, "Meret," *LdÄ* IV, 1 (Wiesbaden, 1980), 80–88.

Bianchi 1978A — R.S. Bianchi, "Egyptian Art from the Bastis Collection," *Apollo* 108, no. 199 (September, 1978), 153–55.

Bianchi 1978B — R.S. Bianchi, *Egyptian Treasures* (New York, 1978).

Bianchi 1981 — R.S. Bianchi, "Two Ex-Votos from the Sebennytic Group," *JSSEA* 11 (1981), 31–36.

Bianchi 1982	R.S. Bianchi, "The Egg-Heads: One Type of Generic Portrait from the Egyptian Late Period," *Wissenschaftliche Zeitschrift der Humboldt-Universität zu Berlin* 2/3 (1982), 149–51.
Bietak and Reiser-Haslauer 1982	M. Bietak and E. Reiser-Haslauer, *Das Grab des 'Anch-Hor, Obersthofmeister des Gottesgemahlin Nitokris* II, Untersuchungen der Zweigstelle Kairo des Österreichischen Archäologischen Institutes V (Vienna, 1982).
Bittel 1934	K. Bittel and A. Hermann, "Grabungsbericht Hermopolis 1933," *MDAIK* 5 (1934), 11–44.
Björkman 1971	G. Björkman, *Kings at Karnak. A Study of the Treatment of the Royal Predecessors in the Early New Kingdom*, BOREAS. Uppsala Studies in Ancient Mediterranean and Near Eastern Civilizations 2 (Uppsala, 1971).
Bogoslovski 1970	E.S. Bogoslovski, "Статуя No. 2101 Государственноро Музея Изобразитембнных Исксств Им.А.С. Пчшкина," ВДИ 1 (111) (1970), 67–85.
Bogoslovski 1974	E.S. Bogoslovski, "Два Памятника Сподвижника Амеихотпа III," ВДИ 2 (128) (1974), 86–96.
Bogoslovski 1979	E.S. Bogoslovski, "Спуги" фараонов богов и частных пну (Moscow, 1979), 208–9.
Bonnet and Valbelle 1975	C. Bonnet and D. Valbelle, "Le Village de Deir el-Médineh. Reprise de l'étude archéologique," *BIFAO* 75 (1975), 429–46.
Borchardt 1930, vol. III	L. Borchardt, *Service des Antiquités de L'Égypte. Catalogue Général des Antiquités Égyptiennes du Musée du Caire. Nos. 1–1294* III, *Statuen und Statuetten von Königen und Privatleuten* (Berlin, 1930).
Bothmer 1960	B.V. Bothmer, in collaboration with H. De Meulenaere and H.W. Müller, *Egyptian Sculpture of the Late Period. 700 B.C. to A.D. 100* (Brooklyn, 1960).
Bothmer 1967	B.V. Bothmer, "Private Sculpture of Dynasty XVIII in Brooklyn," *TBMA VIII. 1966–1967* (1967), 55–89.
Bothmer 1970	B.V. Bothmer, "Apotheosis in Late Egyptian Sculpture," *Kêmi* 20 (1970), 37–48.
Bothmer 1972	B.V. Bothmer, "The Head That Grew a Face. Notes on a Fine Forgery," *MW* 1 (1972), 25–31.
Bothmer 1979	B.V. Bothmer, "Across the Bridge to Egypt," *The Art Gallery* XXII (December–January, 1979), 80–83.
Bothmer 1985	B.V. Bothmer, "The Brussels–Brooklyn Statue of Bakenrenef (Membra Dispersa VI)," *Mélanges Gamal Eddin Mokhtar* I (IFAO BdÉ XCVII, 1) (Cairo, 1985), 99–103.
Botti 1951	G. Botti and P. Romanelli, *Le sculture del Museo Gregoriano Egizio* (Vatican, 1951).
Bresciani 1984	E. Bresciani, "Giuseppe Acerbi e il ritratto di Dioskorous," *Studi e Materiali* 5 (1984), 203–8.
Brovarski 1978	E. Brovarski, *Corpus Antiquitatum Aegyptiacarum. Museum of Fine Arts, Boston.* 1, *Canopic Jars* (Mainz am Rhein, 1978).
Brunelle 1976	E. Brunelle, *Die Bildnisse der Ptolemäerinnen* (Frankfurt am Main, 1976).
Brunner 1977	H. Brunner, "Herz," *LdÄ* II (Wiesbaden, 1977), 1158–68.
Bruyère 1952	B. Bruyère, *Deir el Médineh, Année 1926. Sondage au temple funéraire de Thotmes II (Hat Ankh Shesept ▨)*, FIFAO 4, 4 (Cairo, 1952).
Buechner 1967	T. Buechner, "Historical Introduction," in *The Brooklyn Museum Handbook* (Brooklyn, 1967), 1–36.
Caminos 1955	R. Caminos, "Two Stelae in the Kurnah Temple of Sethos I," in O. Firchow (ed.), *Ägyptologische Studien*, Deutsche Akademie der Wissenschaften zu Berlin, Institut für Orientforschung. Veröffentlichung 29 (Berlin, 1955), 17–29.
Carter 1963	M. Carter, *Egyptian Art. The Cleveland Museum of Art* (1963).
Chassinat 1922	E. Chassinat, *Antiquités égyptiennes de la collection Fouquet* (Paris, 1922).
Cherpion 1977	N. Cherpion, "Mode et société à l'époque amarnienne," *Revue des archéologues et historiens d'art de Louvain* 10 (1977), 18–25.
Cooney 1952	J. Cooney, "Three Egyptian Families of the Old Kingdom," *TBMB* 13, no. 3 (Spring 1952), 1–18.

Cooney 1953	J. Cooney, "Egyptian Art in the Collection of Albert Gallatin," *JNES* 12 (1953), 1–19.
Cooney 1956	J. Cooney, *et al.*, *Five Years of Collecting Egyptian Art. 1951–1956* (Brooklyn, 1956).
Curto 1963	S. Curto, *Gli Scavi italiani a el-Ghiza (1903)*, Centro per le antichità e la storia dell'arte del vicino oriente, Monografie di archeologia e d'arte I (Rome, 1963).
Davies 1982	W.V. Davies, "The Origin of the Blue Crown," *JEA* 68 (1982), 69–76.
Dayton 1980	J.E. Dayton, *et al.*, "Egyptian Blue or Kyamos and the Problem of Cobalt," *Annali Istituto Orientale di Napoli* 40, NS 30 (1980), 319–51.
de Garis Davies and Gardiner 1915	Nina de Garis Davies and A. Gardiner, *The Tomb of Amenemhēt (No. 82)* (London, 1915).
de Garis Davies 1923	Norman de Garis Davies, *The Tomb of Puyemrê at Thebes* II, Publications of The Metropolitan Museum of Art Egyptian Expedition. Robb de Peyster Tytus Memorial Series III (New York, 1923).
de Garis Davies and de Garis Davies 1923	Norman and Nina de Garis Davies, *The Tombs of Two Officials of Tuthmosis the Fourth (Nos. 75 and 90)* (London, 1923).
de Garis Davies 1926	Norman de Garis Davies, *et al.*, *Two Ramesside Tombs at Thebes* (New York, 1926).
de Garis Davies and de Garis Davies 1933	Norman and Nina de Garis Davies, *The Tombs of Menkheperrasonb, Amenmosĕ, and Another (Nos. 86, 112, 42, 226)* (London 1933).
Der Manuelian 1983A	P. Der Manuelian, "An Essay in Reconstruction of Two Registers from the Tomb of Mentuemhat at Thebes (No. 34)," *MDAIK* 39 (1983), 131–49.
Der Manuelian 1983B	P. Der Manuelian, "Prolegomena zur Untersuchung saitischer 'Kopien'," *SAK* 10 (1983), 221–45.
Der Manuelian 1985	P. Der Manuelian, "Two Fragments of Relief and a New Model for the Tomb of Montuemhēt at Thebes," *JEA* 71 (1985), 98–121.
Desroches-Noblecourt 1980	C. Desroches-Noblecourt, "Isis Sothis,—le chien, la vigne—, et la tradition millénaire," *IFAO Livre du Centenaire, 1880–1980* (MIFAO CIV) (Cairo, 1980), 15–24.
De Wit 1958	C. De Wit, "Une représentation rare au Musée du Cinquantenaire," *CdÉ* 33 (1958), 24–28 (Brussels E.5036).
Drenkhahn 1985	R. Drenkhahn, in A. Eggebrecht, *et al.*, *Nofret—Die Schöne: Die Frau im Alten Aegypten, "Wahrheit" und Wirklichkeit* (Hildesheim, 1985).
Eaton-Krauss 1984	M. Eaton-Krauss, *The Representation of Statuary in Private Tombs of the Old Kingdom*, ÄA 39 (1984).
Eigner 1984	D. Eigner, *Die Monumentalen Grabbauten der Spätzeit in der Thebanischen Nekropole*, Untersuchungen der Zweigstelle Kairo des Österreichischen Archäologischen Institutes VI (Vienna, 1984).
El-Banna 1985	E. El-Banna, "À propos du double Phénix," *BIFAO* 85 (1985), 164–71.
The Epigraphic Survey 1980	The Epigraphic Survey, in cooperation with the Department of Antiquities of Egypt, *The Tomb of Kheruef: Theban Tomb 192*, The University of Chicago, OIP 102 (Chicago, 1980).
Fazzini 1972	R. Fazzini, "Some Egyptian Reliefs in Brooklyn," *MW* 1 (1972), 33–70.
Fazzini 1975	R. Fazzini, *Images for Eternity. Egyptian Art from Berkeley and Brooklyn* (San Francisco and Brooklyn, 1975).
Feucht 1977	E. Feucht, "Herzskarabäus," *LdÄ* II (Wiesbaden, 1977), 1168–70.
Fischer 1959	H. Fischer, "A Scribe of the Army in a Saqqara Mastaba of the Early Fifth Dynasty," *JNES* 18 (1959), pp. 233–72.
Fischer 1967	H. Fischer, "The Gallatin Egyptian Collection," *BMMA* 25 (1967), 252–58.
Fuchs 1982	R. Fuchs, "Gedanken zur Herstellung von Farben und der Überlieferung von Farbrezepten in der Antike am Beispiel der in Ägypten verwendeten Blaupigmente," *Diversarum Artium Studia* 1982, 195–208.
Gardiner 1957	A.H. Gardiner, *Egyptian Grammar*, 3rd ed. (London, 1957).
Gitton 1975A	M. Gitton, "Ahmose Nofretere," *LdÄ* I (Wiesbaden, 1975), 102–9.
Gitton 1975B	M. Gitton, *L'Épouse du dieu Ahmes Néfertary. Documents sur sa vie et son culte posthume* (Paris, 1975).

Gitton and Leclant 1977 M. Gitton and J. Leclant, "Gottesgemahlin," *LdÄ* II (Wiesbaden, 1977), 792–812.

Giveon 1984 R. Giveon, "Skarabäus," *LdÄ* V, 7 (Wiesbaden, 1984), 967–82.

Hall 1986 R. Hall, *Egyptian Textiles* (Aylesbury, 1986), 27–39.

Hamilton 1969 R.A. Hamilton, *Plutarch, Alexander: A Commentary* (Oxford, 1969).

Harris 1971 J.R. Harris, "Introduction" to J.R. Harris (ed.), *The Legacy of Egypt*, 2nd ed. (Oxford, 1971), 1–12.

Hayes 1953 W. Hayes, *The Scepter of Egypt. A Background for the Study of the Egyptian Antiquities in The Metropolitan Museum of Art.* I, *From the Earliest Times to the End of the Middle Kingdom* (New York, 1953).

Heerma van Voss 1980 M. Heerma van Voss, "Horuskinder," *LdÄ* III (Wiesbaden, 1980), cols. 52–53.

Helck 1976 W. Helck, "Der Name des Thoth," *SAK* 4 (1976), 131–34.

Helck 1980 W. Helck, "Maat," *LdA* III (Wiesbaden, 1980), 1110–19.

Hopkins 1980 K. Hopkins, "Brother-Sister Marriage in Roman Egypt," *Comparative Studies in History and Society* (1980), 303–54.

Hornung 1975 E. Hornung, "Amenophis I," *LdÄ* I (Wiesbaden, 1975), 201–3.

Hornung 1979 E. Hornung, *Das Totenbuch der Aegypter* (Zurich, 1979).

Hornung 1982 E. Hornung, *Tal der Könige* (Zurich, 1982).

Iversen 1955 E. Iversen, *Canon and Proportion in Egyptian Art* (London, 1955).

James 1974 T.G.H. James, *Corpus of Hieroglyphic Inscriptions in The Brooklyn Museum.* I, *From Dynasty I to the End of Dynasty XVIII*, Wilbour Monographs VI (Brooklyn, 1974).

James 1984 T.G.H. James, *Pharaoh's People* (Chicago, 1984).

Janson 1970 H.W. Janson, *History of Art* (New York, 1970), 139–43.

Junge 1985 F. Junge, "Die Provinzialkunst des Mittleren Reiches in Elephantine" in L. Habachi *et al.*, *Elephantine.* IV, *The Sanctuary of Heqaib*, AVDAIK 33 (Mainz am Rhein, 1985), 117–39.

Kaczmarczyk 1983 A. Kaczmarczyk and R.E.M. Hedges, *Ancient Egyptian Faience* (Warminster, 1983).

Kákosy 1982 L. Kákosy, "Phönix," *LdÄ* IV, 7 (Wiesbaden, 1982), 1030–39.

Krauss 1976 and 1977 R. Krauss, "Untersuchungen zu König Amenmesse (1. Teil)" and ". . . (2. Teil)," *SAK* 4 (1976), 161–99, and 5 (1977), 131–74.

Kuhlmann and Schenkel 1983 K. Kuhlmann and W. Schenkel, *Das Grab des Ibi, Obergutsverwalters der Gottesgemahlin des Amun (Thebanisches Grab Nr. 36), I–II*, AVDAIK 15 (Mainz am Rhein, 1983).

Kyrieleis 1975 H. Kyrieleis, *Bildnisse der Ptolemäer* (Berlin, 1975).

Leclant 1954 J. Leclant, *Enquêtes sur les sacerdotes et les sanctuaires égyptiens à l'époque dite "Éthiopienne" (XXV Dynastie)* IFAO BdÉ 17 (Cairo, 1954).

Leclant 1961 J. Leclant, *Montouemhat, quatrième prophète d'Amon, prince de la ville*, IFAO BdÉ 35 (Cairo, 1961).

Lesko 1972 B. Lesko, "Three Reliefs from the Tomb of Mentuemhat," *JARCE IX. 1971–1972* (1972), 85–88.

Lipińska 1974 J. Lipińska, "Studies on Reconstruction of the Hatshepsut Temple at Deir El-Bahari—A Collection of the Temple Fragments in the Egyptian Museum, Berlin," *Festschrift zum 150 Jährigen Bestehen des Berliner Ägyptischen Museums*, Staatliche Museen zu Berlin, Mitteilungen aus der Ägyptischen Sammlung VII (Berlin, 1974), 163–71.

Lipińska 1976 J. Lipińska, "The Portraits of Tuthmosis III newly discovered at Deir el Bahri," *Mélanges offerts à Kazimierz Michałowski* (Warsaw, 1976).

Lucas 1934 A. Lucas, "Artificial Eyes in Ancient Egypt," *Ancient Egypt and the East* (1934), 84–98.

Lüdecke 1961 C. Lüdecke, "Die Wachsmalerei der Alten," *Fette. Seifen. Anstrichmittel* 63 (1961), 38–41.

Lunsingh-Scheurleer 1984 R.A. Lunsingh-Scheurleer, *Egypte: Eender en anders* (Amsterdam, 1984).

Macurdy 1932 H. Macurdy, *Hellenistic Queens* (Baltimore, 1932).

Malaise 1976	M. Malaise, "Histoire et signification de la coiffure hathorique à plumes," *SAK* 4 (1976), 215–35.
Malaise 1978	M. Malaise, *Les Scarabées de coeur dans l'Égypte ancienne*, Monographies Reine Élisabeth IV (Brussels, 1978).
Manniche 1982	L. Manniche, "The Body Colours of Gods and Men in inlaid Jewellery and related Objects from the Tomb of Tutankhamun," *Acta Orientalia* 43 (1982), 5–12.
Martin 1980	K. Martin "Kanopen II," *LdÄ* III (Wiesbaden, 1980), cols. 316–19.
Martin 1985	G. Martin, *Scarabs, Cylinders and Other Ancient Egyptian Seals: A Checklist of their Publications* (Warminster, 1985).
Martin-Reisman 1978	M. Martin and S. Reisman, "The Surface and Structural Treatment of a Fayum Portrait," *Conservation of Wood in Painting and the Decorative Arts* (eds. N. S. Brommelle, A. Moncrieff, and Perry Smith) (London, 1978), 191–98.
Montet 1951	P. Montet, *La Nécropole royale de Tanis*. II, *Les constructions et le tombeau de Psousennès à Tanis* (Paris, 1951).
Müller 1980	M. Müller, "Drei Amunsbilder aus der Zeit Amenophis III. und Tutanchamuns," *SAK* 8 (1980), 207–15.
Myśliwiec 1976	K. Myśliwiec, *Le Portrait royale dans le bas-relief du nouvel empire*, Travaux du Centre d'Archéologie Méditerranéenne de l'Académie Polonaise des Sciences 18 (Warsaw, 1976).
Myśliwiec 1985	K. Myśliwiec, *Eighteenth Dynasty Before the Amarna Period*, Iconography of Religions XVI, 5 (Leiden, 1985).
Naville 1894–1908	E. Naville, *The Temple of Deir el Bahri* I–VI (London, 1895–1908).
New York Cultural Center 1974	New York Cultural Center, *Grand Reserves. An Exhibition of 235 Objects from the Reserves of Fifteen New York Museums and Public Collections held at the New York Cultural Center in Association with Fairleigh Dickinson University, October 24–December 9, 1974* (New York, 1974).
Nowicka 1984	M. Nowicka, "Théophilos, peintre alexandrien; et son activité," *Studi e Materiali* 5 (1984), 256–59.
Oliver 1979	A. Oliver, Jr., *Beyond the Shores of Tripoli. American Archaeology in the Eastern Mediterranean, 1789–1879* (Washington, D.C., and New York, 1979).
Omlin 1973	J. Omlin, *Der Papyrus 55001 und seine satirisch-erotischen Zeichnungen und Inschriften* (Turin, 1973).
Osing 1977	J. Osing, *Der Tempel Sethos' I. in Gurna. Die Reliefs und Inschriften* I, AVDAIK 20 (Mainz am Rhein, 1977).
Paris 1935–36	*Encyclopédie photographique de l'art*. I, *Les Antiquités égyptiennes du Musée du Louvre* (Paris, 1935–36).
Paris 1976	C. Desroches-Noblecourt *et al.*, *Ramsès le Grand* (Paris, 1976).
Parlasca 1966	K. Parlasca, *Mumienporträts und verwandte Denkmäler* (Wiesbaden, 1966).
Petrie 1909	W.M.F. Petrie, *The Palace of Apries (Memphis II)* (London, 1909).
Philipp 1972	H. Philipp, *Terrakotten aus Aegypten im Aegyptischen Museum* (Berlin, 1972).
Pomeroy 1984	S. Pomeroy, *Women in Hellenistic Egypt from Alexander to Cleopatra* (New York, 1984).
Porter and Moss 1972	B. Porter and R. Moss, assisted by E. Burney, *Topographical Bibliography of Ancient Egyptian Hieroglyphic Texts, Reliefs, and Paintings*. II, *Theban Temples*, 2nd ed., rev. and aug. (Oxford, 1972).
Quaegebeur 1971A	J. Quaegebeur, "Ptolémée II en adoration devant Arsinoé II divinisée," *BIFAO* 69 (1971), 191–217.
Quaegebeur 1971B	J. Quaegebeur, "Documents concerning a Cult of Arsinoe Philadelphos at Memphis," *JNES* 30 (1971), 240–70.
Ranke 1935	H. Ranke, *Die Aegyptischen Personennamen* I (Glückstadt, 1935).
Redford 1986	D. Redford, *Pharaonic King-Lists, Annals and Day-Books. A Contribution to the Study of the Egyptian Sense of History*, SSEA Publications VI (Mississauga, 1986).
Riefstahl 1968	E. Riefstahl, *Ancient Egyptian Glass and Glazes in The Brooklyn Museum*, Wilbour Monographs I (Brooklyn, 1968).

Robins 1983 G. Robins, "The god's wife of Amun in the 18th Dynasty in Egypt," in A. Cameron and A. Kuhrt (eds.), *Images of Women in Antiquity* (Detroit, 1983), 65–78.

Roeder 1969 G. Roeder, *Amarna-Reliefs aus Hermopolis* (ed. R. Hanke) (Hildesheim, 1969).

Romano 1976 J. Romano, "Observations on Early Eighteenth Dynasty Royal Sculpture," *JARCE* 13 (1976), 97–111.

Romano 1983 J. Romano, "A Relief of King Ahmose and Early Eighteenth Dynasty Archaism," *BES* 5 (1983), 103–15.

Russmann 1973 E. Russmann, "The Statue of Amenemope-em-hat," *MMAJ* 8 (1973), 99–112.

Sack-Stolow 1978 S. Sack and N. Stolow, "A Micro-Climate for a Fayum Painting," *Studies in Conservation* 23 (1978), 47–56.

Satzinger 1980 K. Satzinger, *Kunsthistorisches Museum. Ägyptische Kunst in Wien* (Vienna, 1980).

Sauneron 1960 S. Sauneron (tr. by A. Morrisett), *The Priests of Ancient Egypt* (New York, 1960).

Schäfer 1974 H. Schäfer (tr. by J. Baines), *Principles of Egyptian Art* (Oxford, 1974).

Schlögl 1985 H. Schlögl, "Uschebti", *LdÄ* VI, 6 (Wiesbaden, 1985), cols. 896–99.

Schmitz 1978 F.-J. Schmitz, "Zur Lesung und Deutung von ☩☩ und ☩," *GM* 27 (1978), 51–58.

Schneider 1977 H. Schneider, *Shabtis. An Introduction to the History of Ancient Egyptian Funerary Statuettes with a Catalogue of the Collection of Shabtis in the National Museum of Antiquities at Leiden* (Leiden, 1977).

Scott 1952 N. Scott, "Two statue groups of the V Dynasty," *BMMA* 11, no. 4 (December 1952), pp. 116–22.

Seidel 1975 M. Seidel and D. Wildung, "Rundplastik des Neuen Reiches," in Cl. Vandersleyen (ed.), *Das Alte Ägypten* (= Propylaen Kunstgeschichte 15) (Berlin, 1975), 240–55.

Shore 1972 A. Shore, *Portrait Painting from Roman Egypt* (Oxford 1972).

Simpson 1970 W.K. Simpson, "A Statuette of Amenhotep III in the Museum of Fine Arts, Boston," *BMFA* 68 (1970), 260–69.

Smith 1982 H.S. Smith, "The Excavation of the Anubieion at Saqqara," in *L'Égyptologie en 1979: Axes prioritaires de recherches* (Paris, 1982), 281.

Steindorff 1917 G. Steindorff, "Die blaue Königskrone," *ZÄS* 53 (1917), 59–74.

Steindorff 1944–45 G. Steindorff, "Reliefs from the Temples of Sebennytos and Iscion in American Collections," *The Journal of the Walters Art Gallery* 7–8 (1944–45), 38–59.

Taufik 1971 S. Taufik, " 'ir.n.f m mnw.f' als Weihformel. Gebrauch und Bedeutung," *MDAIK* 27 (1971), 227–34.

Tefnin 1976 R. Tefnin, in *Egypte's Glorie* (eds. L. Limme and H. De Meulenaere) (Brussels, 1976), p. 91.

Tefnin 1979 R. Tefnin, *La Statuaire d'Hateshepsout. Portrait royale et politique sous la 18ᵉ Dynastie*, Monumenta Aegyptiaca IV (Brussels, 1979).

Tefnin 1983 R. Tefnin, "Essai d'analyse formelle du visage royal égyptien: un relief de Touthmosis III aux Musées royaux d'Art et d'Histoire de Bruxelles," in H. De Meulenaere and L. Limme (eds.), *Artibus Aegypti. Studia in Honorem Bernardi V. Bothmer . . .* (Brussels, 1982), 153–77.

Thompson 1976A D. Thompson, *The Artists of the Mummy Portrait* (Malibu, 1976).

Thompson 1976B D. Thompson, *Mummy Portraits in the J. Paul Getty Museum* (Malibu, 1976).

Thompson 1976C D. Thompson, "A Painted Funerary Portrait from Roman Egypt," *BMFA* 74 (1976), 115–19.

Trolle 1978 S. Trolle, "An Egyptian Head from Camirus, Rhodes," *Acta Archaeologica* 49 (1978), 139–50.

Vaillancourt D. Vaillancourt, *Étude iconographique et stylistique de la statuaire privée à l'époque d'Amenophis III*, in progress.

Vandier 1958 J. Vandier, *Manuel d'archéologie égyptienne III: Les Grandes Époques—la statuaire* (Paris, 1958).

Van Siclen III 1980 C. Van Siclen III, "The Temple of Meniset at Thebes," *Serapis* 6 (1980), 183–207.

131

Vernus 1978 P. Vernus, *Athribis. Textes et documents relatifs à la géographie, aux cultes, et à l'histoire d'une ville du Delta égyptien à l'époque pharaonique*, IFAO, BdÉ 74 (Cairo, 1978).

Vernus 1980 P. Vernus, "Trois statues de particuliers attribuables à la fin de la domination Hyksôs," *IFAO Livre du Centenaire, 1880–1980* (*MIFAO* CIV) (Cairo, 1980), 179–90.

Vittmann 1977 G. Vittmann, "Zum Verstandnis der Weihformel *irjnf m mnwf*," *WZKM* 69 (1977), 21–32.

von Beckerath 1984 J. von Beckerath, *Handbuch der ägyptischen Königsnamen*, *MÄS* 20 (Berlin, 1984).

Wild 1969 H. Wild, "Note concernant des antiquités trouvées, non à Deir Dronka, mais dans la nécropole d'Assiout," *BIFAO* 69 (1969), 307–9.

Yoyotte 1972 J. Yoyotte, "Les Statuettes momiformes (shabtis)," *École pratique des Hautes Études, V^e section, Sciences Religieuses, Annuaire 1971–1972* (Paris, 1972), 190–91.

Ancient Iranian Art

James F. Romano
Associate Curator of Egyptian, Classical, and Ancient Middle Eastern Art
The Brooklyn Museum

Henri Frankfort, the renowned historian of ancient art, used the term "aesthetic predilection" to describe the unchanging artistic tendencies that flourished in particular regions of the Near East for thousands of years. From the beginning of their training, archaeologists study these patterns, learning to recognize the recurring tastes of each of the areas of the ancient Near East, such as southern Mesopotamia, northwestern Iran, or the Syrian coast.

Thus we know that for more than three thousand years Mesopotamian artisans fashioned the human body in a conical form, emphasized eyes, and frequently combined different materials (stone, gold, silver, shell, and so on) in the same statue or relief. Meanwhile, their neighbors in southwestern Iran displayed a fascination with animal forms, particularly the ibex, and relied on stylized decoration far more than the craftsmen of ancient Iraq. By understanding these patterns, we come to understand why one object is "unquestionably Mesopotamian" while another could only come from the Luristan region of Iran.

Since museum curators acquire objects for their institutions, they must study another type of aesthetic predilection as well. This is the prevailing taste in the ancient-art market. The buying styles of museums and collectors of the recent past can be documented just as precisely as the artistic styles of antiquity. We see that time and again a type of artifact or archaeological material from a particular site will become suddenly popular before falling, inevitably, from favor. Sometimes the factors that make certain antiquities "fashionable" are hard to define; a dealer once assured me, somewhat ingenuously, that Japanese clients are drawn to Persian glass but rarely buy other ancient varieties.

Usually, however, art dealers use the technique of creating a demand to sell what chance has given them as supply. A handful of their goods derive from old American and European collections assembled decades ago from disparate and untraceable sources. Many antiquities seen in today's art galleries, however, reach the market from illicit excavations through a complex network of middlemen. A peasant plowing a field in Iran, Turkey, or Iraq, for example, may unearth an ancient tomb or cemetery. Understandably he will clandestinely remove whatever he finds and sell the objects to a dealer's agent for far more money than he could hope to garner in a year of agricultural labor. Occasionally the professional archaeologist also plays a role in this unfortunate trade. The scientific discovery and excavation of an ancient site can attract locals who plunder the area before the archaeologist has completed the systematic removal and recording of finds, destroying forever the chance to understand the culture that created them. Soon these objects glut the art market. A clever art dealer

tries to convince potential purchasers that such pieces are the very standard by which an ancient Near Eastern collection is measured. Since the dealer has no control over what comes out of the ground, salesmanship often dictates taste. The wise purchaser judges objects on their own merit, not on their momentary popularity.

Many Near Eastern governments try to protect their archaeological heritage from such pillage, but the priorities of most are weapons and food. Some, such as Iran, look upon pre-Islamic antiquities as manifestations of decadent idolatry and make no attempt to safeguard them.

Of course, the number of genuine antiquities is finite, and when a popular supply begins to dwindle it is often replenished by a fresh host of modern forgeries. We can document this process again and again in the history of collecting ancient Near Eastern art. Recently, for example, a series of charming animal figures carved in a stone called dicktite began to appear in the European and New York art markets. Said to come from the Lake Van region of eastern Turkey and northwestern Iran, these pieces were subjected to extensive scientific scrutiny and seemed to be ancient (Kozloff 1981, 9–11). Presumably someone had stumbled upon a hitherto unknown site and looted it. The objects it surrendered became *de rigueur* additions to most ancient Near Eastern collections. In the last two years, however, a disturbingly large number of the Lake Van pieces offered for sale have shown clear signs of modern manufacture. Lake Van forgeries will probably continue to contaminate the market until another type of antiquity surfaces to challenge them for the collector's attention and money. Indeed, this may happen soon. With so many suspicious pieces around, the Lake Van group has become all but useless to archaeologists. (For a discussion of forgeries in the field of ancient Near Eastern art, see Muscarella 1977, passim.)

Because Ernest Erickson's holdings in ancient Near Eastern art in The Brooklyn Museum were all acquired in the 1960s, they provide an informative model of the type of private collection that might have been assembled through the art market at that time. One searches in vain for great works. Instead we encounter an occasional interesting piece (cat. no. 92) or an object not normally found in a small general collection (cat. no. 91). But nearly all the Erickson antiquities are precisely what a collector buying in the 1960s would be expected to own.

The *Ibex Rhyton* (cat. no. 94), for example, belongs to a group of northern Iranian pottery vessels in animal form that appeared by the thousands in the decade's first four years. Their presence in such great numbers followed their removal from countless looted megalithic tombs in the Amlash region. Charles K. Wilkinson, then Curator of ancient Near Eastern art at The Brooklyn Museum, wrote at the time, "Although the significance of many of these [vessels] may escape us, we are not prevented from enjoying or even disliking them as works of art. Many of them are striking in appearance and appeal to the taste of today" (Wilkinson 1963, 3). So popular were these rhytons twenty-five years ago that it is all but impossible to find a Near Eastern collection without at least one. As we have seen, however, once a class of antiquity becomes a "hot item," it is soon followed on the market by clever forgeries. A bull rhyton in the Erickson Collection not included in this exhibition, for instance (86.226.57), may certainly be adjudged modern.

Of all the ancient Near Eastern antiquities perhaps none have enjoyed a more enduring popularity with museums and private collectors than the so-called Luristan bronzes. In the 1960s, when Iran was particularly lax about guarding its borders, trade in these pieces reached unprecedented levels. Not surprisingly, then, twenty of

the twenty-eight ancient Near Eastern objects Mr. Erickson lent to The Brooklyn Museum are bronzes from west and northwest Iran. Of these, only the disk (cat. no. 92) and ax blade (cat. no. 93) appear in this catalogue, and the blade is merely a good example of a common type.

At least one piece in the Erickson Near Eastern collection teaches an important lesson: objects are not always what they first appear to be. Under rudimentary examination, the small painted ewer (cat. no. 95) looks to be a fine representative example of a ceramic form well documented at Tepe Sialk. We have reason to believe, however, that the spout has been restored, enhancing its appearance and thus its commercial value. It is not a true antiquity, and if its disguise had been penetrated years ago Mr. Erickson certainly would not have purchased it.

All of this is not to say that the Erickson material lacks importance for The Brooklyn Museum's ancient Near Eastern collection. Certainly his ceramic vessels enrich our otherwise meager inventory of Iranian pottery, and his bronzes add considerably to our study collection. In terms of provenance, however, it is a very "narrow" group of objects. With one possible exception (cat. no. 96), all come from Iran. Either Mr. Erickson was inexorably drawn to the aesthetic predilections of ancient Persia or, more likely, the dealers who sold to him were buying their objects exclusively from Iranian middlemen.

While assembling his collections Mr. Erickson usually demonstrated rare connoisseurship and judgment. His ancient Near Eastern material, however, is primarily of academic interest. Not one of his ancient Near Eastern pieces ranks with his finest Egyptian, Islamic, or Oriental acquisitions. Yet considering the extreme complexity of ancient Iranian archaeology and what was available when Mr. Erickson was buying, he did quite well.

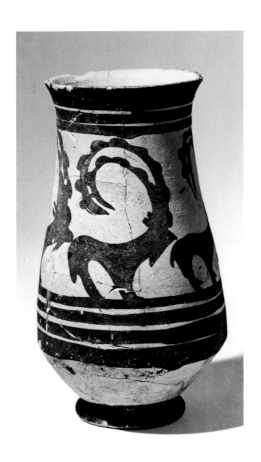

labored close to home. The major sites that produced extraordinary examples of the potter's art between 4000 and 3000 B.C. include Susa (in the southwest), Tepe Hissar (near the Caspian Sea), Tall-i Bakun (in the south), and Tepe Sialk (in the center of modern Iran). Although the shapes and decorative styles of pots from these sites vary enough for archaeologists to identify the probable find spots of individual vessels, certain features remain relatively constant for all Iranian ceramics fashioned at the time. In the second half of this period, for example, the ibex became a ubiquitous motif throughout Iran. The animal was to remain a dominant image in Iranian art for the next three thousand years.

This example features a frieze of five ibexes, all shown in pure profile, facing right, their forms rendered in silhouette. The vessel's shape, a beaker atop a low base, is similar to that of a number of vessels excavated by the Musée du Louvre, Paris, at Tepe Sialk (Ghirshman 1938, pl. LXXII [S.131, S.1749]). The style of the ibexes—note the bumps on their horns and the backward thrust of their bodies—may also be seen on several Tepe Sialk pieces (Ghirshman 1938, pl. LXXIV [S.1748, S.1691], pl. LXXXII [D12]). The archaeological context of these excavated parallels, which date to the end of the fourth millennium B.C. (Dyson 1965), indicates that the Erickson vase should be assigned to the third cultural phase at Tepe Sialk.

At that time Iranian potters began using the potter's wheel, producing shapes far more regular and well defined than those made earlier. The interior of the Erickson piece shows the characteristic concentric rings of wheel-made vessels. Archaeologists are not certain if craftsmen employed a fast wheel or a slower turntable (Porada 1965).

This beaker has suffered considerable damage. At one time it was broken into approximately twenty pieces; the breaks have been repaired in modern times. In addition, some of the black paint has flaked away.

JFR

90 *Beaker with Row of Ibexes*

Central Iran, Kashan region
Sialk III Period, circa 3200–3000
B.C.
Wheel-made painted pottery,
 7¼ × 3⅜ (18.4 × 8.6)
86.226.59
(Illustrated in color on page 11)

Iranian potters of the fourth millennium B.C. rank among the most innovative and accomplished artisans of antiquity. Rather than working at one major geographic center with their products radiating out to other regions, these craftsmen seem to have

91 *Tripod Vase*

Western Iran, Khuzistan region
Circa 1600–1500 B.C.
Painted pottery, 9½ × 9³⁄₁₆
 (24.2 × 23.3)
86.226.58

For a brief period in the middle of the second millennium B.C., the potters of western Iran executed vessels that stood on three short, sturdy legs. These so-called tripod vases featured such geometric motifs as rows of vertical lines, zig-zags, and "bow tie" designs. The painting was usually polychrome, with black or brown as the dominant color and red used for detailing.

The vast majority of excavated tripod vases come from the cemetery of level III at Tepe Giyan in Khuzistan (Conteneau and Ghirshman 1935, pls. 27–29). This Erickson vase, however, displays a "twin sun" motif, seen at the top of the painted columns rising from its legs, that is not known from Giyan III and can only be documented in finds from the later level II. This suggests that the vase either dates to a transitional phase between levels III and II or was produced elsewhere, perhaps at Tepe Djamshidi, where a related artistic tradition flourished.

JFR

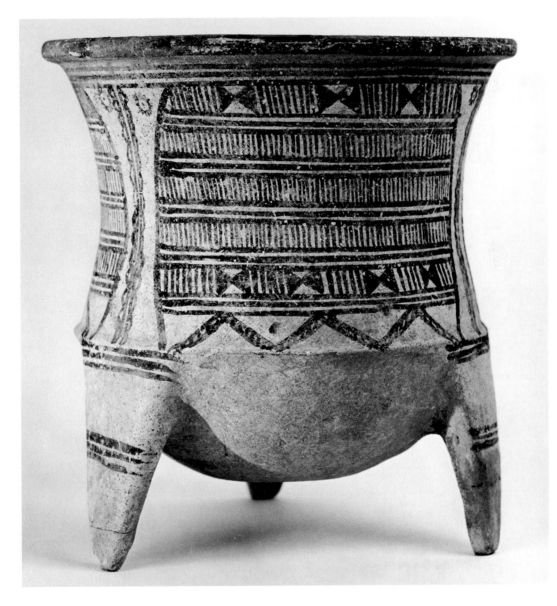

92 Ornament with Mythical Combat Scene

Northwestern Iran, Azerbaijan
region, find spot not known
Twelfth or eleventh century B.C.
Bronze, $3^{13}/_{16}$ (9.7) diameter
86.226.39

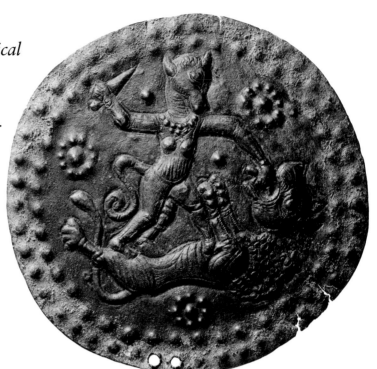

Archaeological excavations in western Iran have uncovered a number of circular sheet-metal disks comparable in size to this example. These pieces usually feature repoussé designs and have at least one pair of punched holes for attachment. Although their exact function remains uncertain, these disks may have served as belt ornaments or decorative dress fittings (Moorey 1971A, 249–51).

Even though the Erickson piece represents a fairly well-known type of object, the complexity of its decoration and one of the elements in its design are unexpected. Such disks usually contain only simple geometric patterns. Here, however, a great one-eyed, bull-headed woman stands atop the stomach of an overturned male lion. This bull-woman, clearly a cyclops, grasps the lion's tongue with one hand while brandishing a pointed dagger in the other. Her head is shown frontally, in contrast to the more familiar profile view. This female, bull-headed cyclops, whose presence may allude to a lost myth or long-forgotten oral tradition, is without parallel in the art of the ancient Near East.

Nevertheless, the basic decorative scheme—a bull-headed hero dispatching a ferocious lion—owes its inspiration to the work of Mesopotamian artisans of the early third millennium B.C. Those craftsmen produced cylinder seals whose dominant motif featured human heroes and bull-men defending their valuable flocks against rapacious predators, usually in hand-to-hand combat (Frankfort 1939, 58–62). Although the popularity of this theme diminished over the centuries, it never completely disappeared from the inventory of ancient Near Eastern art. The Erickson piece demonstrates that the motif survived at least until the end of the second millennium B.C., by which time it had spread eastward into northwestern Iran.

The disk seems to date between 1200 and 1000 B.C. At that time a number of gold and silver vessels were produced with details that call to mind elements of the Erickson disk. The segmentation of the lion's body, for instance, is particularly common on bowls and beakers from Hasanlu and Marlik. These pieces also display the technique of using short strokes to produce vertical "striping" such as that seen on the lion's haunches. Even the pointed dagger seems to be paralleled on the so-called Hasanlu Bowl (Porada 1965, 96–102; Moorey 1974, 186–87). JFR

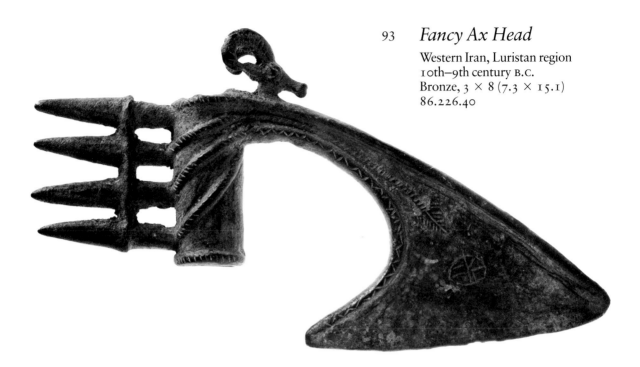

93 Fancy Ax Head

Western Iran, Luristan region
10th–9th century B.C.
Bronze, 3 × 8 (7.3 × 15.1)
86.226.40

Perhaps the most common and least understood artifacts from ancient Iran are the so-called Luristan bronzes. Nearly every major collection of Iranian antiquities contains examples of these bronzes, including elaborate finials and standard terminals, weapons, jewelry, horse trappings, pins, bells, and amulets (Vanden Berghe 1959, 87–97; Porada 1964, 9–31; Ghirshman 1964, 40–82; Godard 1965, 45–86; Porada 1965, 75–89; Van Den Boorn 1985, 36–47).

Despite their ubiquity, little is known of Luristan bronzes. Only a small percentage come from archaeological excavations; the majority derive from illicit digs that began in the 1920s and continue to this day. Although many bronzes said to be from the Luristan region have entered museum and private collections from the art market, archaeologists know the original provenances of only a handful of these pieces and many of them may not come from that area at all. Moreover, the confusion we face when studying these artifacts is compounded by another problem: the appeal they have for the modern collector has spawned hundreds of forgeries, some extremely faithful to their ancient models (Moorey 1971B, 34–36).

That this Erickson ax head is an au-

thentic Luristan bronze is suggested, though not proved, by three known parallels, all of which, like the Erickson piece itself, have a flat, splayed blade decorated with an arrow point, imitation binding on the haft, and four ominous spikes. One of these parallels is in The University Museum, University of Pennsylvania, Philadelphia (acc. no. 30–38–55; Legrain 1934, 3, 17, pl. 15 [47]), another is in the Joukowsky Collection (Muscarella 1985, 18–20 [with complete bibliography]), and a third (cited by Muscarella) was excavated at Xatunban in Luristan—the probable place of the Erickson ax head's manufacture. Since all three parallels were made in the tenth or ninth century B.C., this date would seem to apply to the Erickson example as well.

The tiny ibex head on this ax has no apparent parallels, but a similarly placed feline decorates both the Philadelphia piece and a blade in the Sarre Collection in Berlin (Potratz 1968, pl. IV, 20). On the Erickson blade we also see an incised circle containing short lines. The meaning of this peculiar form is not known. It may represent some primitive mark of ownership recognizable in the preliterate society of ancient Luristan.

JFR

139

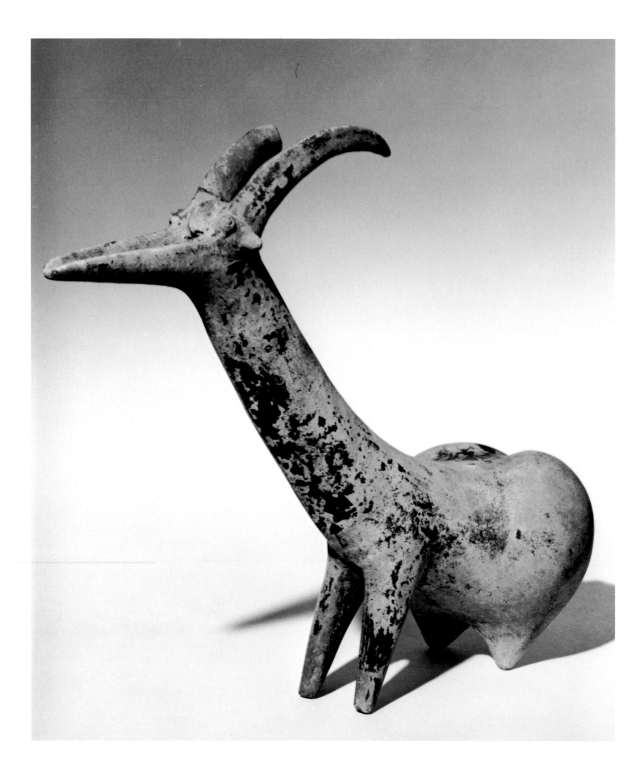

94 *Ibex Rhyton*
Northern Iran, Caspian region
9th–8th century B.C. (?)
Pottery, 10 × 4¼
 (25.5 × 10.8)
86.226.62

In the early 1960s Iranian peasants living near Amlash in the mountainous area southwest of the Caspian Sea discovered a series of megalithic tombs. Many still had their grave goods in place. The peasants illegally opened the tombs, looted them, and sold off their contents to agents for Western art dealers. By the close of the decade, Amlash objects had begun to dominate the antiquities markets in Europe and the United States. When these pieces first appeared in the West, nothing was known about them or the culture that produced them. Although subsequent excavations by the Iranian Archaeological Survey at the nearby site of Marlik provided some understanding of the Amlash remains, the plundering of the ancient cemetery at Amlash means that any knowledge archaeologists might have gained from scientific investigation of the site is now irretrievably lost.

The clandestine digging unearthed various types of artifacts, including gold and silver beakers and bronze statuettes, but by far the most familiar object from Amlash is the pottery rhyton, a vessel modeled in the form of an animal or animal head. These pieces are unpainted and are characterized by a simple juxaposition of geometric forms as well as by bold, striking profiles. They most commonly take the form of a great humpbacked ox; far rarer is the ibex image of the Erickson vessel. The use of the ibex should not surprise us, however, since the dramatic sweep of the creature's long saber-shaped horns had fascinated Iranian craftsmen since at least the fourth millennium B.C. (cat. no. 90).

The vigorous, spirited profiles of the Amlash rhytons hold a strong attraction for the modern collector (Ghirshman 1964, 31; Wilkinson 1963, 3). Indeed, perhaps no other form of ancient Iranian pottery has awakened such acquisitive passions as the beguiling animal vessels of the Caspian region. Unfortunately, the desire to possess Amlash pottery has had a predictable result. When the supply of genuine rhytons eventually diminished, skillfully executed forgeries began to flood the market in their place. Museums and art collectors alike were deceived by these clever imitations. One European museum, for example, recently discovered that the "ancient" black slip covering its prized Amlash rhyton was in fact a thick layer of shoe polish. JFR

95 *Painted Ewer*

Central Iran, Kashan region
Sialk B [VI] Period, 8th–7th century
B.C.
Pottery (restored), 3½ (8.8) high
86.226.63

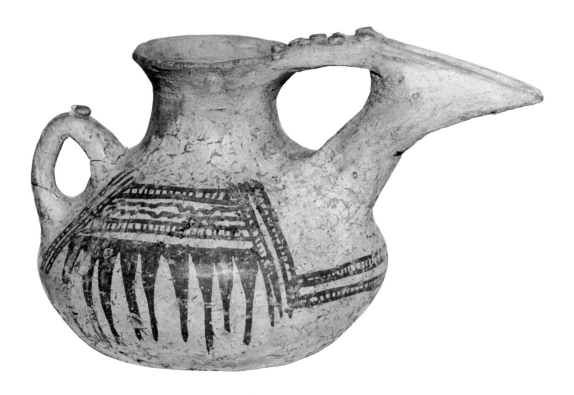

In the early first millennium B.C., the potters of north-central Iran created a fresh ceramic type that was at once charming, functional, and charged with energy. They shaped these vessels in gray or red monochrome or, as with this Erickson ewer, in a buff clay. These pots sport long, straight spouts recalling the neck and beak of a strange majestic bird. The bodies, however, tend to be squat, emphasizing solidity (Ghirshman 1939, frontis., pls. XI–XXI; Herzfeld 1941, 110–11; Ghirshman 1964, 9–16; Porada 1965, 105–7).

The craftsmen who painted these vessels used powerful images of humans and animals, often supplementing them with a limited inventory of geometric designs. Two of the most common nonfigural motifs appear on this ewer: long pendant triangles and the so-called ladder pattern. Porada has speculated that such designs are deliberately combined so as to suggest meaning.

Archaeologists classify this pottery as Sialk B or VI ware, the latter designation referring to the cemetery in level VI at Tepe Sialk that yielded many of the finest examples (Ghirshman 1939). This ewer may have originally come from that site.

The Erickson piece, however, is not quite what we would expect in a Sialk B ewer. The spout is uncharacteristically short and droops at a disturbing angle. The Brooklyn Museum's Conservation Department has found evidence of a fired repair and a shaving down of the original spout. Although these alterations could reflect an ancient reworking, in all likelihood they are modern repairs intended to deceive potential purchasers. The result is an unfortunate pastiche, the combination of a genuine body almost three thousand years old with a spout that bears only casual resemblance to its ancient prototype. JFR

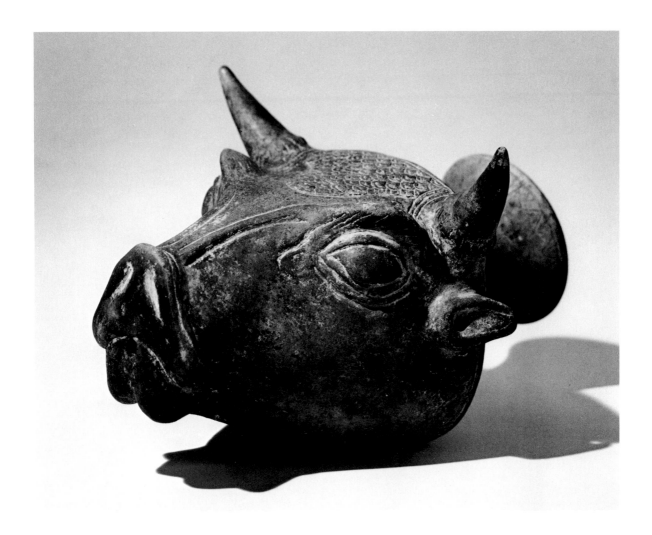

96 *Ox-head Rhyton*

Northwestern Iran (Azerbaijan
region) or eastern Anatolia
8th–6th century B.C.
Pottery, 5¾ × 8½ (14.6 × 21.6)
86.226.61

In the first half of the first millennium B.C.,
a traditional drinking vessel, the rhyton, be-
came one of the dominant pottery types in
the Near East (see cat. no. 94 for an Iranian
example). Its greatest popularity was cen-
tered in the region extending westward from
the Caspian Sea to central Anatolia.

The word "rhyton" comes from the
Greek *rysis*, meaning the running or flowing
of water. Archaeologists now use the term
to refer to pottery crafted in the form of ani-
mal heads or bodies (Porada 1965, 270–71).
A tiny hole in the animal's mouth permitted

the liquid to flow forth in a narrow, steady
stream (Tuchelt 1962, passim).

This rhyton takes the form of an ox
head. In accordance with Iranian taste, the
potter has made extensive use of stylization.
Note, for example, the treatment of the
forelock. The artisan has rendered it with a
network of scales, each containing a central
dot. The eyebrows are similarly stylized, con-
tinuing down the animal's muzzle in ex-
tremely bold ridges, resembling but not re-
producing nature.

The vessel is modeled in dark gray
clay, the characteristic medium of Iron Age
pottery from northern Iran. A note in the
records of The Brooklyn Museum indicates
that the piece was reportedly found in the
area of Ardabil, near the west coast of the
Caspian Sea. For a similar, though less sty-
lized, calf-headed rhyton now in the Norbert
Schimmel collection, see Harper 1974, no.
135. JFR

Works Cited: Ancient Iranian Art

Conteneau and Ghirshman 1935 Georges Conteneau and Roman Ghirshman. *Fouilles de Tépé-Giyan près de Néhavend 1931–1932* (Paris, 1935).

Dyson 1965 Robert H. Dyson, Jr., "Problems in the Relative Chronology of Iran, 6000–2000 B.C.," *Chronologies in Old World Archaeology* (edited by Robert W. Ehrich) (Chicago, 1965), 215–56.

Frankfort 1939 Henri Frankfort, *Cylinder Seals, a Documentary Essay on the Art and Religion of the Ancient Near East* (London, 1939).

Ghirshman 1938–39 Roman Ghirshman, *Fouilles de Sialk près de Kashan, 1933, 1934, 1935*, 2 vols. (*Série Archéologique* IV and V) (Paris, 1938–39).

Ghirshman 1964 Roman Ghirshman, *Persia from the Origins to Alexander the Great* (translated from French by Stuart Gilbert and James Emmons) (London, 1964).

Godard 1965 André Godard, *Art of Iran* (edited by Michael Rogers; translated from French by Michael Heron) (London, 1965).

Harper 1974 Prudence Oliver Harper, in *Ancient Art, the Norbert Schimmel Collection*, exhibition catalogue (edited by Oscar White Muscarella) (Mainz, 1977).

Herzfeld 1941 Ernest E. Herzfeld, *Iran in the Ancient East, Archaeological Studies Presented in the Lowell Lectures of Boston* (London, 1941).

Kozloff 1981 Arielle P. Kozloff, in *Animals in Ancient Art from the Leo Mildenberg Collection*, exhibition catalogue (edited by Arielle P. Kozloff) (Cleveland Museum of Art, 1981).

Legrain 1934 Leon Legrain, *Luristan Bronzes in the University Museum*. Collection catalogue (The University Museum, University of Pennsylvania, 1934).

Moorey 1971A P.R.S. Moorey, *Catalogue of the Ancient Persian Bronzes in the Ashmolean Museum* (Oxford, 1971).

Moorey 1971B P.R.S. Moorey, "Towards a Chronology for the 'Luristan Bronzes'," *Iran* 9 (1971), 113–29.

Moorey 1974 P.R.S. Moorey, *Ancient Persian Bronzes in the Adam Collection* (London, 1974).

Muscarella 1977 Oscar White Muscarella, "Unexcavated Objects and Ancient Near Eastern Art," *Mountains and Lowlands: Essays in the Archaeology of Greater Mesopotamia (Bibliotheca Mesopotamia* VII) (edited by Louis D. Levine and T. Cuyler Young, Jr.) (Malibu, 1977).

Muscarella 1985 Oscar White Muscarella, *Love for Antiquity, Selections from the Joukowsky Collection (Archaeologica Transatlantica* VII), exhibition catalogue (edited by T. Hackens and R. Winkes) (Louvain and Providence, 1985).

Porada 1964 Edith Porada, "Nomads and Luristan Bronzes: Methods Proposed for a Classification of the Bronzes," *Dark Ages and Nomads c. 1000 B.C., Studies in Iranian and Anatolian Archaeology* (edited by Machteld J. Mellink) (Istanbul, 1964), 9–31.

Porada 1965 Edith Porada, *Art of Ancient Iran, Pre-Islamic Cultures* (New York, 1965).

Potratz 1968 Johannes P.H. Potratz, *Luristanbronzen, die einstmalig Sammlung Professor Sarre, Berlin* (Istanbul, 1968).

Tuchelt 1962 Klaus Tuchelt, *Tiergefässe in Kopf-und Protomengestalt, Untersuchungen zur Formengeschichte tierförmiger Giessgefässe (Istanbuler Forschungen* XXVII) (Berlin, 1962).

Vanden Berghe 1959 L. Vanden Berghe, *Archéologie de l'Iran ancien* (Leiden, 1959).

Van Den Boorn 1985 G.P.F. Van Den Boorn, *Oud Iran, Pre-Islamitische Kunst en Voorwerpen in het Rijksmuseum van Oudheden te Leiden* (Zutphen, 1985).

Wilkinson 1963 Charles K. Wilkinson, *Iranian Ceramics* (New York, 1963).

Indian and Southeast Asian Art

Amy G. Poster
Associate Curator of Oriental Art
The Brooklyn Museum

The majority of the Indian and Southeast Asian objects discussed in the following pages were first published by The Brooklyn Museum in 1963 in a catalogue accompanying a special exhibition of Ernest Erickson's Indian and Islamic collection. Although at the time documentation was scarce, recent archaeological and epigraphical evidence has proven that the then-Associate Curator of Oriental Art, Lois Katz, correctly identified and attributed most of the pieces in the collection. While emphasizing the aesthetic qualities that attracted so discerning a collector as Ernest Erickson, we now hope to present these objects to a wider audience in the light of this relevant new documentation.

Mr. Erickson amassed his collection of Indian and Southeast Asian art largely in the decade beginning in the mid-1950s, a period when interest in such art intensified generally and at The Brooklyn Museum in particular. While working closely with the Museum's Oriental Art curators as an adviser on Museum purchases, he built his own collection as a complement to that of the Museum. The thirty-six acquisitions described here and the thirty-two others in the group are pieces of outstanding aesthetic merit.

Although Mr. Erickson generally focused his buying on the earlier periods of any given culture or art form rather than on the more common later objects available to him, his collection of Indian sculpture covers some thirteen centuries of India's rich sculptural tradition, ranging from the Kushan to the Gupta to the medieval period in the north and from the Iksvakhu to the Chola to the Vijayanagara Period in the south. Perhaps his single best-known piece of Indian sculpture is a third-century pale green limestone *Seated Buddha Torso* probably from Nagarjunakonda (cat. no. 98). Until recently, this figure, whose simple form is amplified by the elegantly gathered folds of its drapery, represented the sole example of Amaravati-style sculpture in the round in the United States. Not as rare but just as striking are his sculptures of India's classical age, the Gupta Period (circa 300–550), which embody in their combination of sensuous detail and austere shape an enduring characteristic of Indian art. Worth special note in this regard are a *Seated Buddha* (cat. no. 99) and a *Torso of a Standing Buddha* (cat. no. 100) that relate stylistically to Buddhist sculptures discovered recently at Govindnagar in Mathura. As for sculptures of a later date, which tend to be images of deities that were placed on the walls of Hindu temple exteriors, the collection includes three important examples from central and western India (cat. nos. 103, 104, and 106) and a *Standing Buddha* from Bihar (cat. no. 105) that is one of the best works of the early medieval period in The Brooklyn Museum.

Unlike his Indian sculptures, Mr. Erickson's Indian paintings are not illustrative of the history of their medium. Instead, they concentrate on the high points of various regional traditions, such as seventeenth- and eighteenth-century Mughal and eighteenth-century Rajput and Pahari schools. Here, Erickson sought a specific aesthet-

ics: the works had to be technically refined, and portraits were the main subject of his taste. Almost all his paintings, including leaves from a rare Nepalese palm leaf manuscript that is now dispersed (cat. nos. 118–19), were collected in the late 1950s, when Indian miniatures were already a well-established target of collectors but still only a recent interest in this country.

The Southeast Asian portion of Mr. Erickson's Indian and Southeast Asian collection consists mostly of sculptures from Thailand, of which the seven selected for discussion here are outstanding examples of early Mon or later Khmer-derived styles. Since few secular sculptures exist from the early periods in Thailand, it is not surprising that these seven sculptures are all serene and noble Buddhist images, which like their Indian prototypes were portrayed in a limited number of attitudes conceived as expressions of compassion for all living things. Yet although their attributes conform to the conventional Buddhist iconography, their materials and styles reflect local adaptations. The monuments at Mon religious centers in central Thailand, for instance, were often decorated with stucco images like the four discussed here (cat. nos. 111–14). Delicate as they are, these stucco sculptures were made from molds—a technique employed to ensure consistency.

97 *Salabhanjika Group*

India, Uttar Pradesh, Mathura
Kushan Period, late 2nd century
Mottled red sandstone,
12½ × 10½ (31.8 × 26.7)
86.227.159

The absorption of early Indian fertility cults into the iconographic scheme of Buddhism is demonstrated by the presence of tree goddess, or *salabhanjika*, imagery in Buddhist art. This group of four fragmentary female figures carved in high relief around the base of a rounded concave indentation is an example of such imagery. Although little or no definitive documentation is available for the identification of the figures and their specific role, it has been suggested that the group functioned as a support for a stone basin in which worshipers at a temple cleansed their hands (Czuma 1985, 108). At least two other groups carved around a circular base are known. They are identified as having a Mathura origin by their mottled red sandstone and by their style of carving and naturalistic treatment (Czuma 1985).

The *salabhanjika* was traditionally shown touching the branch of the sacred ashoka tree in a gesture signifying her spiritual power to make the tree bear fruit. This auspicious symbol was enhanced by the goddess's voluptuous form, her varied and generous jeweled ornament, and the arc of her posture. In this example, though fragmented and abraded by wear, these essential characteristics are present (Czuma 1985, 92–93).

The best-preserved figure here is posed with her back arched and her head tilted to her right. Her left arm is raised and bent at the elbow with the hand behind the head. Although her right arm and hand are missing, they were probably raised to touch a branch of the ashoka tree whose leaves are carved all around the group in great detail. The figure wears broad earrings in both ears, multiple bangles or a wide bracelet on her left forearm, and a beaded one-strand necklace that hangs down between her prominent rounded breasts. Her wavy hair falls above her breasts in strands coming from behind her ears. The top is pulled up and looped into a high chignon tied around the base with a jeweled (?) band.

To this *salabhanjika's* right are the remains of another figure whose face is now broken off. Her necklace has four strands joined by a square brooch decorated with an open lotus. Her earrings are similar to the first *salabhanjika's*, but her hair is looped in an even higher chignon tied along the right side of her head with a jeweled band that repeats the pattern seen along the right side of her necklace. To the right of this figure is the head of a third goddess, the rest of whose body is now missing. Her hair is looped high in a similar manner. A fourth figure, the side of whose head can still be seen but whose face and body have broken off, remains only in a most fragmented state.

A late second-century date is suggested for the relief based on stylistic comparisons (Czuma 1985, 101).　　AGP

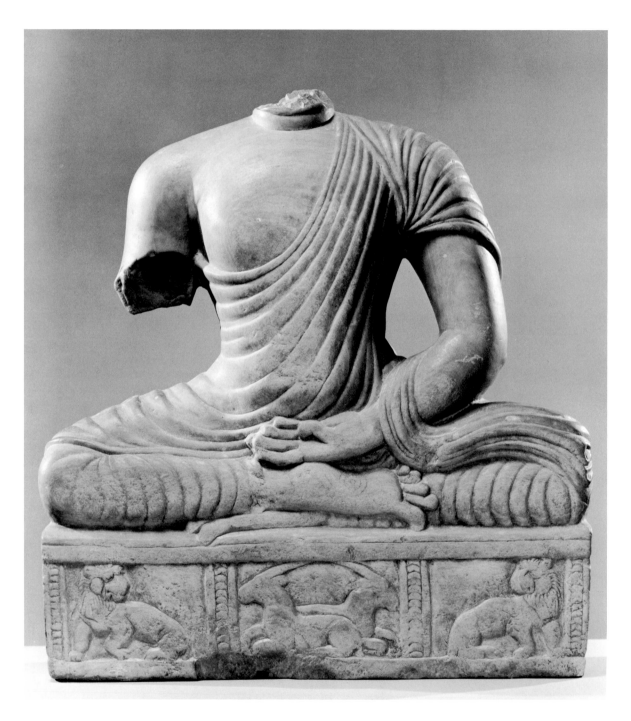

98 *Seated Buddha Torso*

India, Andhra Pradesh, probably
 Nagarjunakonda
Iksvakhu Period, late 3rd century
Pale green limestone, 16¾ × 15
 (42.5 × 38.1)
86.227.24
Provenance: C. T. Loo

Representations of the historical Buddha, Sakyamuni, first occurred in the iconographic scheme of Buddhist monuments in India in the first century. The events of Sakyamuni's life were signified by the position, hand gestures, and attributes of the Buddha figures. Here, for instance, the two deer in the center of the throne indicate that the scene depicted is the Buddha's first sermon in the deer park at Sarnath.

This Buddha is probably from Nagarjunakonda, one of the Buddhist centers of southern India that flourished in the Guntur district and adjacent areas of modern-day Andhra Pradesh from as early as the second century B.C. until the fourth century A.D. These centers are important not only for their role in disseminating Buddhism to southern and southeastern Asia but also for their extensive participation in sea trade that originated from as far west as Rome and for complexes of monuments—primarily religious—erected by their rulers. They are considered among the greatest art centers of ancient India.

The main artistic activity at Nagarjunakonda grew through the patronage of the Iksvakhu rulers, who succeeded the Satavahanas at the end of the second century and ruled until early in the fourth century. Hindu and Buddhist monuments coexisted at the site. While the kings of the dynasty were worshipers of the Brahmanical gods and performers of Vedic ritual, the Buddhist monasteries there were largely the interest of the Iksvakhu queens and princesses whose pious gifts are recorded in the extant donors' inscriptions.

The stone sculptures of Nagarjunakonda, like those of the rest of the surrounding Amaravati region, are of a greenish limestone soft enough to have allowed for subtle carving and precise modeling. Most were reliefs designed to adhere to the brickwork of the monasteries. Freestanding sculptures, however, are also known, including several exquisite late third-century standing Buddhas (Chandra 1985, cat. nos. 21, 70.)

What is stylistically distinctive about Nagarjunakonda limestone Buddhist sculpture is the manner of depicting the monastic robe covering only the left shoulder. Seated images are usually depicted in the *padmasana* position (sitting, with the legs crossed and the feet resting on the thighs) on a lion throne.

This Buddha, head missing, is seated in the *satamaparyanka asana* position (one foot placed on the other with the sole of the right foot visible). His garment, which covers the left shoulder only, falls in deeply modeled folds. The left hand forms the *dhyana mudra* (gesture of contemplation), while the right arm, now missing, was held away from the body, probably in the *abhaya mudra* (gesture of protection). The wheel on the sole of the Buddha's foot is one of the thirty-two major and eighty minor *laksana*, or signs, of the Buddha and refers to the wheel of law, which he set in motion. The two seated lions with their heads turned back that flank the deer on the front of the throne are associated with royal and heroic virtues. AGP

Published: Aschwin Lippe, *The Art of India, Stone Sculpture*, exhibition catalogue (The Asia Society, New York, 1962), cat. no. 26; Lois Katz, *Asian Art: From the Collections of Ernest Erickson and the Erickson Foundation, Inc.*, exhibition catalogue (The Brooklyn Museum, 1963), cat. no. 119; *The Art of Greater India*, exhibition catalogue (Los Angeles County Museum of Art, 1950), cat. no. 34; P. Pal. *Light of Asia: Buddha Sakyamuni in Asian Art*, exhibition catalogue (Los Angeles County Museum of Art, 1984), cat. no. 34.

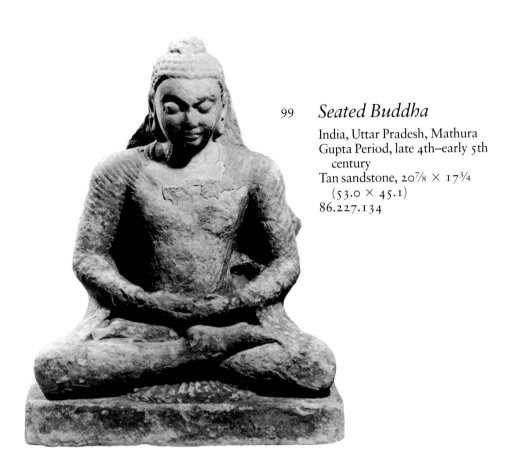

99　*Seated Buddha*

India, Uttar Pradesh, Mathura
Gupta Period, late 4th–early 5th
　century
Tan sandstone, 20⅞ × 17¾
　(53.0 × 45.1)
86.227.134

This relief carving of a Buddha was produced during the Gupta Period (circa A.D. 300–550), a time when the portrayal of the Buddha reached its height. It comes from Uttar Pradesh in northern India, where the patronage of the Gupta empire was situated and where the main repositories of Gupta Period art are located. Like most Gupta art, it embodies naturalism, elegance of line, and an expressive image.

The carving depicts Buddha seated in the *padmasana* position (with his legs crossed and his feet resting on his thighs) on a low base. The hands are in the *dhyana* or *yoga mudra*, "the seal of meditation," with one hand resting on the other. The reverse of the sculpture is unworked, but sections of a nimbus or halo remain on each side of the head.

Identified as a product of the Mathura School, the image conforms stylistically to other seated figures of fourth-century date (Sharma 1984, figs. 132 and 133). These figures have certain features of the earlier Kushan Period, such as squared shoulders and exposed upturned soles, but the more relaxed treatment of torso, drapery, and nimbus, the shape of the head and eyes, and the serene expression point to an early Gupta Period date.

The type of stone seen in Mathura sculpture is a sandstone that is distinctive in color, ranging from red or red mottled with white spots to tan, as in this example. Recent discoveries at Govindnagar confirm the existence of this variation (Sharma 1984, 129), but tan sandstone was less frequently the preferred material. AGP

Published: Lois Katz, *Asian Art: From the Collections of Ernest Erickson and the Erickson Foundation, Inc.,* exhibition catalogue (The Brooklyn Museum, 1963), cat. no. 96.

The torso shown here is a standing Buddhist male figure in high relief against an arched background decorated with a carved floral scroll. The figure is robed in transparent drapery with a U-shaped formation of the garment below the neck. The head, feet, lower arms, and left shoulder are missing.

The torso was formerly attributed to Sarnath because it displays the characteristics of a universal fifth-century Gupta style particularly embodied in sculpture from Sarnath—smooth drapery, a high waist, and a partially relaxed posture. The low-relief carving of a foliate scroll pattern in the borders, a convention often relegated to the decorated aureoles of Buddha images, is common in fifth-century pieces from many sites, however, and while Sarnath sculptures are carved from a fine-grained tan sandstone, this piece is carved in a reddish sandstone usually associated with Mathura. Although smooth drapery, a U-shaped neckline, a stiff, "dwarfish" posture, and an outer robe deeply carved to echo the form of the figure's aureole are unusual features for Mathura sculpture, two standing Buddha images in this style dated to the fourth-fifth century have recently been found there (Sharma 1984, figs. 135 and 147). These discoveries, evidence of artistic ties between the Mathura School and the Sarnath School during the Gupta Period, support a reattribution of the Erickson torso to Mathura. AGP

100 *Torso of a Standing Buddha*

India, Uttar Pradesh, Mathura
Gupta Period, 5th century
Red sandstone, 20¹⁄₁₆ × 13⅝
 (51.0 × 34.5)
86.227.47
Provenance: Nasli M. Heeramaneck
 (1961)

Published: Lois Katz, *Asian Art: From the Collections of Ernest Erickson and the Erickson Foundation, Inc.*, exhibition catalogue (The Brooklyn Museum, 1963), cat. no. 100.

101 *Head of a Buddha*

India, Uttar Pradesh, Mathura
Gupta Period, 5th century
Red sandstone, 9 × 5½
 (22.9 × 14.0)
86.227.57

Even though some of the *laksana* (signs of Buddhahood) are not in evidence here (the *urna*, or mark on the forehead, for instance, is not shown), this subject has been identified as a head of a Buddha because of its snail-curl coiffure and its *usnisha* (cranial bump). Although the piece conforms to the general Gupta Period prototype for a face, it is more sensuous than most Gupta heads, with rounded cheeks, full lips, and eyes half closed in contemplation. Carved from the typical red sandstone of the Mathura region, it shows the refinement of the Mathura style that had taken place by the Gupta Period. The back of the head appears to have been attached to a nimbus, indicating that the whole figure must have been in very high relief. AGP

Published: Lois Katz, *Asian Art: From the Collections of Ernest Erickson and the Erickson Foundation, Inc.*, exhibition catalogue (The Brooklyn Museum, 1963), cat. no. 97.

102 *Vishnu Torso*

India, Uttar Pradesh, Mathura
Gupta Period, 5th century
Red sandstone, 25 × 9
 (63.5 × 22.9)
86.227.160

This torso, identified as a figure of Vishnu by the long *vanamala*, or garland of forest flowers, that falls below the knees, points up the common stylistic features shared by Buddhist and Brahmanical work. The lower part of the torso, from the hips down, is carved in high relief. The figure stands with weight evenly distributed, a pose typical of fifth-century Gupta images, with the knees locked, the front of the thighs bulging slightly, and the legs parted slightly. Because the legs below the knees slant backward as in Kushan sculptures, a date early in the fifth century (or perhaps late in the fourth century) has been suggested.

The figure wears a dhoti draped in typical Gupta fashion with complex curves of diaphanous drapery emphasizing the form of the body (Pal 1978B, 42ff.). Characteristically (Williams 1982, 71), the gathered pleats hang down between the legs, held just below the waist by a sash whose ends hang on the right thigh. Over this dhoti is another cloth, one edge of which rises diagonally from the right calf across the left thigh and another edge of which can be seen along the left calf. One end of this cloth falls in pleats from just below the waist and hangs down on the left thigh. It falls over a sash which, draped in a diagonal from the right hip to the top of the left thigh, was probably tied in a large loop just below the left hip. A one-stranded necklace hangs high on the chest. All is carved with extreme refinement.

AGP

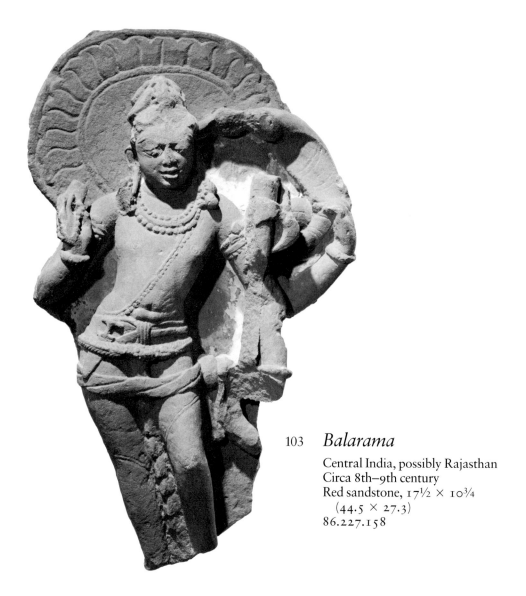

103 *Balarama*

Central India, possibly Rajasthan
Circa 8th–9th century
Red sandstone, 17½ × 10¾
(44.5 × 27.3)
86.227.158

This heroic standing male figure, recognized as a divinity by his four arms and his halo, was formerly identified as Siva but is here identified as Balarama, brother of Krishna and an incarnation of Vishnu. (Professor Donald M. Stadtner kindly provided confirmation of this identification of Balarama and his specific attributes.) He is posed in a thrice-bent position with the left knee flexed and the right hip thrown out. While some of his attributes are obscure or partially damaged, he holds a rosary (*aksamala*) in one of his right hands and a plough (*hala*) in one of his left. The other left hand seems to be resting empty against his cobra hood, which, compared with several side figures of Balarama in larger reliefs of Vishnu, is un-

characteristically placed to his left side. The other right hand may have held a pestle (*musala*) or a club (*gada*).

The figure stands out in high relief against a large halo whose incised border of open lotus petals emphasizes a deeply carved head with high chignon, downcast eyes, and slightly parted lips. The body is generously ornamented with a three-stranded necklace, a sacred thread from the left shoulder to the right hip, a dhoti that cascades in rippling folds under a thick ropelike girdle on the hips, and a sash with incised folds that is knotted at the left side of the upper left thigh. A sword is placed at the figure's waist, and long earrings, armbands, and bracelets complete the decoration. AGP

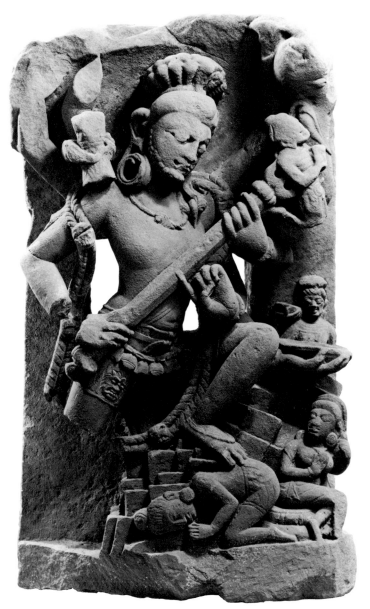

104 *Siva Andhakasura*

Western India, Rajasthan
9th–10th century
Red sandstone, 27¼ × 16⅜
(69.2 × 41.6)
86.227.145

Siva's role as "Destroyer of Demons" is dramatically portrayed in this relief of him killing the blind demon Andhaka (Andhaka-sura Vadhamurti). Eight-armed, he bestrides the rock forms of Mount Kailasa carrying his *trisula*, or trident, on which is impaled the figure of Andhaka with his legs bent back under him and his hands raised in supplication. To capture the blood of the demon, Siva holds one of his emblems, a *kapula*, or skull in the form of an alms bowl, in one of his left hands. He also carries a *damaru* (a small drum in the form of an hourglass), and two of his arms, the hands of which are missing, hold an elephant skin above his head, forming a kind of halo.

Siva is portrayed as enormously powerful, larger than his diminutive attendants and the slain demon. The torsion of his body is emphasized by his superbly carved costume and attributes. He wears a tiger skin, with a mask of an animal (or another demon) on his right thigh. A belt of bells hangs from his waist, and a long braided garland embellished with skulls is draped across his shoulders. For jewelry, he wears a snake for a necklace, beaded anklets on his feet, and a round granular earring in his right ear. His face is bearded, his forehead has a third eye, and his hair is gathered in a top knot of large curls.

Accompanying Siva are his *saktis*, or consorts, who are present to drink the demon's blood. Seated to his left and seen only to her waist is Kali, or Yogesvari, in emaciated form. She holds a skull in the form of a bowl in her right hand, which is raised to shoulder height. Just below her, seated on a lotus throne, is Parvati, or Cinmaya Devi as she is known in her serene aspect, which she resumed when the fight with Andhaka-sura was over. AGP

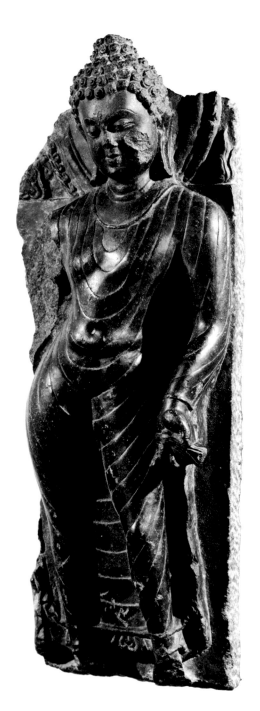

105 *Standing Buddha*

Eastern India, Bihar
Pala Period, circa late 9th century
Black chlorite, 21¾ × 7¾
 (55.2 × 19.7)
86.227.205

This section of a relief depicts a Buddha standing in a slightly exaggerated *tribhanga* (thrice-bent) pose with his left leg thrust slightly forward and bent at the knee. He is broad shouldered and fleshy and wears a clinging robe pleated with looped folds descending from the collar to the hem. The Buddha holds an edge of his robe in his pendant left arm. His hair is done in large snail-shell curls fitting like a cap on his head, and his long ears curve outward in a crescent shape. Behind his head are the remains of a flame-edged nimbus.

Stylistically the image belongs to the Pala, or early medieval, Period, more precisely to the end of the ninth century. The carving is more detailed than that of earlier images (see cat. nos. 98–100), especially in the drapery, and the effect is more stylized. Both the stone and the facial features—an oval face, lotiform eyes, and pursed protruding lips in a sweet smile—as well as the schematic carving of the folds of the garment and the stylized form of the voluptuous torso and thighs are indications of a Bihar provenance, although no other close stylistic parallels have been cited. The piece is one of the finest extant Pala sculptures. The well-preserved youthful face, with its downward gaze and simple accented form, gives the sculpture the grace and charm that Pala art inherited from its Gupta Period precedents, representing medieval Buddhist art at its best. AGP

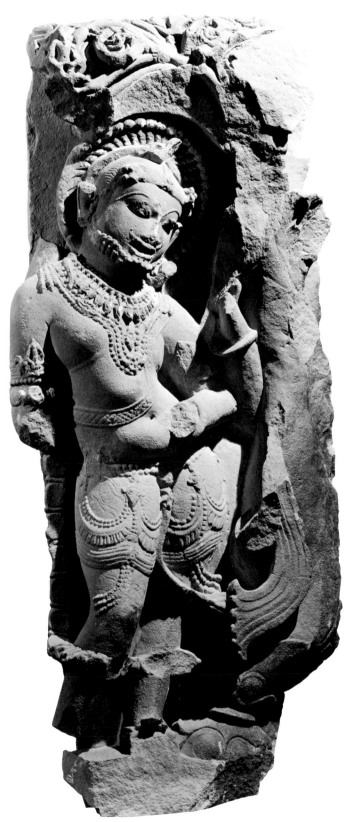

106 *Yama, One of the Dikpalas*

Central India, Madhya Pradesh, Khajuraho
Chandella Period, 11th–12th century
Tan sandstone, 42½ × 16½ (108.0 × 41.9)
86.227.154

Yama, one of the eight guardians of the four directions (*dikpala*), is the protector of the south and the god of death. Although his attributes and both of his right arms and left hands are missing here, one can identify him by the remaining portions of his four arms, by his fierce bearded, mustachioed face with bulging eyes and gaping mouth, and by the long garland of skulls that hangs to his knees along his right side.

The figure stands in the traditional thrice-bent position with the left leg straight and the right leg bent slightly at the knee. He emerges in high relief from the stela background, surrounded by a floral vine that he may have originally held in one of his broken left hands. Another figure once formed part of the relief; the curved end of a scarf it wore remains on the lower left.

Yama's hair is tied and forms a halo of matted locks behind his head. His body is richly ornamented with a five-strand necklace, a thick sacred thread incised with a diamond pattern, a heavily jeweled girdle, and arm bands with a flame or leaflike decoration.

Such profuse ornamentation is associated with late medieval art, particularly that found at Khajuraho, site of some of India's best medieval architecture and temple decoration. Khajuraho panels are typically carved in deep relief with emphasis on the form of the deities and their attendants.

AGP

107 *Parvati*

Southern India, Tamil Nadu
Chola Period, 10th century
Bronze, 16¾ (42.5) high
86.227.27
(Illustrated in color on page 13)

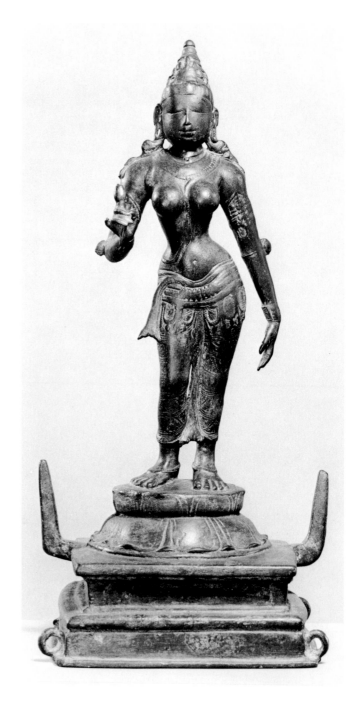

Mr. Erickson collected a superb group of bronze images that display the renowned artistic traditions of the Chola Dynasty. This bronze figure of the goddess Parvati, for instance, embodies the achievements of the Cholas in depicting the human form and casting bronze sculpture. It is one of the masterpieces of the Erickson Collection.

Parvati is here represented as the ideal feminine beauty, with a smiling face, prominent breasts, broad shoulders, a narrow waist, and wide, softly shaped hips. She holds a lotus bud in her right hand and stands on a lotus-shaped pedestal in the *tribhanga* (thrice-bent) pose, with her left hip extended and her right leg bent at the knee. Her right hand is in the *kataka hasta* position, with her thumb and forefinger forming a ring to hold the flower, while her left hand hangs down in the *lola hasta* position like the drooping trunk of an elephant. Parvati typically assumes this pose only when she is seen in association with her consort, Siva. When she is represented independently, as here, she usually has at least four arms.

The base of the sculpture has lashing rings that were used to secure the image to a litter to be carried in procession. Two vertical spikes, one on each side at the back of the plinth, were meant to support an aureole over the image.　　　　　　AGP

Published: Lois Katz, *Asian Art: From the Collection of Ernest Erickson and the Erickson Foundation, Inc.*, exhibition catalogue (The Brooklyn Museum, 1963), cat. no. 106.

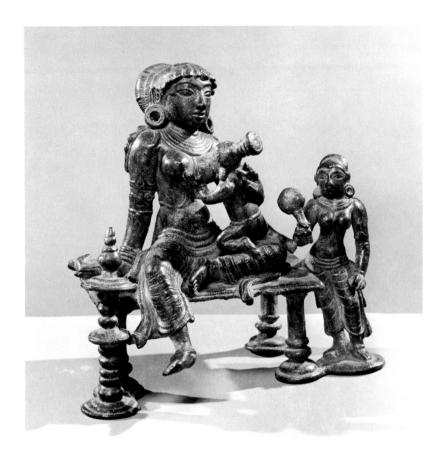

108 *Yasoda-Krishna Group(?)*

Southern India, Tamil Nadu
Chola Period, 13th century
Bronze, 5⅝ × 3¼ (13.0 × 8.3)
86.227.25

The representation of mother and child in deified form, as here, is common to all religions in India. The mother-goddess represents an ideal of all womanhood, as a symbol of both nurturing and abundance.

The child here is Krishna, "the black or dark colored," an avatar of the god Vishnu, the Great Preserver. As told in the *Bhagavata Purana*, he was placed in the care of Yasoda as an infant to avoid his assassination by Kamsa, the tyrannical ruler of Mathura. Forewarned that he would be destroyed by the eighth child born to his sister, Devaki, the mother of Krishna, Kamsa arranged to destroy the child. To avoid this fate, Krishna's father managed to disappear with the newborn baby and exchange him for the daughter of a cowherd born about the same time. Thus was Krishna brought up by Yasoda, wife of the cowherd.

In this bronze sculpture, Yasoda, sitting on a decorated couch, nurses the infant Krishna while an attendant holding a fan or rattle stands at the left. Both females wear clinging clothes with horizontally looped folds and girdles with sash ends that hang down the sides of their legs. Their ornamentation includes large circular earrings, necklaces, rings, armlets, bracelets, anklets, and sacred threads that hang down between their full breasts. Locks of hair fall on their shoulders, while the rest is fixed in a brim extending from the back of the head. Yasoda's hair hangs over her forehead like a scalloped cap. Both faces are round and full with open almond-shaped eyes and ridged crescent-shaped brows meeting above the bridge of their straight noses. The nursing Krishna wears round earrings and a fancy cap shaped like the stem of a cup attached to his head. AGP

Published: Lois Katz, *Asian Art: From the Collections of Ernest Erickson and the Erickson Foundation, Inc.*, exhibition catalogue (The Brooklyn Museum, 1963), cat. no. 107; Walter M. Spink. *Krishnamandala* (Ann Arbor, Michigan, 1971), fig. 22.

109 *Female Divinity (Rati)*

Southern India, Karnataka?
Vijayanagara Period, 14th century
 or later
Bronze, 12¾ (29.0) high
86.227.26

Although problems remain in the identification of this figure, it is thought to represent Rati, the wife of Kama, the god of love in classical literature. Striding on a rectangular base decorated with an incised lozenge-shaped design, she holds a stalk of sugar cane in her left hand and points toward her cheek with the bent fingers of her right. She is drawing a bowstring, an activity characteristic of Kama, who is mentioned frequently in love songs as showering his arrows on lovers.

The figure wears large earrings that touch her shoulders and is adorned with rings, necklaces, armlets, bracelets, and anklets. A large pendant droops below her breasts, which are bound by a four-ply breast band. Her costume consists of a skirt of large leaves held by a girdle. A deep loop suspended from the girdle repeats the pattern of the loop over her breasts, and a leafy tiara echoes the leaf pattern of the skirt. AGP

Published: Lois Katz, *Asian Art: From the Collections of Ernest Erickson and the Erickson Foundation, Inc.*, exhibition catalogue (The Brooklyn Museum, 1963), cat. no. 108; *Journal of the Indian Society of Oriental Art*, 6 (1938) 14, pl. 15, 16.

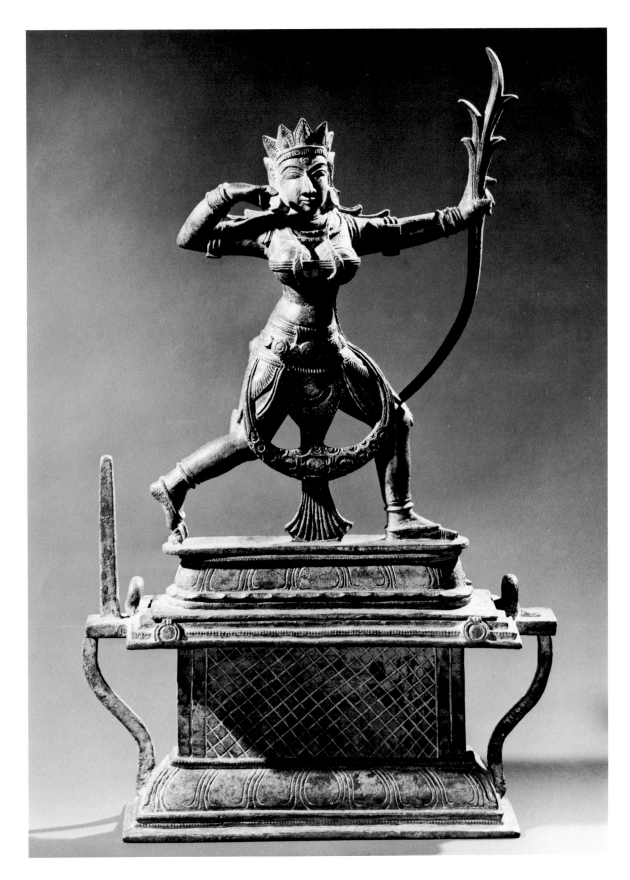

110 *Krishna as a Butter Thief*

Southern India, Tamil Nadu
Vijayanagara Period, 15th century
Bronze, 3 × 3 × 2½
(7.6 × 7.6 × 6.4)
86.227.28

Krishna's exploits as a child are a favorite theme in both sculpture and painting. In this lively bronze, the god is depicted as a crawling infant holding a butterball in his uplifted right hand. He wears a fancy cap and ornaments, a girdle of bells, and a garland of flowers.

The form is one of the typical poses of Krishna as the divine child, described in poetry and religious texts as free from social conventions, whose pranks, stimulated by mischief, are associated with an aspect of divine behavior. Constantly disobeying his parents, he always manages to find the pots of sweet milk and curd, turning them over and tasting the delectable butter he craves. As the "butter thief," he symbolically steals the love of the milkmaids and by extension all motherhood. AGP

Published: Lois Katz, *Asian Art: From the Collections of Ernest Erickson and the Erickson Foundation, Inc.*, exhibition catalogue (The Brooklyn Museum, 1963), cat. no. 109.

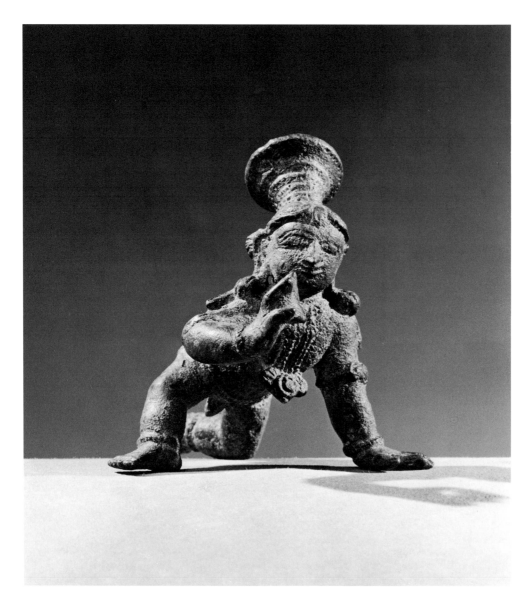

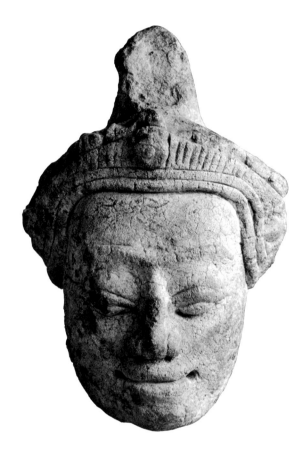

111 *Head of a Bodhisattva*

Thailand, Mon style
Dvaravati Period, circa 7th–8th
 century
Stucco, 4¼ × 2⅝ × 2
 (10.8 × 6.5 × 5.1)
86.227.41

The earliest Buddhist remains in Thailand
date from the fourth or fifth century, when
local styles predicated on Sarnath (India)
prototypes (see cat. no. 100) developed. The
Mon, who ruled in central Thailand from at
least the sixth to the tenth or eleventh cen-
tury, left a rich heritage of sculpture—at once
austere and imposing—in terracotta, stone,
and bronze, as well as the remains of *chedi*,

which like *stupas* in India were solid monu-
ments said to contain relics of the Buddha
or his disciples.

While the main image of a Buddhist
temple would be made in stone, niches in the
temple's base often contained stucco images
like this and the following three fragments
(see cat. nos. 112, 113, and 114). These im-
ages are commonly thought to have been
molded, with details incised after the medi-
um had set.

A group of sites near Bangkok have
been cited as centers for the early phase of
Mon stucco relief work. These include
Nakhon Pathom, Ku Bua (near the Mae
Klong River), and Ratburi, three sites some-
times associated with the Erickson stucco
group. Although the chronological sequence
of these sites has yet to be worked out, and
although none of the Erickson stuccos can
be dated reliably or their provenance con-
firmed, this small head of a crowned figure,
thought to be from Nakhon Pathom, is con-
sidered the earliest of the group. Its high-re-
lief, facial features—a wide mouth, con-
nected and bowed eyebrows, and bulging
eyelids—are typical of Mon Buddha images
found in central Thailand. Seventh- through
ninth-century stuccos from this region uni-
formly depict a characteristic ethnic physiog-
nomy consisting of a rather flat face, pro-
truding eyes, a flat nose, and thick or wide
lips. It has been noted that this particular
face is conceived as a severe mask, with an
almost portraitlike, individual expression.

AGP

Published: Lois Katz, *Asian Art: From the Collection
of Ernest Erickson and the Erickson Foundation, Inc.*,
exhibition catalogue (The Brooklyn Museum, 1963),
cat. no. 112.

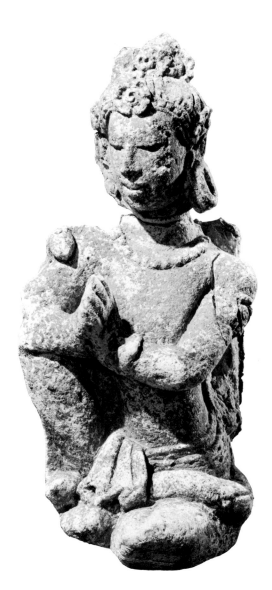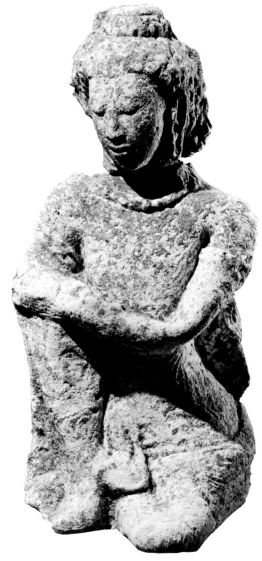

112 *Kneeling Praying Figure*

Thailand, Mon style
Dvaravati Period, circa 7th–8th
 century
Stucco, 10½ × 5¼ × 4
 (26.7 × 13.3 × 10.0)
86.227.162
Provenance: Royal Athena Gallery

113 *Kneeling Praying Figure*

Thailand, Mon style
Dvaravati Period, circa 7th–8th
 century
Stucco, 11 × 5¼ × 4
 (27.9 × 13.3 × 10.0)
86.227.161
Provenance: Royal Athena Gallery

This pair of extraordinary kneeling figurines, originally part of a frieze, are among the finest Mon carvings in stucco of the seventh and eighth centuries. Their kneeling postures are the same, suggesting the typical repetition of figures supporting a central Buddha image in architectural decorations. Each figure faces his right, presenting a three-quarter profile, and sits with body resting on the left foot while the right leg is drawn up as a support for the right elbow. The hands of one of the figures (cat. no. 112) still remain, joined as if in supplication. The hands of the other are missing, but the position of the arms is the same.

Of the two figures, the jewelry in number 112 is more apparent, showing a necklace, a large round earring worn in the left ear, upper arm bands on the left arm, and a bracelet on the left wrist. The same adornments existed on number 113 but are less clearly preserved. Both figures wear a similar skirt, or dhoti, looped around the waist with a flamboyant pleated end between the legs. Again, these details are more clearly preserved in number 112, which is more attenuated and more delicately modeled than number 113. Although greatly repaired or possibly made up from a number of fragments, the figures are consistent in form, posture, and attire with excavated bas reliefs from Nakhon Prathom in central Thailand.

The head of number 112 shows a detailed headdress and head ornaments, while that of number 113 exhibits remains of snail-shell curls and possibly an *usnisha* (cranial protuberance). Both heads had been broken off their bodies and then replaced. The faces particularly show strong Indian influence. The attenuated body of number 112, although in a seated pose, is comparable to a stucco fragment in the National Museum, Bangkok, from Brah Pathamacetiya, Nagara Pathama (Bowie 1960,65). AGP

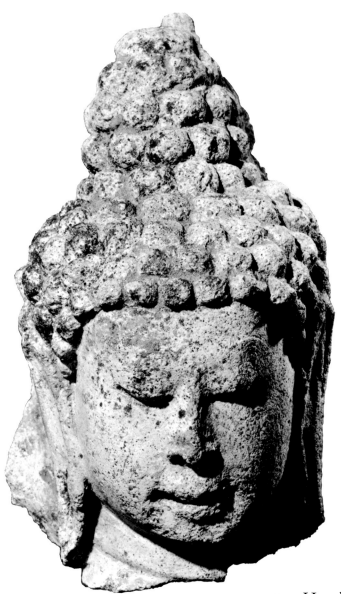

114 *Head of a Buddha*

Thailand, Mon style
Circa 8th–9th century
Stucco, 5¾ × 3½ (14.6 × 8.9)
86.227.156

This distinctive head is identified as a Buddha by its attributes: rows of large curls surmounted by a tall *usnisha* (cranial protuberance); elongated earlobes; and prominent downcast eyes. The style is similar to that of remains discovered at Ku Bua that date from the middle of the Mon Dynasty.

AGP

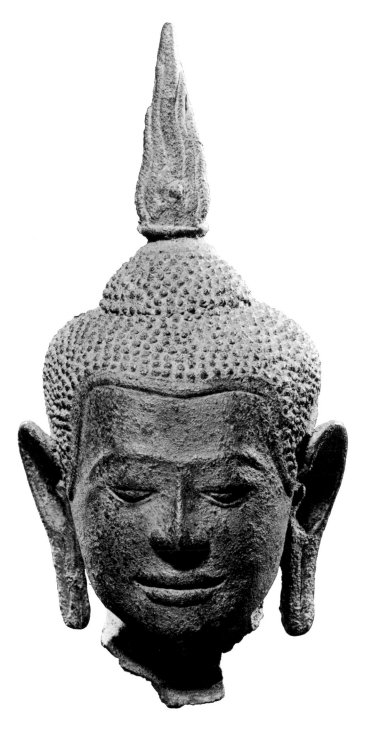

115 *Head of a Buddha*

Thailand, U-Tong style
13th–14th century
Bronze, 9 × 4⅜
(22.9 × 11.0)
86.227.41

The term "U-Tong" is used to classify numerous types of sculptural images combining Mon, Khmer, and Thai characteristics—a stylistic amalgam first identified in a horde of bronzes discovered in 1957 in a crypt in Ayudhya, Thailand (Krairiksh 1977,42). Although Ayudhya was the main center of production, U-Tong bronzes were also made in Cambodia. Three subdivisions of the style can be distinguished: Group A—those images resembling the Mon style; Group B—those with squared Khmer-looking faces and flame finials; and Group C—those with oval faces.

This Buddha head can be assigned to Group B on the basis of its squared Khmer-looking jaws and its flame finial. Its other characteristics include tiny snail curls, a band around the hairline, long slit ears, a slightly arched brow ridge following the line of the hair band, slightly curved eyes, a straight, fleshy nose, and a small mouth with long drawn corners (Boisselier 1975,165).

AGP

Published: Lois Katz, *Asian Art: From the Collections of Ernest Erickson and the Erickson Foundation, Inc.,* exhibition catalogue (The Brooklyn Museum, 1963), cat. no. 114.

116 *Head of a Buddha*

Northern Thailand, Chieng-Sen
 style
14th–15th century
Gilt bronze, 10⅝ × 8½
 (27.0 × 21.6)
86.227.157
Provenance: H.R.H. Prince Bhamu-
 pan Yukold

From the late thirteenth to the mid-sixteenth century, northern Thailand was the seat of the independent kingdom of Lan-na. This kingdom was established by the Thai rulers of Chieng-Sen who in 1292 conquered the old Mon city of Lampur and in 1296 founded a new capital at Chieng-Mai. In 1441 one of their number, Tiloka, a devout Buddhist, mounted the throne. Under his sponsorship, a golden age of Buddhist art and letters began.

The characteristic Buddhist art found at Chieng-Sen during this period is here represented by a life-size head of a Buddha cast in bronze. Its hair in tight snail-shell curls forms a slight peak in the center of the forehead. Although the finial of the *usnisha* is missing, the raised base for it, ascending from the top of the head, remains. The high arched eyebrows, the incised line for the top of the eyelids, the lotiform shape of the eyelids, the nose curved slightly down at the tip with flared nostrils, the wide mouth, the chin with incised oval line, and the long pierced ears curved out slightly at the upper tip and lower lobe are all features of fourteenth- or fifteenth-century style in northern Thailand. Remains of gilding cover much of the piece. AGP

117 *Head of Avalokitesvara*

Northern Thailand, Chieng-Sen
 style
Circa 15th century
Stucco, 6¾ × 4 (17.1 × 10.2)
86.227.172

Although most northern Thai stuccos are crowned Buddha images, *bodhisattvas*, or enlightened beings, are also represented. This head, for instance, depicts Avalokitesvara Bodhisattva, a male saint in Mahayana Buddhism who was worshiped throughout Thailand and Cambodia. Its ornate crown and deeply incised facial features belong to the later Thai stucco styles. It was probably originally part of a complex frieze composition constructed on a core of terracotta that served as an armature to affix the figures to the frieze matrix.

The face is elongated, with full bowed lips, a long narrow hooked nose, flared nostrils, protruding and downcast eyes, lotiform eyelids, highly arched brows, and an *urna* standing out in high relief in the form of a flower on the forehead. Identification of the details of the diadem is more difficult. It was originally thought to contain a diminutive figure of a seated Dhyani Buddha, suggesting the identification of Avalokitesvara, but there is now some question whether this is indeed a figure in the crown or merely a stylized rosette. Stucco heads from the Wat Chedi Chet Yot, which this head resembles, frequently wear crowns with a stylized rosette motif (Boisselier 1975, figs. 11, 106). The motif of rows of incised curls alternating with raised curls and interspersed with banks of repeated vertical lines was employed in headdresses of Buddhist images in bronze throughout the period. AGP

118 *Folio from a Gandavyuha Manuscript*

(Top)
Nepal
12th century
Colors on palm leaf, 2 × 21⅝
 (5.1 × 54.9) each
86.227.136

119 *Folio from a Gandavyuha Manuscript*

(Bottom)
Nepal
12th century
Colors on palm leaf, 2 × 21⅝
 (5.1 × 54.9) each
86.227.137

Detail of cat. no. 118

Detail of cat. no. 119

The earliest evidence of the practice of preparing illuminated manuscripts in eastern India and Nepal dates to circa A.D. 1000. These early works, principally intended to bestow spiritual merit on a patron and his family, were made of palm leaves, with the text written in Sanskrit and illuminations painted in small square panels on both sides. Such manuscripts became more and more refined over the next two centuries.

The two leaves shown here are from a dispersed undated manuscript (Pal 1978A, 47 ff.). Other pages from the manuscript are located in the Los Angeles County Museum of Art (Pal 1985, 195–97), the Virginia Museum of Fine Arts, Richmond, the Seattle Art Museum, the Cleveland Museum of Art, and the Edwin Binney 3rd Collection.

The manuscript was formerly identified as the *Astasharika Prajnaparamita* (the Perfect Wisdom Sutra), but Dr. Pratapaditya Pal has reidentified it as the popular Sanskrit Mahayanist text *Gandavyuha*, often called "The Pilgrim's Progress of Buddhism." Citing the folios from the Cleveland Museum of Art, the Seattle Art Museum, and the Los Angeles County Museum of Art, he has attributed the style to twelfth-century Nepal (Pal 1978A, 47 ff., pls. 34–36). While expounding the basic function of spiritual teachers in Mahayana philosophy, the text describes the pilgrimage of Sudhana, a merchant's young son, and his encounters with a series of guides, teachers, hermits, monks, *bodhisattvas*, deities, and animals in a forest (Pal 1982, fn. 4). The popularity of the text

is indicated by the prominence of more than forty *Gandavyuha* panels carved in relief in the ninth-century temple at Borobudur, the chief monument in Central Java (Kempers 1976, 120 ff).

Like the other known *Gandavyuha* leaves, the two palm leaves in the Erickson Collection are sumptuously decorated. The Sanskrit text, which appears on both sides of the leaves, is divided into three sections by two holes for the threading of the pages. A square panel in the center of the obverse side of each page depicts figures in a typical abbreviated fashion, their profiles outlined in black against an uncluttered background. This style is closely related to the contemporaneous Pala tradition in eastern India, but the simple figural style of the narrative is more lyrical, graceful, and lively. Cat. no. 118, painted on a blue background, depicts an unidentified seated divinity representing a divine teacher. He holds a text in his left hand and lectures to a kneeling figure of Sudhana. Cat. no. 119, painted on a red background, depicts Sudhana standing in a yellow garment and holding a lotus in his left hand. A reclining deer, painted in blue, is shown to his right, and a forest setting is suggested by the large green leaves of two banana trees. Neither illustration appears to bear any immediate connection to the text it accompanies. AGP

Published: Lois Katz, *Asian Art: From the Collections of Ernest Erickson and the Erickson Foundation, Inc.*, exhibition catalogue (The Brooklyn Museum, 1963), cat. nos. 118A, 118B.

120 Illustration from a Kalpasutra Manuscript

Western India, Gujarat
15th century
Opaque watercolor and
 gold on paper, 4½ × 11⅜
 (11.4 × 28.9)
86.227.48

The *Kalpasutra* is one of the canonical works of Jainism, an essentially Indian religion based on devotion to austerity. Along with the *Kalakacarya-katha*, it was one of the favorite Jain texts chosen for illustration. Large numbers of these texts have been preserved, though works of distinguished quality are rare.

This particular *Kalpasutra* illustration is in the western Indian style, which is characterized by linear, flat forms, sharp angular contours, restricted colors, a red background, and faces generally in profile with the further eye protruding into space. The scene depicts the Jain saint Mahavira, seated on a spired throne with a mouth cloth in hand, preaching the Samacari (KSam 64 [Hr 311]), i.e. the "Rules for Monks at the Paryusana Season," the third part of the *Kal-*

pasutra. The panel is painted in white, blue, black, and gold on the usual red ground and is surrounded by the text, which is written in black Devnagari script. On a lower seat before Mahavira, a monk receives instruction. In the row below, six figures are seated on cushions: (from right to left) two laywomen (or goddesses), two nuns, and two laymen. The audience figures seem to constitute the Sangha, or Order. At the end of the Samacari it is stated that Mahavira delivered the Paryusana Kalpa in the Caitya (shrine) Gunasilaka, in the town of Rajagrha, surrounded by many monks (Brown 1934, pl. 44, figs. 150, 151).

This folio differs from a representation of the scene in a similar, undated manuscript of the *Kalpasutra* in the Freer Gallery of Art, Washington, D.C. The Freer manuscript is divided in two independent panels, with Mahavira preaching to a monk as one picture (Brown 1934, fig. 150) and three laymen, three laywomen, and two nuns in three separate registers of a second picture (Brown 1934, fig. 151). AGP

Published: Lois Katz, *Asian Art: From the Collections of Ernest Erickson and the Erickson Foundation, Inc.*, exhibition catalogue (The Brooklyn Museum, 1963), cat. no. 120.

121 Harinaigamesin Carrying the Embryo

Illustration from a *Kalpasutra*
 Manuscript
Western India, Gujarat
16th century
Opaque watercolors and
 gold on paper, 4 × 3
 (10.2 × 7.6)
86.227.49

This Jain illumination depicts the hieratic, effigylike character Harinaigamesin, an antelope-headed divinity who was instructed by Sahra (Indra) to exchange the embryo of the Jain saint Mahavira with another embryo so that the saint could be born to a noble family (KS 28 [JTR 228]). Harinaigamesin is seen here striding with great vigor, holding Mahavira's embryo in his right hand. Below his feet is a peacock, apparently his vehicle (see Brown 1934,18).

Although this fragment is not dated, it is similar to an illustration from a *Kalpasutra* manuscript dated Samvat 1577 (A.D. 1520). That illustration depicts Harinaigamesin facing left with the embryo in his left hand. His *dhoti* has a different pattern from the one in the Erickson illustration (Brown 1934, pl. 5, fig. 15). AGP

Published: Lois Katz, *Asian Art: From the Collections of Ernest Erickson and the Erickson Foundation, Inc.*, exhibition catalogue (The Brooklyn Museum, 1963), cat. no. 119.

122 *Hunter and
Two Cheetahs*

India, Mughal School
Akbar Period, circa 1575
Opaque watercolor on paper,
　3 × 8¼ (7.6 × 21.0)
86.227.167
Provenance: No. 540 in the Kele-
　kian Collection

This fragment of a page contains an uniden-
tified scene of a man with a bow and arrow
in his hand and a quiver of arrows on his
back. His body is thrust to the left with his
head turned back over his shoulder toward
two cheetahs reclining in tall grass. He wears
a *jama* (coat) over pants pulled up to the
knees. At the far left are two entwined trees.
The picture is surrounded by Persian script
in panels, and the whole is set on a mount
of paper decorated with a floral scroll of pal-
mette design. The fragment is painted in a
manner that anticipates the fully developed
Akbar Period style shown in numerous im-
perial albums of the 1580s and 1590s.

AGP

123 *Tent Encampment*

India, Mughal School
Akbar Period, circa 1590–1600
Opaque watercolor and gold on
 paper, 9⅛ × 6¾
 (23.2 × 17.1)
86.227.165

This episode from an unidentified manu-
script represents a prince holding an audi-
ence of his attendants at a temporary en-
campment. The prince, wearing a green
costume with a dagger in his sash, sits cross-
legged on a platform adorned with rugs and
pillows while an attendant offers him food
on a tray. Four attendants stand to his left.
In the left corner foreground, an attendant
carries a quail on his right arm. To the atten-
dant's right, two other attendants watch the
scene, one with a finger pointing to his
mouth in a gesture of amazement. In the
center of the painting is a low table contain-
ing ewers and bowls. To the right and behind
it, a gourd hangs on a stand made of three
spears. The man to the left of the table bows
low, while the one to the right stands at rest.
Two more attendants stand with hands
clasped to the left of the platform, which is
covered by a canopy trimmed with a red,
white, and blue lozenge design. In the left
background can be seen two men leading
camels. Behind them in the distance are low
hills and the outline of a town. For a compar-
able tent and canopy, compare the painting
Jahangir Receives an Artist in Camp, circa
1605 (Skelton 1982, cat. no. 37). AGP

124 *Portrait of Mirza Dakhani, later known as Naubat Khan*

By Har Das, son of Anup Citra
India, Mughal School
Aurengzeb Period, circa 1650
Color wash on paper, 7 × 4⁹⁄₁₆
(17.8 × 11.6)
86.227.56

This fine drawing shows a bearded man seated in profile. He is called Naubat Khan or Mirza Dakhani and is identified by the inscriptions on the reverse, which also give the artist's name. According to Robert Skelton, Keeper of the Indian Collection at the Victoria & Albert Museum, London, the inscriptions are quite specific about the sitter, although neither of his names appears among the list of Mansabdars of Aurangzeb given by M. Athar Ali (Athar Ali 1968). Skelton suggests that the names are probably absent because "both are titles only and not his actual name" (Skelton 1986). Skelton continues:

There were two men called Naubat Khan who held rank under Shah Jahan (Athar Ali, The Apparatus of Empire, 1985). One died in that reign and the other, named Jamshed,

cannot be equated with any other known person. If Naubat Khan was the title of the functionary in charge of the ceremonial music, there must have been a number of office holders in the reigns of Shah Jahan and Aurangzeb. The title "Mirza Dakhani" also tells us little. Perhaps he was from the Deccan. There was a Jamshid Bijapuri who held rank under Aurangzeb, but there is no evidence to suggest that this is him.

Skelton translates the Persian inscription, which reads "taṣwīr i mīrzā dakhanī kih naubat khān shudah būd 'amal i muṣawwir har dās walad i anūp chatar," as follows: "Likeness of Mirza Dakhani who had become Naubat Khan, work of the artist Har Das son of Anup Chatar."

There are also two inscriptions in Rajasthani Hindi. The one on the left reads

"tasvīr naubat khan kadīm nām mirzā dakhanī pātsyāh aurangzeb b. sar yanayat [Persian, 'ināyat?] kadīm khānaijād chalaun main. sipāhī khūb-fahmī dā. rangīn [dā. may be an abbreviation for dāhṛī, beard] atabārī pātsyāhī [that is, i'tibārī pādshāhī]. Skelton translates this as: "Likeness of Naubat Khan, former name Mirza Dakhani. Padshah Aurangzeb [elevated him in favor?]. Formerly [he was] a Khanazad [that is, born in imperial service] . . . [beard, colored] Soldier of good perception worthy of trust."

The one on the right, which reads "musavar har dās anūp chitr kā betā," he translates as "The painter Har Das son of Anup Chitr." Both Hindi inscriptions are headed by the auspicious "Srī."

Skelton argues that the sitter was originally Mirza Dakhani and later, under Aurangzeb, became Naubat Khan. The English inscription, he claims, "is in the handwriting of Stanley Clarke, whose wrong date in the early 17th century seems to have led people astray, although he was correct in his other details. . . . The suggestion that he might be 'Abd urRahim has no foundation" (Skelton 1986).

The figure holds the pipe of a *hookah* in one hand and a flower in the other. Various accoutrements are set around him, and he rests against a large bolster. The face and turban are emphasized in colors. AGP

Published: Lois Katz, *Asian Art: From the Collections of Ernest Erickson and the Erickson Foundation, Inc.*, exhibition catalogue (The Brooklyn Museum, 1963), cat. no. 124; *Loan Exhibition of Antiquities: Coronation Darbar 1911*, exhibition catalogue (Museum of Archaeology, Delhi, 1911) cat. no. C. 104; Beach 1978, 130 (attributed in these catalogues to Mir Hashim).

125 Portrait of Two Scribes Seated with Books and Writing Table Amid Gold Flowers

Section of a margin of a royal album page
India, Mughal School
Shah Jahan Period, circa 1640–50
Watercolors and gold on paper,
 2 × 9⅝ (5.1 × 24.4)
86.227.153
Provenance: Charles Kelekian

Illuminated borders (called *hashiya*) were a frequent convention of Mughal royal albums. In albums of Shah Jahan (Falk 1976, cat. no. 122) and his heir apparent, Dara Shikoh, they often included figures. This section of a margin from an album of Shah Jahan, for instance, portrays two men, possibly partners or scribes, dressed in brown robes and white scarves and seated amid clusters of gold flowers. The man on the left with an open book on the ground in front of him is reciting to the man in the center. At the far right is a low desk with a pair of glasses, pens, decorated manuscript pages, and a blue floral jar enclosed in a gold casing. This seated, face-to-face arrangement of posed figures was common in portraits of the period and a popular convention in marginal drawings.

In its sumptuousness and refinement this unsigned work invites comparison to signed figures by the great artists of the Jahangir and Shah Jahan courts. These artists were noted for their finely detailed subtle character studies in brush with color washes.

AGP

126 *Portrait of Shah Jahan (?)*

India, Mughal School
Late 17th century
Ink drawing with slight color on
 paper, 6⁵⁄₁₆ × 3½
 (16.0 × 8.9) exclusive of borders
86.227.164

This formal portrait, which displays model-
ing achieved through subtle washes of ink,
shows an isolated standing figure of a
bearded nobleman facing his left. The noble-
man's right hand rests on his sword hilt with
the sword blade pointed downward and
touching the ground between his feet. His
left arm is flexed with the hand raised and
cupped slightly, as if holding something.
Flowers are interspersed in a row along the
lower border, and birds are indicated in the
upper edge.

There is an inscription in the lower
left corner with the artist's name, Manohar,
and a date that reads variously as 902 and
1038 A.H. (circa A.D. 1666). Portraits by
Manohar, a painter who began his career in
the Mughal emperor Akbar's time, are noted
for a distinctive style of modeling charac-
terized by shaded contours and uncolored
interior spaces (Beach 1978, 132). Because
the quality of rendering here is not as em-
phatic, detailed, or subtle as his authenti-
cated works, questions have been raised
about this portrait's authenticity.

For another, earlier, portrait by Man-
ohar see his *Portrait of Emp. Shah Jahan* of
1640–50 (Sotheby catalogue, December 1,
1969, lot 148); and for another figure of the
same period, see J. LeRoy Davidson, *The Art
of the Indian Sub-Continent from Los
Angeles Collections*, exhibition catalogue
(U.C.L.A. Art Galleries, March 1968), cat.
no. 134, p. 89. AGP

127 *Portrait of a Prince*

India, Mughal School
Aurengzeb Period, late 17th century
Opaque watercolor on paper, 6 × 4
 (15.2 × 10.2)
86.227.139

The colors, costume details, and stylization of clouds seen in this careful study of a young prince are typical of Aurengzeb Period paintings, circa 1675. Holding a flower and standing facing his right, the prince wears a white patterned *jama* (coat) and yellow and gold boots. He is isolated against a background of pale washes of blue and green. The formal pose in three-quarter profile with the face in full profile follows a convention established in early seventeenth-century Mughal portraiture. AGP

Published: Lois Katz, *Asian Art: From the Collections of Ernest Erickson and the Erickson Foundation, Inc.*, exhibition catalogue (The Brooklyn Museum, 1963), cat. no. 123.

128 *Bhairava Raga*

Page from a dispersed *Ragamala*
 series
India, Rajasthan, Amber
Circa 1700
Opaque watercolor and silver on
 paper, 10⅞ × 6¾ (27.6 × 17.1)
86.227.53

Ragamala paintings depict the thirty-six *ragas* and *raginis*, or modes and sub-modes, of traditional Indian music. Paintings that follow the iconography, composition, and classifications of what Ebeling terms the "Amber Tradition" are the type represented here (Ebeling 1973, 137–38, 186–88). This style takes its name from Amber, the former capital of Jaipur. The earliest Amber *Ragamala* series is dated to 1640 (Gangoly 1934; Ebeling 1973, 187).

This painting depicts a *raga* about Bhairava, a manifestation of Siva, who is shown here as a yogi dressed in white and seated on a tiger skin in a pavilion. He is flanked by two musicians and a fan bearer and is identified by his special attributes— the third eye, the necklace of human skulls, and the source of the Ganges River springing from his head (Ebeling 1973, C2). The Hindi text of the *raga* is inscribed in Modaka meter at the top of the page.

For related paintings from this dispersed *Ragamala* series, compare Goetz 1950, 33–47; Czuma 1975, cat. no. 97; and Ebeling 1973, 188. Other pages from the set are published in Gangoly 1934. AGP

Published: Klaus Ebeling, *Ragamala Painting* (Basel, 1973), p. 188; Lois Katz, *Asian Art: From the Collections of Ernest Erickson and the Erickson Foundation, Inc.*, exhibition catalogue (The Brooklyn Museum, 1963), cat. no. 127.

129 *Vishnu on Garuda*

India, Punjab Hills, Basohli or
 Nurpur
Circa 1725
Opaque watercolor, silver, and gold
 on paper, 8³⁄₁₆ × 5⁷⁄₈
 (20.8 × 14.9)
86.227.140

The blue god Vishnu is shown here in profile
on his four-armed eagle mount, Garuda.
Crowned with the traditional diadem sur-
mounted by a peacock feather, he is himself
four-armed and holds a conch, a lotus
flower, a mace, and a *cakra* (discus)—his di-
vine attributes. Both he and Garuda are
adorned with jewelry emphasized by raised
surfaces and details painted in the ubiquitous
hot yellow associated with the so-called Hill
painting of Basohli and Nurpur.

The figures are set in a monochro-
matic yellow-green background with a strip
of water bordered by polychrome flowers in
the foreground. A small band of blue-and-
white sky is shown at the top of the page,
which is surrounded by simple black-and-
red borders. The colors and dynamic presen-
tation of the deities are typical of Basohli or
Nurpur paintings from the first quarter of
the eighteenth century. AGP

130 *Balarama Kills the Ass Demon*

Scene from a *Bhagavata Purana*
 series (Chapter 10)
India, Punjab Hills, Bilaspur
Circa 1725
Opaque watercolor and silver on
 paper, 8⅛ × 11 (20.6 × 27.9)
86.227.166

The exploits of the cowherd Krishna and his brother Balarama in the idyllic forest of Brindavan are narrated in the tenth chapter of the *Bhagavata Purana*, a later scripture that has been a popular subject of Hindu paintings throughout the history of such painting in India. Some of their miraculous trials revolve around their combat with a variety of demons, each sent by their evil uncle Kamsa. In one scene, the demon Dhenuka, in the form of an ass, is killed by Balarama, while Krishna deals with Dhenuka's relatives who enter the forest:

Then Krishna and Balarama with perfect ease caught hold of these assaulting asses by their hind legs, and struck them against the palm trees. Then the ground of the forest was covered over with palm-fruits, palm twigs and the dead bodies of the Daityas [Dhenuka and his relatives] and resembled the beautiful firmament covered over with clouds [Kinsley 1975, 21].

In this illustration of the scene, the action flows clockwise from the right middle ground, where the ass demon is pictured grazing. In the foreground Balarama and a cowherd, on the right, watch as the animal, in the center, runs away. Then, in the left foreground, Balarama, Krishna, and the cowherd bend over the dying ass, which lies on the ground near a tree. These scenes take place on the bank of a river. Trees occupy most of the middle ground. Behind them at the top the head of Krishna or Balarama is seen four times. The painting is done in varied shades of blue (which predominates) and green, as well as silver (which has oxidized) for the water of the river.

Another page from the same *Bhagavata Purana* series is also in The Brooklyn Museum (acc. no. 69.125.4), but the series is otherwise dispersed, with eight pages in the Museum für Volkerkunde, Berlin (Waldschmidt 1929–30, pls. LI, LII, LIII), where they are dated to the middle of the seventeenth century and attributed to the school of Jammu. Others from the series have also been published (Enbom 1986, cat. no. 106; Archer 1976, cat. no. 62). The attention to such details as the fur of the ass demon and the foliage of the trees — thought to stem from Mughal influence in Bilaspur pictures of this date — is common to all the paintings in the series, which is considered one of the finest examples of the Bilaspur style. AGP

183

131 *Page from a Krishna Rukmini Series*

India, Punjab Hills, Nurpur
Circa 1760
Opaque watercolor on paper,
 8 × 11½ (20.3 × 29.2)
86.227.202
Provenance: Balak Ram Sah of
 Srinagar, Garhwal; Mukandi Lal

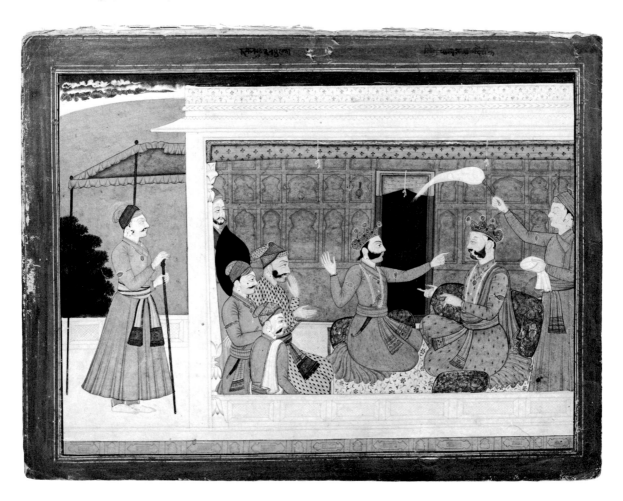

This page from a dispersed *Krishna Rukmini* series depicts an interior scene in which Shishupal beseeches Bhism, king of Vidarbha, the father of Krishna's consort Rukmini, for the hand of Rukmini in marriage. The painting depicts Shishupal in an agitated mood, with one of his friends supporting him in his arguments with the king.

The page belongs to a set of twelve paintings from a *Krishna Rukmini* series attributed to Nurpur on the basis of style and the palette of red, brownish-pink, and mauve. That this set of Nurpur paintings once belonged to the Garhwal Royal collection may be due to the close relations between the ruling families of the two states in the first half of the nineteenth century (Archer 1973, 400).

Other pages from this series are in the collection of Edwin Binney 3rd and in the Baekeland collection. AGP

Published: Mukandi Lal, *Garhwal Painting* (New Delhi, 1968), pl. xxv.

132 *Velvet Border with Design of Individual Plants*

India, Mughal School
Shah Jahan Period, circa 1630–50
Knotted pile fabric with ground
 weave showing warp on two
 levels, wool pile, cotton warp, and
 wefts of silk and cotton,
 12⅛ × 35 (30.8 × 88.9)
86.227.206

The tradition of carpets imitating royal paintings can be documented from as early as the Akbar Period, 1556–1605 (Brand and Lowry 1985, 113), a time when carpets were also reproduced in painting (Beach 1978, 168). This long rectangular carpet border is based on architectural decoration on revetment panels from imperial monuments, such as the Taj Mahal, built during Shah Jahan's reign, 1628–59 (Skelton 1982, cat. no. 203). Its repeated flower design consists of a central row of alternating tulips and carnations and upper and lower rows of stylized floral patterns. A comparable Mughal cut-velvet border with floral designs from the Victoria & Albert Museum, London, was published by the Arts Council of Great Britain (1976, cat. no. 94). AGP

Works Cited: Indian and Southeast Asian Art

Archer 1973 W.G. Archer, *Indian Paintings from the Punjab Hills* (London and New York, 1973).

Archer 1976 W.G. Archer, *Visions of Courtly India* (Washington, D.C., International Exhibitions Foundation, 1976).

Arts Council of Great Britain 1976 Arts Council of Great Britain, *Arts of Islam* (London, 1976).

Athar Ali 1968 M. Athar Ali, *The Mughal Nobility under Aurangzeb* (Bombay, 1968).

Athar Ali 1985 M. Athar Ali, *The Apparatus of Empire* (Bombay, 1985).

Barrett 1954 D. Barrett, "The Late School of Amaravati and Its Influences," *Art and Letters,* 28 (1954), 41–53.

Beach 1978 Milo C. Beach, *The Grand Mogul: Imperial Painting in India, 1600–1660,* exhibition catalogue (Sterling and Francine Clark Art Institute, Williamstown, Massachusetts, 1978).

Boisselier 1975 Jean Boisselier, *The Heritage of Thai Sculpture* (New York, 1975).

Brown 1934 W. Norman Brown, *Miniature Paintings of the Jain Kalpasutra* (Washington, D.C., 1934).

Bowie 1960 Theodore Bowie, *The Arts of Thailand,* exhibition catalogue (Bloomington, Indiana, 1960), cat. no. 28.

Brand and Lowry 1985 M. Brand and G. Lowry, *Akbar's India,* exhibition catalogue (New York, 1985).

Chandra 1985 Pramod Chandra, *The Sculpture of India,* exhibition catalogue (Washington, D.C., 1985).

Czuma 1975 Stanislaw Czuma, *Indian Art from the George P. Bickford Collection,* exhibition catalogue (Cleveland Museum of Art, 1975).

Czuma 1985 Stanislaw Czuma, *Kushan Sculpture: Images from Early India,* exhibition catalogue (Cleveland Museum of Art, 1985).

Davidson 1968 J. Le Roy Davidson, *Art of the Indian Sub-Continent from the Los Angeles Collections,* exhibition catalogue (U.C.L.A. Art Council Art Galleries, 1976).

Diskul, Warren, Pokakornvijan, and Baidikul 1982 Prof. M. C. Subhadradis Diskul, William Warren, Oragoon Pokakornvijan, and Viroon Baidikul, *The Suan Pakkad Palace Collection* (Bangkok, 1982).

Ebeling 1973 Klaus Ebeling, *Ragamala Painting* (Basel, 1973).

Ehnbom 1986 Daniel J. Ehnbom, *Indian Miniatures: The Ehrenfeld Collection,* exhibition catalogue (New York, 1986).

Falk 1976 T. Falk, *Persian and Mughal Art* (London, 1976).

Gangoly 1934 O.C. Gangoly, *Ragas and Raginis,* 2 vols. (Calcutta, 1934).

Goetz 1950 Hermann Goetz, *The Art and Architecture of Bikaner State* (Oxford, 1950).

Kempers 1976 A.J. Bernet Kempers, *Ageless Borobudur* (Sevire/Wassenaar, 1976).

Kinsley 1975 David R. Kinsley, *The Sword and the Flute* (Los Angeles, 1975).

Krairiksh 1977 Piriya Krairiksh, *Art Styles in Thailand* (Bangkok, 1977).

Krishna 1976 A. Krishna, "Scribes of India," *Chhavi* (Banaras, 1976).

Pal 1978A P. Pal, *The Arts of Nepal II* (Leiden, 1978).

Pal 1978B P. Pal, *The Ideal Image,* exhibition catalogue (New York, The Asia Society, 1978).

Pal 1985 P. Pal, *Art of Nepal,* exhibition catalogue (Los Angeles County Museum of Art, 1985).

Sharma 1984 R.C. Sharma, *Buddhist Art in Mathura* (Delhi, 1984).

Skelton 1982 R. Skelton, *The Indian Heritage,* exhibition catalogue (Victoria & Albert Museum, London, 1982).

Skelton 1986 R. Skelton, letter to Amy Poster, August 13, 1986.

Waldschmidt 1929–30 E. Waldschmidt, "Illustrations de la Krishna-Lila," in *Revue des Arts Asiatiques* 6, no. 4 (1929–30), 197–211.

Williams 1982 J. Williams, *The Art of Gupta India* (Princeton, New Jersey, 1982).

Zebrowski 1983 M. Zebrowski. *Deccani Painting* (London, 1983).

Islamic Art

Sheila R. Canby
Associate Curator of Islamic Art
The Brooklyn Museum

Ernest Erickson began collecting Islamic art in the 1950s, at a time when the study of that art was in its infancy. Although a few major treatises on Persian painting were available, there was only one reliable survey of Islamic ceramics (by Arthur Lane) and no definitive book on Islamic metalwork. For the most fundamental understanding of Islamic art, scholars were forced to read numerous articles or flex their muscles heaving the *Survey of Persian Art* to a table. Even then the inscriptions on works of art often remained unread, and Islamicists frequently based their attributions on information provided by less than reliable sources.

Despite these pitfalls, Mr. Erickson's instincts and knowledge led him to acquire well and at times brilliantly. Not only does his Islamic collection stand up in light of recent scholarship, but it also contains examples whose importance as historical documents equals their beauty and rarity.

One cannot fully appreciate the merits of Mr. Erickson's Islamic acquisitions apart from the permanent collection of The Brooklyn Museum. Beginning in 1954, when he loaned several exceptional Islamic ceramics to the Museum, he systematically filled lacunae in the Museum's collection with pieces that the Museum would otherwise have had great difficulty acquiring. The Museum owned only one small shard of Fatimid lusterware, for instance, when he loaned it four pieces of this type from all periods of that dynasty (see cat. nos. 136–39).

Although ceramics predominate in Mr. Erickson's Islamic collection, he also acquired metalwork, paintings, textiles, and carpets. As with his other collections in The Brooklyn Museum, he tended to concentrate on the classical art of any given region—be it Iranian, Islamic Egyptian, Turkish, or Iraqi. Thus, Seljuq ceramics, Tulunid textiles, Ottoman tiles, and Caucasian carpets are all well represented here.

The seventy-odd Islamic pieces catalogued in this book account for nearly half of Erickson's Islamic loans to The Brooklyn Museum. In certain cases the catalogue entry can add little to what was known about the piece when Erickson acquired it, while in other cases recent excavations and publications have greatly increased our understanding of the object. All the entries take for granted a basic knowledge of Islamic history and the geography of Western Asia and Egypt.

The history of this region is rife with sectarian and interracial struggles that divided the great dynasties and led to the establishment of semiautonomous regimes. At times powerful dynasties such as the Fatimids in Egypt (969–1171), the Mongols in Iran (1256–1353), the Ottomans in Turkey, Syria, the Levant, and Egypt (1281–1924), and the Safavids in Iran (1501–1722) played a major role in the development of artistic styles. At other times either the style associated with a particular dynasty came to fruition in the declining years of that dynasty's power, as with Seljuq ceramics, or the style of objects made at one political center derived from that of another center.

What remains constant in this history is the remarkable speed with which ideas traveled within the Muslim world and the amazing manner in which Islamic artists adapted to those ideas. One of the many strengths of the Ernest Erickson Collection is its ability to capture this kaleidoscopic quality in its presentation of the ever-changing, ever-fertile field of Islamic art.

133 *Bowl*

Iraq
10th century
Ceramic, monochrome lusterware,
 buff body, 10½ (26.7) diameter
86.227.80

The simple, bold form of the peacock that adorns this bowl characterizes the tenth-century monochrome lusterwares made in Iraq during the 'Abbasid caliphate. Features such as the "contour panels" with rows of V-shaped hatching that surround the bird, the "peacock's eye" band at the bird's neck and tail, the leafy spray in its beak, and the circles containing lines of V's on the exterior of the bowl are all commonly found on 'Abbasid tenth-century lusterwares. Although the multiclawed feet of the bird may appear strange, these, too, are consistent with other lusterwares of the period (Ettinghausen 1960, fig. 3).

While some of the letters of the Arabic word inscribed on the bird's tail are missing because of damage, the last two letters of the word *baraka*, or "blessing," have survived. On the glazed foot of the bowl the first three letters of *lisahibihi*, or "to the owner," remain. The two words together form a phrase repeatedly found on early Islamic ceramics, but rarely, if ever, do we find one word of the phrase on the interior of the bowl and the other on the exterior.

The abstract form of the peacock suggests that this piece and others in this group held a talismanic significance for their tenth-century owners. In other words, a peacock or the word *baraka* touched off

beneficial associations of greater resonance than we might imagine today.

Although the largest number of excavated 'Abbasid monochrome lusterwares was found at Samarra, the 'Abbasid capital from 836 to 883 (Sarre 1925), presumably these wares were produced in other major Iraqi centers as well, such as Baghdad and Basra. Monochrome lusterwares were an outgrowth of the polychrome lusterware production of the ninth century, which in turn is thought to have developed out of two techniques of luster glass-making: linear decoration of clear glass with metallic pigments and millefiori or mosaic glass (Caiger-Smith 1985, 24). In the ninth century luster potters had concentrated on duplicating the multicolored staining effect found on luster glass and used the pigments that result in shining gold passages only sparingly. Apparently the realization that such pigments, when fired properly, would create the shimmering appearance of gold led to the popularization of monochrome luster decoration (Caiger-Smith 1985, 29). SRC

Published: Lois Katz, *Asian Art: From the Collections of Ernest Erickson and the Erickson Foundation, Inc.*, exhibition catalogue (The Brooklyn Museum, 1963), cat. no. 1; The Arts Council of Great Britain, *The Arts of Islam*, exhibition catalogue (The Hayward Gallery, London, 1976), cat. no. 262.

189

134 *Bowl*

Iraq
9th century
Ceramic, opaque white glaze,
 cobalt-blue decoration, yellowish
 body, 2½ × 8½ (6.4 × 21.4)
86.227.14

This inscribed bowl belongs to one of the earliest and most distinctive groups of Islamic ceramics. Such bowls have long been considered to have been inspired by Chinese prototypes. Not only the shape of the bowl, with its curved walls, everted rim, and ring foot, but also its opaque white glaze derive from Chinese white stoneware bowls exported to the Middle East in quantity in the ninth and tenth centuries (Whitehouse 1979, 49). Since many cobalt blue-and-white bowls of this type were excavated at Samarra, they have traditionally been assigned a date coinciding with the period between 836 and 883, when the 'Abbasid capital was moved from Baghdad to Samarra (Sarre 1925, 44–50). Recent excavations at Siraf on the Iranian side of the Persian Gulf bear out the conclusions concerning Chinese influence on such wares but suggest a slightly later date in the ninth century for their introduction. David Whitehouse points out that Islamic plain white wares and those decorated with cobalt blue appear in the stratigraphy of Siraf simultaneously with Chinese white stoneware beginning about 850 A.D. (Whitehouse 1979, 56–57). Production is assumed to have continued for most of the rest of the ninth century. Of the most innovative classes of Islamic ceramics found at Samarra and Siraf, plain white and blue-and-white wares are the only ones that can be exclusively dated to the ninth century, while lusterware and splash ware belong to the tenth century (Whitehouse 1979, 60).

The decoration of ninth-century Iraqi blue-and-white wares consists of Arabic inscriptions, floral and geometric designs, and combinations of epigraphy and floral or geometric ornament. The inscription on this bowl reads "Among those things Abu'l-Taqi made." The name "Abu'l-Taqi" has been read as "Abu'l-Baghi" by George Miles, according to The Brooklyn Museum's records. However, as unusual as the name Abu'l-Taqi, meaning "father of the pious one," might be, it is more acceptable than Abu'l-Baghi, meaning "father of the prostitute." Another bowl with the same signature is in the Keir Collection (Grube 1976, 41,

no. 8), and its inscription has been translated as "The work of Abu al-Jafar" (Grube 1976, 38). Such a reading cannot be correct since the name Ja'far would be missing the letter 'ayn.

Although the earliest Islamic potters signed their wares, the prominence of the signature on this bowl is noteworthy. Ernst Grube suggests that rather than celebrating the unique quality of the individual object, such inscriptions reflect a new self-consciousness on the part of the owners of such pieces. In other words, at this time patrons may have come to think of themselves as collectors, a notion "supported also by the frequent occurrence of such formulae as 'Among the things made by . . . ,' rather than the more direct 'Work of . . .'" (Grube 1976, 42).

The stark beauty and simplicity of this blue-and-white bowl and others of its type must have appealed greatly to people throughout the Muslim world. Not only were these wares exported to Iran, Syria, Egypt, and Spain but they were also imitated, most notably in Iran. Aesthetically they relate to early 'Abbasid *tiraz* textiles, in which one primary line of writing is embroidered or woven into a plain white ground. While one might ponder if an actual connection between *tiraz* textiles and Iraqi blue-and-white epigraphic pottery exists, there can be no question that the decoration of ceramics with Arabic script and other ornament in glazes of various colors, pioneered in ninth-century Iraq, had an enormous impact on the following millennium of Islamic ceramic production. Furthermore, the use of cobalt blue on a white ground, first manifested in 'Abbasid blue-and-white wares, has remained a source of continued inspiration for Muslim potters up to the present day. SRC

Published: Lois Katz, *Asian Art: From the Collections of Ernest Erickson and the Erickson Foundation, Inc.*, exhibition catalogue (The Brooklyn Museum, 1963), cat. no. 7; Myriam Rosen-Ayalon, *Memoires de la Délégation Archéologique en Iran, Tome, L, Mission de Susiane: La Poterie Islamique* (Paris, 1974), p. 233 and pl. LVIX; Grube 1976, p. 35, note 2.

135 *Plate*

Iraq
'Abbasid Period, 9th–10th century
Ceramic, opaque white glaze,
 greenish turquoise decoration,
 yellowish body, 14¾
 (37.4) diameter
86.227.88
Provenance: Collection of
 J. Holmes; Collection of
 Mrs. Christian R. Holmes

This striking plate, decorated with an Arabic inscription that is bordered above and below by a winged pomegranate, poses difficult problems of dating and provenance. With its everted rim, slightly curved base, well-defined cavetto, and absence of a foot, the piece generally relates in shape to a group of plates associated with Samarra in Iraq (Fehervari 1973, 45, no. 15; and Sarre 1925, pl. xxvi). However, the two plates that resemble this one most closely are nearly identical to it in decoration as well as in shape. One is in the Kuwait National Museum and the other (now in the Museum of Fine Arts, Boston) was excavated at Rayy in Iran (A.R.H[all] 1934, 57, fig. 5).

Since the availability of cobalt blue was supposedly limited to Iraq in the ninth and tenth centuries, the use of greenish turquoise glaze for the inscription may indicate that the plates in this group are Iranian imitations of the cobalt blue-and-white wares of ninth-century Iraq. On the other hand, the yellowish composite body of the Erickson piece militates in favor of an Iraqi provenance, for it is generally assumed that the finely milled "Samarra body" was exclusively of Iraqi manufacture at least until the end of the tenth century. The likelihood of an Iraqi origin is further underscored by the existence of a similarly shaped plate in the Barlow Collection, which is decorated in a combination of green, yellow, and cobalt-blue glazes typical of ninth- and tenth-century Iraq. From examples of ninth- and tenth-century Iraqi blue-and-white and lusterwares found at Rayy we can be certain that ceramics were being exported to Rayy from 'Abbasid Baghdad. Thus, the attribution of these plates to Iraq, despite the excavation of the Boston example at Rayy, is not too farfetched.

With regard to the date of the plate in the Museum of Fine Arts, Boston, and by implication those in the Kuwait National Museum and the Erickson Collection, A.R. Hall has stated that the plate excavated at Rayy "occurred in the Umaiyad-'Abbaside layer of a test square at Bibi Zubaida, and should not be dated later than the ninth century" (A.R.H[all] 1934, 58). Unfortunately, since the excavation was never published, we have little way of knowing what other ceramics or objects were found near the plate to confirm the ninth-century date. Nonetheless, two aspects of the decoration of the Erickson, Boston, and Kuwait plates support the ninth-century date. First, the motif of the pomegranate or palmette flanked by wings found on the Erickson Collection piece relates it to a polychrome lusterware tile exported from Baghdad to the mosque of Qairawan in North Africa in 894 (Migeon 1927, vol. 2, p. 171, fig. 323). In the Qairawan example the "wings" resemble leaves, but as in the Erickson plate two of them are associated with one palmette. While the motif is somewhat more stylized on the Erickson plate than on the Qairawan tile, its usage probably did not extend beyond the first years of the tenth century.

The second reason for assigning this plate a ninth-century date is based on its inscription. The use of wedge-shaped terminals on the vertical letters is entirely consistent with the large class of Iraqi blue-and-white wares (see cat. no. 134), which are attributed to the ninth century. Not only is the same epigraphic style evident on the Kuwait, Boston, and Erickson plates, but also the Kuwait and Erickson plates are inscribed with the very same phrase, a signature, "The work of Abu'l-'Abbas." As discussed previously (cat. no. 134), prominently displayed signatures were fairly common on ninth-century 'Abbasid ceramics. However, finding two of three known pieces of a specific type signed by the same man is highly unusual. For lack of evidence to the contrary and because of their great similarity the bowls of this group should be considered the work of one man. As such they demonstrate the remarkable consistency of the potter, Abu'l-'Abbas, and suggest that he responded to his market by producing wares of a recognizable type distinct from the other ceramics of the day. SRC

Published: Arthur Upham Pope, editor, *A Survey of Persian Art* (London and New York, 1938), vol. II, p. 1486, vol. V, pl. 572C; Phyllis Ackerman, *Guide to the Exhibition of Persian Art* (New York, 1940), p. 149, case 10C; Parke-Bernet Galleries, Inc., *Art Collection of the late Mrs. Christian R. Holmes*, April 15–18, 1942, cat. no. 367, lot 701; Lois Katz, *Asian Art: From the Collections of Ernest Erickson and the Erickson Foundation, Inc.*, exhibition catalogue (The Brooklyn Museum, 1963), cat. no. 6; Grube 1976, p. 35, note 2.

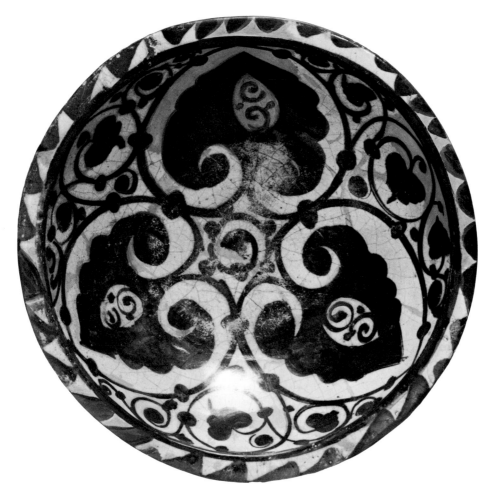

136 *Bowl*

Egypt
Fatimid Period, 10th–11th century
Ceramic, monochrome lusterware,
 pink earthenware body,
 2⅜ × 9¼ (6.1 × 23.5)
86.227.187

In 969 the capital of Egypt, al-Fustat, fell to the Fatimids, an Isma'ili Shiite dynasty that had spent most of the tenth century establishing itself in North Africa. To substantiate their claims of independence from the 'Abbasid caliphate, the Fatimids energetically set out to redefine their environment in their own terms. Thus, they founded a new town, al-Qahirah or Cairo, adjacent to al-Fustat, and in 970 began construction of the mosque of al-Azhar. Many ambitious architectural projects followed as the dynasty accumulated wealth from trade throughout the Mediterranean. Art in every form, from textiles and ceramics to carved rock crystals

and gold jewelry, reflected the opulence and vigor of the Fatimid dynasty. While the court itself has been compared to that of the Byzantines both for its lavishness and for its secrecy, the society as a whole enjoyed great prosperity and the fruits of brilliant cultural activity.

The most ubiquitous reminders of the vast artistic output of the Fatimid Period are the great number of lusterware ceramics found in almost every museum's Islamic collection. Although the technique of decorating ceramics with luster glaze may have developed in Egypt independently of 'Abbasid influence, the distinctive style of Fatimid lusterwares is an outgrowth of 'Abbasid Iraqi monochrome lusterwares. The use of scallops on the rim, contour panels around animals, humans, and plants, and the decoration of the exterior of the bowl with circles and dashes all derive from 'Abbasid Iraqi ceramics. However, by the early eleventh century Fatimid potters had forged a new

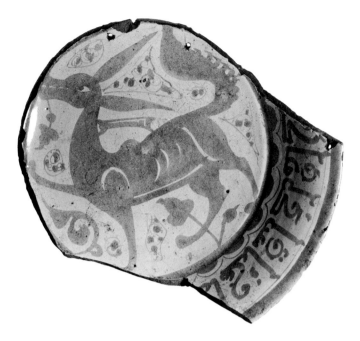

137 *Fragment of a Plate*

Egypt
Fatimid Period, 11th century
Ceramic, monochrome lusterware,
 pink earthenware body,
8⅝ (21.8) diameter
86.227.82

decorative style, and by the end of the dynasty in 1171 the original reliance on 'Abbasid models was all but forgotten.

The study of Fatimid lusterwares is hampered by a severe lack of dated or datable pieces and the complicated archaeology of the main source of such wares, the trash heaps of al-Fustat. Two securely datable pieces, one in the Benaki Museum, Athens, and the other in the Islamic Museum in Cairo (Philon 1980, 198, fig. 404; Jenkins, 1968, 364, fig. 13) both were made during the reign of al-Hakim, 996–1021. The date of the Cairo piece can further be narrowed to 1011–13 on the basis of its inscription (see Jenkins 1967). Stylistically the two datable pieces differ, with the Benaki fragment, signed by Muslim, an early eleventh-century potter, exhibiting a nervous, sketchy quality and the Cairo fragment showing a clean, symmetrical look. While such variation is to be expected from a society as pluralistic as that of the Fatimids, it makes for great difficulty and disagreement in the dating of other Fatimid ceramics, even those signed by Muslim.

Questions of date aside, the four Fatimid pieces in the Erickson Collection represent three important decorative types within the range of the ware. Although collectors have sought out pieces in which human or animal figures are represented, such pieces are far outnumbered by those with nonfigural decoration, either vegetal, geometric, epigraphic, or a combination of these. The complete bowl (cat. no. 136) is decorated on the interior with three large palmettes and a vine scroll, on the flat, everted rim with scallops, and on the exterior with circles and dashes in red luster. The large palmettes and vine scroll closely resemble the background ornament of a bowl depicting a seated drinker in the Benaki Museum (Philon 1980, fig. 463) which is signed "Tabib" and dated by Philon to the late tenth, early eleventh century. On the basis of its straightforward, uncluttered composition, more akin to its 'Abbasid predecessors than to twelfth-century Syrian lusterwares, the Erickson bowl should also be assigned a late tenth-, early eleventh-century date.

With its long ears, the quadruped in the fragment of a plate (cat. no. 137) resembles a rabbit. Its long, bushy tail and large snout, however, are more foxlike or canine than rabbitlike. The animal strides across the plate with a palmette dangling from its mouth amid stray fillers of palmettes and arabesque panels. The interior sides of the plate are decorated with an inscription above a band of scallops. Circles and dashes appear on the exterior. Such rabbitlike animals appear frequently in Fatimid ceramics, textiles, and metalwork, but no specific iconography has been assigned to them. The jaunty character of the creature and the general good wishes expressed in the inscription strongly suggest that these animals were considered beneficial and perhaps even lucky. According to Abbas Daneshvari, rabbits in medieval Persian literature embody qualities of goodness and cleverness (Daneshvari 1982, 24). Such positive connotations would certainly have appealed to the owner of this or similiar plates. Tentatively this piece can be dated to the eleventh century on the basis of the loose but lively treatment of forms and the openness of the composition, qualities that contrast with the smaller scale and more cluttered decoration of wares commonly assumed to be later.

The two remaining Fatimid fragments are decorated with human figures—a haloed person (cat. no. 138) and a cavalier on horseback (cat. no. 139). Because of the way the fragment is broken, it is difficult to determine whether the haloed figure is a dancer, drinker, musician, or something entirely different. The scarf that flies up from under the figure's arm suggests movement such as one might expect from a dancer.

The fragment contains several interesting motifs. First, the halo with its cross-hatched band is somewhat rare in Fatimid ceramics. Although they may have originally been intended for important personages, haloes apparently had no religious significance. By the late twelfth century, when the Fatimid period had ended and Egyptian lusterware potters had moved to Syria, they were used with great regularity. One might then imagine that the use of the halo in this Fatimid piece supports a late date, perhaps the late eleventh or early twelfth century. This date would be further endorsed if one accepts the twelfth-century dating of a bowl in the Freer Gallery of Art, Washington, D.C. (Atil 1973, cat no. 58) in which a dancer's coiffure, sleeve, and breasts are treated in a fashion quite similar to those on the Erickson Collection fragment. However, the face of the Erickson figure, with its bow-shaped brow, its sharply focused eyes, and its chin defined by a dot, even more closely resembles that of the lutanist on a bowl signed by Muslim (Philon 1980, fig. 468).

While the Erickson piece is neither signed by nor attributable to Muslim, it raises questions concerning the longevity of certain pictorial styles in Fatimid art. In other words, did artists emulate Muslim and/or his atelier throughout the eleventh century, presumably long after he had died? Did works bear his name even when he himself had not made them? If, as Oleg Grabar has suggested, the figural style of Fatimid lusterwares became current only after the dispersal of the court treasuries in 1067, then the work signed "Muslim" that contains figures certainly was not by the artist himself and could only have been by a member of his atelier or by an emulator (Grabar 1972). The conclusion of Helen Philon that the pieces signed by Muslim were done by him or his workshop in the early eleventh century seems more likely. However, we are still left with the Erickson piece and others like it, which derive from the works of artists such as Mus-

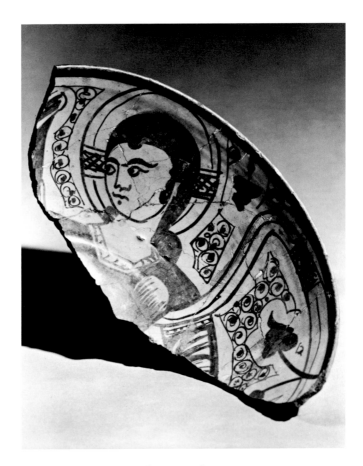

138 *Fragment of a Bowl*

Egypt
Fatimid Period, 11th century
Ceramic, monochrome lusterware,
 pink earthenware body,
 9½ (24.1) long
86.227.81

lim but are not of exactly the same style or quality. Rather than date all such works to the late eleventh and twelfth centuries, as Grabar suggests, or to the late tenth and early eleventh centuries, as Philon has done, a dating of these figural pieces that extends across the whole eleventh century might make the most sense. Thus, one might account for the enormous range in style and quality that occurs in these ceramics. Presumably pieces made for the court were of better quality than those made for everyone else. However, major stylistic differences and the retreat from the extreme expressiveness evident in Muslim's lutanist must indicate an advance in time as well as different hands.

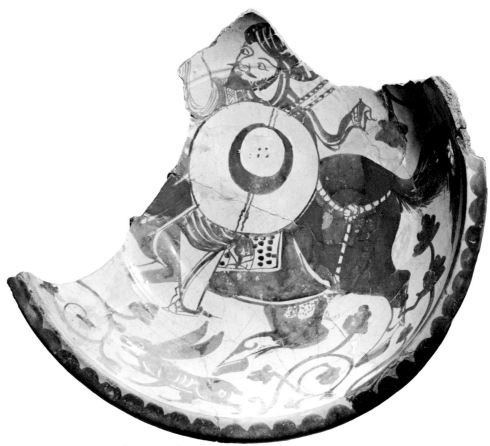

139　*Fragment of a Bowl*

Egypt
Fatimid Period, 11th century
Ceramic, monochrome lusterware,
　pink earthenware body, 15½
　(39.3) diameter
86.227.83

The most impressive Fatimid piece in the Erickson Collection shows a bearded cavalier riding a horse that canters across the surface of the bowl. The cavalier holds a large shield adorned with a crescent in his left hand and raises his right arm so that his bare forearm is visible. Below a rabbit trots alongside the horse and rider through palmette vines. The rider's foreshortened foot, his intense sideward gaze, and the scarf or turban end trailing out behind him all heighten the sense of his rapid movement through space.

Stylistically this piece falls within the same general category as the fragment of a haloed person and it probably dates from the mid-eleventh century. The subject of a mounted warrior relates it to a large group

of ceramics decorated with images of the princely cycle. Scenes of hunting, fighting, feasting, and entertainment by dancers and musicians were consistently popular in the Muslim world from Umayyad times onward. Such images confirmed the status quo not only for royal patrons but also for members of the wealthy middle class who acquired these wares. While many other Fatimid examples of horsemen are extant and more complete than this one, few exhibit the earthy vitality of this piece.　　SRC

Published: Cat. no. 137: Lois Katz, *Asian Art: From the Collections of Ernest Erickson and the Erickson Foundation, Inc.*, exhibition catalogue (The Brooklyn Museum, 1963), cat. no. 5. Cat. no. 138: Katz 1963, cat. no. 4. Cat. no. 139: Katz 1963, cat. no. 3.

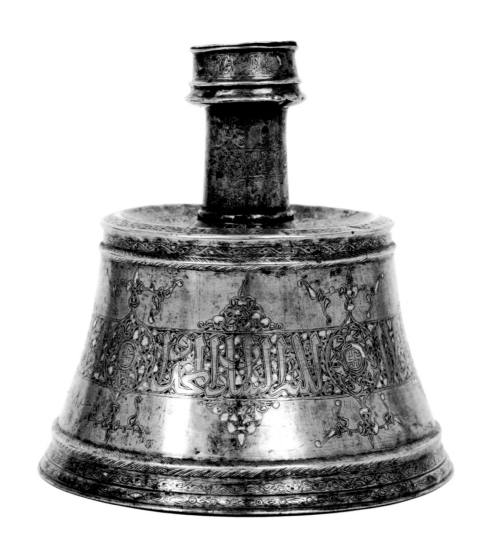

140 *Candlestick*

Egypt or Syria
Mamluk Period, first half of 14th
 century
Engraved and punched brass,
 with silver inlay, 11¾ × 11
 (29.8 × 27.9)
86.227.197

This handsome brass candlestick, inlaid with silver, typifies the subimperial production of Mamluk metalworkers. In its shape, decoration, and inscriptions the piece conforms to a type prevalent in the first half of the fourteenth century, the period of Sultan Nasir al-Din Muhammad, the greatest early Mamluk patron of the arts. The candlestick consists of a body in the shape of a truncated cone with a repoussé ridge near the base and another near the shoulder, a cylindrical neck soldered to a raised section in the center of the shoulder, and a socket with two ridges above and below an inscription. The socket has been soldered and nailed to the neck. Despite the repairs the three sections probably were all originally from the same piece because they bear the same decoration and inscriptions.

Although much of the silver inlay is gone, the traces of it that remain and the punched lines on the letters and ornament that would have held the missing inlay suggest that this was once a sumptuous object. The main decoration consists of an inscription band of *thuluth* script in four parts. Above and below the middle of each inscription section is a triangular cartouche containing an entwined arabesque. The inscription sections are punctuated by four medallions alternately consisting of six birds in flight and an interlaced arabesque around a geometric fretwork roundel. The medallions terminate above and below in trefoils from which spring split palmettes. The outer edge of the shoulder is adorned with a band of interlaced arabesque, while nearer the neck is a wider arabesque band with three roundels dividing it into three sections and three simplified trefoils above and below the middle of the sections. The neck is decorated with a three-part kufic inscription and three medallions of the type found on the base. A three-part *naskhi* inscription divided by three fretwork roundels adorns the socket.

While this candlestick is neither signed nor dated, the inscriptions may provide a clue to more precise dating. On the base is inscribed: "Perpetual glory and prosperity and long life to you, O great master [of] long-lived fame and glory and long life. Nobility everlasting." On the socket this inscription is abbreviated: "Glory and prosperity and and [*sic*] long life to you, O great master of long-lived fame."

The partly legible kufic inscription on the neck includes similar complimentary terms. Interestingly enough, the inscription on the base closely approximates that found on an exceptionally beautiful basin in the Victoria and Albert Museum, London, which Esin Atil has dated to circa 1300 (Atil 1981, 69, no. 18). Although the interior decoration of the basin is far more elaborate than the simple arabesques and inscriptions of the candlestick, the exterior of the basin reflects a similar interest in the contrast of plain and decorated surfaces intersected by an inscription band.

The exterior of another basin in the Kuwait National Museum is decorated in a fashion so similar to that of the candlestick that there can be no doubt of their having been made in the same period (Jenkins 1983, 94). Since the inscription on the Kuwait basin mentions the name of al-Nasir, the date of the basin and, by extension, the candlestick cannot be later than 1341, the year of al-Nasir's death. No mention of the ruler is found on the candlestick. Thus, its patron was most likely a private citizen not connected with the court, since even ministers' and courtiers' names appear often on Mamluk metalware. The name Sahib 'Ali ibn Ishaq is engraved twice on the candlestick in the form of graffiti, but these are most likely marks of ownership from a period later than the fourteenth century. SRC

Textile Fragment: A Hare

Egypt
Tulunid Period, 868–905
Wool and linen wefts,
 linen warps, tapestry-woven,
 18 × 11 (45.7 × 27.9)
86.227.97

In 868 Ahmad Ibn Tulun, the son of a Turkish military slave, came to Fustat (Cairo) as the representative of the caliph's governor of Egypt. The governor chose to remain in Samarra, the 'Abbasid capital, and Ibn Tulun consolidated his own power as the ruler of a semi-independent province. While he continued to pay some taxes to the caliph in Baghdad, he built his own city next to Fustat and had his own army. Both Ahmad Ibn Tulun's personality and the unique relationship of his regime to the 'Abbasid caliphate influenced the form that art and architecture took under his patronage. Ibn Tulun combined great skill as a military organizer and a careful administrator of finances with a deep respect for Islamic law and religious authorities. Thus, while he took advantage of the political disarray in Samarra, he maintained his allegiance to the nominal caliph Mu'tamid. Since the caliph's brother, al-Muwaffaq, had illegally usurped the caliphate, Ibn Tulun was under no obligation to him (Grabar 1957, 46–47). According to Islamic law, Ibn Tulun's semiautonomous regime could be considered the defender of the rightful caliph against his upstart brother.

Three years after Ibn Tulun's death in 884 the caliph confirmed the Tulunid family's governorship of Egypt and Syria for the next thirty years. Thus, when Ibn Tulun's son, Khumarawayh, succeeded his father, he was allowed to maintain the military and financial structure Ibn Tulun had built. With his love of luxury and fairly secure political position vis-à-vis the 'Abbasids, Khumarawayh appears to have enjoyed a more re-laxed reign than that of his father. Unfortunately, he was assassinated in 896, leaving a considerably depleted treasury. The following nine years of weakness enabled the 'Abbasids to reclaim Fustat in 905 (Grabar 1957, 46–47).

The major artistic bequest of Ibn Tulun is his mosque, built from 876 to 879. It is both the monumental expression of Ibn Tulun's de facto rule and magnificent architecture that reflects the art of Samarra rather than introducing a radically new Tulunid style. In textile production a similar duality existed in Tulunid times for, while the factories of the Nile Delta continued to make *tiraz* textiles for the 'Abbasid caliphs in Iraq, Ibn Tulun's court commissioned textiles from Middle and Upper Egyptian workshops for its own use. These textiles, such as the two here, rely on Coptic techniques of tapestry weaving in wool and linen on linen warps and were presumably woven by

Textile Fragment: A Speckled Deer

Egypt
Tulunid Period, 868–905
Wool and linen wefts,
 linen warps, tapestry-woven,
 14 × 8½ (35.5 × 21.6)
86.227.96

are frequently found in Coptic textiles. However, the palette of undyed linen, olive green, brown, and blue has little in common with Coptic tapestries, many of which make liberal use of red. Instead, these earthy tones probably reflect 'Abbasid influence. The large size and weight of the piece suggest that it is a fragment of a textile made for domestic use, such as a wall or floor covering.

The second Tulunid textile under consideration depicts a spotted deer or gazelle eating leaves beneath a canopy of fronds. As with the other fragment, the palette of this piece consists of earthy tones of ocher, undyed linen, dark blue, and olive green. The fine weave and relatively light weight of the fragment combined with its large scale indicate that it is also from a domestic textile, though one with less need for durability than a floor covering, such as a coverlet. The motif of the deer enjoyed popularity in Egypt in early Islamic times and derives from the Late Antique artistic vocabulary. By the time of Ahmad Ibn Tulun whatever religious symbolism that might have been attached to depictions of deer in earlier eras had long since dissipated. Presumably, as with the hare/dog, such animals connoted general good luck and bounty, the visual equivalent of the good wishes inscribed on so many early and medieval Islamic objects. SRC

Copts. On the most striking Tulunid textiles we find rendered in geometric or abstract designs the play of light and shade and negative and positive space associated with the 'Abbasid "beveled style" of carving architectural ornament. Yet pieces of Tulunid manufacture often hark back to their Coptic antecedents in the motifs used and in the similarly large scale. Nevertheless, the fact that most Tulunid textiles with figural representation depict luxurious flora and fauna demonstrates the Tulunid desire to emulate the art of the Samarra court.

The textiles here share the technical and stylistic traits of the Tulunid group. Both are tapestry-woven in wool and linen on a linen ground. One fragment shows a hare or long-eared dog ready to spring enclosed in a medallion surrounded by wide tan leaves. The tapestry-weaving technique and the use of medallions to enclose and set off motifs

Published: Lois Katz, *Asian Art: From the Collections of Ernest Erickson and the Erickson Foundation, Inc.*, exhibition catalogue (The Brooklyn Museum, 1963), cat. nos. 68 and 69.

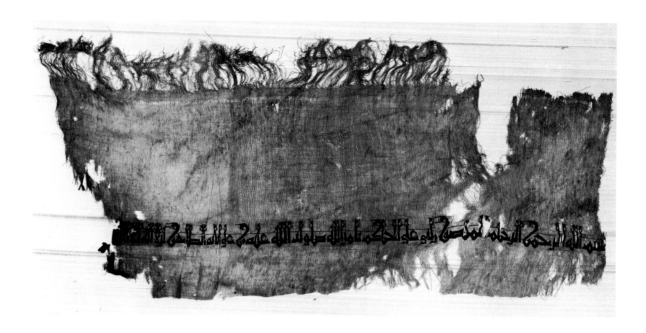

143 *Tiraz Textile Fragment*

Egypt
Fatimid Period, reign of al-Hakim,
 996–1021
Linen ground, silk tabby-woven
 inscription, 10⅜ × 24
 (26.3 × 61.0)
86.227.100

Even before the Muslim conquest of Egypt, textile manufacture played a major role in the region's economy. Characteristically, the Arab conquerors of Egypt adapted preexisting textile workshops to their own purposes, ordering for domestic and sartorial use large quantities of textiles woven and decorated according to the new Islamic taste. Perhaps the most distinctive type of early Islamic textile was the *tiraz*, a class of textiles decorated with formulaic inscriptions and produced in a system of state-run factories. This *tiraz* factory system, which probably originated in Iran under the Sasanians (Serjeant 1942, 62), was superimposed in Egypt on existing Coptic workshops in the Nile Delta and Fayyum regions. In addition to the Arabic inscriptions on Egyptian *tiraz* textiles we find nonepigraphic decoration derived from the vocabulary of Coptic weaving.

The inscriptions on *tiraz* textiles from Egypt, Mesopotamia, and Iran normally include some or all of the following information: the *bismillah* (the opening phrase of all

but one Qur'anic verse), a pious wish, the titles and name of a member of the caliph's family, a governor, or the minister who superintended the *tiraz*, the weaver's name, the place of manufacture, and the year. With such inscriptions *tiraz* functioned somewhat like medals or coins. Like medals, *tiraz* made in private or royal factories were distributed to members of the court or presented as robes of honor. Like coins, *tiraz* made in public factories were sold to the general populace.

With regard to weaving techniques in the 'Abbasid Period, after 850 Egyptian weavers in the Nile Delta changed from tapestry weaving with wool on a linen or wool ground to embroidery with silk on a linen ground. Meanwhile, tapestry weaving with wool on a wool or linen ground continued in the Fayyum and Upper Egypt. Then in the second third of the tenth century the Delta weavers returned to tapestry weaving, but in silk on a linen ground (Kuhnel and Bellinger 1952, 2). While the use of tapestry weaving in wool on a wool or linen ground continued unabated in the Fayyum and Upper Egypt, changes in technique are evident in *tiraz* textiles from the Nile Delta.

Having established a separate caliphate in Cairo, the Fatimids took control of Egyptian *tiraz* workshops and ordered textiles inscribed with the names of their own leaders rather than those of the 'Abbasid caliphs. Stylistically, however, the earliest Fatimid *tiraz* textiles conform to those made

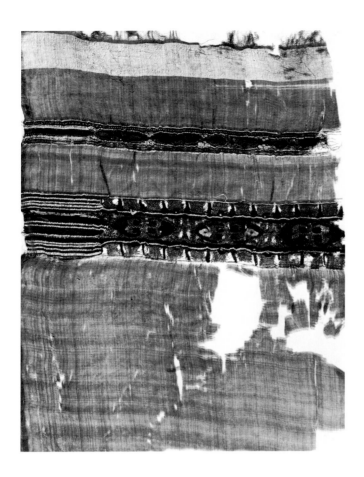

144 *Tiraz Textile Fragment*

Egypt
Fatimid Period, circa 1050
Silk ground, silk, gold-and-silver
 tabby-woven decorative band,
 13½ × 10⅝ (34.3 × 27.0)
86.227.104
Provenance: Frederic Pratt Collection

for the 'Abbasid caliphs. Often, as with cat. no. 143, they contain kufic inscriptions and no other decoration. While the use of ornamental bands with floral and animal motifs first appeared in 'Abbasid *tiraz* textiles during the reign of al-Muti' (946–974), the simpler *tiraz* pieces continued to be produced in Egypt until the end of the reign of Caliph al-Hakim (ruled 996–1020).

The style of the inscription on cat. no. 143, with the hooked, flourished heads of its vertical letters, as well as the information contained within it, indicates that the textile was woven during the reign of al-Hakim. The inscription reads: "In the name of God the merciful, the compassionate, al-Mansur Abu'l-'Ali al-Hakim bi Amr Allah, God's benedictions upon him and his pure ancestors. There is no God but God." Although the piece is fragmentary and does not include the date or place of manufacture, the "short protocol" of the inscription relates the piece to two textiles dated by Kuhnel to the end of al-Hakim's reign (Kuhnel and Bellinger 1952, 69–70). The textile's fringe suggests that it was used as a turban.

Despite its fragmentary condition, the second Fatimid *tiraz* textile under consideration (cat. no. 144) bears out the often repeated claims of Fatimid love of luxury. The ground of the piece consists of gossamer-fine green silk adorned with two tabby-woven decorative bands and one contrasting stripe in gold silk. The wider of the two decorative bands is bordered above and below by a pseudo-inscription of repeating *lam*s and *mim*s. The main decoration of the bands consists of pairs of heart-shaped palmettes set against a ground of now-tarnished silver threads (silver strips wrapped around a silk core). Similarly produced gold threads form horizontal stripes on either side of the palmette bands. Although the inscription is illegible, the format and the use of paired heart-shaped palmettes relate this piece to one in The Textile Museum in Washington, D.C., inscribed with the name of a vizier who served the caliph al-Mustansir between 1050 and 1058 (Kuhnel and Bellinger 1952, 75, 73.433, pl. XXXIV). Thus, a mid-eleventh-century date for the Erickson piece seems reasonable.

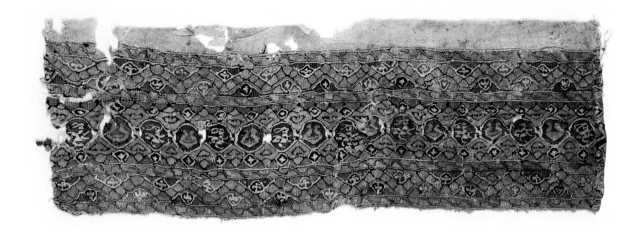

145 *Textile Fragment*

Egypt
Fatimid Period, early 12th century
Linen ground, silk tapestry-woven
 decorative band, 3½ × 10⅜
 (8.9 × 26.3)
86.227.102

The latest of the three Fatimid textiles considered here (cat. no. 145) consists of a wide decorative band in three sections woven in silk on a linen ground. In the center section a chain of medallions encloses rabbits and addorsed birds. Bordering the center section above and below are bands of rinceaux and debased flowers. By the second half of the eleventh century such bands of ornament on textiles had overtaken inscriptions, and, in turn, the inscriptions were increasingly reduced to meaningless pseudo-kufic script or omitted entirely, as on this piece. Few pieces of this type contain historical information, but those that do are inscribed in *naskhi*, or cursive, script and date from the late eleventh or twelfth century (Combe 1940, 271, no. 19; Kuhnel and Bellinger 1952, 80–81, 73.680 and 73.199). Dated late Fatimid textiles have a higher ratio of writing to ornament than those with pseudo-inscriptions. Yet on both the epigraphic and the purely ornamental textiles the elements of the decorative bands have been reduced in scale and compressed, producing a visual effect quite different from the simple *tiraz* textiles of the early eleventh century.

The transformation in style from early Fatimid *tiraz* textiles to those of the late period in some ways parallels that of Fatimid ceramics. In both media the tendency was to move from large-scale, easily legible forms to decoration consisting of many small-scale elements. The reasons for such a change may be rooted in social and political developments in Fatimid Egypt. As the Fatimids consolidated their power and established their independence from the ʿAbbasid caliphate, their artists moved away from ʿAbbasid models. In textiles the decorative motifs that gained currency in the eleventh century often derived from the Coptic textile-weaving vocabulary, such as cartouches containing animals or figures and rinceau borders. The decreasing use of inscriptions in the late eleventh and twelfth centuries may well reflect the economic and political eclipse of the Fatimid caliphs, which resulted in the dispersal of the royal treasuries in 1065 and increasing defeat at the hands of military foes. Thus, the whole function of *tiraz* textiles as a mark of caliphal power and generosity was rendered moot by the impotence and relative penury of the late Fatimid leaders. Nonetheless, the taste for fine textiles remained unabated in Egypt, and weavers, presumably at the official *tiraz* manufactories, continued to produce vast quantities of decorative textiles. SRC

Published: Cat. no. 143: Lois Katz, *Asian Art: From the Collections of Ernest Erickson and the Erickson Foundation, Inc.*, exhibition catalogue (The Brooklyn Museum, 1963), p. 37, cat. no. 71. Cat. no. 144: Katz 1963, cat. no. 72 and ill. Cat. no. 145: Katz 1963, cat. no. 75.

146 *Bowl* (Top)

Northeastern Iran or Transoxiana
9th–10th century
Ceramic, transparent colorless glaze,
 black slip, white engobe,
 buff earthenware body,
 4⁹⁄₁₆ × 14 (11.5 × 35.5)
86.227.19

147 *Bowl* (Bottom)

Northeastern Iran or Transoxiana
9th–10th century
Ceramic, transparent colorless glaze,
 brown slip, white engobe,
 buff earthenware body,
 5¹⁄₁₆ × 16¾ (13.7 × 42.5)
86.227.8

The type of pottery represented by the six pieces shown here was produced in the northeastern provinces of Iran, Khurasan, and Transoxiana during the ninth and tenth centuries. By 875 the Samanid family had established an autonomous dynasty in Transoxiana with its capital at Bukhara. In return for defeating the Safarrid dynasty in Khurasan, the 'Abbasid caliph granted the Samanids the governorship of that province in 900. Thus, by the tenth century the Samanids controlled a vast and important area of the Eastern Islamic world, including the major cities of Merv, Samarkand (Afrasiyab), Bukhara, Balkh, and Nishapur. Although wares excavated at Nishapur and Samarkand are the best known from this region today, presumably each of the major Samanid cities had kilns of its own where ceramics similar to those shown here were produced.

In the 1930s The Metropolitan Museum of Art, New York, and the Iranian government excavated the Samanid city of Nishapur. As a result of this official interest in the site, looters and commercial "archaeologists" helped themselves to ceramics and other objects the excavators had not found. Most likely the majority of Samanid ceramics in Western collections come from Nishapur, not only because it has been the best-known Samanid site in this century but also because most of the other important Samanid cities have been under Soviet con-

trol for the last seventy years, limiting the possibility of export to the West. Nevertheless, any of the cities mentioned above could be the source for most types of Samanid ceramics.

Charles K. Wilkinson, one of the excavators of Nishapur and author of the book *Nishapur: Pottery of the Early Islamic Period*, classifies the Samanid ceramics of that city in twelve groups according to glaze and decoration. He states that all the wares were produced in the tenth century and that no definite chronology of these wares could be established through the stratigraphy of the site. Within specific groups one might postulate a chronology on the basis of style, but confirming archaeological data, such as which coins were found with which ceramics, are not available. Despite marked stylistic differences between the twelve types of wares, the evidence at Nishapur suggests that various styles of ceramics were fired in the same kilns (Wilkinson 1973, xxxix–xl).

The four types of Samanid ceramics shown here demonstrate the stylistic variety within a single type (cat. nos. 146–48) as well as from group to group that is typical of the whole school. The clarity of the design on these pieces is achieved by the use of a slip, either white or colored, covering the pink or buff earthenware body, on which decoration was painted in metallic pigments mixed with slip. By adding slip to the pigments, potters could keep them from running. Designs in dark brown or black are often in slight relief and embellished with incising. Customarily, a clear lead glaze covers the decorated surface.

According to Wilkinson's classification, "black-on-white wares" constituted one of the most numerous groups of ceramics excavated at Nishapur. Well represented in the Erickson Collection (cat. nos. 146–48), these wares are among the most beautiful of all Islamic ceramics. In general, they consist of three types—those decorated with Arabic writing or pseudo-writing, those with nonepigraphic ornament, and those with a combination of epigraphic and other decoration. As discussed by Lisa Volov (Golombek), the inscriptions on Samanid epigraphic pottery are invariably in Arabic and most often express pithy sentiments, such as those found on two of the bowls here (cat. nos. 146 and 147): "Peace is that which is silent and only his speech will reveal the [?] of the man with faults" and "Planning before work

protects you from regret; patience is the key to comfort" (Volov 1966, 133). In her thorough analysis of the embellished kufic script on the epigraphic wares, Volov discusses the two Erickson bowls. First, she notes that the script on cat. no. 146 is angular, of the type that will develop interlaced forms, whereas on cat. no. 147 "the stroking is much freer. . . . Verticals tend to become diagonal and curving lines appear with greater frequency" (Volov 1966, 116). The variety of writing styles, ornament, and even the color of the slip—dark brown in the case of cat. no. 146 and light brown on cat. no. 147—suggests that more than one workshop was in operation. In fact, Wilkinson notes that vertical letters with tips bent to one side and bifurcated were found in Samarkand (Afrasiyab) as well as in Nishapur (Wilkinson 1973, 93). Volov has demonstrated a development of plaited kufic over time, relating it to coins and architectural monuments. Thus, cat. nos. 146 and 147 can be dated to the late ninth or early tenth century.

With its design of a stylized swanlike bird on the interior bottom and a continuous band of an elipse-and-lozenge motif beneath the rim, cat. no. 148 clearly falls into the nonepigraphic group of black-on-white wares. The crisp execution of the ornament on this bowl and the balance and harmony of its composition match that of cat. nos. 146 and 147. With three bowls of equally high quality, identical in technique and close in date, one might ask whether the epigraphic pieces were made for the same patrons and purposes as the nonepigraphic ones and whether the sources of inspiration were similar. The high quality of potting and the large size of the pieces support the notion that they were expensive and probably available only to wealthy patrons. Volov has suggested that the epigraphic wares were produced for "an Arab aristocracy residing within Samanid domains, or . . . a highly moralistic class of frontier warriors serving as Defenders of the Faith on the borders" of the Islamic world (Volov 1966, 108). If the patrons were Arabs, would they not have been more inclined to patronize pottery that imitated or closely resembled the wares of the 'Abbasid capital (see cat. nos. 133–35) much as their contemporary in Egypt, Ahmad Ibn Tulun, had done? A variety of Samanid wares do, in fact, copy 'Abbasid prototypes (Wilkinson 1973, 54, 179–204).

inspired Samanid epigraphic pottery. The idea of a single band of simplified angular Arabic writing on a white surface may have first reached Khurasan in the form of *tiraz* textiles presented as gifts to the "frontier warriors" by the 'Abbasid caliph. While Samanid epigraphic pottery has a greater visual impact than *tiraz* textiles, the makers of both textiles and pottery relied on the same conventions, the rhythm and balance of vertical and horizontal letters against a white ground, to achieve their desired effect. That the inscriptions on the bowls are maxims or good wishes instead of the official formulae of *tiraz* textiles simply points up the difference between pieces made for personal use and those made for the government.

As for cat. no. 148, although its high quality suggests a well-to-do owner, the decoration of a bird and geometric band could have appealed to any number of people. As with the epigraphic wares, the ultimate source of inspiration may be in 'Abbasid art. Although the particular style of the bird, with its long legs and neck, owes little to 'Abbasid ceramics, stylized birds are a popular motif on ninth- and tenth-century 'Abbasid lusterwares (see cat. no. 133). Similarly, the geometric band may have been borrowed from an 'Abbasid textile design. Woven textiles with bands of lozenges and other geometric forms were produced in ninth- and tenth-century Iraq and presumably were exported to Khurasan. (For an example of this type of design see Kuhnel and Bellinger 1952, 11, 73.634, and pl. IV.) In fact, the extensive textile trade of early Muslim times has long been suspected to have been the source of much long-distance artistic inspiration.

In contrast to cat. nos. 146–48, cat. nos. 149–50 are smaller in size and somewhat more thickly potted. Nonetheless, they are all attractive and stylistically distinct, demonstrating the richness of Samanid ceramic production. The interior surface of cat. no. 149 has been divided into six triangular segments. Tomato-red segments with rows of ovoids alternate with segments containing an arabesque with three floriated leaves in dark brown slip on a white engobe ground. A band of dark brown lunettes on a white ground runs around the rim. The potter has employed the technique of scratching through the slip, seen in the interlaced letters of cat. no. 146, to define and sharpen the leaves and flowers in the black-

148 *Bowl*

Northeastern Iran or Transoxiana
9th–10th century
Ceramic, transparent colorless glaze,
 black slip, white engobe,
 buff earthenware body,
 4½ × 15 (11.4 × 38.1)
86.227.18

The "frontier warriors," on the other hand, might have been Iranians, recently converted to Islam and, as such, intensely enthusiastic about all things Muslim, including one of the central features of Islam, the Arabic language. As Iranians, these people might be expected to have been less influenced by or attracted to the ceramics of Baghdad and Samarra since most of those wares contain no overt religious or caliphal significance. However, in a more general sense the aesthetic of one form of 'Abbasid art, *tiraz* textiles (see cat. no. 143) may have

149 *Bowl* (Top)

Northeastern Iran or Transoxiana
9th–10th century
Ceramic, transparent colorless glaze,
 black-and-red slip, white engobe,
 buff earthenware body,
 2⅝ × 6½ (6.7 × 16.7)
86.227.4

150 *Bowl* (Bottom)

Northeastern Iran or Transoxiana
10th century
Ceramic, transparent colorless glaze,
 light green slip, dark brown
 engobe, buff earthenware body,
 2½ × 8½ (6.3 × 21.5)
86.227.20

on-white segments and to produce the
ovoids in the red segments. The use of black
slip on a white ground and of incising
through the slip clearly relates this bowl tech-
nically to the black pieces of this type, called
"polychrome-on-white wares" by Wilkin-
son (Wilkinson 1973, 128–57). Many con-
tain inscriptions and decorative motifs simi-
lar to those found on black-on-white wares.
Yet, as Wilkinson has noted, the decoration
is freer and less restrained on the polychrome
group (Wilkinson 1973, 129).

The potter of cat. no. 150, from the
group Wilkinson calls "Slip-Painted Ware
with Colored Engobe" (Wilkinson 1973,
158–78), has adapted two of the decorative
principles of cat. nos. 146–48 to an entirely
different purpose. Here the ground color of
the bowl is brownish-black engobe deco-
rated with stylized birds in pale green on the
sides and in the center. The bird in the center,
with its long neck and half-palmette wings,
is a cousin of the bird in cat. no. 148, though
rendered in a far more painterly fashion. The
legless birds on the sides resemble repeating
inscriptions, though no word is legible. As
in some polychrome-on-white wares, the
areas between the primary motif are deco-
rated with contour panels. The borrowing
and transformation of motifs or techniques
found on black-on-white wares charac-
terizes this and the polychrome-on-white
ware bowl, though in both groups many
forms of ornament exist that owe nothing to
the black-on-white wares.

208

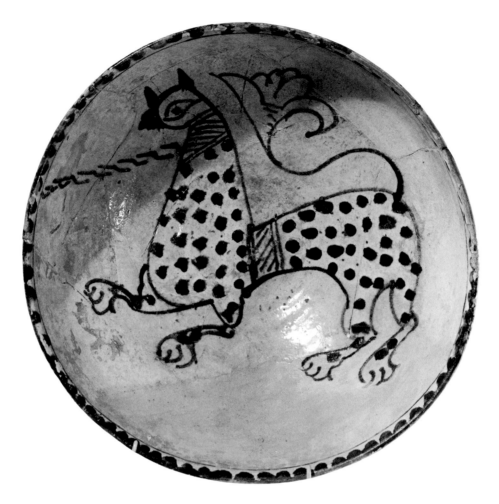

151 *Bowl*

Northeastern Iran or Transoxiana
10th century
Ceramic, transparent colorless glaze,
 yellow-staining black slip,
 white engobe, buff earthenware
 body, 3½ × 8⁵/₁₆ (8.9 × 21.1)
86.227.85

The last Samanid piece to be discussed, cat. no. 151, depicts a spotted cheetah on a chain in "yellow-staining black" slip (Wilkinson 1973, 213–28). The animal's tail curves up, terminating in a leafy spray. According to Wilkinson, only one or two examples of this ware with depictions of cheetahs were excavated at Nishapur (Wilkinson 1973, 215). However, many museums contain examples of such bowls adorned with a single cheetah. Probably be-

cause so few were unearthed at Nishapur, Wilkinson attributes these pieces to the late eleventh century, well after the fall of the Samanid dynasty (Wilkinson 1973, 215). Possibly they are earlier but were made at a site other than Nishapur. Despite the total lack of stylistic relationship with the black-on-white wares, this piece does reveal a continued interest in the contrast of a simply colored motif on a white background. Unfortunately, one cannot say whether such a preoccupation was maintained in Khurasan and Transoxiana for a limited period, say twenty-five years, or as long as two centuries.

SRC

Published: Cat. no. 146: Lois Katz, *Asian Art: From the Collections of Ernest Erickson and the Erickson Foundation, Inc.*, exhibition catalogue (The Brooklyn Museum, 1963), cat. no. 10; Volov 1966, 118, 113, fig. 3. Cat. no. 147: Katz 1963, cat. no. 9; Volov 1966, fig. 1; Cat. no. 148: Katz 1963, cat. no. 12; Cat. no. 149: Katz 1963, cat. no. 16; Cat. no. 150: Katz 1963, cat. no. 14; Cat. no. 151: Katz 1963, cat. no. 21.

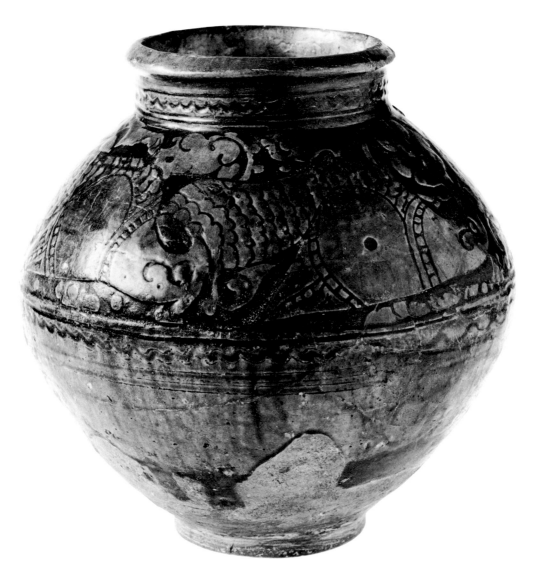

152 *Jar*

Northwest Iran
12th century
Ceramic, transparent green glaze,
 white slip, reddish earthenware
 body, 8 × 8 (20.3 × 20.3)
86.227.182

Slip-painted earthenware pottery enjoyed
long-lived popularity in Iran. From at least
the tenth century on, potters used the sgraf-
fiato technique, incising through the slip to
produce designs by contrasting the dark
color of the exposed ceramic body with the
areas covered by white slip. In the twelfth

century the technique led to a new decorative method called "champleve," which entailed carving sections covered with white slip to expose larger portions of a pot's earthenware body. This champleve technique is one of the hallmarks of the group of ceramics from which the jar and bowl under discussion here come. Traditionally this group has been called "Garrus ware," a trade name that refers to the town in northwestern Iran where the pottery is said to have been found.

Before the publication of the excavations at Takht-i Suleiman in the 1970s some art historians dated Garrus wares as early as the ninth–tenth centuries while others placed them as late as the fourteenth. Rudolf Schnyder, however, has convincingly dated the group to the late twelfth, early thirteenth century on the basis of comparable finds at Takht-i Suleiman (Schnyder 1973, 92). Among these finds, vessels decorated with images of birds, as on the jar here, were common. But the human and mythological imagery found on many of the best-known pieces of this type, as well as on the bowl here, does not appear to have figured significantly at Takht-i Suleiman. Certainly the subject of sphinxes, the image on the bowl, was a familiar one on ceramic and metal objects of the twelfth and thirteenth centuries in Iran. However, the strange facial type of this sphinx with its elongated eyes and brows and bizarre hairdo may lead one to question the authenticity of the piece. As Ernst Grube has noted (Grube 1976, 108), neither the authenticity nor the iconographic significance of this "mythological" group of Garrus wares has been satisfactorily determined. According to Fehervari some "mythological" Garrus wares have been excavated; so presumably the whole group should not be dismissed as fake (Fehervari 1973, 66). As for the significance of the motifs on these strange pots, Schnyder suggests that the influx of Central Asian Turks to northwestern Iran in the eleventh century might have caused the development of the distinctive style and technique associated with this group (Schnyder 1973, 94). Likewise, the imagery on the pots may reflect either the taste of a new clientele or a native reaction to an immigrant population. SRC

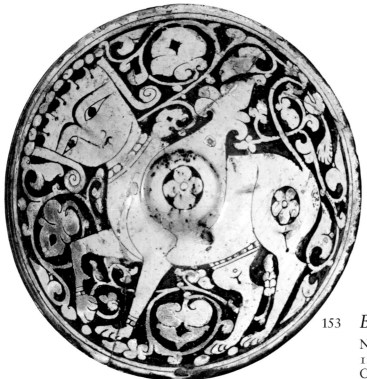

153 *Bowl*

Northwest Iran
12th century
Ceramic, transparent colorless glaze, white slip, manganese underglaze, reddish earthenware body,
2½ × 7⅛ (6.3 × 18.1)
86.227.177

154 Bowl

Iran
Mid-12th century
Ceramic, transparent bluish glaze,
 black slip, white engobe, buff
 earthenware body, 3⅜ × 7¼
 (8.6 × 18.4)
86.227.76

In the distinctive group of Seljuq ceramics called "silhouette ware" the decorative elements are painted in black slip under a transparent colorless, green, or turquoise glaze. As with Samanid slipwares (cat. nos. 146–51) the slip-painted decoration is applied thickly enough to form a slight relief under the glaze. In some pieces the potter covered the whole object with black slip and then produced the design by carving away the slip to reveal the white body of the pot. Like Samanid black-and-white wares the outlines of the designs are sharp and the details are incised through the slip. As Oliver Watson has pointed out, this technique "anticipates the under-glaze painted wares of the beginning of the 13th century," although the designs in this earlier group are characteristically stiff (Arts Council of Great Britain 1976, 242, no. 339).

Traditionally, silhouette wares have been attributed to Rayy. However, while those with turquoise glaze over black slip were excavated there in the 1930s (unpublished examples are in The University Museum, University of Pennsylvania, Philadelphia, and the Museum of Fine Arts, Boston), the black-and-white ware of the type in the Erickson Collection was not found there. In fact, the stylistic differences within the group of black-and-white silhouette wares as a whole and the three Erickson pieces seen here in particular suggest that several ateliers were engaged in the manufacture of this ware.

Cat. nos. 154 and 155 share technical and stylistic traits not in evidence in cat. no. 156. Both have a buff earthenware body, transparent glaze with a blue-green tinge, and black decoration in low but tangible relief. While the magnificent bird with spread wings in cat. no. 154 makes it a far more elaborately ornamented object than cat. no. 155 with its striped body and neck and simple arabesque beneath the rim, both pieces are broadly conceived, consisting of substantial, even bold forms. The rendering of these forms relates the pieces to a large group of silhouette wares with colorless and turquoise glaze that might have been produced in one atelier (see Pope 1938, pls. 745–46).

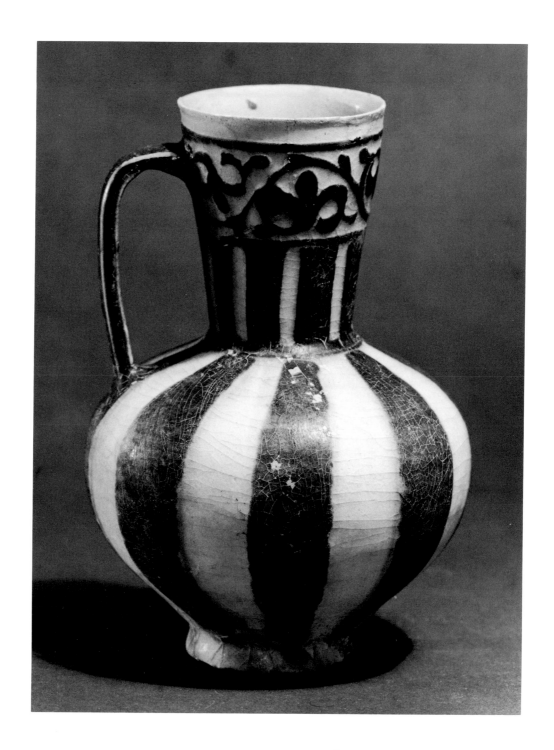

155 *Jug*
Iran
Mid-12th century
Ceramic, transparent colorless glaze,
 black slip, white engobe, buff
 earthenware body, 7 × 4¾
 (17.8 × 12.0)
86.227.77

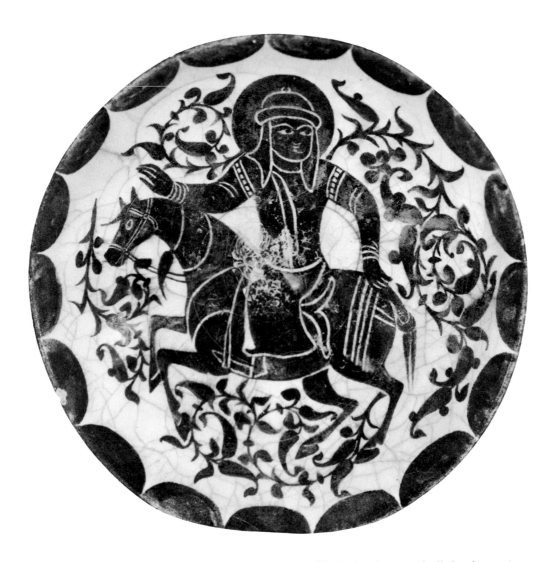

156 *Bowl*

Iran
Mid-12th century
Ceramic, transparent colorless glaze,
 black slip, white engobe, white
 body, 2⅝ × 8¾ (6.7 × 22.3)
86.227.7

In contrast to cat. nos. 154 and 155,
cat. no. 156 relates to another group of
silhouette wares in which figural decoration
is prevalent. Here a haloed horseman twists
in his saddle to face the viewer while his
horse trots to the left amid scrolling ara-
besques. Unlike cat. nos. 154 and 155 the
body of cat. no. 156 is white frit. Black slip
scallops ring the rim, and a group of four
dots placed at intervals adorn the exterior.
Unlike cat. no. 154 the central motif does

not fill the bowl. Instead all the decorative
elements are smaller in scale and more tightly
rendered. The scallops on the rim, the spiky
arabesque in four distinct clumps, and the
use of incising through the slip to depict folds
and horse trappings relate the piece to a bowl
in the Barlow Collection (Arts Council of
Great Britain 1976, 241, no. 336). Although
these pieces cannot be assigned to a specific
site of origin, their arabesque decoration re-
sembles the so-called waterweeds motif
often found on Kashan ceramics of the thir-
teenth century. Apparently in the mid-
twelfth century, the period of these silhouette
wares, the two major styles of Seljuq ceram-
ics, Rayy and Kashan (after the cities of the
same name), were already well defined. In
the thirteenth century the ceramic produc-
tion of Rayy and Kashan was unsurpassed
in the Muslim world for both the range and
quality of their form and decoration. SRC

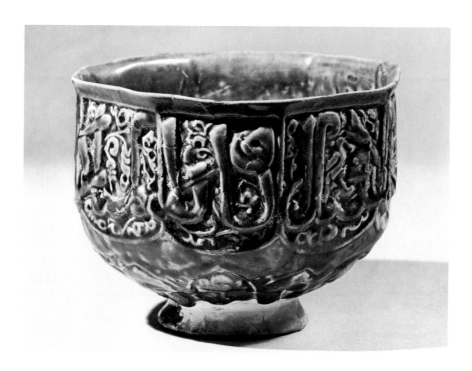

157 *Octagonal Bowl*

Signed "Hasan al-Qashani"
Iran
12th century
Ceramic, transparent cobalt-blue
glaze, off-white frit body, molded
decoration, 4½ × 6
(11.4 × 15.2)
86.227.89

Despite the political Balkanization of the Seljuq sultanate in the twelfth century, the production of ceramics reached extraordinary proportions in Iran during this era and the ensuing periods of Khwarazmian and Mongol domination. To the myriad variations of color and design evident in groups of ceramics such as the Samanid wares (cat. nos. 146–51) were now added innovations of body and glaze types as well as new shapes and techniques for achieving them. Sizable caches of twelfth- and thirteenth-century pottery have been found at numerous sites in north central and northeastern Iran, but the lack of kiln wasters or excavation reports makes the precise identification of sources difficult. Occasionally works contain signatures or relate to ceramic tiles in architectural settings that support the attribution of certain stylistic groups of wares to specific sites. Yet even this type of information does not discount the possibility of the importation of ceramics and the movement of potters from one center to another.

The two molded pieces here characterize much of what is innovative in Seljuq ceramics. First, on both pieces the body type, known as frit ware, and the alkaline glaze that covers it represent new developments in Islamic ceramic technology that took place in the eleventh century. Simply put, a frit body is hard, gritty, and white with a high silica content, which is highly compatible with glazes fluxed with alkali (Wilkinson 1973, 259.) The thin, strong walls of fritware pieces lend themselves to the decorative techniques such as molding and piercing that enjoyed popularity in the twelfth century. As excavations at Nishapur have shown, molds such as those used for the bowl and jar here were made from "master models" made of wood or unglazed, fired frit ware (Wilkinson 1973, 261).

The octagonal bowl with a slightly flaring foot and transparent cobalt-blue glaze contains the following *naskhi* inscription on a ground of vegetal arabesque: "Power and prosperity, [damage], good fortune and favor and dominion; the work of Hasan al-Qashani." In shape, signature, and inscription the bowl is apparently identical to one in the Freer Gallery of Art, Washington, D.C. (Atil 1973, no. 22) and one in The

Metropolitan Museum of Art, New York (68.223.9). Atil claims that the inscription on the Freer bowl consists of only three words—power, prosperity, and dominion—spread over seven panels, but the Erickson Collection example includes at least three more words. Unfortunately, the only conclusion one can draw from the name of the potter is that he or his family came from Kashan. As for the source of the bowl, the master model, the mold, and the bowl itself all could have been made in Kashan, or the model could have been made in Kashan and exported to another site where the bowl was made, or all the components could have been made by Hasan al-Qashani at a site other than Kashan.

The similarly molded and glazed jug on a high foot exhibits the exceptional compositional abilities of Seljuq potters. Between bands of repeating leaves, braid, and vertical panels runs a *naskhi* inscription inhabited by birds, a harpy, a fox, a rabbit, and possibly a mouse. Along some of the letters the wall of the jug has been pierced, allowing for light to filter through the sides of the vessel. The inscription contains only good wishes: "Power and victory and increase and great prosperity, loyal prince [?]." In a provocative discussion of molded relief wares of this type Ernst Grube cites metalwork as the source of the shapes of octagonal and round cup-shaped bowls (Grube 1976, 164). Likewise, pear-shaped jugs such as the one here may derive from metal prototypes in which, inci-

dentally, bands of vegetal, epigraphic, and geometric ornament played an increasingly important role in the late twelfth and thirteenth centuries. Furthermore, Grube suggests that the whole group of similarly decorated molded wares, whether or not they contain the signature of Hasan al-Qashani, were the work of that potter. Such a statement seems excessive considering the possibility of molds or master models of Hasan al-Qashani being used by other potters. Nonetheless, this unsigned jug certainly equals the bowl in the liveliness of its molded ornament and the attractiveness of its shape.

SRC

Published: Cat. no. 158: Lois Katz, *Asian Art: From the Collections of Ernest Erickson and the Erickson Foundation, Inc.*, exhibition catalogue (The Brooklyn Museum, 1963), cat. no. 28; Charles K. Wilkinson, *Nishapur: Pottery of the Early Islamic Period* (New York, 1973), p. 261, called "jug"; Atil 1973, no. 22; Grube 1976, p. 164, note 7; Cat. no. 159: Katz 1963, cat. no. 27.

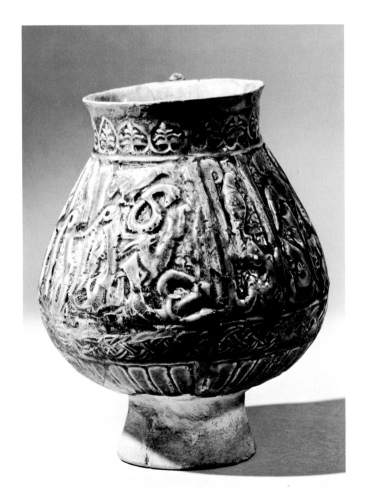

158 *Jug*

Iran
12th century
Ceramic, transparent cobalt-blue
 glaze, off-white frit body, molded
 decoration, 7 × 5½
 (18.0 × 14.0)
86.227.17

159 *Jug*

Iran
12th century
Ceramic, transparent colorless glaze,
 cobalt-blue underglaze, white frit
 body, 6 × 4¾ (15.5 × 12.0)
86.227.22

Repeatedly in the history of Islamic ceramics potters were inspired by fine, imported Chinese wares. Not only the shapes of Chinese ceramics but also their white glazes and their hard, thin paste appealed to medieval Middle Eastern potters. With the advent of frit ware, Islamic potters could emulate, though never duplicate, the thin walls, crisp forms, and translucent whiteness of Sung Chinese white wares.

The large group of twelfth-century Iranian white wares is represented in the Erickson Collection by this fluted jug. The piercing beneath the rim and the splashes of cobalt-blue underglaze typify this type of al-kaline glazed ware. Moreover, such details underscore the Iranian potters' use of Chinese models as a point of departure, not as a model to be slavishly imitated. As with the molded wares (cat. nos. 157–58), this type of pottery has been found at all the major Seljuq sites of north central and north-eastern Iran. SRC

Published: Lois Katz, *Asian Art: From the Collections of Ernest Erickson and the Erickson Foundation, Inc.*, exhibition catalogue (The Brooklyn Museum, 1963), cat. no. 26.

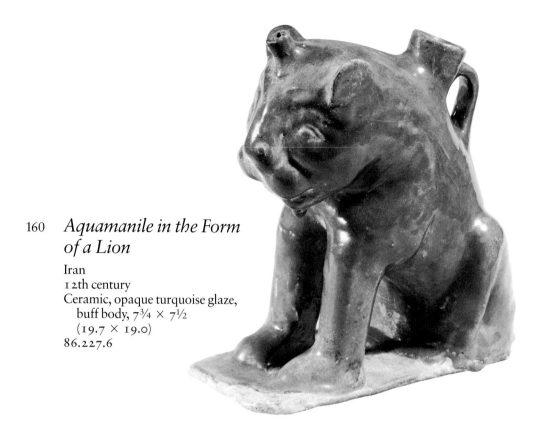

160 *Aquamanile in the Form of a Lion*

Iran
12th century
Ceramic, opaque turquoise glaze,
 buff body, 7¾ × 7½
 (19.7 × 19.0)
86.227.6

This aquamanile, or pitcher, in the form of a lion relates both to a large group of Seljuq glazed ceramic figurines and to metal aquamanilia of similar date. Seated on a flat plaque of buff paste, the lion is covered with an opaque turquoise glaze. A handle and a funnel into which liquid would be poured intersect the middle of the lion's back, while a smaller spout, now broken, for pouring the liquid juts out from the middle of the lion's forehead. Large numbers of figurines with comparable body and glaze have been unearthed at Rayy, Gurgan, and other north central Iranian sites, the region to which this lion must be attributed.

In his enlightening discussion of the function of such figurines, especially those with no evident utilitarian purpose, Ernst Grube suggests that they may have been used in ceremonies or as protective images (Grube 1976, 239–45). Even though the function of the Erickson lion as a pitcher is obvious, it, too, might have held a certain symbolic meaning for its owner. The lions that appear on the walls and gates of thirteenth-century Iranian and Mesopotamian towns presumably served an apotropaic function. On the other hand, eleventh-century Spanish and Egyptian fountains and aquamanilia in the form of lions appear to have symbolized power and victory. Oleg Grabar has demonstrated, furthermore, that the famous eleventh-century lion fountain of the Alhambra was a re-creation of "a luxurious setting associated with Solomon," the paradigm of princely virtues in medieval Islam (Grabar 1978, 128–29). Without knowing the identity of the original owner of the Erickson Collection lion, one cannot be absolutely certain of its iconographic significance. However, the repeated association of lions, both standing and seated, with water in the form of fountains and aquamanilia supports the idea that they symbolize power, success, and luxury. This interpretation would be in keeping with similar sentiments expressed in inscriptions on other ceramic and metal objects that not only bless the owner but also wish him power, victory, prosperity, and so on. SRC

Published: Lois Katz, *Asian Art: From the Collections of Ernest Erickson and the Erickson Foundation, Inc.*, exhibition catalogue (The Brooklyn Museum, 1963), cat. no. 30.

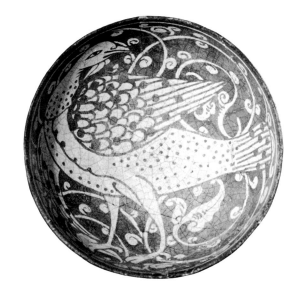

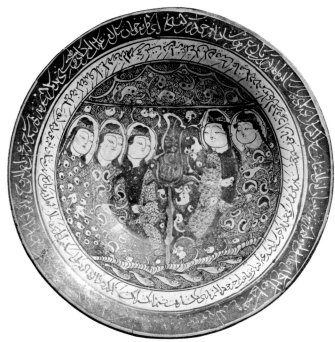

161 *Bowl* (Top)

Iran, Kashan
Late 12th century
Ceramic, lusterware, white frit body,
 2¼ × 5⅝ (5.2 × 14.2)
86.227.62

162 *Bowl* (Bottom)

Iran, Kashan
1210–20
Ceramic, lusterware, cobalt-blue in-
 glaze, white frit body,
 3⅜ × 13 (8.0 × 33.0)
86.227.16

As the 'Abbasid and Fatimid lusterwares in the Erickson Collection demonstrate, the technique of lusterware was first mastered in the Islamic world by potters in Iraq in the ninth century. This exceptional technique was known to a limited number of potters who migrated within the Islamic world, for it appeared suddenly in a fully mastered form in Fatimid Egypt in the late tenth century (see cat. nos. 136–39), in Ayyubid Syria in the twelfth century, and in Iran in the late twelfth century.

The group of Iranian lusterwares illustrated here represents the major styles, periods, and types of objects outlined in a recent, brilliant book by Oliver Watson (Watson 1985). Thanks to Watson, we now have a far more thorough understanding of the stylistic development, technical aspects, and iconographic significance of Iranian lusterwares of the twelfth to fourteenth centuries.

Until recently scholars have attributed Iranian lusterwares to several different centers—Rayy, Kashan, Gurgan, and Saveh—on the basis of style and the different types of lusterwares found at those sites. Watson, however, demonstrates convincingly that Kashan was the only source of lusterware manufacture in twelfth- to fourteenth-century Iran. The distribution of these wares throughout Iran and beyond attests to the marketing skills of Kashani merchants, not to the geographic dispersal of lusterware kilns (Watson 1985, 38–41). Thus, the lusterware painting style previously associated with Rayy is now viewed as the first of the Kashan styles, which Watson calls "monumental" (Watson 1985, 45). The interior of cat. no. 161 typifies this style with its large central figure of a bird in reserve on a luster

ground before a simple, looping split-pal-mette leaf arabesque. Likewise, the exterior, decorated in a spiky formalized arabesque in luster on a white ground, is also characteristic of the style. Although the extant examples in this style are not dated, their close relationship to late Fatimid lusterwares suggests that they were among the first works done by Egyptian potters who emigrated from Cairo in the final days of the Fatimid dynasty (969–1172) in the last quarter of the twelfth century.

Concurrently with the monumental style developed the so-called miniature style, which Watson claims derives from miniature painting (Watson 1985, 70). Pieces in this style exhibit qualities that were fully exploited in the next phase of luster decoration, the Kashan style. These traits include painting the design in luster rather than using the luster as a ground, reducing the scale of figures and decorative motifs, and scratching through the luster.

Here the Kashan style appears in full flower in a magnificent bowl of circa 1210–20 (cat. no. 162). Although this piece was previously thought to be dated Jumada II 614 AH—September 1217—no such date appears in the inscription. The central design of the bowl consists of five figures, three at the left and two at the right, seated facing a cobalt-blue tree that contains a bird. Fish swim in a pond below, and an arabesque in a semicircular panel above denotes the sky. Around the flat rim and in the cavetto runs the Persian inscription, scratched through the luster and written in luster respectively. Compared to cat. no. 161, the most striking feature of this piece is the variety and minuteness of pattern. Not only are the figures' robes made up of tiny but distinct patterns of curls, leaves, and peacock feathers, but the water and sky are also filled with curls either painted in luster or scratched through the luster. The same subject with fewer

figures appears on another lusterware bowl dated 1217 (Bahrami 1949, pl. LXXIV), leading one to suspect that a talking bird, a familiar theme of Persian mystical literature, is the subject of these pieces. Watson has noted that the inscriptions on these lusterwares rarely, if ever, relate directly to the scenes (Watson 1985, 152), and a partial reading of the inner inscription band here bears him out:

> O you whose intent is to hurt me for months
> and years
> Who are free from me and cheerful at the
> anguish of my heart.
> You promised me not to break your promise
> any more,
> It is I, dear, who have caused this break.
> —Bahrami 1949, 120

But if such inscriptions, which are often popular love poems or Qur'anic verses, do not describe the pictorial subject matter of these wares, they do, together with the scenes, suggest certain Sufi mystical interpretations centering on the attainment of oneness with God.

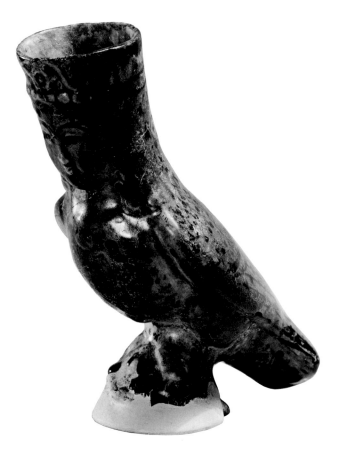

163 *Vase in the Shape of a Harpy*

Iran, Kashan
Circa 1200
Ceramic, lusterware, transparent
 cobalt-blue glaze, buff body,
 7½ (19.0) high
86.227.66

164 *Tile in the Shape of a Seated Figure*

Iran, Kashan
1215–20
Ceramic, lusterware, cobalt-blue
 inglaze, buff body, 5½ × 4
 (14.0 × 10.1)
86.227.69

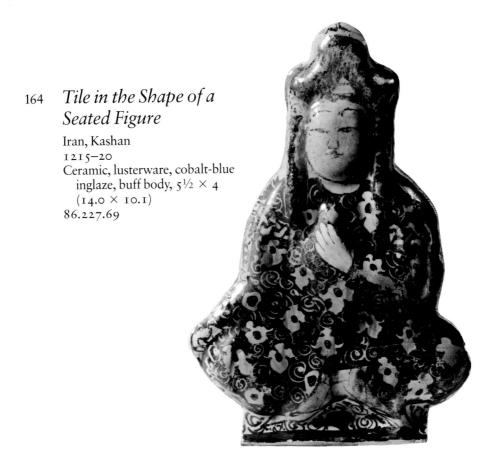

In addition to bowls and other vessels, figurines similar to the Erickson monochrome-glazed lion (cat. no. 160) are also found decorated with luster glaze. Here a cobalt-blue, luster-glazed harpy (cat. no. 163) that could have functioned as a vase or a drinking vessel exemplifies a group of figures made exclusively in the pre-Mongol period (Watson 1985, 117). The details of the crown, face, and wings of the figure are molded and decorated with luster in the miniature style, further defining the creature's wings, breast, and head. Seemingly inherited from Egyptian or Syrian potters, the use of transparent cobalt-blue and transparent or opaque turquoise glazes appears with regularity in conjunction with luster decoration, either to emphasize details or to cover the whole object. Although harpies and other fanciful beasts presumably bore magical and auspicious connotations, the precise iconographic significance of this harpy eludes us.

Related to the harpy vase is the molded tile of a human figure here (cat. no. 164), which shows a long-haired man or woman sitting with one hand raised to his or her chest. Done in the Kashan style of 1215–20, it reveals another aspect of the luster potter's skill. Unfortunately, the hand has been repaired, making it impossible to determine what the figure originally held, though often such figures clasp goblets. A ridge, possibly designed to fit between two flat tiles, runs down the center of the unglazed back. From the late twelfth through the fourteenth century luster potters adorned buildings with sequences of such tiles in a variety of forms. Watson identifies three major types: *mihrabs* (prayer-niche tiles), frieze tiles, and star and cross tiles. While the great majority of tiles of known provenance come from shrines and tombs, luster tiles from secular settings have also been found (Watson 1985, 134). Despite the Muslim prohibition against human imagery in a religious setting, many of the shrines and tombs with luster-tile decoration contain tiles depicting human beings. Consequently, one cannot assign the Erickson Collection tile with any certainty to a specific type of building or tile sequence.

165 *Eight-Pointed Star Tile*

(Top)
Iran, Kashan
Circa 1310
Ceramic, lusterware, cobalt-blue
 inglaze, buff body, 8¼ × 8¼
 (21.0 × 21.0)
86.227.73

166 *Eight-Pointed Star Tile*

(Bottom)
Iran, Kashan
Circa 1310
Ceramic, lusterware, cobalt-blue
 inglaze, buff body, 8¼ × 8¼
 (21.0 × 21.0)
86.227.70

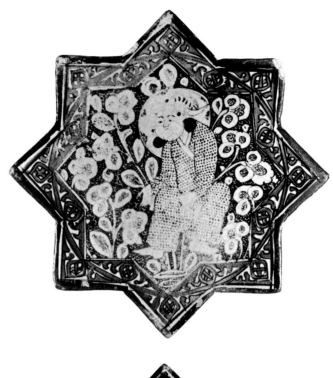

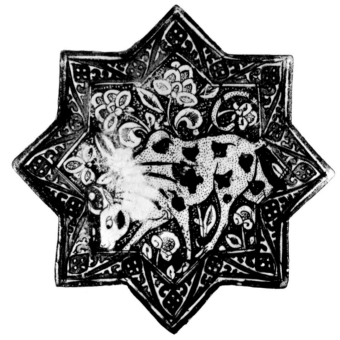

Because luster-tile production came to a near halt following the Mongol invasion of Iran in 1220, only a handful of pieces are datable to the 1220s, 1230s, or 1240s. By the 1250s, however, production increased, continuing with ups and downs until 1339, the year of the last dated luster tile (Watson 1985, 142). The three eight-pointed star tiles seen here (cat. nos. 165–67) represent this period, which is known as the Il-Khanid era. On the basis of comparison with a tile of 1310 in the Museum of Fine Arts, Boston (Watson 1985, 119), cat. nos. 165 and 166 can be dated to about the same time. Cat. no. 165 pictures a haloed figure seated in a landscape of leafy plants, while cat. no. 166 shows a bull grazing in a similar landscape. The borders of both tiles consist of lozenge and branch designs in cobalt blue on a white ground. As with the Boston tile, the leaves are reserved in white against the luster ground and contain speckled interiors. On the reverse of cat. no. 166 the shadow of another luster tile is visible as a result of the two tiles having been fired too close to each other. Cat. no. 167, in which a turquoise deer leaps through a landscape of leafy plants above a small pool containing a fish, exhibits the careless but lively painting associated with the late 1320s and early 1330s. As with so many star tiles, this piece is inscribed in luster on its border with an untranslated love poem.

Neither the nature of the poem nor the images of the deer, bull, and seated figure preclude these tiles from having been used in a shrine or tomb. As Watson has convincingly shown, star tiles with figural motifs were used in popular religious buildings of Shiites and Shiite sympathizers (Watson 1985, 154). Although the original significance of such tiles and the sequences into

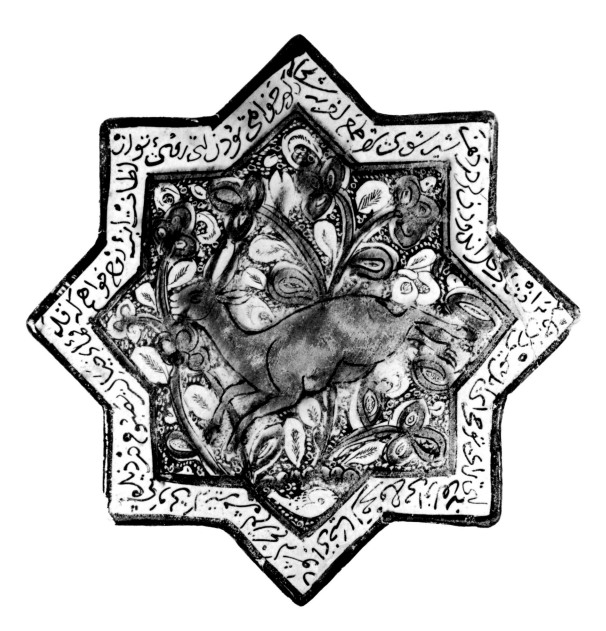

which they fit are lost to modern viewers, one can safely assume that these pieces held symbolic and possibly mystical meaning for viewers of the thirteenth and fourteenth centuries. Furthermore, the very nature of lusterware—its shimmering surface, the complex interplay of negative and positive, of lustered and reserved surfaces—lends itself to a mystical state of mind in which one cannot be sure whether what one sees is real or illusory. Such a preoccupation with reality and illusion lies at the core of Islamic, and especially Shiite, mystical thought. Iranian lusterware of the twelfth to fourteenth century is thus the quintessential visual expression of this form of mysticism. SRC

167 *Eight-Pointed Star Tile*

Iran, Kashan
Circa 1330
Ceramic, lusterware, cobalt-blue
 and turquoise inglaze, buff body,
 8¼ × 8¼ (21.0 × 21.0)
86.227.71

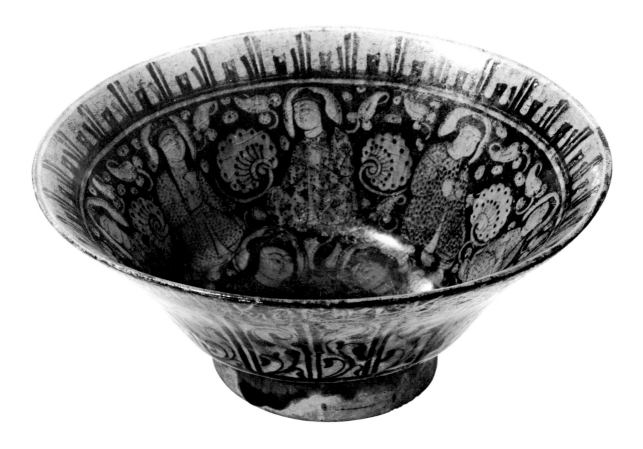

168 *Bowl*

Iran, Kashan
Circa 1210
Ceramic, transparent turquoise
glaze, black underglaze,
white frit body, 4⅛ × 9¾
(10.5 × 24.8)
86.227.9

In decoration and shape the black-under-turquoise glazed bowl illustrated here (cat. no. 168) typifies the finest pre-Mongol Kashan wares produced between 1200 and 1220. Its interior decoration consists of two seated drinking figures on the bottom surrounded by four pairs of seated figures holding wine cups or gesturing to one another. A repeating kufic inscription of the word "Allah" on a ground of tight curls runs around the interior

of the rim. The exterior is decorated with vertical panels of waterweeds—a trademark of Kashan underglaze ceramics—and a Persian poem around the rim. In its profile the bowl conforms to a characteristic Kashan shape, current about 1200, of which the flaring walls, high ring foot, and angled juncture of wall and foot are the distinguishing traits.

The depiction of fleshy half-palmettes, the reserving of the figures against a dark ground, and the use of minute patterns to depict textiles all relate the bowl to Kashan-style lusterwares of about 1210. As Watson has demonstrated, Kashan luster potters on occasion combined luster and other glazes on the same piece, and lusterwares were fired in the same kilns as wares with turquoise glaze (Watson 1985, 36). Thus, this bowl may have been produced by someone working closely with luster potters, if not by a luster potter himself.

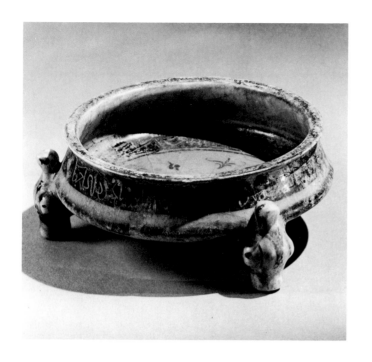

169 *Dish on Three Legs*

Iran, Kashan
Early 13th century
Ceramic, transparent turquoise
glaze, cobalt-blue inglaze,
black underglaze, white frit body,
2⁹/₁₆ × 6⁵/₁₆ (6.6 × 16.0)
86.227.15

Also related to the bowl is the small dish on three bird-shaped feet seen here (cat. no. 169). This dish, which derives from metal prototypes usually identified as incense burners (Pope 1938, pl. 1287B), is decorated on its interior with a central whorl of eight fish, four of which radiate from a center point and four of which form the outer edge of the circle. Four waterweed and stylized floral motifs lie in the area between the central whorl and the inscription band that forms the outer border of the base of the dish. On the exterior below the everted lip runs another Persian inscription which, like its counterpart on the interior, has been scratched through the black underglaze. Because of extensive iridescence, neither inscription is fully legible. A cobalt-blue underglaze band demarcates the transition from wall to base on the exterior of the dish and another runs along its rim. While birds like those that form the feet of the dish often adorn incense burners of various shapes, the fish on the interior suggest that the piece was used to contain liquid of some sort. Although this liquid might have been lamp oil, the contents of such a dish could just as well have been edible or potable.

Both the dish and the bowl illustrate the technological advance toward true underglaze painting. Unlike the cobalt-blue and turquoise pigments of 'Abbasid ceramics, which were painted directly onto the white unfired glaze (see cat. no. 134), the underglaze black and blue pigments of Kashan wares could be applied directly onto the unglazed surface before covering the piece with transparent turquoise or colorless glaze (Watson 1978, 87). Since the pigments of Kashan wares were not immediately absorbed into the glaze and rested on the frit body, the potter could treat them like paint. Thus, Kashan potters had far greater flexibility of design and brushwork than their predecessors. As Watson notes (Watson 1978, 92), although the earliest Iranian underglaze painting developed around 1200, the slip wares of the ninth to eleventh centuries (cat. nos. 146–51) and the champleve and silhouette wares of the eleventh to thirteenth centuries (cat. nos. 152–56) illustrate that Islamic potters had long had an interest in producing bichrome and polychrome ceramics. It wasn't until the development of the fritware body in the eleventh or twelfth century, however, that they finally had the body they needed for true underglaze painting. SRC

Published: Cat. no. 168: Lois Katz, *Asian Art: From the Collections of Ernest Erickson and the Erickson Foundation, Inc.*, exhibition catalogue (The Brooklyn Museum, 1963), cat. no. 47. Cat. no. 169: Katz 1963, cat. no. 50.

Mina'i ware, a luxury ceramic ware unique to Iran, is represented here by two pieces. The name assigned to the ware means enamel and refers to a process in which over-glaze pigments of black, red, white, and gold leaf are fused by means of a second firing to an existing white- or turquoise-glazed ground and an inglaze of cobalt-blue, turquoise, green, and purple decoration. In the bowl here (cat. no. 170) most of this palette has been used to depict a narrative scene of the type associated with pre-Mongol and Il-Khanid manuscript illustration. In the interior of the bowl a royal figure holding a scepter is seated on a throne with an attendant at either side and a crouching dog or wolf at his feet. A cypress entwined by a flowering vine bifurcates the composition, setting off the enthronement group from five petitioners who kneel or stand on a carpet at the right. Another dog or wolf similar to the one on the left strides toward the tree in the foreground. A pond or river teeming with fish forms a proscenium for the main figural grouping, while above, a flock of acrobatic birds swoops and flutters in the sky. The interior border contains an interlace of vertical lines alternating with a floral element. Paired vertical lines and arabesque units decorate the exterior.

Because of a dearth of dated and signed *mina'i* wares, the period and provenance of such pieces have only general parameters. The dated examples range from 1186 to 1242, and the signatures include that of Abu Zaid, the leading luster potter of the early thirteenth century, whose name is found on a piece combining luster and *mina'i* techniques. Since Abu Zaid worked in Kashan, we must assume that at least some *mina'i* wares were produced there. However, they have also been attributed to Rayy and Saveh, and one inscribed piece bears the name of its patron with the nisba, the name referring to the place from which a person or his ancestors comes, "Kirman-shah," a city in Fars, the southern province of Iran (Atil 1973, no. 39).

Indicating different workshops or different periods or both, the pictorial decoration of *mina'i* ware falls into four general categories: large-scale figural scenes with one or two figures; medium-scale figural scenes like cat. no. 170 in which one episode is depicted; small-scale figural scenes with numerous figures engaged in similar activities but compositionally set off from one

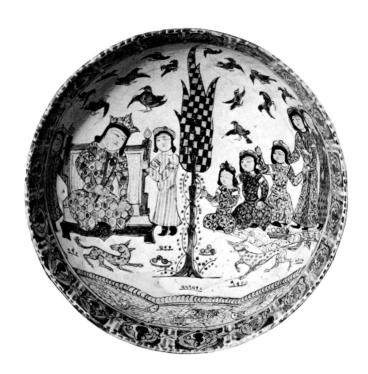

170 *Bowl*

Iran
Late 12th, early 13th century
Ceramic, black, red, gold-leaf over-
glaze, green, brown, yellow,
cobalt-blue, and turquoise in-
glaze, opaque white glaze, white
frit body, 3⅜ × 8½ (9.5 × 21.0)
86.227.61
(Illustrated in color on page 15)

another; and nonfigural compositions consisting entirely or primarily of arabesque or geometric designs over the whole surface of the piece. In addition to cup-shaped bowls like the one here, *mina'i* potters produced jugs, ewers, vases, inkwells, and tiles, often embellishing their pieces with molded elements. Despite the seemingly specific nature of the scenes depicted in cat. no. 170 and many other wares of the second type, only a few of the scenes on these pieces can be linked to historical events or to episodes from the Persian national epic, the *Shahnameh*. As with Fatimid lusterwares, scholars do not agree on whether the patrons of *mina'i* wares were royal or middle-class individuals. Whoever they were, they must have paid large sums for such refined, technically complex wares.

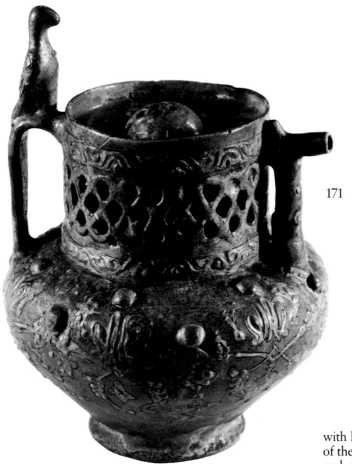

171 *Vase in the Form of
a Pitcher*

Iran
Mid-13th century
Ceramic, white, red, gold-leaf over-
 glaze, opaque transparent glaze,
 7¾ (19.6) high
86.227.67
Provenance: Mrs. Clarence Blair,
 Chicago

In the vase illustrated here (cat. no.
171) we encounter the *mina'i* technique in a
different, probably later manifestation from
that in the bowl. Although the bulbous body,
high neck, spout, and handle of this piece
are typical of a pitcher, the details of its con-
struction suggest that it functioned as a vase.
Instead of being open at the top, it is entirely
closed there except for a round pierced bulb
in the center. Through the openwork trellis
pattern of the neck one can see a cylindrical
element that rises on the interior of the vase
from the base to the shoulder level. This cyl-
inder connects with another pierced bulb at
the bottom. Since the spout joins the shoul-
der, it *is* possible that the piece was used as
a jug. However, the latticework neck and the
bulb at the top lend themselves to the inser-
tion of flower stems. The use of the cylinder
on the interior remains a mystery.

With the exception of the bird on the
handle and the stylized crouching animals
with heads in relief that adorn the shoulder
of the piece, the decoration consists of floral
and geometric motifs, many of which are
molded in relief and painted with white, red,
and gold-leaf overglaze on an opaque tur-
quoise ground. The increased use of molded
elements and gold-leaf overglaze marks an
intermediate step between pre-Mongol
mina'i wares of the late twelfth–early thir-
teenth century and *lajvardina* wares of the
late thirteenth–early fourteenth century.
Thus, cat. no. 171 and works of its style
should be assigned to the mid-thirteenth cen-
tury. Just as the lusterware technique fell into
disuse after the Mongol conquest and was
then revived during this period, *mina'i* pot-
ters might have ceased or slowed production
for ten or twenty years until a new or reestab-
lished class of wealthy patrons again sought
their services. SRC

Published: Cat. no. 170: Lois Katz, *Asian Art: From
the Collections of Ernest Erickson and the Erickson
Foundation, Inc.*, exhibition catalogue (The Brooklyn
Museum, 1963), cat. no. 39. Cat. no. 171: Katz 1963,
cat. no. 44; Koechlin and Migeon 1965, pl. XXIX and
cover.

172 Ten-Pointed Star Tile

Iran
Mid-15th century
Ceramic, gold-leaf overglaze,
 opaque turquoise, cobalt-blue,
 and white glaze, off-white body,
 15 × 14½ × 1¼
 (38.1 × 36.8 × 3.2)
86.227.196

By the twelfth century glazed ceramic tile-work had joined brick and stucco as an important medium of architectural decoration in Iran. The monochrome glazing of the earliest tiles soon gave way to luster and polychrome glazing of small tiles made for interior use and polychrome tile mosaic for both interior and exterior purposes. Because each piece in a tile mosaic had to be cut to fit with those around it, like pieces in a jigsaw puzzle, the mosaic technique was highly complicated and time-consuming. Thus, by the early fifteenth century tilemakers had developed a new technique, cuerda seca, which achieved nearly the same results as tile mosaic with far less effort. Using the cuerda seca technique, the potter would separate differently colored glazes on the tile with "a dark, greasy pigment, which burned dry [in firing] and confined them in their proper areas" (Lane 1957 [1971], 42).

The two halves of this ten-pointed star tile demonstrate the clarity of design made possible by the cuerda seca technique. In the center eight gold lozenges enclose an eight-pointed star. This star is echoed first by the twenty-pointed star formed by the interlaced white and turquoise strips and next by the ten points of the tile itself. The resolution of the interlaced strips into floral and vegetal elements is typical of the interplay of geometric and vegetal ornament found in much fourteenth- and fifteenth-century Iranian architectural decoration.

On the basis of its close relation to a slightly more complex twelve-pointed star tile in The Metropolitan Museum of Art, New York, from the *madrasa*, or school of theology, at Khargird built in 1444–45 (Jenkins 1983, no. 38), the Erickson tile can be safely dated to the mid-fifteenth century. At least two other tiles are identical in design, if not size, to The Metropolitan Museum example. One, in the Victoria and Albert Museum, London, is said to have come from Khamsar near Kashan, but such an attribution does not necessarily refute the mid-fifteenth-century dating of The Metropolitan Museum tile.

Although its present mounting makes the Erickson tile appear as if it had been sawed in half and later rejoined, the potter or architect may have intended to use each half separately along the border of a section of wall. Truncated motifs that imply the continuation of a design are common in Islamic art, and the straight edge of the half-tile would have fit such a use. SRC

173 *Dish*

Iran
Second half 17th century
Ceramic, lusterware, transparent
 colorless glaze, cobalt-blue under-
 glaze, white frit body, 1⅞ × 8¼
 (4.8 × 21.0)
86.227.190

Despite the serious decline of lusterware pro-
duction in the fourteenth century, knowl-
edge of the technique was tenuously main-
tained during the fifteenth and sixteenth cen-
turies before its revival in the second half of
the seventeenth century. This dish exhibits
the physical traits common to many seven-
teenth-century lusterwares: a hard, white
composite body, underglaze cobalt-blue dec-
oration, transparent colorless glaze, and
dark brown luster glaze. Around the central
rosette and leaf design and two narrow con-
centric bands runs a continuous stylized
landscape scene. Here the spiky grasses and
floral sprays recall the bichrome and poly-
chrome wares attributed to seventeenth-cen-
tury Kirman. However, as Lane notes, the
body of such lusterwares is quite different
from that of Kirman pottery (Lane 1957

[1971], 102). Instead the use of cobalt blue
and the notion of depicting a landscape in
the cavetto of the dish derive in a general
sense from Chinese ceramics. In the seven-
teenth century increased trade with China
and the growth of Iranian ports on the Per-
sian Gulf resulted in large numbers of Chi-
nese export ceramics entering Iran, and these
in turn had an immediate stylistic impact on
Iranian ceramic styles.

 Little evidence supports an attribu-
tion of seventeenth-century Iranian luster-
wares to Kirman or any other specific site.
According to Lane, the large proportion of
wine bottles among the lusterwares might
suggest the wine-making center of Shiraz as
the source of such wares, but no inscribed
ceramics or other documentation exists to
support this theory (Lane 1957 [1971],
104). Although the Erickson dish contains a
tassel mark on its foot that eventually may
help to identify its potter or workshop, the
state of knowledge of sixteenth- and seven-
teenth-century Iranian ceramics lags well be-
hind that of medieval wares, making the
specific attribution of a date or place of man-
ufacture for this piece currently impossible.

SRC

174 *Earring*

Western Iran, Iraq, or Syria
11th–12th century
Gold, wire and sheet, granulated
 and filigree decoration, 1¾ × ¹¹/₁₆
 (4.5 × 18)
86.227.127

The study of medieval Islamic jewelry poses more questions of provenance and date than perhaps any other area of Islamic art. Among the most portable and ubiquitous of art forms, jewelry from one part of the Islamic world could easily have been seen and owned by people from other distant Muslim regions. As James Allan notes, not only did trade flourish across the Muslim world, but devout Muslims also made the *hajj*, or pilgrimage, to Mecca, where they mingled with other Muslims from all over the world (Allan 1986, 6). Thus, motifs and techniques of jewelry making are rarely limited to one locale. Even the recent catalogue by Marilyn Jenkins and Manuel Keene, which relates the Islamic jewelry in The Metropolitan Museum of Art, New York, to scientifically excavated examples whenever possible, points up

the difficulty of assigning certain pieces of medieval gold jewelry to specific sites (Jenkins and Keene 1982).

Given the problems with the field of Islamic jewelry as a whole, it is not surprising that the question of the provenance of this gold crescent-shaped, box-constructed earring should puzzle us. In the 1963 catalogue of the Ernest Erickson Asian Collection the piece was attributed to ninth–tenth-century Iran, although the basis for the dating was not clear. The two sides of the earring consist of openwork filigree of twisted wire and granulation. On the exterior face seventeen hemispheres made of sheet and covered with granulation line the outer edge. One such hemisphere punctuates the upper edge of the same face, and larger hemispheres with pyramids of granulation adorn the surface that joins the two faces. To either side of the band of hemispheres run narrower bands of S-shaped twisted wires and loops for enclosing pearls or precious stones. The published pieces to which the earring relates most closely have been variously attributed to Iran, Syria, or Iraq. Jenkins and Keene consider granulated pyramids and hemispheres and loops for pearls to be indicators of Iranian origin (Jenkins and Keene 1982, 72–73). Yet the use of disks instead of long strips of gold to support the filigree derives from common Egyptian practice. Thus, as Jenkins and Keene suggest for several earrings in the collection of The Metropolitan Museum, such a piece must have been manufactured to the west of Iran and the east of Egypt (Jenkins and Keene 1982, 74). In fact, an earring in The Metropolitan Museum of similar shape to the Erickson Collection piece has analogies with earrings in both Iraqi and Syrian museums (Jenkins and Keene 1982, 74). Consequently, a tentative date of the eleventh-twelfth century and an attribution to Syria or Iraq for the Erickson earring would be in keeping with the recent scholarship of Jenkins and Keene. SRC

Published: Lois Katz, *Asian Art: From the Collections of Ernest Erickson and the Erickson Foundation, Inc.,* exhibition catalogue (The Brooklyn Museum, 1963), cat. no. 67.

These four metal objects illustrate the high level of metal production in Iran in the eleventh to fourteenth centuries. Along with silver objects not represented here, such cast bronze and beaten brass objects constitute the great majority of medieval Islamic metalwares. As these wares demonstrate, all sorts of utilitarian objects were fashioned of metal and often embellished with inlaid, traced, or pierced decoration. Furthermore, inscribed examples reveal that the patrons of metal objects ranged from butchers to princes. As with Kashan ceramics of the late twelfth and thirteenth centuries, the finest Iranian metalwork is thought to have been produced in certain regions at certain times and exported to other areas. From the mid-twelfth century until the Mongol invasion in 1220, the province of Khurasan was the leading metalwork center in Iran. But the metalworkers of Khurasan apparently fled from the Mongols, setting up shop first in northwest Iran and by the second quarter of the thirteenth century in northern Mesopotamia. During the fourteenth century, Fars province in southern Iran became the home of a flourishing metalworking industry presumably centered in Shiraz.

The cast bronze foresection of a horse illustrated here (cat. no. 175) poses problems concerning its original function. With a vertical lug on its section that would have fit into an aperture of an adjoining piece, this horse must have been used as the leg of a sizable object. But what sort of object would that have been? Although the most likely candidate is a lampstand or a footed stand used to support a platter, the existing examples of such objects do not include detachable legs in the shape of horses. Moreover, while many three-legged lampstands have legs terminating in hooves, those with animal-shaped legs are quite rare (Pal 1973, no. 278). Still, the lug on the section of the horse is identical to those used to join the various sections of tall lampstands. If the horse did function as the leg of a lampstand it could have belonged to an object of a size and type no longer extant. The engraved mane, ears, blaze, and the roundel on the horse's chest are in keeping with the eleventh- to twelfth-century bronzes of Khurasan in which surfaces are adorned but not entirely covered with decoration. Such an early date may explain the lack of a surviving example of the type of lampstand from which the horse would have come.

175 *Foot in the Form of a Horse*

Iran
11th–12th century
Bronze, cast, engraved, 6¼ × 2⅛
(15.9 × 5.4)
86.227.124

In all media Seljuq art is characterized by a profusion of zoomorphic ornament. Even objects designed for the most grisly purposes, such as the surgical saw seen here (cat. no. 176), were deemed worthy of decoration. Thus, the maker of this bronze implement cast its handle in the form of a lion whose forelegs curve down and into a bird's head. This type of lion with knobs on the ends of its ears appears on a number of twelfth-century incense burners (Baer 1983, fig. 41) as well as on another surgical saw in the Seattle Art Museum (Bowie 1970, no. 260, identifies the animal as a horse). While the lion on the Erickson Collection saw is engraved on his eyes, body, and haunch with curved lines echoed on the square section that joins the handle with the blade, the lion on the more elaborate saw in Seattle is decorated with an allover fish-scale pattern, has a long tail that curves toward his body, terminating in a five-petaled flower, and joins a blade engraved with the repeating phrase "The kingdom is God's." Despite its simpler decoration, the Erickson Collection saw must date from the same period as the Seattle example, i.e. the twelfth century. Although the Seattle saw has been identified as a "ceremonial saw from Gurgan" (Bowie 1970, 47), the type of ceremony in which it might have been used is a mystery, and without knowledge of the conditions in which it was found at Gurgan one cannot attribute its manufacture to that site, a major source of commercial excavations in the 1950s and 1960s.

176 *Saw with Lion-Shaped Handle*

Iran
12th century
Bronze, cast, engraved, 4 × 13½
 (10.2 × 34.3)
86.227.126

177 *Jug*
Iran
First half 13th century
Brass, inlaid with silver, chased and
 engraved, 5½ (14.0) high
86.227.123
Provenance: D.G. Kelekian

233

While the hardness and durability of bronze were suitable for the production of tools such as saws, early Islamic metalworkers preferred to use silver for luxury wares such as cups, bowls, and dishes. By the end of the third quarter of the eleventh century, however, even the minting of silver coins had ceased, signaling a severe shortage of the metal that would continue for two centuries (Allan 1976, 20). To compensate for the lack of silver, metalworkers turned to fashioning vessels of brass and bronze that were embellished with small amounts of silver and copper in the form of inlaid decoration. The earliest dated inlaid bronze is a pen box of 1148 in the Hermitage in Leningrad. By the end of the twelfth century, inlaid objects of the highest quality were being produced in Khurasan and, following the Mongol invasion, in northwest Iran and northern Mesopotamia. Because of the movement of artists and the shared characteristics of the different schools, though, attribution of thirteenth-century inlaid metalwares to a specific site is often difficult and inexact. The inlaid jug illustrated here (cat. no. 177), for instance, the finest metal object in the Erickson Collection, presents just such a problem.

Although its handle is missing, the shape—a high, wide neck, bulbous body, and flaring foot—and the discolored, smooth areas on the neck and body to which the handle was once attached clearly indicate that this vessel functioned as a jug. Its decoration consists of six horizontal bands of varying width containing epigraphic, figural, and geometric embellishment. Around the neck runs an Arabic inscription in human-headed *naskhi* (cursive) script that reads "Glory, success, dominion, safety, happiness, care, and long life to the owner." Another human-headed *naskhi* inscription with two variations on the first (the order of the words for safety and happiness is reversed, and the word "intercession" replaces "care") adorns the foot. Despite the lack of historical information contained in these inscriptions, the style of the human heads recalls two inscribed objects discussed by D.S. Rice (1955 30–31)—a pen case dated 1210 and a slightly later cup, now in Naples. As on the pen case, certain vertical letters are placed at an angle and end in animal heads. As on the cup, the tops of the human heads are flat and their hair is uniformly depicted by a horizontal line across the figures' brows.

On the shoulder of the jug and below the widest section run two bands consisting of cheetahs, dogs(?), and rabbits calmly chasing one another. As Rice has pointed out with regard to similar subjects on the Wade Cup (1955, 10), the animals hardly seem to lust for one another's blood. Rather, they provide movement and a transition from the main decorative band on the body of the jug to its foot and neck. The narrow band between the lower animal frieze and the foot consists of a geometric interlace punctuated by roundels containing harpies, auspicious creatures common on twelfth- and thirteenth-century Iranian metalwork. The theme of the geometric interlace recurs not only in the main decorative band, where it appears in the interstices between roundels, but also on the base of the jug, where it forms a roundel itself.

The main decorative band, ringing the bulge of the body, consists of the twelve signs of the zodiac in roundels on a ground of geometric interlace. The first sign, Aries, appears to the left of the now-missing handle. A comparison of the depiction of the zodiacal signs with those on the Wade Cup (Rice 1955, fig. 13a–f, fig. 14a–f) reveals marked similarities. Not only has the maker of the Erickson jug chosen to conflate the two prevailing zodiacal systems in the same fashion as the maker of the Wade Cup, but the poses of a majority of the tiny figures are extremely similar as well. The only exceptions to the Wade Cup vignettes are Pisces, which consists of two fish forming a border for the missing handle; Cancer, where the moon is not personified as it is on the Wade Cup; and Capricorn and Aquarius, in which the figures face forward and left, respectively, rather than to the right. While representations of the zodiac are common on medieval Islamic metalwork, the close similarities between the Wade Cup and the Erickson Collection zodiacs suggest that these two vessels are close in date and provenance. Thus, if we accept Rice's attribution of the Wade Cup to a northwest Persian workshop of the first third of the thirteenth century, the Erickson Collection jug could not have been made later than 1250, and circa 1240 would be a likely date. As for the iconographic significance of the jug's decoration, each section expresses or symbolizes auspicious sentiments, though a more specific explanation eludes us and may not have been intended in the first place.

178 *Casket*

Iran, Fars province
14th century
Brass, inlaid with silver, chased and
 engraved, 5½ × 4½
 (14.0 × 12.0)
86.227.121
Provenance: André Peytel, Paris;
 Hagop Kevorkian, New York

The fourth metal object here, a brass casket inlaid with silver (cat. no. 178), typifies the work of the fourteenth-century school of Fars province. The piece consists of a lid with a handle, a rectangular box, and four everted feet. The bottom of the box is attached to the sides by six metal strips that intersect the rosettes on the sides. Set amid arabesques, one lobed roundel containing a seated musician decorates each of the short ends of the casket. The front, which would have been intersected by the clasp, now missing, is adorned with two roundels, one with a piper and one with a singer or finger cymbalist. On the back a central roundel of a tambourinist is flanked by two smaller roundels of z-fret patterns. The top of the lid echoes the back with a large central roundel containing a seated drinker and subsidiary roundels of z-fret patterns on either side. A repeating pseudo-inscription on an arabesque ground fills the angled side of the lid, and a braided chain runs along the band of the lid that joins with the box. Despite the loss of much of the silver inlay, the composition relates closely to a group of boxes of this shape containing similar musicians and revelers. The repetition and uniformity of motifs within this group, which is attributed to fourteenth-century Fars, suggest that the nature of patronage of such objects had changed from "custom work" to something more akin to mass production. Although great, personalized inlaid metal objects continued to be made in the fourteenth century, their patrons were preponderantly Mamluk Egyptian and Syrian rather than Iranian.

SRC

Published: Cat. no. 175: Lois Katz, *Asian Art: From the Collections of Ernest Erickson and the Erickson Foundation, Inc.*, exhibition catalogue (The Brooklyn Museum, 1963), cat. no. 62. Cat. no. 176: Katz 1963, cat. no. 61. Cat. no. 177: Parke-Bernet, cat. no. 1479, Dec. 16 and 17, 1953, no. 239; Ackerman 1940, p. 290, case 52F; Katz 1963, cat. no. 65. Cat. no. 178: Ackerman, 1940, p. 289, case 52D; Katz 1963, cat. no. 66.

179 Textile Fragment

Iran
First quarter 17th century
Silk and silver, double cloth,
9½ × 7 (24.1 × 17.8)
86.227.106
Provenance: Kelekian Collection

In order to strengthen the government and economy of the Safavid empire, Shah 'Abbas I, who reigned from 1587 to 1629, encouraged the trade of Iranian goods with Europe. Armenian-Iranian merchants traveled to European markets to sell raw and woven silk, and European fortune hunters, priests, and traders came to Iran in unprecedented numbers in response to the shah's relatively open policy toward them. Thus, Europeans entered the artistic vocabulary of Safavid painters and textile makers, who apparently considered them both exotic and humorous.

This red-and-white silk-and-silver double-cloth fragment, one of at least five in Western collections, demonstrates the technical skill and visual charm of textiles made during 'Abbas I's reign. In the quantity and minuteness of its detail it equals the finest textiles of the period. The main motif of its repeating pattern is a ship with two Europeans standing on either side of the mast and a skipper in a forecastle at each end. Below this are two tub-shaped boats, each containing three Persians, one of whom holds the tiller. Between the boats are a fish and a duck. Although further research is needed to identify the origin of the elaborate standard mounted on the mast, the full dress of the ship with its four flags suggests that the scene represents the arrival of an important European embassy or trade mission at an Iranian port, most likely Bandar 'Abbas, which was developed by Shah 'Abbas after he wrested control of the Straits of Hormuz from Portugal in 1615.

Previous publications have assigned the fragments of this textile to Yazd, circa 1600 (Weibel 1952, 117). While the date cannot be more than twenty-five years early, the attribution to Yazd rests on shaky ground —the assumption that all the early seventeenth-century figural silk double cloths known today were woven or inspired by the weaver Ghiyath of Yazd. In addition, it has been noted that the pattern is equally legible on both sides of the fabric (Welch 1973, 67). While this is true, examination of the textile under magnification reveals that the side on which silver forms the background was intended as the obverse, but because of the loss of silver thread the original texture is gone. Moreover, the dark, or red, faces of the Europeans on this side could not have been intended, since Iranian artists traditionally portrayed only Indians and Africans with dark skin. SRC

Published: Lois Katz, *Asian Art: From the Collections of Ernest Erickson and the Erickson Foundation, Inc.*, exhibition catalogue (The Brooklyn Museum, 1963), cat. no. 77.

180 *Azerbaijan Textile Panel*

Greater Iran, Caucasus
18th century
Linen ground, silk embroidery,
 58 × 48 (147.3 × 121.9)
86.227.109

Although the group of embroideries to which this panel belongs has been attributed to Azerbaijan, they were apparently produced in a more extensive region of the Caucasus and northwest Iran. Five types of Azerbaijan embroideries dating from the late seventeenth to the nineteenth century have been isolated (*Hali* 1985, vol. 7, no. 2, 81). Type 2, of which the piece here is an example, is characterized by embroidery in tent-stitch needlepoint on a linen or cotton ground and by a stylistic relationship with classical Caucasian carpets. A comparison with a dragon carpet in the Erickson Collection (cat. no. 201) reveals a related treatment of lancet and palmette leaves. The central octagon, rosette, or star figures in many similar examples, which are usually dated to the eighteenth century. Produced during a period of political disarray in Iran, these textiles demonstrate a flourishing provincial textile milieu with a wealth of variations on a few themes. SRC

181 *Arjasp's Horsemen Killing Luhrasp, from the "Second Small Shahnameh" of Firdausi*

Iraq, Baghdad
Circa 1300
Opaque watercolors, ink,
 and gold on paper,
 6¾ × 5⅛ (17.2 × 13);
 miniature: 1¹¹⁄₁₆ × 4¾
 (4.3 × 12.1)
86.227.131
Provenance: H.K. Monif

M. Shreve Simpson's recent major study of the group of *Shahnameh* manuscripts from which these illustrations come has contributed greatly to our understanding of the milieu in which they were produced (Simpson 1979). From Dr. Simpson's book we learn that they are from a dispersed manuscript called the "Second *Small Shahnameh*" and represent respectively *Arjasp's Horsemen Killing Luhrasp* (cat. no. 181) and *Bahram Gur at the House of Baharam the Jew* (cat. no. 182). As the result of a lengthy analysis, Simpson attributes three of the four extant *Small Shahnameh* manuscripts to Baghdad, the winter quarters of the Mongol rulers of Iran around 1300. B.W. Robinson has subsequently argued on the basis of certain linguistic and stylistic oddities that all four manuscripts are Sultanate Indian (Robinson 1984, 34). Yet the preponderance of motifs associated with slightly later Mongol

painting in the three manuscripts discussed by Simpson strongly supports her Iranian (i.e. Baghdad) attribution.

In *Arjasp's Horsemen Killing Luhrasp* one of the innumerable battle scenes of the Persian national epic is represented. Here the former Shah of Iran, Luhrasp, has been felled by the soldiers of the leader of the perennial enemy land of Turan, Arjasp. The artist has successfully communicated the urgency of the attack by portraying the horsemen leaning far forward to shoot their arrows at Luhrasp, who has fallen to the ground while his horse gallops away. The round earpieces of the soldiers' helmets are but one of the typical Mongol motifs found repeatedly in the miniatures of the *Small Shahnameh* manuscripts. In illustrations of more peaceful episodes such as *Bahram Gur at the House of Baharam the Jew* the composition is often simpler and the psycholog-

182 *Bahram Gur at the House of Baharam the Jew, from the "Second Small Shahnameh" of Firdausi*

Iraq, Baghdad
Circa 1300
Opaque watercolors, ink, and gold on paper,
6⅝ × 5¼ (16.8 × 13.3);
miniature: 1⁹/₁₆ × 4¹³/₁₆
(4.0 × 12.2)
86.227.130
Provenance: H.K. Monif

ical relationship of the figures more apparent. Here, the king Bahram Gur, who liked to travel incognito, has asked Baharam for a night's lodging. Baharam has consented on the condition that Bahram Gur clean up after his horse and pay for any damage done. As tiny as it is, this painting illustrates the scene exactly as described, with Bahram Gur laying down his sword and saddlecloth while Baharam gestures toward the spot on the floor where his lodger will sleep.　SRC

Published: Cat. no. 181: Lois Katz, *Asian Art: From the Collections of Ernest Erickson and the Erickson Foundation, Inc.*, exhibition catalogue (The Brooklyn Museum, 1963), cat. no. 55; Simpson 1979, p. 379. Cat. no. 182: Katz 1963, cat. no. 56; Simpson 1979, p. 380, fig. 43.

183 *Sufra'i Kills Khushnawaz in a Night Battle, from a "Shahnameh" of Firdausi*

Iran, Shiraz
1341
Watercolors, ink, and
 gold on paper:
 page, $9\frac{1}{2} \times 3\frac{5}{8}$ (24.1 × 9.2);
 miniature, $3\frac{5}{8} \times 9\frac{1}{2}$
 (9.2 × 24.1)
86.227.133
Provenance: H.K. Monif

Whereas the artist of the illustrations to the *Second Small Shahnameh* (cat. nos. 181–82) delighted in rendering figures, textiles, and the trappings of battle in minute detail, the artist of this battle scene has painted with a broad brush. Outlined in black, the major elements of the composition, such as the horses, soldiers, trees, and clouds of dust, have been sketchily colored. Although this effect is increased by the abrasion of the surface, the original paint appears to have been a thin wash in a simple palette of red, gray, orange, brown, and purple with black and gold details.

The colophon of the manuscript from which this miniature comes (ex-Vever Collection, now in the Sackler Gallery of the Center for Asian Art, Washington, D.C.) contains the date 741 A.H./A.D. 1341 and the patron's name, Vazir Qawam al-Din Hasan, first minister of the Inju ruler of Fars province, Abu Ishaq (ruled 1335–53), and patron of the renowned poet Hafiz. Ernst Grube states that the manuscript originally had close to one hundred paintings now in public and private collections in Europe and America (Grube 1962, 31). The Erickson Collection folio is marked in the upper left corner of the recto with the number 246, below which it has been stamped with an upside-down owner's seal, tentatively read in part as "Shaykh Abu Safi."

Despite the symmetry of the composition, the curling waves of dust and the galloping horses give the painting a great sense of movement. Possibly the gray wash within the contours of the dust clouds was intended to convey the nocturnal setting of the battle. The red ground, standard in the miniatures of this manuscript, serves to set off the figures and horses but does nothing to localize the scene. Grube has suggested that the paint-ings of the Inju school may hark back to "ancient Iranian wallpainting," of which almost nothing is known (Grube 1962, 32).

The difference in conception between this work and the *Small Shahnameh* illustrations is obvious in its larger scale as well as in the freedom and simplicity of its rendering. While this style is in keeping with the few extant Inju works of the 1330s, its provincial nature greatly complicates the identification of its sources. Oddly enough, the closest works of art in terms of composition and palette, particularly the uneven red, are *mina'i* bowls of the late twelfth, early thirteenth century (see cat. no. 170). Unfortunately, no documentation exists to prove a real connection between *mina'i* potters who might have fled south to escape the Mongols and the artists who illustrated Inju manuscripts in the 1330s and 1340s.　　SRC

Published: Lois Katz, *Asian Art: From the Collections of Ernest Erickson and the Erickson Foundation, Inc.*, exhibition catalogue (The Brooklyn Museum, 1963), cat. no. 57.

In the second quarter of the sixteenth century, manuscripts with elaborate borders painted in gold on colored paper came into vogue. A small number of early fifteenth-century manuscripts contain human and animal figures in their borders, and even more rarely does decoration in gold appear in the margins of fifteenth-century manuscripts. Nevertheless, the fifteenth-century examples appear to have inspired sixteenth-century artists.

By 1557, the date of the *Yusuf and Zulaikha* manuscript from which this page comes, a second generation of Safavid artists was decorating colored borders with gold. Although the freedom of the earlier examples has given way to a somewhat more regular design, the use of gold still shows remarkable virtuosity. In keeping with the earlier sixteenth-century borders with gold decoration, the recto of this page is painted with an elegant scene of deer, rabbits, foxes, and birds in a landscape. The leaping deer and foxes provide a rhythm matched on the verso by an elegant floral arabesque. In the original manuscript the landscape and animal scene would have faced a similar border while the arabesque would have been placed opposite another arabesque.

According to Friedrich Sarre, the original Western owner of the manuscript from which this page was removed, the scribe was Mahmud ibn Ishaq al-Shihabi of Herat. When the Uzbeks took Herat in 1528, Mahmud and his family were forced to move to Bukhara, where Mahmud studied with the great Herati calligrapher Mir 'Ali. Later he joined the service of Shah Husain Balkhi Shihabi in Balkh and added the title Shihabi to his name. According to the biographer Qāḍi Ahmad, his calligraphy was highly regarded by his contemporaries, but even in his own day it was quite rare because he spent much of his time teaching instead of practicing his art (Qāḍī Aḥmad/Minorsky 1606/1959, 132). SRC

184 *Page from a "Yusuf and Zulaikha" Manuscript*

Scribe: Mahmud ibn Ishaq al-
 Shihabi
Afghanistan, Balkh
1557
Gold on colored paper, ink on paper,
 10⅛ × 6 (26.0 × 15.4)
86.227.192

Published: P.W. Schulz, *Die Persisch-islamische Miniaturmalerei* (Leipzig, 1914), vol. I, p. 105.

الصورة تحتوي على نص فارسي في الأعلى والأسفل

185 *The Friends of 'Ali at the Hunt, from a "Khavarannameh" of Muhammad Ibn Husam*

Iran, Turkman style
Circa 1477
Opaque watercolors and
 ink on paper, 8 × 6⅝
 (20.3 × 16.8)
86.227.132
Provenance: H.K. Monif

In the second half of the fifteenth century, several styles of painting coexisted in Iran. One of these, the Turkman style, is represented in its most characteristic form by the illustrations to a dispersed manuscript of the *Khavarannameh* of Ibn Husam (d. 1470). Modeled on the *Shahnameh*, the *Khavarannameh* details of the life of 'Ali, the most important figure in Shi'a Islam. Apparently the manuscript originally contained one hundred fifty-five miniatures, of which the largest group is in the Museum of Decorative Arts in Tehran and the rest in American and European collections. The colophon, which is dated 1450, may be spurious, but a number of miniatures signed "Farhad" bear the date 1477, a likely date for all the illustrations. Unfortunately the place in which the manuscript was made is not mentioned, thus causing much discussion among art historians. Although some scholars favor the Herat area (most recently Welch 1985, 62), Tabriz or Shiraz seems more likely. The Turkmans controlled both these cities in the second half of the fifteenth century, and early sixteenth-century painting from Tabriz and Shiraz shows a debt to works such as the *Khavarannameh* miniatures.

In both these Erickson Collection paintings the figures are arranged on a ground of clumps of vegetation in which the edges of the leaves are yellow. The faces have sharply delineated features and noses with white highlights. Although later Turkman manuscripts tend toward repetitious, dry compositions, a variety of poses, a rich palette, and attention to detail distinguish the *Khavarannameh* miniatures. Nevertheless, the lack of ruling and borders above and below the miniatures suggests a cursory

186 *Piruz Receives 'Ali, from a "Khavarannameh" of Muhammad Ibn Husam*

Iran, Turkman style
Circa 1477
Opaque watercolors and
 ink on paper, 8¹¹/₁₆ × 6½
 (22.1 × 16.5)
86.227.128
Provenance: H.K. Monif

treatment on some levels. Possibly, as the discrepancy between the dates of the colophon and the paintings would suggest, the manuscript was illustrated twenty-seven years after the scribe wrote it. Thus, the person responsible for making the rulings around the miniatures would not have done his job in concert with the miniature painter as was usually the case.

These two pages are numbered and can be identified in a general sense. In the scene of *The Friends of 'Ali at the Hunt*, page 29, a horseman lassos an onager, or wild ass, in the foreground while his cronies stab a spotted leopard and shoot a wild goat behind him. Although the text describes the hunt and the feast that ensued down to the barbecued kebabs, the names of the hunters are not mentioned. Probably they include Abu'l Mihjan and Malik, 'Ali's boon com-

panions. The enthronement scene (cat. no. 186), page 298, shows King Piruz seated in a tent receiving 'Ali and his soldiers. From the figure at the right who raises his forefinger to his mouth in amazement to the arabesque decoration of the canopy and the figure of 'Ali seated on a stool with his head cocked, the motifs are those that recur throughout the *Khavarannameh* illustrations. Nonetheless, the careful execution and effective composition endow the scene with life and interest. SRC

Published: Cat. no. 185: Lois Katz, *Asian Art: From the Collections of Ernest Erickson and the Erickson Foundation, Inc.*, exhibition catalogue (The Brooklyn Museum, 1963), cat. no. 59. Cat. no. 186: Katz, 1963, cat. no. 58.

187 *Ferangis Returns to Iran with Giv and Her Son, Kai Khusrau, from a "Shahnameh" of Firdausi*

Iran, Shiraz
Late fifteenth, early sixteenth
 century
Opaque watercolors, gold, and ink
 on paper, 9½ × 5⁷⁄₁₆
 (24.1 × 13.7)
86.227.173

In this painting one can observe the debt that the late fifteenth-century Turkman artists of Shiraz owed to the broadly conceived miniatures of earlier Turkman manuscripts such as the *Khavarannameh* (see cat. nos. 185–86). The clumps of light green vegetation, the gold sky, and the cocked head of the figure to the right of the tree all recall the *Khavarannameh* miniature *Piruz Receives 'Ali* (cat. no. 186). Yet here the scale is smaller, the figures slimmer, and the treatment of ornament more cursory. In the sixteenth century, when Shiraz became Iran's main center of commercial manuscript production, large numbers of manuscripts were illustrated there in a manner that was derived from the fifteenth-century Turkman style but that also reflected trends in imperial painting from the court at Tabriz and later Qazwin.

In this illustration, one of four from this *Shahnameh* in the Erickson Collection, Ferangis is depicted returning to Iran after Giv has found her son, Kai Khusrau. The group has resorted to fording the river on horseback because the ferryman asked too much money for the crossing. Small specks of gold paint have been mixed with the watercolor used for the river, causing the water to shimmer when seen in a raking light. The spectators on the horizon and the leaping fish in the river are elements that were later incorporated in the standard repertoire of sixteenth-century Shiraz painting.

SRC

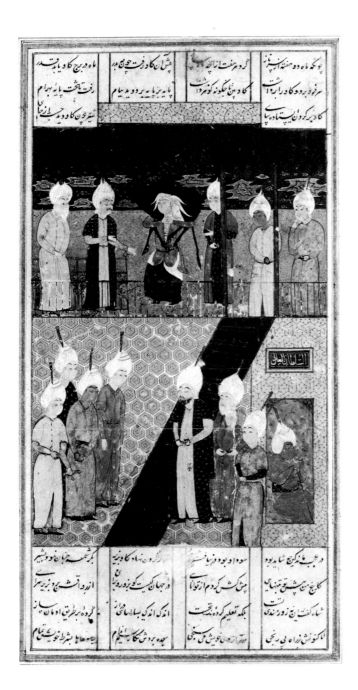

188 *Practice Makes Perfect, from a "Haft Paikar" of Nizami*

Iran, Shiraz
1530–40
Opaque watercolors, gold, and ink
 on paper: page, 11¼ × 7³∕₁₆
 (28.5 × 18.2); miniature,
 5¾ × 4⅛ (14.6 × 10.5)
86.227.150

This popular scene from the *Haft Paikar*, or Seven Thrones, of Nizami depicts Fitnah, the former consort of Bahram Gur, whom he had rejected because she taunted him. Although Bahram Gur ordered one of his servants to kill her, the servant harbored her instead. Determined to win her way back into the king's favor, Fitnah carried a calf up a flight of stairs every day, her strength growing in ratio to the size and weight of the calf. When it was fully grown, news reached Bahram Gur that a certain woman was able to carry a cow upstairs. In disbelief Bahram Gur hastened to observe this feat and discovered to his surprise that the strong woman was none other than Fitnah. Upon reaching the top of the stairs, she quipped, "Practice makes perfect."

Here, Fitnah is shown on the balcony facing Bahram Gur and his servant. The onlookers at her back and below include several dark-faced slaves and a portly servant in the doorway. While the long batons in the men's turbans indicate a sixteenth-century date, the simple composition of the painting underscores its provincial nature. Most likely it was painted at Shiraz in the late 1530s. However, the oddly jagged clouds may point to another, as yet unidentified, source. SRC

189 *Young Man Holding a Cup*

Signed: Muhammad 'Ali
Iran, Isfahan
1650–60
Ink on paper, 4½ × 2¼
(11.4 × 5.7)
86.227.168

In this signed drawing of a *Young Man Holding a Cup*, the mid-seventeenth-century artist Muhammad 'Ali reveals his debt to the paragon of late sixteenth, early seventeenth-century court painting, Riza-yi 'Abbasi. Like Riza, he exploits the calligraphic potential of line by defining contours, such as the youth's shoulder or collar, with a line of varying thickness. Although he was the son of Malik Husayn Isfahani, a painter active in the second third of the seventeenth century, his work has closer affinities with Riza's late oeuvre than with that of his own father. In keeping with the prevailing style of the mid-seventeenth century, he bore down on his brush to produce solid, static forms, while employing an ink wash to depict the sweeping hill in the foreground.

This small drawing exhibits the characteristics of Muhammad 'Ali's style that differentiate it from the work of his contemporaries Muhammad Yusuf and Muhammad Qasim. His youths' eyes are usually large and intelligently focused, and their mouths are often quite broad with well-defined corners. Their sideburns follow a formula in which the part closest to the ear ripples and the front part more or less follows the contour of the cheek. Despite their somewhat lifeless, hard drapery, Muhammad 'Ali's figures have personality, displaying a minimum of the fatuous foppery associated with many mid-seventeenth-century portraits by other artists. SRC

246

*Majnun in the Desert
Pleads with a Hunter to
Free a Fawn, from a
"Layla and Majnun" of
Nizami*

Iran, Khurasan
Dated 24 Dhu'l Hijja 975 A.H./
 January 9, 1578
Bound manuscript, modern leather
 binding, 50 folios, including 3
 miniatures of opaque watercolors,
 gold and ink on paper: binding,
 9¾ × 7¼ (24.8 × 18.4);
 folios, 9½ × 6⅞
 (24.1 × 17.5) each
86.227.191

From 1556 to 1574 Shah Tahmasp (ruled 1525–76) renounced painting, wine, and all other tastes that deviated from the strict adherence to Islamic religious practice. Forced to seek new patrons, many of his finest court artists traveled to Khurasan province to enter the service of his nephew, Sultan Ibrahim Mirza, Governor of Mashhad from 1556 to 1564 and resident of Sabzevar from 1564 to 1574. Although Ibrahim Mirza's artists presumably returned with him to Qazwin, the capital, in 1574, their sojourn in Khurasan had an impact on local artists that lasted for at least a decade.

This small bound manuscript of *Layla and Majnun* of Nizami, dated 1578, contains three miniatures in typical Khurasan style of the 1570s. In the first and second miniatures, *Layla and Majnun at School* and *Majnun at the Ka'ba*, the compositional simplicity associated with Khurasan miniatures is evident. Unlike the commercial manuscripts of Shiraz in the same period, the scale of the figures is large and their number

limited. Moreover, in the school scene the architectural decoration is discreet, with certain areas left entirely unadorned. In the other, most charming of the three miniatures Majnun, the young boy driven mad by his love for Layla, pleads in the desert with a hunter to free the fawn he has caught in a net. The wild animals who befriended Majnun are shown amid rocky outcroppings surrounding a stream fed by a waterfall. The distinctive group of slippery rocks at the lower left recalls those of the Safavid court artists Mirza 'Ali and Shaykh Muhammad during their Mashhad and Sabzevar years. Most likely the anonymous artist of this manuscript was familiar with the work of such artists, even if his own skills and the purse of his patron, one Malik al-Wahāb, did not permit him to equal their efforts.

The Urdu inscription on the modern binding and the English inscription on the flyleaf describe the manuscript's recent provenance as follows: "Given to me by Muh[ammad] Ali [sic] Khan Arif Aghai, a jagudar of the Hyderabad State and Assistant Vazir in the Nazm-i Jamiat at Hyderabad, on the occasion of the coronation of His Majesty the King Emperor, in token of his loyalty and respect." The English inscription is signed by Lord Harding, Viceroy of India, and dated July 1911. The manuscript could have reached India soon after its completion, for a lively market in Persian manuscripts existed in India from the late sixteenth century onward. SRC

191 *Inside Half of a Book Cover*

Iran
16th century
Tooled leather, gilt paper filigrane,
paint and gilding, 18 × 12
(45.7 × 30.5)
86.227.189

In the sixteenth century, bookbinders, like illuminators, expanded their repertory to include landscapes with animals. They used these scenes only on the exterior of book covers, however, for they continued to decorate the insides of bookbindings with geometric and vegetal patterns, albeit in an array of bright colors as on this example.

In order to achieve the allover, orderly pattern seen here, the binder would have stamped the leather with metal dyes and tooled the surface. He then would have painted the cartouches and applied gilt paper filigrane cut into finely interlaced vines and leaves reminiscent of illuminated manuscript pages. The two borders around the main panel consist of cartouches and four-lobed medallions; the embossed gold elements of the inner border contrast effectively with the polychrome elements of the outer border, which is decorated in the same technique as the panel. The similarities between such book covers and illuminated headings and pages underscore the close cooperation that must have existed between the various artists employed in the libraries where books were designed and produced. SRC

192 *Shaped Spandrel Tile*

Turkey, Iznik
1560–70
Ceramic, transparent colorless glaze,
 cobalt-blue, turquoise, black, and
 red underglaze, off-white body,
 5¼ × 8 (13.0 × 20.3)
86.227.183

By the mid-sixteenth century the ceramic kilns of Iznik to the southwest of Istanbul had been producing underglaze-decorated wares for some seventy-five years. First cobalt blue alone and later cobalt blue, turquoise, and green were used for a variety of decorative schemes ranging from formalized arabesques or geometric designs to naturalistically depicted flowers. While tiles were also made, they did not come to dominate Iznik ceramic production until about 1550. At that time, shortly after the restoration of the exterior of the Dome of the Rock in Jerusalem (1545–46) and coincidental with the construction of the vast Suleymaniye Complex in Istanbul (1550–57), the output of tiles increased dramatically. For the rest of the sixteenth century and the first quarter of the seventeenth, a vogue prevailed for decorating the interiors of all sorts of public and private buildings with the underglaze-painted tiles of Iznik.

Contemporary with this fashion came the discovery of an effective way to add red to the potter's palette, resulting in colorful tiles of the type represented here. This tomato red, called Armenian bole, was applied thickly to the robust off-white ceramic body of the tiles and essentially held in place by the transparent glaze. At first the red was used sparingly for details, but by about 1575 it was applied extensively and at times was the predominant color on a tile or vessel.

Despite the large number of Iznik tiles in public and private collections, surprisingly little is known about the specific buildings for which they were made. Apparently extra tiles were produced for the large mosques, but the majority of tiles in museums and private collections must have come from destroyed or renovated buildings. Thus, the precise provenance of the tiles here remains a mystery. Nonetheless, the presence of red pigment in cat. nos. 192–95 and the highly naturalistic treatment of flowers, leaves, and grapes in cat. nos. 192, 193, and 194 enable us to date them to the second half of the sixteenth century.

Because of the limited use of red, cat. no. 192 is probably the earliest of the group,

datable to the 1560s. In addition to carnations, which along with tulips were a favorite flower of Ottoman artists in all media (see cat. no. 197), its decoration includes clusters of grapes. Although early sixteenth-century blue-and-white Iznik bowls often contained grape clusters in imitation of Ming Chinese blue-and-white wares, such grape cluster and leaf decoration in polychrome is rarely found on tiles. The curling vine tendrils and disposition of the leaves here exhibit the naturalism associated with mid-sixteenth-century Iznik wares.

Similarly, the wavy sprays of hyacinth, rose, and carnation in cat. no. 194 evoke the freshness of a garden in spring. Since it is bordered on top with a floral rinceau on a cobalt-blue ground, this tile may have fit into the upper row of a dado panel. Its brilliant red roses underscore the increasingly bold use of the tomato-red pigment and suggest a date in the 1570s or later.

The fourth tile in this Iznik group (cat. no. 195) reveals yet another aspect of the tilemaker's decorative vocabulary. Here the continuous pattern of a formal yet dynamic leaf and vine arabesque is punctuated by a central trefoil and leaf design.

As one might expect with regard to extensive tile programs designed for large buildings, the potters used cartoons for some, if not most, of their tiles, thus ensuring a high degree of standardization. Another tile from the same frieze as cat. no. 195 (Petsopoulos 1982, cover illustration) demonstrates the consistency attained in the best of the Iznik tile friezes. Datable to about 1575, these tiles with their brick-red background and rhythmic blue-and-white decoration epitomize the third great style of Iznik ceramics, which have remained consistently desirable to collectors since the time they were made.

By the end of the seventeenth century the once flourishing kilns of Iznik had all but disappeared. As John Carswell has pointed out, their decline coincided with the disarray of the Ottoman sultanate in the mid-seventeenth century when the Turks became more concerned with "keeping the empire together, rather than engaging in expansionist enterprises" (Carswell 1982, 86). To salvage what was left of the ceramic industry the Ottoman sultans had the remaining potters of Iznik brought to Tekfur Saray in Istanbul, where they revived earlier Iznik designs on tiles.

193 *Rectangular Tile*

Turkey, Iznik
1560–70
Ceramic, transparent colorless glaze,
 cobalt-blue, green, and red under-
 glaze, off-white body, 8¾ × 3½
 (22.2 × 8.9)
86.227.198

194 *Tile* (Top)

Turkey, Iznik
1570–75
Ceramic, transparent colorless glaze,
 cobalt-blue, turquoise, and red
 underglaze, off-white body,
 13⅛ × 12⅞ (33.3 × 32.7)
86.227.185

195 *Rectangular Tile* (Bottom)

Turkey, Iznik
Circa 1575
Ceramic, transparent colorless glaze,
 cobalt-blue, black, and red under-
 glaze, off-white body, 6⅛ × 9⅞
 (15.7 × 25.2)
86.227.142

196 *Hexagonal Tile*

Turkey, Tekfur Saray
18th century
Ceramic, transparent turquoise
 glaze, black underglaze, off-white
 body, 10⅜ × 10⅜
 (26.4 × 26.4)
86.227.194

Cat. no. 196 typifies the production
of Tekfur Saray in its uneven turquoise glaze
over black and its use of the classic *chinta-
mani* motif. This motif, which in its purest
form consists of a cluster of three balls and

a pair of wavy lines, became quite popular
as an Ottoman textile design in the fifteenth
century and continued in use on textiles and
ceramics into the 1700s. Walter Denny as-
serts that it originated in a Buddhist Chinese
context as a representation of "pearls borne
on the waves of the sea," a symbol of power
and good luck (Denny 1982, 126). Sub-
sequently, especially following the Mongol
conquest of Iran, the balls developed into
crescents as here and the motif itself gained
additional connotations. The underlying
symbolism, however, remained basically
"masculine and heroic" (Denny 1982, 128).

SRC

197 *Velvet Panel*

Turkey
17th century
Cut velvet, silk and silver, 55 × 23
 (139.7 × 58.4)
86.227.108

Among the numerous arts of Ottoman Tur-
key collected by Westerners, Bursa velvets
have ranked high since the fifteenth century.
Located southeast of Istanbul in Bithynia,
Bursa was a major center of textile manufac-
ture and trade and a depot for silk cocoons
imported from Iran. The Ottoman textile
industry was organized both there and in
Istanbul according to a guild system tightly
controlled by the government in order to
maintain high quality and collect taxes on
the lucrative trade with Europe.

Flowers, particularly carnations and
tulips, played a central role in Ottoman tex-
tile design, and great numbers of silver and
cut-red velvet lengths comparable to the
piece here have survived. As Walter Denny
has pointed out, two examples are rarely
identical despite their "superficial similari-
ties" (Denny in Petsopoulos 1982, 129). Be-
cause documentation that would lead to pre-
cise dating of these velvets is lacking, one
must turn to the seemingly endless variations
of their details for clues to their chronology.
The dating of this velvet to the early seven-
teenth century is thus based on its simplified
stem and leaves and the inclusion of a bul-
bous ovary not evident in velvets assigned to
the first half and middle of the sixteenth cen-
tury (Denny in Petsopoulos 1982, pl. 1).
Pieces like this were used as decorative panels
on walls or were cut to form for clothes or
furnishings. SRC

253

198 *Star Ushak Carpet*

Turkey
17th century
Wool, 136 × 75
 (345.3 × 190.5)
86.227.114

We know from the appearance of star Ushak carpets in European paintings that they were being produced by the first third of the sixteenth century. As for medallion Ushak carpets, they began to be made slightly later in that century. Yet despite the attribution of these carpets to Ushak, a town in western Anatolia, there is no evidence for Ushak having been a carpet-making center until the seventeenth century.

The star Ushak carpet illustrated here (cat. no. 198) displays the standard design of the star Ushak group—an eight-pointed star enclosing a white interlace repeated in the field. The corner elements suggest a repeat of the star with less pronounced points, and a floral band fills the border. Both star and medallion Ushak carpets derived their floral and arabesque motifs from Persian carpets whose designs were far more curvilinear than the traditional angular, geometric ornament of Turkish carpets.

199 *Medallion Ushak Carpet*

Turkey
17th century
Wool, 204 × 100
 (518.5 × 259.1)
86.227.113
Provenance: Collection of U. & L.
 Benquiat; Collection of I. Zado
 Noorian

The influence of Persian carpets is especially notable in Ushak medallion carpets. As with the Persian prototypes, for example, the field of the Ushak medallion carpet seen here (cat. no. 199) contains a central medallion with small pendants above and below it. The partial star medallions on the sides of the field and the repeated ogival medallions at the ends, however, deviate from the partial repeats of medallions that fill the corners of the field on the Persian models. Moreover, the strongly contrasting palette of the red medallion on a rich blue field containing a bold white floral arabesque differs markedly in sensibility and from the subtle interplay of color design found on sixteenth-century Persian carpets. Despite the areas of repair on this medallion Ushak carpet, it remains a noble example of the fine art of Turkish weavers.

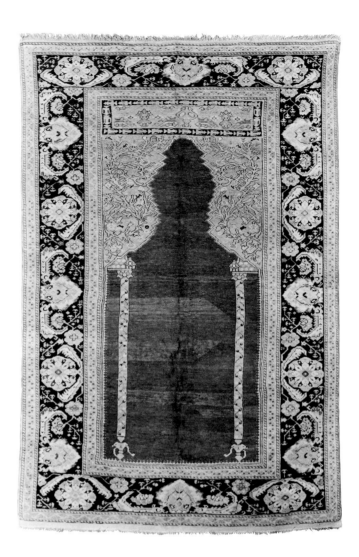

200 *Ghiordes Prayer Rug*

Turkey
19th century
Wool, 70 × 48
 (180.4 × 122.0)
86.227.118

Nineteenth-century carpets of Turkey often contain motifs that echo the court-manufactured rugs of the sixteenth and seventeenth centuries. In its composition, for instance, the Ghiordes prayer rug illustrated here (cat. no. 200) conforms to a traditional type consisting of a prayer niche flanked by columns in the field and a wide floral border within two lesser borders. The branching arabesque in the spandrel of the prayer niche recalls the far more naturalistic arabesque in the field of the earlier medallion carpet, while the rather stiff flower-and-leaf design in the border ultimately derives from the flower-and-leaf borders of sixteenth-century prayer rugs like the prime example in The Metropolitan Museum of Art, New York (Mackie 1974, pl. I). Over time the mosque lamps included in the niches of many prayer rugs were transformed into ewers, such as those

used for ritual ablutions. By the nineteenth century the religious function of these ewers seems to have been forgotten, and they appear, as in this carpet, as supports for columns and as a repeating motif in the border of a decorative band above the niche. Compared to Ottoman carpets of the sixteenth and seventeenth centuries, Ghiordes rugs of the nineteenth century seem stiff and naive. Nonetheless, the appreciation for such commercially produced carpets has continued unabated both in Turkey and abroad.

SRC

Published: Cat. no. 198: Anderson Galleries, December 4–5, 1925, no. 31; Parke-Bernet, cat. no. 402, November 4–6, 1942, lot 522; Lois Katz, *Asian Art: From the Collections of Ernest Erickson and the Erickson Foundation, Inc.*, exhibition catalogue (The Brooklyn Museum, 1963), cat. no. 80. Cat. no. 199: Katz 1963, cat. no. 84.

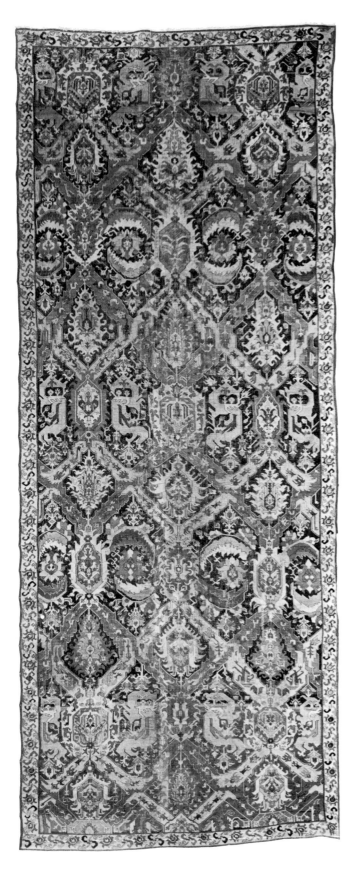

201 *Dragon Carpet*

Caucasus
Late 17th, early 18th century
Wool, Ghiordes knot: field, cream,
 yellow, green, blue, and red on
 blue ground; border, yellow, gold,
 green, blue, red, and brown on
 white ground, 274 × 106
 (696.4 × 264.8)
86.227.115

In keeping with his program to develop foreign trade, Shah 'Abbas I (ruled 1587–1629) established commercial carpet manufactories in the Caucasus in the early seventeenth century. Although there are only a few extant rug fragments that can be attributed to that time, the existence of a large number of eighteenth-century dragon carpets attests to the success of Shah 'Abbas's venture. The dragon carpet here (cat. no. 201) exhibits a characteristic design associated with the early eighteenth-century group: a lattice pattern of overlapping serrated bands that form compartments containing palmettes, dragons, or lancet leaves. As the style of Caucasian dragon carpets developed, the dragons and other animals became increasingly stylized or were replaced by floral motifs. Thus, where a seventeenth-century example would alternate dragons with a lion and a *ch'i-lin* pair, this carpet contains two lancet leaves enclosing a palmette. Charles Ellis has proposed that the basic composition of Caucasian dragon carpets derives from "a lost group of Kirman rug designs . . . allied to the vase carpets, but which contained many animal forms" (Ellis 1975, 13), whereas the dragons and other animals ultimately recall Chinese motifs brought West in the Mongol conquest.

202　*Floral Carpet*

Caucasus, Karabagh region
19th century
Wool, Ghiordes knot, 183 × 88
 (464.8 × 223.5)
86.227.103

Just as a stylization process took place within the dragon carpet group, so certain nineteenth-century Caucasian carpets echo their eighteenth-century predecessors. Thus, the second carpet here (cat. no. 202), tentatively attributed to Karabagh, features a design of highly geometric lancet leaves springing from diamond medallions that is evidently inherited from a mid- to late eighteenth-century Karabagh type called a "cypress carpet" (Ellis 1975, pl. 24). In the prototype, the lancet leaves spring from the sides of the diamonds while cypress trees grow from their points. In the Erickson example, extremely stylized trees are contained in the cartouches between the diamonds, and, as with many of the eighteenth-century cypress carpets, the ground is red. Yet the refinement and prettiness of the earlier version have given way to a stiff, muscular style.

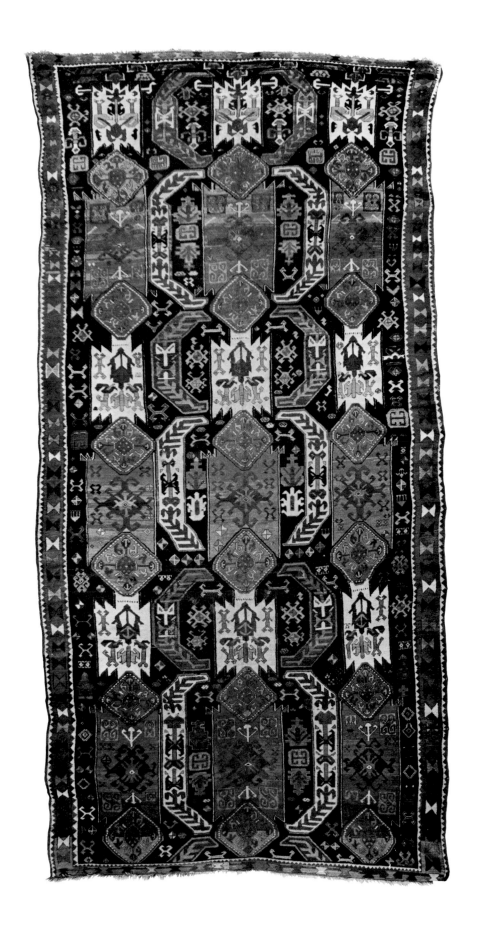

259

203 *Palmette Carpet*

Caucasus
Early 19th century
Wool and silk, Ghiordes knot: field,
white, light blue, and yellow on
dark blue ground; border, yellow
and green on red ground,
129 × 73 (327.8 × 185.5)
86.227.116

Related to Caucasian carpets, the
third carpet here (cat. no. 203), presents
problems of attribution and dating. The
group of palmette carpets from which it
comes has been variously assigned to the
Caucasus and northwest Iran, and this at-
tribution is confused by the similarity in de-
sign between pieces with Senna knots, a sign
of Iranian manufacture, and others with
Ghiordes knots, a characteristic of the
Caucasus and Turkey. Since the Erickson
piece has Ghiordes knots, it is attributed here
to the Caucasus. Charles Ellis has noted that
in addition to the customary wool, and later
cotton, of Caucasian carpets, the Erickson
carpet contains silk in its foundation (Ellis
1975, 21). The presence of this silk, together
with the carpet's small size, may indicate a
nineteenth-century date, though the design
with its rows of palmettes is extremely clear
and the weaving fine. Ellis has suggested that
the composition of the palmette carpets was
inspired by Turkish velvets or brocades (see
cat. no. 197). SRC

Published: Cat. no. 201: Lois Katz, *Asian Art: From
the Collections of Ernest Erickson and the Erickson
Foundation, Inc.*, exhibition catalogue (The Brooklyn
Museum, 1963), cat. no. 83. Cat. no. 203: Katz 1963,
cat. no. 82; Ellis 1975, fig. 18.

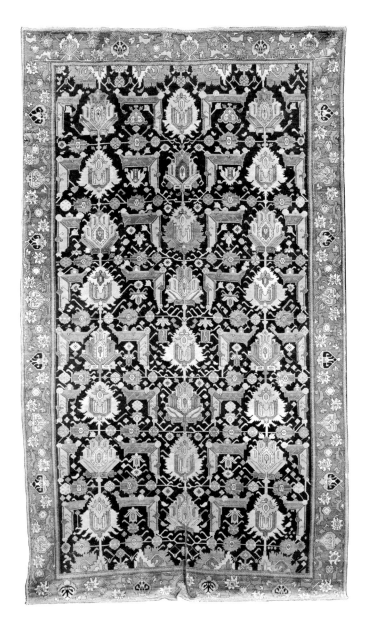

Works Cited: Islamic Art

Ackerman 1940 Phyllis Ackerman, *Guide to the Exhibition of Persian Art*, exhibition catalogue (Iranian Institute of America, New York, 1940).

Allan 1976 James W. Allan, "Silver: The Key to Bronze in Early Islamic Iran," *Kunst des Orients*, XI, 1 (1976), 5–21.

Allan 1986 James W. Allan, "Islamic Jewellery and Archaeology," *Islamic Jewellery*, exhibition catalogue (Spink and Son, Ltd., London, 1986), 5–16.

Atil 1973 Esin Atil, *Ceramics from the World of Islam*, exhibition catalogue (Freer Gallery of Art, Washington, D.C., 1973).

Atil 1981 Esin Atil, *Renaissance of Islam: Art of the Mamluks*, exhibition catalogue (Smithsonian Institution, Washington, D.C., 1981).

Bahrami 1949 Mehdi Bahrami, *Gurgan Faiences* (Cairo, 1949).

Bowie 1970 Theodore Bowie, *Islamic Art Across the World*, exhibition catalogue (Indiana University Art Museum, Bloomington, 1970).

Caiger-Smith 1985 Alan Caiger-Smith, *Lustre Pottery* (London, 1985).

Carswell 1982 John Carswell, "Ceramics," *Tulips, Arabesques & Turbans*, edited by Yanni Petsopoulos (New York, 1982).

Combe 1940 Etienne Combe, "Tissus Fatimides du Musée Benaki," *Mélanges Maspero III, Mémoires de l'Institut Français d'Archéologie Orientale*, 68 (1940).

Daneshvari 1982 Abbas Daneshvari, "Symbolism of the Rabbit in the Manuscript of Warqa Wa Gulshah," *Islamic Art and Architecture* I, *Essays in Islamic Art and Architecture in Honor of K. Otto-Dorn* (Malibu, 1982), 21–28.

Denny 1982 Walter Denny, "Textiles," *Tulips, Arabesques & Turbans*, edited by Yanni Petsopoulos (New York, 1982).

Ellis 1975 Charles Grant Ellis, *Early Caucasian Rugs*, exhibition catalogue (The Textile Museum, Washington, D.C., 1975).

Ettinghausen 1960 Richard Ettinghausen, *Medieval Near Eastern Ceramics in the Freer Gallery of Art* (Washington, D.C., 1960).

Fehervari 1973 Geza Fehervari, *Islamic Pottery: A Comprehensive Study Based on the Barlow Collection* (London, 1973).

Grabar 1957 Oleg Grabar, *The Coinage of the Tulunids*, Numismatic Notes and Monographs, no. 139 (New York, 1957).

Grabar 1972 Oleg Grabar, "Imperial and Urban Art in Islam: The subject matter of Fatimid Art," *Colloque International sur l'Histoire du Caire* (Cairo, 1972), 173–89.

Grube 1962 Ernst J. Grube, *Muslim Miniature Paintings* (Venice, 1962).

Grube 1976 Ernst J. Grube, *Islamic Pottery of the Eighth to the Fifteenth Century in the Keir Collection* (London, 1976).

Hali 1985 Ernest J. Grube, "Azerbaijan Prices," *Hali*, 7, 2, issue 26 (April–June 1985), 80–81.

A.R.H.[all] 1934 A.R. H[all], "The Persian Expedition, 1934," *Bulletin of the Museum of Fine Arts, Boston*, 33, 198, 55–59.

Jenkins 1967 "The Palmette Tree: A Study of the Iconography of Egyptian Lustre Painted Pottery," *Journal of the American Research Center in Egypt*, 6 (1967), 65–84.

Jenkins 1968 Marilyn Jenkins, "Muslim, an Early Fatimid Ceramist," *The Metropolitan Museum of Art Bulletin*, N.S. 26 (1967–68).

Jenkins 1983A Marilyn Jenkins, *Islamic Art in the Kuwait National Museum* (London, 1983).

Jenkins 1983B Marilyn Jenkins, "Islamic Pottery, A Brief History," *The Metropolitan Museum of Art Bulletin*, N.S. 40 (Spring 1983), 1–52.

Jenkins and Keene Marilyn Jenkins and Manuel Keene, *Islamic Jewelry in The Metropolitan Museum of Art*, exhibition catalogue (The Metropolitan Museum of Art, New York, 1982).

Koechlin and Migeon 1956 Raymond Koechlin and Gaston Migeon, *Cent Planches en Couleurs, Art Musulman*, edited by Yvonne Brunhammer (Paris, 1956).

Kuhnel and Bellinger 1952 Ernst Kuhnel and Louisa Bellinger, *Catalogue of Dated Tiraz Fabrics* (Washington, D.C., 1952).

Lane 1947 Arthur Lane, *Early Islamic Pottery* (London, 1947).

Lane 1957	Arthur Lane, *Later Islamic Pottery* (London, 1957).
Mackie 1974	Louise W. Mackie, *Prayer Rugs*, exhibition catalogue (The Textile Museum, Washington, D.C., 1974).
Migeon 1927	Gaston Migeon, *Manuel d'Art Musulman* 2 (Paris, 1927).
Pal 1973	Pratapaditya Pal, ed., *Islamic Art*, exhibition catalogue (Los Angeles County Museum of Art, 1973).
Petsopoulos 1982	Yanni Petsopoulos, ed., *Tulips, Arabesques & Turbans* (New York, 1982).
Philon 1980	Helen Philon, *Early Islamic Ceramics, ninth to late twelfth centuries* (London, 1980).
Pope 1938	Arthur Upham Pope, *A Survey of Persian Art* (New York, 1938).
Qāḍī Aḥmad/Minorsky 1959	Qāḍī Aḥmad, translated by V. Minorsky, *Calligraphers and Painters* (Washington, D.C., 1959).
Rice 1955	D.S. Rice, *The Wade Cup in the Cleveland Museum of Art* (Paris, 1955).
Robinson 1984	B.W. Robinson, "Areas of Controversy in Islamic Painting: Two Recent Publications," *Apollo* (July 1984), 32–35.
Sarre 1925	Friedrich Sarre, *Die Keramik von Samarra, Die Ausgrabungen von Samarra*, 2 (Berlin, 1925).
Schnyder 1973	R. Schnyder, "Mediaeval Incised and Carved Wares from North West Iran," *The Art of Iran and Anatolia, Colloquies on Art & Archaeology in Asia* 4 (London, 1973), 85–95.
Simpson 1979	Marianna Shreve Simpson, *The Illustration of an Epic: The Earliest Shahnama Manuscripts* (New York, 1979).
Volov 1966	Lisa Volov, "Plaited Kufic on Samanid Epigraphic Pottery," *Ars Orientalis*, 6 (1966), 107–34.
Watson 1978	Oliver Watson, "Persian Silhouette Ware and the Development of Underglaze Painting," *Decorative Techniques and Styles in Asian Ceramics, Colloquies on Art & Archaeology in Asia* 8 (London, 1978), 86–103.
Watson 1985	Oliver Watson, *Persian Lustre Ware* (London, 1985).
Weibel 1952	Adele Weibel, *Two Thousand Years of Textiles* (New York, 1952).
Welch 1973	Anthony Welch, *Shah 'Abbas and the Arts of Isfahan*, exhibition catalogue (Asia House Gallery, New York, 1973).
Welch 1985	Anthony Welch, in Musée d'art et d'histoire, Geneva, *Treasures of Islam*, exhibition catalogue (Musée Rath, Geneva, 1985).
Whitehouse 1979	"Islamic Glazed Pottery in Iraq and the Persian Gulf: The Ninth and Tenth Centuries," *Annali dell'Istituto Orientale di Napoli*, 39, N.S. XXIX (1979), 45–62.
Wilkinson 1973	Charles K. Wilkinson, *Nishapur: Pottery of the Early Islamic Period* (New York, 1973).

Other Works

This list of works in the Erickson Collections at The Brooklyn Museum that are not in the exhibition is arranged by collection in the following order: Ancient Andean art, Central American art, North American Indian art, Oceanic art, African art, Ancient Egyptian art, Ancient Iranian art, Indian and Southeast Asian art, Islamic art, and Decorative Arts. Dimensions of the artworks are given first in inches then in centimeters; height precedes width precedes depth.

Ancient Andean Art

Garment Border Fragment
Peru, South Coast, Paracas
300–100 B.C.
Wool, 18¾ × 21 (47.6 × 53.3)
86.224.105

Garment Border Fragment
Peru, South Coast, Paracas
300–100 B.C.
Wool, 39 × 6½ (99 × 16.5)
86.224.102

Garment Border Fragment
Peru, South Coast, Paracas
300–100 B.C.
Wool, 16⅞ × 6⅞ (42.9 × 17.5)
86.224.98

Mantle Border Fragment
Peru, South Coast, Paracas
300–100 B.C.
Wool, 74 × 7 (188 × 17.8)
86.224.111

Mantle Fragment
Peru, South Coast, Paracas
300–100 B.C.
Wool, 12¼ × 10½ (31.1 × 26.7)
86.224.96

Border Fragment
Peru, South Coast, Paracas
300–100 B.C.
Wool, 5¹¹⁄₁₆ × 3¾ (14.5 × 9.5)
86.224.97

Textile Fragment
Peru, South Coast, Paracas
300–100 B.C.
Wool, 13⅜ × 6¹¹⁄₁₆ (34 × 17)
86.224.99

Mantle
Peru, South Coast, Paracas
300–100 B.C.
Wool, 110 × 48½ (281 × 124)
86.224.90

Mantle
Peru, South Coast, Paracas
300–100 B.C.
Wool, 34⅝ × ¾ (88 × 1.9)
86.224.128

Poncho
Peru, South Coast, Paracas
300–100 B.C.
Wool, 21¾ × 23¼ (55.2 × 59.1)
86.224.95

Shawl
Peru, South Coast, Paracas
300–100 B.C.
Cotton, wool, 91⁷⁄₁₆ × 14¹⁵⁄₁₆
 (232.2 × 38)
86.224.69

Effigy Vessel
Peru, South Coast, Nasca
200–700
Ceramic, polychrome slip,
 5¹¹⁄₁₆ × 7¹⁄₁₆
 (14.5 × 7.5 × 18)
86.224.54

Effigy Vessel
Peru, South Coast, Nasca
300–600
Ceramic, polychrome slip,
 7¼ × 6¼ × 5⅝
 (18.4 × 15.9 × 14.3)
86.224.12

Effigy Vessel
Peru, South Coast, Nasca
300–600
Ceramic, polychrome slip, 5¼ × 4
 (13.6 × 10.4)
86.224.115

Figure
Peru, South Coast, Nasca
300–600
Ceramic, polychrome slip,
 10³⁄₁₆ × 3¾
 (27.5 × 9.5)
86.224.58

Bowl
Peru, South Coast, Nasca
200–700
Ceramic, polychrome slip, ⅝ × 5⁹⁄₁₆
 (1.6 × 14.2)
86.224.52

Bowl
Peru, South Coast, Nasca
200–700
Ceramic, polychrome slip, 3¼ × 4¾
 (8.2 × 12)
86.224.56

Bowl
Peru, South Coast, Nasca
200–700
Ceramic, polychrome slip, 2⁷⁄₁₆ × 5⅝
 (6.2 × 14.3)
86.224.53

Double-spout Vessel
Peru, South Coast, Nasca
300–500
Ceramic, polychrome slip, 6½ × 5⅛
 (16.5 × 13)
86.224.6

Jar
Peru, South Coast, Nasca
100–300
Ceramic, polychrome slip, 3¾ × 4¾
 (9.5 × 11.9)
86.224.114

Jar
Peru, South Coast, Nasca
100–300
Ceramic, polychrome slip, 5 × 6⅛
 (12.7 × 15.6)
86.224.169

Jar
Peru, South Coast, Nasca
300–500
Ceramic, polychrome slip, 6 × 3¾
 (15.2 × 9.5)
86.224.8

Jar
Peru, South Coast, Nasca
300–600
Ceramic, polychrome slip, 7¹¹⁄₁₆ × 4½
 (19.5 × 11.5)
86.224.9

Jar
Peru, South Coast, Nasca-Huari
600–900
Ceramic, polychrome slip,
 3¹⁵⁄₁₆ × 2³⁄₁₆ (10 × 5.5)
86.224.7

Head Ornament
Peru, South Coast, Nasca
300–600
Cotton, hair, 15¾ × 10¼ (40 × 26)
86.224.60

Textile
Peru, South Coast, Nasca
300–600
Wool, 22¹/₁₆ × 14⁹/₁₆ (56 × 37)
86.224.28

Textile
Peru, South Coast, Nasca
300–600
Wool, 56⁵/₁₆ × 17¹¹/₁₆ (143 × 45)
86.224.2

Plaque
Peru, North Coast, Moche
100–300
Gilded copper, cotton, 11¾ × 5½
 (29.9 × 13.9)
86.224.193

Mask
Peru, North Coast, Moche
100–300
Copper, 7¹¹/₁₆ (19.5) high
86.224.198

Figurine
Peru, North Coast, Moche
100–300
Copper, 3 × 1⁹/₁₆ (7.7 × 4)
86.224.190

Effigy Vessel
Peru, North Coast, Moche
200–700
Ceramic, 9¹/₁₆ × 7⁵/₁₆ (23 × 18.5)
86.224.44

Effigy Vessel
Peru, North Coast, Moche
200–500
Ceramic, bichrome slip,
 5¹¹/₁₆ × 1¾ × 2¾
 (14.5 × 4.5 × 7)
86.224.55

Effigy Vessel
Peru, North Coast, Moche
200–700
Ceramic, bichrome slip, 9¹/₁₆ × 6¹¹/₁₆
 (23 × 17)
86.224.45

Effigy Vessel
Peru, North Coast, Moche
200–500
Ceramic, bichrome slip, 9½ × 5½
 (24.2 × 13.9)
86.224.116

Portrait Head Vessel
Peru, North Coast, Moche
200–500
Ceramic, bichrome slip,
 13 × 6½ × 5⅛
 (33 × 16.5 × 13)
86.224.180

Portrait Head Vessel
Peru, North Coast, Moche
200–500
Ceramic, slip, 10¹/₁₆ × 7¹/₁₆ × 8¹¹/₁₆
 (25.5 × 18 × 22)
86.224.80

Stirrup-spout Vessel
Peru, North Coast, Moche
200–700
Ceramic, 9¹³/₁₆ × 6⁵/₁₆ (25 × 16)
86.224.43

Stirrup-spout Vessel
Peru, North Coast, Moche
200–500
Ceramic, bichrome slip, 10¼ × 6⁵/₁₆
 (26 × 16)
86.224.47

Stirrup-spout Vessel
Peru, North Coast, Moche
100–700
Ceramic, bichrome slip, 9¹³/₁₆ × 5½
 (25 × 14)
86.224.46

Portrait Head Vessel
Peru, North Coast, Moche style
Authenticity uncertain
Ceramic, bichrome slip,
 11 × 4½ × 7⁵/₁₆
 (28 × 10.8 × 19.4)
86.224.10

Textile Border
Peru, Huari
600–900
Cotton, wool, 28¹⁵/₁₆ × 6⅛
 (73.5 × 15.5)
86.224.73

Textile Border
Peru, Huari
600–900
Cotton, wool, 13 × 6⁵/₁₆ (33 × 16)
86.224.72

Textile Fragment
Peru, Huari
600–900
Cotton, wool, 17⅛ × 15⅜
 (43.5 × 39)
86.224.71

Cap
Peru, Huari
800–1000
Wool, 3⅛ × 4½ (8 × 11.5)
86.224.91

Spoon
Peru, South Coast, Ica(?)
1000–1470
Silver, 3¹/₁₆ × 1⅝ (7.8 × 4.2)
86.224.86

Jar
Peru, Central Coast, Chancay
1000–1400
Ceramic, slip, 15¹⁵/₁₆ × 4⅛
 (40.5 × 10.5)
86.224.135

Textile
Peru, Central Coast
1000–1400
Cotton, 31⅛ × 7¹¹/₁₆ (79 × 19.5)
86.224.138

Textile
Peru, Central Coast
1000–1400
Cotton, 37¹³/₁₆ × ⁷/₁₆ (96 × 1)
86.224.129

Textile Strip
Peru, Central Coast(?)
1000–1400
Wool, 41 × 12⅝ (104.1 × 32.1)
86.224.94

Textile Fragment
Peru, Central Coast
1000–1400
Wool, 7⅞ × 12³/₁₆ (20 × 31)
86.224.3

Border Fragment
Peru, Central Coast
1000–1400
Wool, 43¹¹/₁₆ × 12³/₁₆ (111 × 31)
86.224.139

Sash
Peru, Central Coast(?)
1000–1400
Cotton, 98¾ × 4½ (250.8 × 11.4)
86.224.101

Textile Fragment
Peru, Central Coast
1000–1400
[Material?], 10¼ × 36⅝ (26 × 93)
86.224.131

Textile Fragment
Peru, Central Coast
1000–1400
Wool, 36⅝ × 21¼ (93 × 54)
86.224.130

Garment Border Fragment
Peru, Central Coast
1000–1400
Cotton, 24½ × 10¾ (61.6 × 27.3)
86.224.108

Headband (?)
Peru, Central Coast(?)
1000–1400
Cotton, 40 × 2⁹/₁₆ (10.2 × 6.5)
86.224.100

Cap
Peru, Central Coast
1000–1400
Cotton, 10 × 4⅜ (25.4 × 11.1)
86.224.92

Tump Line
Peru, Central Coast
1000–1400
Wool, 116¹⁵/₁₆ × 1¹¹/₁₆ (297 × 4.3)
86.224.65

Pouch Containing Coca Leaves
Peru, Central Coast
1400–1500
Wool, 4⁵/₁₆ × 3¹³/₁₆ (11 × 9.7)
86.224.62

Scale Beam and Bags
Peru, Central Coast
1000–1400
Wood, cotton, 10¹³/₁₆ (27.5) long
86.224.79a,b

Mask
Peru, Central Coast
1000–1400
Wood, shell, fabric, 12⅝ × 7⅜
 (32 × 18.7)
86.224.125

Earplugs
Peru, North Coast, Chimu
1000–1500
Wood, shell, turquoise, mother-of-
 pearl, 2³/₁₆ × 1⅜ (5.5 × 3.5) each
86.224.120a, b

Earplugs
Peru, North Coast, Chimu
1000–1500
Silver, gold, stone, 3¹/₁₆ (7.8) diameter
 each
86.224.194 a,b

Earplugs
Peru, North Coast, Chimu
1000–1500
Silver, 1¾ × 2⅜ (4.5 × 6) each
86.224.31 a,b

Tupu
Peru, North Coast, Chimu
1000–1500
Silver, 10⁷/₁₆ (26.5) long
86.224.184

Tupu
Peru, North Coast, Chimu
1000–1500
Silver, 9⁵/₁₆ (23.7) long
86.224.186

Tupu
Peru, North Coast, Chimu
1000–1500
Copper, 5¹¹/₁₆ × ¹¹/₁₆ (14.4 × 1.8)
86.224.88

Tupu
Peru, North Coast, Chimu
1000–1500
Copper, 4¹⁵/₁₆ (12.5) long
86.224.89

Tupu
Peru, North Coast, Chimu
1000–1500
Silver, 9⁹/₁₆ (24.3) long
86.224.185

Mask
Peru, Chimu(?)
1000–1500
Reeds, feathers, wool, 10⅝ × 14³/₁₆
 (27 × 36)
86.224.123

Mask
Peru, North Coast, Chimu
1000–1400
Wood, paint, 11⅞ × 6⁷/₁₆
 (30.2 × 16.4)
86.224.124

Parrot Figure
Peru, Chimu(?)
1000–1500
Silver, 1¼ × ¹⁵/₁₆ × 1⅞
 (3.2 × 2.3 × 4.7)
86.224.24

Head
Peru, North Coast, Chimu
1000–1500
Gold, 3⅜ × 2¾ × 2¾ (8.5 × 7 × 7)
86.224.21

Ornament
Peru, North Coast, Chimu
1000–1500
Bronze, 3¹⁵/₁₆ × 2 (10 × 5)
86.224.122

Scale Beam
Peru, North Coast, Chimu
1000–1500
Bronze, 2³/₁₆ × 4⁵/₁₆ (5.6 × 11)
86.224.119

Staff Top(?)
Peru, North Coast, Chimu
1000–1500
Bronze, 3¹/₁₆ × 3¼ (7.7 × 8.3)
86.224.118

Effigy Vessel
Peru, North Coast, Chimu
1000–1500
Ceramic, bichrome slip, 9¾ × 6½
 (24.8 × 16.5)
86.224.173

Necklace
Peru, Chimu (?)
1000–1500
Copper, 7⅞ × 1³/₁₆ (20 × 3)
86.224.42

Figure
Peru, Chimu(?)
Authenticity uncertain
Bronze, 2³/₁₆ × 1 × 1³/₁₆
 (5.5 × 2.5 × 3)
86.224.20

Crab Amulet
Peru
1000–1500
Gold, 1⅜ × ¹¹/₁₆ (3.5 × 1.8)
86.224.36

Crab Amulet
Peru
1000–1500
Gold, 1⁷/₁₆ × ⅝ (3.7 × 1.6)
86.224.37

Figurine
Peru, North Coast
1000–1400
Turquoise, 2¼ × 1½ (5.7 × 3.8)
86.224.165

Staff Head / Rattle
Peru, North Coast, Chimu or Inca
1400–1500
Bronze, 2⅜ × 1¾ (6 × 4.5)
86.224.38

Knife
Peru, North Coast, Chimu or Inca
1400–1500
Bronze, 6⅜ × ⅝ (16.2 × 1.6)
86.224.41

Pouch
Peru, Inca
1470–1532
Cotton, wool, 6¹¹/₁₆ × 5⅞ (17 × 15)
86.224.63

Effigy Vessel
Peru, Inca
1470–1532
Stone, 3¹/₁₆ × 2³/₁₆ × 4¾
 (7.8 × 5.6 × 12)
86.224.85

Textile
Peru, Pachacamac(?)
Pre–1500
Cotton, 189⁵/₁₆ × 25³/₁₆ (482.5 × 64)
86.224.59

Necklace
Peru, South Coast(?)
Pre–1500
Spondylus shell, cotton, wool,
 23¾ (60.4) long
86.224.199

Sling
Peru, South Coast, Ica
Pre–1500
Wool, 67¹¹⁄₁₆ × 1³⁄₁₆ (172 × 3)
86.224.82

Sling
Peru, South Coast, Ica
Pre–1500
Wool, 87 × 1⁷⁄₈ (221 × 4.7)
86.224.81

Mantle
Peru, South Coast, Ica(?)
Pre–1500
Cotton, 58¼ × 15³⁄₈ (148 × 39)
86.224.75

Textile
Peru, Central Coast
Pre–1500
Cotton, wool, 41⁵⁄₁₆ × 24¹³⁄₁₆ (105 ×
 63)
86.224.68

Tump Line
Peru, Central Coast
Pre–1500
Wool, 96¹⁄₁₆ × 1³⁄₈ (244 × 3.5)
86.224.66

Tump Line
Peru, Central Coast
Pre–1500
Wool, 94½ × 2³⁄₁₆ (240 × 5.5)
86.224.67

Shirt
Peru
Pre–1500
Cotton, 17½ × 27⁹⁄₁₆ (44.5 × 70)
86.224.74

Textile Fragment
Peru
Pre–1500
Cotton, wool, 13 × 10¼ (33 × 26)
86.224.64

Shirt
Peru
Pre–1500
Cotton, wool, 29½ × 44⁵⁄₁₆
 (75 × 112.5)
86.224.70

Pouch
Peru
Pre–1500
Cotton, wool, 11¹³⁄₁₆ × 5⁷⁄₈ (30 × 15)
86.224.61

Ornament
Peru
Pre–1500
Antler horn, 3⅛ × 2³⁄₁₆ (8 × 5.5)
86.224.76

Ornament
Peru
Pre–1500
Antler horn, 3³⁄₈ × 2 (8.5 × 5)
86.224.77

Flask
Peru
Pre–1500
Wood, coral, shell, cotton, wool,
 5½ × 2³⁄₁₆ (14 × 5.5)
86.224.78

Puma Head Amulet
Peru
Pre–1500
Bronze, ¹¹⁄₁₆ × ⁹⁄₁₆ × ³⁄₈
 (1.8 × 1.5 × 1)
86.224.34

Stave
Northern Peru
Pre–1500
Bronze, 12³⁄₈ × 1½ (31.5 × 3.8)
86.224.27

Head
Peru
Pre–1500
Bronze, 1⁹⁄₁₆ × 1³⁄₈ (4 × 3½)
86.224.39

Miniature Mask
Peru
Pre–1500
Gold, 1³⁄₁₆ × 2 (3 × 5)
86.224.23

Figure
Peru
Pre–1500
Silver, 2 × ¹³⁄₁₆ (5 × 2)
86.224.87

Figurine
Peru(?)
Pre–1500
Stone, 2³⁄₈ × ¹⁵⁄₁₆ × ½
 (6.1 × 2.3 × 1.3)
86.224.35

Ax
Peru or Argentina
Pre–1500
Bronze, 8¹¹⁄₁₆ × 5 (22 × 12.7)
86.224.26

Textile
Bolivia, Andean Highlands
19th century
Wool, 83⁷⁄₈ × 31⅛ (213 × 79)
86.224.32

Central American Art

Alligator Amulet
Panama(?)
Date uncertain
Silver, stone, shell, 1³⁄₈ × ¾
 (3.5 × 1.9)
86.224.40

North American Indian Art

Mask
North America, Oklahoma, Missis-
 sippi Culture
1200–1500
Wood, 2¼ × 1⁷⁄₁₆ (5.7 × 3.7)
86.224.159

Mask
North America, Oklahoma,
 Mississippi Culture
1200–1500
Wood, 2¼ × 1⁷⁄₁₆ (5.7 × 3.7)
86.224.160

Mask
North America, Oklahoma,
 Mississippi Culture
1200–1500
Wood, 2¼ × 1⁷⁄₁₆ (5.7 × 3.7)
86.224.161

Belt
North America, Navajo
20th century
Silver, leather, 32 (81.3) long
86.224.155

Wrist Guard
North America, Navajo
20th century
Leather, turquoise, silver, 3⁵⁄₈ × 2½
 (9.2 × 6.4)
86.224.158

Bird Rattle
North America, Northwest Coast
20th century
Wood, paint, fiber, 15¼ × 3³⁄₈
 (38.7 × 8.6)
86.224.156

Oceanic Art

Screen
Thailand or Indonesia
17th/18th century
Leather, 15⁹⁄₁₆ × 20¹¹⁄₁₆
 (39.5 × 52.5)
86.224.127

Screen
Indonesia
19th century
Leather, 54 × 48 (137.2 × 121.9)
86.224.204

Staff
Indonesia, Sumatra, Batak
19th/20th century
Wood, cotton, horsehair, metal, 68½
 (174) long
86.224.178

Pestle
Polynesia, Marquesas Islands
20th century
Stone, 8½ × 5¼ (21.6 × 13.3)
86.224.157

Lime Spatula
Papua New Guinea, Massim region
20th century
Wood, 11½ (29.2) long
86.224.147

Lime Spatula
Papua New Guinea, Massim region
20th century
Wood, 17 (43.2) long
86.224.148

Pendant (hei tiki)
New Zealand, Maori style
20th century, authenticity uncertain
Bone, 2 × 1⅛ (5.1 × 2.9)
86.224.153

African Art

Horn
Zaire, Pende
19th–20th century
Ivory, 19¾ × 3 (50.2 × 7.6)
86.224.145

Charm
Zaire, Luba
19th–20th century
Ivory, 3¼ × ¾ × 1³⁄₁₆ (8.3 × 1.9 × 3)
86.224.166

Bell
Gabon, Tsogo
19th–20th century
Iron, wood, paint, 16¾ (42.5) high
86.224.146

Equestrian Figure
Mali, Dogon
19th–20th century
Wood, 15¾ × 3⅝ (40 × 9.2)
86.224.150

Mask
Ivory Coast, Baule
19th–20th century
Wood, paint, 16¼ × 9 (41.3 × 22.9)
86.224.151

Mask
Ivory Coast or Liberia, Dan
19th–20th century
Wood, 9¼ × 6⁵⁄₁₆ (23.5 × 16)
86.224.201

Weight
Ghana, Ashanti
19th–20th century
Bronze, 5½ × 2½ (14 × 6.4)
86.224.164

Ancient Egyptian Art

Stela in the Form of a False Door
Egypt
Late Old Kingdom–early Middle
 Kingdom, circa 2200–2000 B.C.
Limestone, 25⅜ × 15¹⁵⁄₁₆ × 4½
 (64.0 × 40.5 × 11.4)
86.226.29

Statuette of a Standing Hippopotamus
Egypt
Middle Kingdom, probably Dynasty
 XII, circa 1994–1781 B.C.
Glazed faience, 7⁷⁄₁₆ (18.8) long
86.226.2

Face of a Woman
Egypt
New Kingdom, early Dynasty XVIII,
 circa 1500–1450 B.C.
Limestone, 2¾ × 2½ (7.0 × 6.4)
86.226.36

Relief of a Statue of Tuthmosis III
Egypt, Deir el Bahri
New Kingdom, Dynasty XVIII,
 reign of Tuthmosis III,
 circa 1479–1425 B.C.
Limestone, 6⅞ × 6⁷⁄₁₆ (17.5 × 16.3)
86.226.3

Relief of a Bowing Courtier
Egypt, Hermopolis but originally from
 El Amarna
New Kingdom, Dynasty XVIII,
 Amarna Period,
 circa 1345–1330 B.C.
Limestone, 8¼ × 15⁵⁄₁₆ × 2⅞
 (21.0 × 38.8 × 4.8)
86.226.26

Relief of a Woman
Egypt, presumably El Amarna
New Kingdom, Dynasty XVIII,
 Amarna Period,
 circa 1345–1330 B.C.
Limestone, 9¹⁄₁₆ × 21¹⁄₁₆ × 1⁹⁄₁₆
 (23.1 × 53.5 × 4.0)
86.226.33

Toilet Dish in the Form of an Oryx
Egypt
New Kingdom, late Dynasty
 XVIII–Dynasty XX,
 circa 1330–1075 B.C.
Faience, 2¹¹⁄₁₆ × 4¹³⁄₁₆ × ¹³⁄₁₆
 (7.1 × 12.3 × 2.0)
86.226.16

Relief of Two Men with Horses
Egypt
New Kingdom, Dynasty XIX,
 circa 1291–1185 B.C.
Sandstone, 9¼ × 18¹³⁄₁₆ × 1⅝
 (23.5 × 47.8 × 4.2)
86.226.31

Relief of a Nobleman
Egypt, Thebes
Late Period, late Dynasty
 XXV–early Dynasty XXVI,
 circa 670–650 B.C.
Limestone, 3¹³⁄₁₆ × 5½ (9.7 × 14.0)
86.226.5

Relief of a Nobleman
Egypt, Thebes
Late Period, late Dynasty
 XXV–early Dynasty XXVI,
 circa 670–650 B.C.
Limestone, 6⁹⁄₁₆ × 5 (16.6 × 12.7)
86.226.9

Hieroglyphs in Raised Relief
Egypt, Thebes
Late Period, probably early
 Dynasty XXVI,
 circa 664–610 B.C.
Limestone, 4⅜ × 3⁷⁄₁₆ (11.1 × 8.8)
86.226.10

Relief of a Workman
Egypt, Thebes
Late Period, probably early
 Dynasty XXVI,
 circa 664–610 B.C.
Limestone, 5 × 5¾ (12.7 × 14.6)
86.226.6

Torso of a Man Named Ziharpto
Egypt
Late Period, Dynasty XXX,
 reign of Nectanebo II,
 360–342 B.C.
Schist, 18⁹⁄₁₆ (47.1) high
86.226.17

Head of a Man
Egypt
Ptolemaic Period,
 circa 310/05–30 B.C.
Granite, 2⁹⁄₁₆ (6.5) high
86.226.13

Bolti Fish
Egypt
Early Roman Period,
 circa 1st–2nd century
Bronze, 6 (15.3) long
86.226.12

Rim Fragment from a Vessel
Egypt
Early Roman Period, 1st–2nd century
Faience, 1¹⁵⁄₁₆ × 1¹¹⁄₁₆ × 1³⁄₁₆
 (5.0 × 4.4 × 3.1)
86.226.23

Relief with Vine Motif
Egypt, Behnasa
Coptic Period, 5th–6th century
Limestone, 8³⁄₁₆ × 20⁷⁄₈ × 2¹¹⁄₁₆
 (20.8 × 53.0 × 6.8)
86.226.27

Openwork Plaque
Egypt(?)
Roman Period(?), authenticity
 uncertain
Ivory, 2³⁄₁₆ × 3¹³⁄₁₆ × ³⁄₈
 (5.6 × 9.6 × .45)
86.226.4

Ancient Iranian Art

Tripod Vase
Iran
Circa 1200 B.C.
Pottery, 5 × 3 (12.7 × 7.6)
86.226.60

Spoon
Iran
Circa 11th century B.C.
Copper, 7½ × 2½ (19.0 × 6.4)
86.226.54

Ax Head
Iran
Luristan, circa 11th century B.C.
Bronze, 2½ × 3¾ (6.4 × 9.5)
86.226.41

Miniature Ax Head
Iran
Circa 11th century B.C.
Bronze, ³⁄₈ × 1 (0.9 × 2.5)
86.226.49

Miniature Ax Head
Iran
Circa 11th century B.C.
Bronze, 2⁵⁄₈ (6.7) long
86.226.50

Man with Upraised Arms
Iran
Circa 10th century B.C.
Bronze, 2³⁄₈ × 2 (6.0 × 5.1)
86.226.43

Dagger
Iran
Luristan, circa 9th century B.C.
Bronze, 10¾ (27.3) long
86.226.37

Miniature Horse
Iran
Luristan, circa 9th century B.C.
Bronze, 1¾ × 2¼ (4.4 × 5.7)
86.226.48

Miniature Horse
Iran
Amlash, circa 9th century B.C.
Bronze, 1 × 1¼ (2.5 × 3.2)
86.226.51

Miniature Horse
Iran
Amlash, circa 9th century B.C.
Bronze, ⁷⁄₈ × 1½ (2.2 × 3.8)
86.226.52

Fibula
Iran
Amlash, circa 9th century B.C.
Bronze, ¾ × 1¼ (2.2 × 3.2)
86.226.53

Miniature Humped Bull
Iran
Amlash, circa 9th century B.C.
Bronze, 1½ × 1¾ (3.8 × 4.4)
86.226.55

Miniature Stag
Iran
Amlash, circa 9th century B.C.
Bronze, 1¼ × 1³⁄₈ (3.2 × 0.9)
86.226.56

Ornament with Ducks
Iran
Circa 9th–10th century B.C.
Bronze, 2½ × 4⁵⁄₈ (6.5 × 12.2)
86.226.45

Bowl
Iran
Luristan, circa 9th–7th century B.C.
Bronze, 6½ (16.5) diameter
86.226.38

Pin with Bull Terminal
Iran
Circa 8th century B.C.
Bronze, 10¾ × 1¹⁄₁₆ (27.3 × 2.7)
86.226.46

Pin with Human Terminal
Iran
Circa 8th century B.C.
Bronze, 6¾ × 1¾ (17.1 × 4.4)
86.226.47

Bracelet
Iran
Luristan, circa 8th century B.C.
Bronze, ¼ × 3 (0.6 × 7.6)
86.226.42

Horse Ornament
Iran
Circa 8th century B.C.
Bronze, 1¾ × 3 (4.4 × 7.6)
86.226.44

Bowl
Iran
Achaemenid Period, 6th century B.C.
Bronze, 1½ × 5¾ (3.8 × 14.6)
86.226.64

Bull
Iran
Probably modern
Pottery, 10 × 12 (25.4 × 30.5)
86.226.57

Indian and Southeast Asian Art

Transportation of the Relics
India, Gandhara region
Kushan Period, 1st–2nd century
Gray schist, 6¼ × 11 (27.5 × 15.0)
86.227.34

Head
India, Mathura region
Kushan Period, circa 2nd century
Red sandstone, 8 × 6 (20.0 × 15.5)
86.227.32

Head
India
Kushan Period, circa 2nd century
Terracotta, 2³⁄₈ (5.5)
86.227.33

Head of a Male
India, Mathura
Kushan Period, 2nd–3rd century
Red-gray sandstone, 6½ (16.5)
86.227.135

Female Bust
India, Mathura region
Gupta Period, 5th century
Red sandstone, 7¼ × 11½
 (19.0 × 29.0)
86.227.23

Head
India, Mathura
Gupta Period, 5th century
Terracotta, 3¾ × 3 (9.5 × 7.5)
86.227.146

Relief Fragment Depicting a Yaksi
India, Mathura
Gupta Period, circa 6th century
Mottled red sandstone, 20 × 7¼
 (50.8 × 18.4)
86.227.169

Head of a Buddha
Nepal, Lauriya-Nandangarh
6th century
Red terracotta, 6¼ × 4¼
 (15.8 × 10.8)
86.227.170

Head
Nepal, Lauriya-Nandangarh
6th century
Red terracotta, 4½ × 4¼
 (11.5 × 10.8)
86.227.171

Standing Buddha
Thailand
Dvaravati Period, 8th century
Bronze, 11½ × 3¾ (29.3 × 10.0)
86.227.29

Ritual Bell
Central Java
9th century
Bronze, 5¾ × 6¼ (14.7 × 14.5)
86.227.44

Bodhisattva Manjusri as Manhughosa
India, Bihar
Pala Period, circa 9th–10th century
Gray stone, 13½ × 8¾ (33.0 × 22.8)
86.227.45

Uma-Mahesvara
India, Bihar
Pala Period, circa 10th century
Black chlorite, 14½ × 9¼
 (38.0 × 23.0)
86.227.30

Shardula and an Elephant
India, Orissa
Circa 10th–11th century
Sandstone, 16 × 6½ (42.0 × 16.0)
86.227.31

*Bracket Figure Representing a
 Drummer*
India, Southern Rajasthan
Circa 12th century
White marble, 29¾ (75.7)
86.227.180

Buddha Sheltered by Mucalinda
Thailand
Lopburi Period, 12th century
Gray sandstone, 20½ × 9⅞
 (52.1 × 25.0)
86.227.37

Fragment of a Head
Thailand
Khmer Period, Lopburi style, 12th–
 13th century
Stucco, 4½ (11.0) high
86.227.42

Male Head
Cambodia
Khmer Period, Angkor Thom style,
 late 12th, early 13th century
Gray sandstone, 7 (18.2)
86.227.39

Female Figure
Cambodia
Khmer Period, Post-Bayon style, late
 13th century
Gray sandstone, 31½ × 10
 (80.0 × 25.4)
86.227.38

Unidentified Disciple of the Buddha
Japan
Muromachi Period, circa 16th century
Wood, 30½ (77.3) high
86.227.207

Dagger
Sri Lanka
17th century
Bronze with silver mount and red
 velvet sheath 16 × 2½ (36.5 × 6.0)
86.227.36a,b

*Sword and Silver-Mounted Wood
 Sheath*
Sri Lanka
17th century
Bronze with pierced-work ivory
 handle, 29 (73.7) long
86.227.35a,b

Nayika, from a Rasikapriya Series
India, Malwa
1634
Opaque watercolors on paper,
 7¾ × 6⅛ (19.6 × 15.5)
86.227.51

Study of a Pair of Doves
India, Mughal School
Style of circa 1650
Opaque watercolors on paper,
 5¾ × 3 (14.6 × 7.6)
86.227.152

Page from a Ragamala Series
India, Rajasthan, Mewar
Late 17th century
Opaque watercolors on paper, 8½ × 6
 (21.5 × 15.2)
86.227.138

*Portrait of Abu'l Hasan, the Last
 Sultan of Golconda*
India, Deccan, Hyderabad
Late 17th, early 18th century
Opaque watercolors and gold on
 paper, 7½ × 5
 (19.1 × 12.7)
86.227.50

Pair of Earrings
Nepal
17th or 18th century
Silver inlaid with turquoise, 3⅞
 (10.0)
86.227.43a,b

Chess Piece
India, Rajasthan
18th century (?)
Ivory, 2¾ (7.0) high
86.227.46

Nayika Scene
India, Delhi School
18th century
Opaque watercolors on paper,
 18 × 12 (45.7 × 30.5)
86.227.55

Prince Seated on a Terrace
India, Rajasthan
Early 18th century
Opaque watercolors on paper,
 18½ × 12½ (40.7 × 31.8)
86.227.54

Portrait of Phul Kaur of Jaipur
India, Rajasthan
Late 18th century
Opaque watercolors on paper, 10 × 7
 (25.5 × 17.8)
86.227.52

Ganesha with Two Attendants
Frontispiece of a manuscript
India, Punjab Hills, Kangra
Circa 1790
Opaque watercolors on paper,
 6⅜ × 9 (15.7 × 22.9)
86.227.178

Islamic Art

These works are arranged by country,
medium, and, within those categories,
chronologically.

Textile Fragment
Iraq
9th century
Cotton and wool, compound twill,
 15½ × 13 (39.3 × 33)
86.227.143

Textile Fragment
Iraq
9th century
Cotton, 12½ × 9 (31.7 × 22.8)
86.227.144

Fragment of a Bowl
Egypt or Syria
12th–13th century
Ceramic, blue, black, and gray
 underglaze decoration, transparent
 colorless glaze, 5 (12.7) diameter
86.227.58

Tile
Syria
16th century
Ceramic, cobalt-blue, turquoise, and
 white glazes, 11 × 11½
 (28.0 × 29.2)
86.227.90

Tile
Syria
16th century
Ceramic, cobalt-blue, purple, and
 turquoise glazes, 11½ × 11½
 (29.2 × 29.2)
86.227.91

*Tiraz Textile Fragment Inscribed with
 the Name of Caliph al-Muti'*
Egypt, Fatimid Period
946–974
Linen, tapestry-woven inscription,
 15 × 23½ (38.1 × 59.7)
86.227.99

Tiraz Textile Fragment
Egypt, Fatimid Period
11th century
Linen, tapestry-woven decoration,
 7 × 7¾ (17.8 × 19.7)
86.227.101

Tiraz Textile Fragment
Egypt, Fatimid Period
11th century
Linen, tapestry-woven decoration,
 13¼ × 7 (33.7 × 17.7)
86.227.98

Bowl
Iran, Nishapur
10th century
Ceramic, white engobe, brown, yellow,
 and green slip, transparent colorless
 glaze, 3⅛ × 8¼
 (8.0 × 21.0)
86.227.1

Bowl
Iran, Nishapur
10th century
Ceramic, white engobe, brown, yellow,
 and green slip, transparent colorless
 glaze, 3¼ × 8½ (8.3 × 21.5)
86.227.3

Bowl
Iran, Nishapur
10th century
Ceramic, white engobe, brown slip,
 transparent colorless glaze,
 4⅛ × 12¼ (10.6 × 31.3)
86.227.5

Bowl
Iran, Nishapur
10th century
Ceramic, white engobe, brown, yellow,
 and green slip, transparent colorless
 glaze, 4⅛ × 10⅝
 (26.9 × 10.3)
86.227.13

Bowl
Iran, Nishapur
10th century
Ceramic, brown and white slip, trans-
 parent colorless glaze, 3⅛ × 11
 (8.0 × 28.2)
86.227.21

Bowl
Iran
10th century
Ceramic, Sari ware, white engobe,
 brown, yellow, and green slip,
 transparent colorless glaze,
 2¾ × 6½ (6.3 × 20.7)
86.227.2

Bowl
Iran
10th–11th century
Ceramic, Sari ware, white engobe,
 brown, green, and yellow slip,
 transparent colorless glaze,
 2½ × 6¾ (6.3 × 17.1)
86.227.84

Bowl
Iran
11th century
Ceramic, brown, green, and yellow
 slip, transparent colorless glaze,
 3 × 8½ (7.6 × 21.6)
86.227.86

Fragment of a Bowl
Iran
11th–12th century
Ceramic, champleve ware, white slip,
 transparent colorless glaze,
 2½ (6.9) high
86.227.87

Bowl
Iran
11th–12th century
Ceramic, champleve ware, transparent
 green glaze, 2½ × 7 (6.3 × 17.8)
86.227.179

Lamp with Long Neck
Iran
12th century
Ceramic, turquoise glaze, 11 (28) high
86.227.68

Bowl
Iran, Kashan
13th century
Ceramic, black and blue underglaze
 decoration, transparent colorless
 glaze, 4 × 8½ (10.2 × 21.6)
86.227.74

Bowl
Iran, Kashan
13th century
Ceramic, black and blue underglaze
 decoration, transparent colorless
 glaze, 3¼ × 8¼
 (8.3 × 21.0)
86.227.75

Tile
Iran, Kashan
13th century
Ceramic, molded, lusterware with
 cobalt-blue and turquoise
 underglaze decoration,
 10¹⁵⁄₁₆ × 9⁷⁄₁₆ (27.8 × 24.0)
86.227.141

Bowl
Iran, Kashan
13th century
Ceramic, black and blue underglaze
 decoration, transparent colorless
 glaze, 4¼ × 7½
 (10.8 × 19.1)
86.227.10

Bowl
Iran, Kashan
13th century
Ceramic, black and blue underglaze
 decoration, transparent colorless
 glaze, 2¾ × 12½ (7.0 × 31.7)
86.227.12

*Bowl Depicting Bahram Gur and
 Azadeh*
Iran, Rayy
13th century
Ceramic, Minai ware, 3¹³⁄₁₆ × 8¼
 (9.7 × 20.9)
86.227.11

*Bowl Depicting a Falconer and Four
 Pairs of Seated Figures*
Iran, Rayy
13th century
Ceramic, Minai ware, 8⅛
 (20.6) diameter
86.227.65

*Bowl Depicting a Seated Figure
Surrounded by Sphinxes and
Winged Lions*
Iran, Rayy
13th century
Ceramic, Minai ware, 3¼ × 7
(8.3 × 17.8)
86.227.63

*Bowl Depicting Two Lion Hunters
on Horseback*
Iran, Rayy
13th century
Ceramic, Minai ware, 3½ × 7½
(8.9 × 19.0)
86.227.60

Bowl
Iran, Rayy
13th century
Ceramic, lusterware, transparent blue
glaze on exterior, 2½ × 5½
(6.3 × 14.0)
86.227.64

Jug
Iran
13th century
Ceramic, incised, transparent
turquoise glaze, 8 × 5½
(20.3 × 14.0)
86.227.59

Jug
Iran
13th century
Ceramic, Lajvardina ware, 7⅛ × 4½
(18.1 × 11.4)
86.227.195

Octagonal Star Tile
Iran, Kashan
Dated 680 A.H./1283 A.D.
Ceramic, lusterware with turquoise
underglaze decoration, 8 (20.3)
wide
86.227.72

Vase
Iran
13th century
Ceramic, green glaze, 5 × 4
(12.7 × 10.2)
86.227.79

Bowl
Iran
13th–14th century
Ceramic, Sultanabad ware, blue, black,
and turquoise underglaze decora-
tion, transparent colorless glaze,
3⅜ × 8½ (8.6 × 21.6)
86.227.78

Plate
Iran, Kirman
18th century
Ceramic, brown slip, transparent
colorless glaze, 8¾ (22.2) diameter
86.227.193

*Foot of a Lampstand in the Form of a
Gazelle*
Iran
12th century
Bronze, hollow cast, 7⅜ × 4
(18.2 × 10.2)
86.227.125

Incense Burner
Iran
12th century
Bronze, incised and openwork decora-
tion, 10 × 4 (25.4 × 10.2)
86.227.122

*Two Folios from a "Khamseh" of
Nizami: Bahram Gur Hunting and
a Text Page*
Iran, Shiraz
Circa 1481
Opaque watercolor and ink on paper,
miniature: 4 × 4/16 (10.2 × 10.3)
86.227.129

*Folio from a "Shahnameh": A King
and a Visitor with Attendants*
Iran, Shiraz
Late 15th, early 16th century
Opaque watercolor and ink on paper,
9½ × 5⅞/16 (24.1 × 13.7)
86.227.174

*Folio from a "Shahnameh": The Battle
of Rustam and the Khan of Chin*
Iran, Shiraz
Late 15th, early 16th century
Opaque watercolor and ink on paper,
9½ × 5⁷/16 (24.1 × 13.7)
86.227.175

*Folio from a "Shahnameh": A King
and Courtiers in a Garden*
Iran, Shiraz
Late 15th, early 16th century
Opaque watercolor and ink on paper,
9½ × 5⁷/16 (24.1 × 13.7)
86.227.176

*Folio from a "Shahnameh": The
Iranians Capture Afrasiyab's
Fortress*
Iran, Shiraz
Circa 1580–90
Opaque watercolor and ink on paper:
sheet, 14½ × 8¾ (36.8 × 22.2);
miniature, 11⅝ × 6⅜
(29.5 × 16.2)
86.227.148

*Folio from a "Shahnameh": Rustam
Fighting Puladvand Div*
Iran, Shiraz
Circa 1580–90
Opaque watercolor and ink on paper:
sheet, 14⁹/16 × 8¹⁵/16 (37 × 22.7);
miniature, 9⁹/16 × 6¾
(24.3 × 17.1)
86.227.149

*Folio from a "Shahnameh": The
Death of Rustam and His Killing of
Shaghad*
Iran, Shiraz
Circa 1580–90
Opaque watercolor and ink on paper:
sheet, 14½ × 8¾ (36.8 × 22.2);
miniature, 10 × 7 (25.4 × 17.8)
86.227.151

Man Holding a Pomegranate
Falsely ascribed to Riza-yi 'Abbasi
Iran, Isfahan
Dated 1028 A.H./A.D. 1618
Ink and light color on paper: sheet,
12⅝ × 8¼ (32.0 × 21.6);
miniature, 4⁵/16 × 2⁵/16 (11.7 × 6.5)
86.227.163

Inside Flap of a Book Cover
Iran
16th century
Leather, gesso and opaque watercolor,
10 × 4¼ (25.4 × 10.8)
86.227.188

Textile
Iran
16th–17th century
Silk and wool, 62 × 36
(157.5 × 91.4)
86.227.11

Textile Fragment of a Hunting Scene
Iran
17th century
Silk brocade, 14½ × 14
(36.8 × 35.6)
86.227.107

Textile Fragment
Iran
17th century
Silk brocade, 28½ × 12½
(72.4 × 31.7)
86.227.203

So-called Buyid Textile
Iran
20th century
Silk, 32¾ × 34 (83.2 × 86.4)
86.227.181

Textile Fragment with Animal Combat
Iran
17th-century style
Silk brocade, 19⅝ × 19½
 (49.8 × 49.5)
86.227.105

*Textile Fragment with Young Men
 Reading*
Iran
17th-century style
Silk brocade, 10 × 14 (25.4 × 35.5)
86.227.147

*Textile Fragment with Hunter on
 Horseback*
Iran
17th-century style
Silk brocade, 10 × 17½
 (25.3 × 43.5)
86.227.155

Medallion Carpet
Iran
18th century
Wool and cotton (?), 274 × 99
 (698.4 × 2511.6)
86.227.110

Garden Carpet
Iran
20th century, 18th-century style
Wool, 190 × 118 (502.9 × 284.6)
86.227.117

Bowl
Turkey
Byzantine Period, 13th century
Ceramic, sgraffiato ware, reddish
 brown glaze, 3½ × 6⅛
 (8.9 × 15.5)
86.227.186

Plate
Turkey, Isnik
Circa 1560
Ceramic, cobalt-blue, turquoise, red,
 and white glazes, 2½ × 13¾
 (6.5 × 30.5)
86.227.201

Tile
Turkey, Isnik
Second half of 16th century
Ceramic, cobalt-blue, turquoise, red,
 and white glazes, 7½ × 11¾
 (19 × 29.7)
86.227.184

Tile
Turkey
Second half of 16th century
Ceramic, transparent colorless glaze,
 cobalt-blue and turquoise
 underglaze, off-white body,
 10¼ × 9½ (26.0 × 24.1)
86.227.199

Tile
Turkey
16th century
Ceramic, cobalt-blue, turquoise, red,
 and white glazes, 9½ × 9¾
 (24.1 × 24.8)
86.227.200

Textile Panel
Turkey
17th–18th century
Silk brocade, compound twill,
 41 × 27 (104.1 × 68.6)
86.227.204

Cushion Cover
Turkey
Late 18th century
Linen, embroidered, 42½ × 41¼
 (107 × 104.8)
86.227.112

Prayer Rug
Turkey, Ghiordes
18th century
Wool warp, weft, and pile, 66 × 48
 (167.7 × 122.0)
86.227.92

Prayer Rug
Turkey, Ghiordes
18th century
Wool warp, weft, and pile, 72 × 51
 (183.0 × 129.6)
86.227.120

Prayer Rug
Turkey, Ghiordes
18th century
Wool, 70 × 50 (177.9 × 127.1)
86.227.119

Prayer Rug
Turkey, Kula
18th century
Wool, 74 × 49 (188.1 × 124.6)
86.227.93

Prayer Rug
Yugoslavia, Pirot
19th century
Wool, kilim, 61 × 39 (155.1 × 99.1)
86.227.95

Carpet
Caucasus, Shirvan
19th century
Wool warp, weft, and pile, 70 × 43
 (177.9 × 109.3)
86.227.94

Decorative Arts

Plate
Spain
Early 16th century
Tin-glazed earthenware, 2½ × 17⅞
 (6.3 × 42.8)
86.225